ARTISTS AND TRADITIONS

USES OF THE PAST IN CHINESE CULTURE

ARTISTS

EDITED BY CHRISTIAN F. MURCK

AND

THE ART MUSEUM, PRINCETON UNIVERSITY

TRADITIONS

DISTRIBUTED BY PRINCETON UNIVERSITY PRESS

Designed by Bruce Campbell
Type set by William Clowes & Sons Ltd., London
Printed by Princeton University Press, Princeton, New Jersey

Library of Congress Catalogue Card Number 74–77300
International Standard Book Number 0–691–03909–7

Distributed by Princeton University Press, Princeton,
New Jersey 08540

To Irene and Earl Morse

CONTENTS

FOREWORD BY WEN C. FONG ix

INTRODUCTION BY CHRISTIAN F. MURCK xi

PART I

THE PAST IN CHINESE CULTURAL HISTORY

THE ARTS AND THE 'THEORIZING MODE' OF THE CIVILIZATION 3
F. W. Mote

'INNER EXPERIENCE': THE BASIS OF CREATIVITY IN NEO-CONFUCIAN
THINKING 9
Wei-ming Tu

TRADITION AND CREATIVITY IN EARLY CH'ING POETICS 17
James J. Y. Liu

THE RELATIONSHIP OF EARLY CHINESE PAINTING TO ITS OWN PAST 21
Alexander C. Soper

PART II

MODES OF ARCHAISM IN PAINTING

LI KUNG-LIN'S USE OF PAST STYLES 51
Richard Barnhart

THE USES OF THE PAST IN YÜAN LANDSCAPE PAINTING 73
Chu-tsing Li

ARCHAISM AS A 'PRIMITIVE' STYLE 89
Wen C. Fong

PART III

ORTHODOXY AND INDIVIDUALISM

TUNG CH'I-CH'ANG'S NEW ORTHODOXY AND THE SOUTHERN SCHOOL
THEORY 113
Wai-kam Ho

CONTENTS

ENDING LINES IN WANG SHIH-CHEN'S 'CH'I-CHÜEH': CONVENTION AND CREATIVITY IN THE CH'ING 131
Yu-kung Kao and Tsu-lin Mei

THE WAN-LI PERIOD VS. THE K'ANG-HSI PERIOD: FRAGMENTATION VS. REINTEGRATION? 145
Jonathan Spence

THE STYLE OF SOME SEVENTEENTH-CENTURY CHINESE PAINTINGS 149
Harrie A. Vanderstappen

THE ORTHODOX MOVEMENT IN EARLY CH'ING PAINTING 169
James Cahill

PART IV
A MODERN PERSPECTIVE

THE ORTHODOXY OF THE UNORTHODOX 185
Richard Edwards

ORTHODOXY AND INDIVIDUALISM IN TWENTIETH-CENTURY CHINESE ART 201
Michael Sullivan

CHINESE AND JAPANESE NAMES AND TERMS 207

THE CONTRIBUTORS 219

INDEX 223

FOREWORD

On May 17, 1969, a colloquium on Chinese art entitled "Artists and Traditions," jointly sponsored by the Departments of Art and Archaeology and East Asian Studies at Princeton, was held in conjunction with an exhibition of Chinese paintings called "In Pursuit of Antiquity," organized by the Princeton University Art Museum.[1] The panel that gave papers and participated in the discussions included both historians of Chinese art and scholars in various areas of Chinese cultural and intellectual history.

We are grateful to the contributors to this volume, as well as to other active participants in the colloquium: William T. de Bary, Tseng Yu-ho Ecke, Sherman E. Lee, James T. C. Liu, Max Loehr, Peter Swann, Nelson I. Wu, and many others. F. W. Mote, cofounder of Princeton's Ph.D. program in Chinese art, did much to inspire and guide the colloquium proceedings. The editor of this volume, Christian F. Murck, is a Ph.D. candidate in Ming intellectual history at Princeton. Having spent countless hours with the transcription of the day-long colloquium discussion, Mr. Murck coordinated the rewriting of the essays by their authors, organized them into the present book form, and also wrote the excellent Introduction.

Because Mr. Murck has been living in Kyoto for the past two years, many people have had to help with the production of the book. Lucy Lo, Curator of the Far Eastern Art Seminar at Princeton, once again lent her patient and indispensable hand to this project. Virginia Wageman of the Princeton Art Museum made sure that the illustrations and other details of the book met her usual high standards. Jean Owen edited the manuscript with a wonderful sensitivity to the material. Kasey Grier searched out photographs from all over the world, handled all the permissions, and wrote the illustration captions—all with tremendous energy and concern.

The publication of this volume was carried out with the help of a grant from the Publication Fund of the Department of Art and Archaeology.

<div style="text-align: right">

WEN C. FONG
Department of Art and Archaeology

</div>

1. See Roderick Whitfield, with an Addendum by Wen Fong, *In Pursuit of Antiquity: Chinese Paintings of the Ming and Ch'ing Dynasties from the Collection of Mr. and Mrs. Earl Morse* (Princeton, N.J., 1969).

INTRODUCTION

The basic hypothesis of this collection of essays is that interaction with the past is one of the distinctive modes of intellectual and imaginative endeavor in traditional Chinese culture. Such a hypothesis stimulates more doubts and questions than it resolves. It is obviously not tenable in the same way in all areas of cultural activity regardless of period: how then are its historical permutations to be defined, both generally for Chinese culture as a whole and particularly for separate fields and genres? Western concepts of originality, creativity, and orthodoxy, to mention a few that seem applicable, are obviously value-laden and far from constituting universals: how are they to be understood in the Chinese context? These questions suggest the central problems of this volume.[1]

Some examples may demonstrate the subtlety of the specific problems to which our attention is directed. The relationship of the Chinese to their past has rarely been more concisely expressed than by Confucius: "The Master said, 'I transmit rather than create; I believe in and love the ancients.'"[2] It is widely known that Confucius was indeed the heir rather than the progenitor of a long and sophisticated culture, in whose earliest records can be found interest in the past and concern for the commemoration of the activities of men. One can surely find earlier references to the past, so what is the importance of this passage? For one thing, it appears to pose certain difficulties for committed Confucians of later generations: how is Confucius as mere transmitter consistent with Confucius as inspired by a sense of mission and as the founder of their school? To a certain extent this passage could be ignored as indicating Confucius' humility; it did not always suffice to impede the impulse toward hagiography that by the end of the Han dynasty established Confucius as the Uncrowned King (su-wang) and Sage to whom

1. I would like to thank the following colleagues for their helpful comments on earlier versions of this introduction and for advice and support throughout the process of editing this book: Wen C. Fong, Lucy Lo, F. W. Mote, Jeannette Mirsky, Alfreda Johnson Murck, Jean Owen, David Sensabaugh, Judy Spear, and Virginia Wageman.
2. *Analects* VII.1. James Legge's translation in *The Chinese Classics* (London, 1865–95), 1 : 195, has been slightly modified.

authorship or editorial revision of the Classics was ascribed. Modern scholarship, relying on evidence other than this puzzling passage in the *Analects*, has been skeptical of the tradition of Confucius as author-editor.[3] It has not really come to grips with the central problem of Confucius' own and the later Confucians' understanding of their relation to the past. For hagiography was not the only response of Confucianism to the personal role of the Sage.

If we shift our perspective and ask not whether Confucius wrote the *Spring and Autumn Annals*, but how his statement of his relation to his cultural heritage was perceived by later Chinese, Chu Hsi's sophisticated comment on the above passage from the *Analects* is crucial:

> Transmit [*shu*] means simply to hand down from the old; make [*tso*] means to create or originate. Therefore, to create is impossible except for a Sage, whereas to transmit is within the capacity of a Worthy.... In trimming the *Book of Poetry*, fixing the *Rites* and *Music*, commenting on the Chou *Book of Changes*, and editing the *Spring and Autumn Annals*, Confucius was in all cases handing down what was old from the former Kings and never added his own creation. Thus his speaking of himself in this manner was due not only to his unwillingness to claim the role of creative Sage, but also to his unwillingness to attach himself openly to [the ranks of] the ancient Worthies. Thus as his virtue became fuller and fuller, his heart became more and more unassuming; he himself did not realize [the extent of] the humility of his words. However, at that time the work of creation was fairly complete; the Master therefore made a Great Synthesis [*ta-ch'eng*] of the various Sages and struck a Mean. Although this was "transmission," his merit was twice that of "making." One must understand this also.[4]

Chu Hsi's commentary summarizes the Confucian tradition surrounding the passage, and yet goes beyond it in locating Confucius' greatest achievement: he "made a Great Synthesis." Thus he returns to the central thrust of the original and makes us see that Confucius could indeed be creative without departing from the ancients, could indeed be a model scholar and teacher in a highly literate culture without having written books. What really matters in the Chinese view is the leap of imagination that enables one to comprehend the heritage and the moral courage to live by that sagely vision.

We have here a problem with multiple layers: Chu Hsi's commentary is an example of his own attempt at a Great Synthesis. Faithful to his model, he presents his prodigious scholarship in commentaries, letters, lectures, and conversations; he is transmitter rather than creator. It was the explicit claim of Chu's Tao-hsüeh school that the line of transmission of true Confucian learning had been broken off after Mencius, to be continued again only by the Five Masters of the Northern Sung. Chu Hsi's role in the South-

3. For example, see the comments of H. G. Creel, *Confucius: The Man and the Myth* (New York, 1949). pp. 102ff.

4. *Ssu-shu chi-chu, Ssu-pu pei-yao* ed., *Lun yu, chüan* 4, p. la.

ern Sung, with Lü Tsu-ch'ien, was to synthesize the Northern Sung thinkers in the great anthology *Chin-ssu-lu*[5] and to demonstrate the analytical power and subtlety of his view of the Confucian classics in a series of great commentaries. Proscribed as False Learning in his own time, Chu Hsi's teachings made claims to exclusive moral and cultural authority that were disliked by many of his contemporaries.[6] We thus have every reason to take seriously his comment that the merit of transmission is twice that of creation: it bears not only on the text in question, but also on Chu Hsi's own motivation and ideals as a Confucian.

The discussion above has certainly not dissolved the issue of individual achievement, but perhaps it suggests that when we stress the innovations of a thinker, his contribution to the development of Chinese culture, we should be aware that our perspective differs from his. For the Confucian the tendency was to see it as a problem of transmission and it was not in the least paradoxical that so many of the greatest Confucian thinkers were, like Confucius and Chu Hsi, out of step with their times and unacceptable to many of their contemporaries: they responded to the ancients. Though the individual's right or necessity to do that could not in theory be abrogated, his specific achievement in so doing was always open to challenge.

Turning to art, we find, in examining the relationships of artists to their stylistic models of the past, problems equally as complex as those in intellectual history. The difference between orthodox and individualist, for example, is harder to describe than that between the merely conventional and the inspired use of the past. One painter who was undoubtedly both individualist and inspired, yet who nevertheless felt the impact of the past, was Tao-chi (1641–ca. 1720). A social and political nonconformist, an artist who rejected slavish obedience to past styles, he said:

> For the self to be self, there must be a selfhood. The beards and eyebrows of the ancients may not grow in my face, nor could their lungs and bowels be placed in my torso. I shall vent my own lungs and bowels, and display my own beard and eyebrows. Though at times my painting may come near to so-and-so, it is he who comes to accommodate me, and not I who willfully imitate his style. It is naturally so! Wherefore indeed have I studied the past without attempting for transformation?[7]

This attitude receives clear visual expression in his painting *Landscape after Ni Tsan*.[8] The familiar Ni Tsan motifs, withered trees and a lonely pavilion, are present, yet hardly

5. Translated by W. T. Chan as *Reflections on Things at Hand* (New York, 1967).
6. See James T. C. Liu, "How Did a Neo-Confucian School Become the State Orthodoxy?" *Philosophy East and West* 23 (1973): 483–505; John Haeger, "The Intellectual Context of Neo-Confucian Syncretism," *Journal of Asian Studies* 33 (1972): 499–513.
7. Ju-hsi Chou, "In Quest of the Primordial Line: The Genesis and Content of Tao-chi's Hua-yü-lu" (Ph.D. diss., Princeton University, 1969), p. 154. The original text can be found in ch. 3 of *Hua-yü-lu*.
8. This painting is dated 1697 and is in The Art Museum, Princeton University. It is published in Wen Fong, "The Problem of Forgeries in Chinese Painting," *Artibus Asiae* 25 (1962): 95–119, pls. 15, 17; Richard Edwards et al., *The Painting of Tao-chi: Catalogue of an Exhibition, August 13–September 17, 1967, Held at the Museum of Art, University of Michigan* (Ann Arbor, 1967), p. 79 and pl. 13.

recognizable, rendered in wet, limpid brushstrokes that are completely different from the cool, dry spirit of Ni Tsan. The background motif is suddenly much taller and brought very close to the picture plane, eliminating the long expanse of open water found in the major Ni attributions. The elegant, yet firmly conceived and precisely executed, structure found in both Ni Tsan's brush technique and in his treatment of spatial relationships is missing in the Tao-chi. It may be surprising first, that such a self-consciously independent artist should have explored such a familiar model and second, that the visual connection should be so tenuous.

In his colophon on the 1697 painting, Tao-chi writes: "The noble gentleman Ni's paintings are like sand in the waves, and the pebbles in the rapids. Turning and flowing they emerge from Nature and their ethereal, pure, and rich breath coolly overawes us. Later generations have merely copied his dry and lonely, cold and restrained aspects. That is why their paintings lack the distant spirit."[9] The "distant spirit" (yüan-shen) that Tao-chi finds lacking in the more literal versions of Ni Tsan's style reflects a concept that appears often, under various names, in Chinese thought and aesthetics. It is paradoxical only at first glance to find it here as well. For while Tao-chi, for social and personal as well as stylistic reasons, rejects the slavish imitation of old masters that one finds in diluted orthodoxy, he advances to a new level the Tao (Way) of painting realized by the great artists of the past. What is important to painters such as Tao-chi is not to imitate Ni Tsan's mannerisms but to grasp the distant spirit, to participate as he did in painting as a natural, creative energy.

What we are considering in these essays is whether and how the Chinese could look upon Tao-chi's relation to Ni Tsan as being fundamentally within the same matrix as Chu Hsi's to Confucius. Our hypothesis has the unsettling virtue of cutting across many conceptual categories, thus opening new possibilities for comparison and discussion.

I have presented our concerns from the broad point of view of Chinese culture. In fact, of course, the original colloquium was stimulated by concrete objects: the paintings from the collection of Mr. and Mrs. Earl Morse shown at Princeton in 1969. The Morse collection represents an unusual endeavor: it is an attempt to illustrate the entire career of a single artist, Wang Hui (1632–1717), with examples from his major periods and styles and from his teachers and followers. As may be seen in the catalogue of that exhibition, *In Pursuit of Antiquity* by Roderick Whitfield, Wang Hui's career was long and successful. His painting extended the artistic program of Tung Ch'i-ch'ang (1555–1636) with a brilliance that lapsed into repetition and perseverance only in his later years. Although he never took the examinations and came from a relatively humble background, Wang Hui established himself at the center of power in his society. As Jonathan Spence's essay in this volume makes clear, Wang Hui's artistic orthodoxy was socially acceptable throughout the Chinese elite. Yet, although he depended on his art for his livelihood and

9. For other translations, see Fong, "Problem of Forgeries," pp. 113–15; Edwards, *Painting of Tao-chi,* p. 22.

served briefly as a court painter, he was never classed as a professional painter or decorator because he exemplified and extended, as no one else in his time could, the tradition of literati painting.[10]

The leading figure among the Four Wangs who dominate Ch'ing painting, Wang Hui has been regarded as the epitome of orthodoxy in Chinese art. Modern Western scholarship has not been particularly sympathetic to this movement in the Ch'ing period. The modern rediscovery of Tao-chi and the other individualists and eccentrics has tended to focus attention on their art, which is visually more accessible to the Western eye and aesthetically easier to deal with in terms of originality and invention than the works of the Four Wangs. In recent years American scholarship has produced such major exhibitions as *Fantastics and Eccentrics* (1967) at the Asia House Gallery and *The Painting of Tao-chi* (1967) at the University of Michigan.[11] In the presence of these superb paintings, it became clear that they should not be understood in isolation from the context of other artists and that often their assumptions and stylistic roots were similar to those of the orthodox painters. Thus, considering the colophon to Tao-chi's masterpiece *Waterfall on Mount Lu*, Richard Edwards remarks, "It is difficult to quarrel with the implied boast that Tao-chi has caught the grandeur of the past, but on his own terms."[12] This was precisely the aim of Wang Hui. The same point can be made from the other side of an imaginary dialogue between the two artists. Examining such paintings in the Morse collection as *The Colors of Mount T'ai-hang* (1669) or *Imitating Chü-jan's "Mist Floating on a Distant Peak"* (1672), one might consider the calligraphic energy coursing through Wang Hui's work in the light of Tao-chi's "single stroke" (*i-hua*), a concept that emphasized the brushstroke as a natural force, as a visual equivalent of natural processes of growth and change. On the 1672 hanging scroll, Wang Shih-min (1592–1680) says:

> As I unroll and examine it, I find the ink lustrous and brilliant, and a *yüan-ch'i* [primal breath] filling the composition. A feeling of joyful exhilaration moves freely in it, and the texture strokes are divinely inspired. Since [this painting] has already opened a new life for Master Chü, why should I want the original? Shih-lao [Wang Hui] is certainly an artist whose craft competes with creation itself.[13]

Wang Chien (1598–1677) remarks on the same painting:

> This winter, brother Shih-ku [Wang Hui], on his way through Lou-[tung], showed me this scroll, which he has made for the censor Tsai-weng. In its distant and subtle effects it almost surpasses the original. Even though the brilliant metamorphosis of the brushwork comes from Wang Hui's natural gifts, might he not have tossed away this

10. For a discussion of a professional painter, see James Cahill, "Yüan Chiang and His School," pt. 1, *Ars Orientalis* 5 (1963): 259–72; pt. 2, *ibid.*, 6 (1966): 191–212.
11. See the catalogues by Edwards, *Painting of Tao-chi*, and James Cahill, ed., *Fantastics and Eccentrics in Chinese Painting* (New York, 1967).
12. *Painting of Tao-chi*, p. 52.
13. Translated by Roderick Whitfield, *In Pursuit of Antiquity: Chinese Paintings of the Ming and Ch'ing Dynasties from the Collection of Mr. and Mrs. Earl Morse* (Princeton, N.J., 1969), pp. 114–15.

yeh-kuang [pearl that glows in the night] had he not met Tsai-weng's discerning eye? I would like to congratulate myself privately on encountering three great happy events in one day: I have actually seen a living incarnation of Chü-jan; I have admired at a distance the cultivated air of Tsai-weng; and I have come into close contact with Shih-ku's personal manner.[14]

These colophons suggest differences between Tao-chi and Wang Hui; we feel strongly the differing conditions of patronage and historical consciousness that divide these two great artists. Yet we also feel an essential congruence of concern for the past and of calligraphic line as a vehicle of expression in the works of both.

In conjunction with the opening of the Wang Hui exhibition, the colloquium at which these papers were first presented was held in an auditorium adjoining the Princeton University Art Museum. With the paintings immediately at hand, it was possible to refresh one's eye between sessions, to discuss the works themselves with colleagues, and thus to move conveniently from academic discussion to the objects and back. This seems to me more than simply a convenience, or a luxury. The objective art-historical structure so painstakingly built up depends on the historian's ability to establish similar understandings of quality and expression with his colleagues. This sometimes leads to tremendous strain on the resources of descriptive language as we try to express the many levels of intellectual and emotional responses to the objects themselves. The communication established is sometimes tenuous, fragile, and subjective—easily broken by the weight of excessive hyperbole. Having the paintings so close at hand was both humbling and exhilarating, bringing one back from abstract ideas about them to their special reality.

In order to provide a sharp introduction to the basic problems of the colloquium, we have grouped together four papers in Part I, "The Past in Chinese Cultural History." Frederick W. Mote's subtle, evocative essay examines the apparent paradox of a culture that emphasizes the present moment rather than the past or future, yet finds a basis of authority and validation in historical experience; that reveres tradition, yet, far from slavishly bowing under its weight, makes it a vehicle for creative, revolutionary archaism. In explicating the tension and the sense of possibility inherent in this situation, Mote presents ideas frequently returned to by the other contributors.[15] Wei-ming Tu's paper focuses on the history of thought rather than on the analysis of general cultural patterns and is primarily devoted to a study of inner experience as one of the defining principles of all Chinese thought. The paper suggests that the relationship between one philosopher and his predecessors should be understood not as intellectual reflection or analysis, but as *shen-hui*, "spiritual communication." Thus it would seem that the relationship one might expect to have with Confucius, or with the Duke of Chou in Confucius' own case, is historical in the sense that the ancient master existed and is known to us through

14. *Ibid.*, p. 115.

15. See F. W. Mote, *The Intellectual Foundations of China* (New York, 1971), for a more extended discussion of the Chinese world view and its implications.

historical records and historic achievements; it is simultaneously ahistorical in that it is experienced on an inner level in which one transcends temporal sequence to become the master's contemporary. We may see here a line of approach to Tao-chi's painting after Ni Tsan or Wang Hui's recasting of Northern Sung idiom in the handscroll depicting Mount T'ai; if so, we have another confirmation of the "unitary civilization" presented by Mote. James J. Y. Liu's paper on early Ch'ing poetics changes the perspective, dealing with the controversy among Ch'ing critics over the proper use of tradition in writing poetry. In part this was a disagreement over technique: should modern poets strictly follow the diction and forms of the past, or is it more important to achieve a fresh expression, either of one's own personality or of nature? When Liu notes that many of his critics were pluralists in the theoretical positions they took and reminds us that orthodoxy was understood in both moral and aesthetic terms, he raises complex, delicate questions that recur throughout this volume. Alexander C. Soper's paper explores in some detail the consequences of a point noted by Mote in his essay: "Painting, regardless of how early it may have become an independent high art form, did not become fixed as an appropriate activity of the elite until the Sui-T'ang era." The dilemma of the critics and historians examined by Soper was that painting, as a late comer, did not have a clearly defined "antiquity." Thus, although the T'ang art historian Chang Yen-yüan devised periodization schema based on the Three Antiquities format, Soper shows that the effort displays both chronological and critical uncertainty. Modern painting was clearly more advanced in depicting reality in T'ang times than anything previous, yet Chang points out that it has lost the tranquillity and nobility of high antiquity. In the Sung and Yüan periods the problem was resolved: painters now had long-established models from the past upon which to draw. Soper is able to document thoroughly the increased currency of the word *ku*, "antique," in critical terminology relating to painting, the increased importance of great collections, and the conscious practice of drawing on stylistic traditions for inspiration and formal elements. An unresolved tension should be noted: Soper from his vantage point of the internal history of painting and calligraphy argues that painting was essentially free of the "cult of the past" prior to the Sung, whereas Mote, characterizing Chinese culture generally, argues that, insofar as it was a part of the elite, high culture painting was governed by its values even if it could not refer to an ideal past when dealing with technical or critical questions.

In Part II, "Modes of Archaism in Painting," three papers focus specifically on the uses of the past by Chinese artists. Richard Barnhart discusses the extraordinary range of historical models used by Li Kung-lin, one of the creators of literati painting in the Northern Sung. Noting Li's capacity to draw on different stylistic traditions when painting different subjects, Barnhart suggests that subject matter in painting may be analogous to script form in calligraphy. A given subject for Li Kung-lin was associated with certain historical models, each with characteristic compositions and brush techniques. Thus in reconstructing and attempting to understand Li's art, we must not only look for common formal and expressive elements in his painting, but we must also expect a dazzling

variety of visual positions that relate to the stylistic traditions associated with particular subjects. In this process, the concept of period style becomes more complex, requiring precise delineation; from the time of Li Kung-lin on, part of our task involves the study of the creative historical vision of the artist. Chu-tsing Li's essay on the Yüan period devotes much of its attention to the protean figure of Chao Meng-fu, whose uses of the artistic heritage of his day were so influential during the Yüan and later. Li makes an interesting presentation of Chao's development in landscape painting, where he rejected his immediate heritage of Southern Sung styles and, returning to the ancient models, recapitulated the history of landscape painting from Ku K'ai-chih to the Northern Sung. After describing Chao's personal style, Li writes: "Yet these elements were formed from his intense interest in and study of paintings of old masters. They were the crystallization of his contacts with the past, not direct imitation of any one single master or his works. He grasped the classical spirit and developed a classical style." Wen C. Fong's paper carries the analysis of this phenomenon a step further, discussing the role of movements to "return to the archaic" (fu-ku) in Chinese art. In calligraphy, figure painting, and landscape painting, Fong finds a common pattern of development in which fu-ku movements follow an initial evolution of formal vocabularies. Studying this pattern, he differentiates two types of archaism, the primitive and the classical. In the context of this problem, Ch'en Hung-shou's (1598–1652) response to past models, such as that of Kuan-hsiu (832–912) in particular, contrasts sharply with that of Tung Ch'i-ch'ang, Chao Meng-fu, or Li Kung-lin. Fong argues that Tung and Chao may be called "classicists" because they deliberately sought an artistic renewal through "learned revival of ancient models," whereas Ch'en's return to the past was in search of an "exotic, primitive manner" through which he could express his own "whimsical and iconoclastic" vision. As the lively discussion that accompanied the original presentation of these papers showed, the use of such terms as "classical" or "archaic" to describe aspects of Chinese art arouses some uneasiness. Obviously no exact analogy to Western art history is intended; even in the Western context such terms as "baroque," "manneristic," etc., have been extended far beyond their original, relatively precise (if pejorative) denotation of a specific period and style. The more serious issue is whether such terminology drawn from Western art history clarifies or confuses discussions of Chinese art. One contribution of these papers is a detailed effort to demonstrate precisely what their authors mean by the terminology they use: they present specific paintings and concrete links between past and present, urging us to look and to describe what we see. Certainly the study of the historical development of the relation of Chinese artists to the past must be carried much further, yet these three papers indicate that this line of research will be fruitful.

Part III, "Orthodoxy and Individualism," presents those papers which deal specifically with the late Ming and Ch'ing periods and with the consequences of Tung Ch'i-ch'ang's dominance. We are accustomed to view Tung as magisterial critic, powerfully abstract artist, determined collector, wealthy landlord. A man successful in politics and socially conservative, he had a revolutionary impact on art; his formidable presence looms in the background of all discussions of late Ming and early Ch'ing art. It is the extraordinary

achievement of Wai-kam Ho's paper to open new perspectives on this familiar figure by studying his critical concepts in the context of Ming intellectual history. Instead of looking back from the Four Wangs for the theoretical basis of their painting, we see Tung Ch'i-ch'ang in the company of the literary, artistic, and philosophical issues of his own time. Instead of the font of orthodox precepts, we see an incisive rejection of the orthodox dualism of sixteenth-century revivalists in literature, an emphasis on the creative process itself as self-realization, a liberating insistence on transformation (*pien*) and momentum (*shih*) in painting.

Ho's paper sets the stage for another reappraisal, the brief study of Wang Shih-chen's ending lines by Yu-kung Kao and Tsu-lin Mei. Ch'ing poetry has attracted few readers in the West; for the most part it has seemed overly erudite and derivative, too often the conventional product of a social occasion. In concretely demonstrating that creative understanding of the old forms was possible even after so many centuries of the study and practice of poetic composition, Kao and Mei have both enhanced our understanding of the poetic conventions themselves and sharpened our awareness of the possibilities the past presented to the Chinese literati. Creativity is not synonymous with innovation in the Chinese tradition, nor is orthodoxy flatly opposed to originality.

The last three papers in Part III deal with the problem of sharpening the concept of orthodoxy as it is used in late Ming and Ch'ing art history. Jonathan Spence's paper continues the reflections on the Ch'ing elite that were begun in *Ts'ao Yin and the K'ang-hsi Emperor* (1966) and extended to the art world in his article on Tao-chi for the Michigan catalogue.[16] Implicit in his discussion is the fascinating and still unresolved question of whether historical and social acceptance exerts a formal, stylistic influence on painting: how was Wang Hui's social acceptability related to his artistic orthodoxy? The links between elite taste, class, and individual artists' styles are singularly unclear in the case of China; a convincing social history of Chinese art remains to be written.

Late Ming and Ch'ing artists were divided into schools based on stylistic and regional criteria by Chinese critics from the eighteenth century on; no one fundamentally challenges the relationships they perceived. The labels "orthodox" and "individualist," however, are the contribution of modern scholarship in the English language. Thus we sometimes feel the nagging sense of a gap between the Chinese actuality and the connotations of the terms we use to describe it. Harrie A. Vanderstappen studies some of the earlier artists involved, particularly Wang Chien-chang, a fascinating late Ming figure whose painting serves as an example of the state of stylistic flux immediately following Tung Ch'i-ch'ang. Examining pairs of orthodox and individualist paintings from the seventeenth century, Vanderstappen demonstrates their common concern with the representation of nature and with forms "sanctioned by traditions." Thus he cautions us to look at the paintings before assuming they are from different worlds. James Cahill takes the complementary approach of presenting the reasons, historical and stylistic, for the distinction between the two schools. Not the least of these, as he makes clear, is the self-image of the orthodox painters: acutely concerned with genealogy and united by

16. "Tao-chi, An Historical Introduction," in Edwards, *Painting of Tao-chi*, pp. 11–20.

common values, they insisted on their position as the true heirs of Tung Ch'i-ch'ang's Southern tradition. The orthodox painters are far more cohesive as a school than the individualists, as one would expect; Cahill's other studies have reminded us that there is a still largely uncharted maze of regional schools, masters and pupils, and artists who do not fit any of our present classifications.[17]

One of the drives of art history as a discipline is toward universality; the concept of style, developed to a formidable degree of sophistication in the formal analysis of European art, has proven to be indispensable in the study of Chinese painting. Although we are only in the beginning stages of a comparative history of art, Richard Edwards boldly takes a comparative approach in considering the basic way of seeing of Chinese artists in his paper in Part IV, "A Modern Perspective." Contrasting the Chinese mode to the flat, shattered space of Cubism and to the spatial relationships in the Japanese artist Sesshū's works (died ca. 1506), he suggests that a basic element in all Chinese art is the ultimate unity of space. Concluding the volume, Michael Sullivan widens our view to include contemporary developments, briefly examining the development of Chinese painting since 1949. His argument that Chinese artists have rejected both socialist realism and bourgeois abstraction in favor of traditional ways of seeing, painting, and conceiving of the artistic process will surprise those who have preferred to emphasize the destructive aspects of the Chinese revolution. Donald J. Munro, in discussing Chinese philosophy, has articulated a distinction between a conscious heritage from the past, susceptible to conscious attempts to change or jettison it, and an unconscious heritage, so much part of the mental set that it does not present itself as a target for revision or attack.[18] Sullivan's essay would suggest that perhaps some elements of artistic expression and ideation are very deeply rooted indeed.

In considering what we are doing when we study the art and culture of a society removed from our own in time and values, like that of traditional China, it is a useful exercise to return to ostensibly familiar material in our own heritage. In his book *Mannerism*, John Shearman provides a more than usually interesting example, for he is studying a period and a style in European art that many people now find precious, inexplicable, and unsatisfying. Shearman refers to mannerism as a "vulnerable style" because its aesthetic values which flourished so proudly, among them complexity, capriciousness, and artificiality, are double-edged and can be turned against it by those with different standards.[19] It is all too easy to criticize it for precisely those qualities it sought to attain, yet attempts to understand Mannerism from our modern vantage point can be equally dangerous:

In the attempt to rescue 16th century art from the ill repute that much of it enjoyed

17. See *Fantastics and Eccentrics* and *The Restless Landscape ; Chinese Painting of the Late Ming Period* (Berkeley, Calif., 1971).

18. *The Concept of Man in Early China* (Stanford, Calif., 1969), p. 162.

19. *Mannerism* (Harmondsworth, 1967), p. 186. I am indebted to David Sensabaugh for his suggestion that I read this book.

in the 19th century, it has been endowed with virtues peculiar to our own time—especially the virtues of aggression, anxiety and instability. They are so inappropriate to the works in question that some pretty odd results are bound to follow (the 16th century viewpoint of works of art was admirably relaxed). My conviction is that Mannerist art is capable of standing on its own feet. It can and ought to be appreciated or rejected on its *own* terms, and according to its own virtues, not ours. This raises no particular difficulty unless we succumb to a certain aesthetic squeamishness, for some of the relevant virtues are, unquestionably, hard to accept today.[20]

The same problems and the same warning apply to the study of the Ch'ing orthodox school, whose social and artistic values are so distant from our own. In a general sense, in studying Chinese culture we have disadvantages and advantages somewhat different from those faced by Shearman. We gain the advantage of an external and inherently comparative point of view; we face the difficulty of penetrating sympathetically a frame of reference even more distant than that of sixteenth-century Europe.[21]

In the colloquium itself and throughout the process of revision for publication, we have frequently found ourselves approaching our basic hypothesis with differing terminology, reflecting fundamental divergences in viewpoints and interest in varying aspects of the problems. Yet we hope that it is precisely in the contrast afforded here, rather than in any superficially imposed uniformity, that one of the potential contributions of this volume lies. We hope that these essays will suggest lines of research and questioning, and will encourage scholars to face the challenge to pay heed to one another even when it requires relaxing the hard-won precision of a specialized disciplinary approach.

Finally, we might return to the idea of a "Great Synthesis" (ta-ch'eng) that we noted in Chu Hsi's commentary on the *Analects*. When we again find such an accomplishment attributed to Wang Hui by his contemporaries, it comes as no surprise.[22] Such was the challenge presented by Chinese art and the Chinese cultural tradition; it was difficult to avoid, still more difficult to meet successfully. Fortunately our standards and aims are less overwhelming; we may hope that our attempts at historical reconstruction will bring an awareness of the accomplishments and the standards of those we have studied with such pleasure.

Christian F. Murck

20. *Ibid.*, p. 15.

21. Incidentally, it was during the sixteenth century that Europe began to have increased contact with China and Chinese artifacts. Chinese and other Asian objects were in great demand as exotica to make up the collections of curiosities that were then fashionable. See Donald Lach, *Asia in the Making of Europe*, vol. 2 (Chicago, 1970), *A Century of Wonder, Book One: The Visual Arts*, ch. 1, "Collections of Curiosities," pp. 7–55. We know of earlier periods of trading activity and can speculate that there must have been much more contact between East and West than can be documented today. However, the difficulties of Europeans and Chinese who came into contact with each other's high culture in modern times and attempted to appraise it systematically can hardly be overstated. A general lack of appreciation or understanding dominates the comments of many Europeans and Chinese of even later periods on each other's painting. See Michael Sullivan, "The Heritage of Chinese Art," in Raymond Dawson, ed., *The Legacy of China* (Oxford, 1964), pp. 165–72, for a succinct discussion of this problem.

22. Whitfield, *In Pursuit of Antiquity*, p. 43.

PART I
THE PAST IN CHINESE CULTURAL HISTORY

THE ARTS AND THE 'THEORIZING MODE' OF THE CIVILIZATION

F. W. Mote

INSIDE AND OUTSIDE VIEWS

Poetry, prose, calligraphy, and painting, perhaps most usually in that descending order, have for the last thousand years or more been regarded as the major arts of Chinese civilization. In the subjective judgment that has been generated from within China, this is surely so. From without, in our variously "objective" views of Chinese culture, we tend to agree, although, as might be expected, we normally reverse the order. Painting has immediate appeal even to those on the outside, and it therefore has stimulated the most widespread concern and evaluative efforts among those four artistic activities. Among the "barbarians," as soon as the stage has been passed in which trinkets and baubles are collected (including elegant ones like the porcelains, the brocades, and the jade play-things), the next stage usually has been to collect paintings. Frequently too this has been coupled with non-Chinese notions about the arts, such as demanding artistic recognition for "mere crafts" like sculpture. There are discernible native styles in this, of course; the English as collectors seem never to have taken painting seriously. Occasionally non-Chinese (especially other East Asians) have aspired to the admiration and understanding of calligraphy. Sometimes distant outsiders have read Judith Gautier and Hans Bethge and Arthur Waley and Florence Ascough and have thought they were savoring Chinese poetry. Or they have read one of the many translations of the *Lao Tzu* and used it to confirm their views about the world soul.

In the serious concern for Chinese arts, however, from among the four major arts as the Chinese defined them, the outsiders usually have settled on painting. They have developed views about its achievements and its masterworks that are quite acceptable— as external reflections on one civilization by another. And they have sometimes gone further, beyond connoisseurship.

Within recent decades our studies of China have begun to achieve some sophistication. As the exoticism fades, Chinese painting is brought to stand on the same ground as other art, and we find that there are significant alternatives to uninformed though sensitive connoisseurship. To be sure, Wang Hui's paintings are intriguingly beautiful works of art, to be viewed and experienced just for that quality. Like other great art works,

however, they are at the same time monuments to the cultural dynamism of traditional China; they are documents of the processes that kept China a coherent and integral civilization. It does not depreciate their absolute value as art if we seek to understand them in the same sort of relative terms we might also use to understand a Confucian philosopher, a Ch'ing period statesman, or Mao Tse-tung's momentous little red book. For some students of China and of painting, it enhances Wang Hui's works—their value as art—to know how they fit into their cultural world and what the maker thought they embodied of his Great Tradition.

Cultural historians hope to concern themselves more intelligently with all the major and minor arts, as with other facets of the traditional civilization. When they ask art historians to help them, it is not, I think, to misuse art—or to abuse art historians. The growing sophistication of Chinese studies demands that we use the special information of others as supplements to our own more completely than we have done before. It is in the spirit of intellectual community that I will include art, about which I know too little, in the general remarks that follow.

THE ARTS AND THE CULTURE

Poetry, prose, calligraphy, and painting have not always been cultivated as appropriate activities of China's elite. Literature existed as high art before the others and long before its aesthetic component was analyzed and identified as such—the latter attempt dating perhaps only from the end of the Han period. Aesthetic values became well established as legitimate and conscious concerns of cultivated men in the third and fourth centuries of our era. Calligraphy too became an independent art from approximately that time. It acquired its first great patron saints in the two Wangs, whose achievement was to endow the Chinese written word, the already venerable icon of civilization, with new aesthetic values alongside all the others. Painting, regardless of how early it may have become an independent high art form, did not become fixed as an appropriate activity of the elite until the Sui-T'ang era, which is very late for the history of Chinese culture. Its modes were already well established before these arts, as arts, were drawn into the core of the lives of all educated men. Artistic activities possessing identity and status within the Great Tradition, they had to conform to the already well-established ways of that tradition.

Chinese civilization developed its own particular formulas for analyzing cultural phenomena, for explaining change, for assigning value. These formulas possessed, of course, their formalized names and labels—clichés by which they could be called to mind. As outsiders we sometimes look upon these cultural clichés with a literal-mindedness belonging clearly to a discrete cultural tradition (our own), or with a simple-mindedness that displays our still superficial understanding of them. When Chinese said that all the cultural forms to which they assigned value were "antique" (ku), they were not saying literally that they were explicit imitations of particular ancient

prototypes. Association may have been possible with many prototypes, or unnecessary with any. Chinese who insisted upon such associations were not speaking literally, but neither were they mouthing meaningless or superficial ideas. Our problem is to determine what the special language of these critical formulas means in specific historical instances.

Throughout critical discussions of poetry, prose, calligraphy, and painting, many of the key terms are employed in apparently parallel fashion, and the values present in the one activity are readily convertible to those of others. Nor are those same critical and evaluative terms limited to usage in the arts. The arts acquired them from philosophy, government, and the other great concerns of the civilization—indeed, acquired them rather late in the history of their wider usage. It was a unitary civilization, and these specialized uses of ideational modes within the realm of creative artistic activity never lost their intimate relationship with the other aspects of life. More than in any other mature civilization, perhaps, traditional Chinese civilization was one in which the artists —poets, writers, calligraphers, and painters—were one group with the elite of government and society, with the elite in the world of affairs, both as producers and as audience.

THE ARTS AND THEORY

On the level of artistic theory the arts were part of one unitary theorizing mode from which all the other nonartistic activities also drew their intellectual orientations. Ideational inputs were similar for all. Does this then come dangerously close to suggesting that the arts were denied the freedom necessary for creative activity? We all know from the artistic production poured forth by traditional China that this was not so. How then does that fact fit into what seems to have been a limiting intellectual milieu? Was it not one that deprecated the new and strange and that at the same time suggested a compelling parity of the antiquely valid and the ethically proper? Literally, and simply understood, it was. But the theorizing mode was both complex and subtle.

The arts could, somewhat late in the history of the civilization (third through sixth centuries), and with some never fully overcome difficulties, nonetheless acquire explicitly aesthetic grounds for their existence. But they never could (nor indeed seemed to claim the need to) escape from the same responsibilities that all other activities of cultivated man had to bear. The forms of artistic expression were all considered by the Chinese to convey (tsai) the Great Way (Tao) of their entire cultural tradition, the same Great Way that had to be achieved in personal cultivation and manifested in social and political institutions. When all of these things are under obligation to fashion themselves in some extraordinary (i.e., not vulgarized) way, in the same spirit and on the same models as those of the past, in order to possess value, we cannot be literal-minded in our understanding of how that imitation was accomplished. Nor can we conclude that the Chinese must have been simpleminded in their application of the same formulas. How did the revered ancient models work in the life of Wang Hui the painter, or in the lives and achievements of philosophers, statesmen, poets?

5

THE INEXORABLE PAST

There is an apparent anomaly in Chinese civilization with regard to the uses of the past: the defining criteria for value were inescapably governed by past models, not by present experience or by future ideal states of existence. Yet the entire purpose of civilization and men's individual lives was to realize the maximum from this present moment, not to blindly repeat some past nor to forego the present in preparation for some anticipated future. All Chinese intellectual traditions shared this fundamental attitude, and foreign value systems buckled before it. It transformed Buddhism in China and it frustrated Christianity. It is not irrelevant to the problems of modernization and socialist change.

This anomaly in the relationship of past to present values must, I think, be explained by the nature of ultimate authority for human action, and for values, as thinkers in the Chinese tradition defined it. In their Great Tradition, neither individuals nor the state could claim any theoretical authority higher or more binding than men's rational minds and the civilizing norms that those human minds had created. That is a tenuous basis of authority, and since it could not easily be buttressed by endowing it with nonrational or superrational qualities, it had to be buttressed by the weight granted to historical experience. In order to counter overly erratic individualism in the present, the past had to be regarded as more compelling than mere accidents of history could be. Russell Kirk in his essay on the conservative mind in the West refers to the conservatives' belief that "tradition and sound prejudice can provide checks upon man's anarchic impulse."[1] But the Chinese purpose was broader. Unlike Western conservative thinking, it developed within an absence of nonrational authority, and had to remain more reasonable. And its intent was more constructive than merely that of providing checks on individual action; it was to preserve man's access to positive and highly humanistic values. No conflict with "freedom" was necessarily implied—though to raise this issue is to inject our parochial point of view. Briefly stated, the Chinese past had to become greater than the Chinese present in order for the accumulated wisdom of human civilization to impose its guiding function, to keep the all-important present on the track.

Yet this humane view of human civilization idealized man's achievements as the only enduring and transcendent value in life. Man's psyche is the only instrument for achieving acts of value, for knowing what may possess value, for devising the means of realizing it in present situations. The human mind, possessing the experience of the historical past, is the only instrument for achieving any kind of greatness, and it is unaided by divine grace, superrational intervention, or the mysteries of some unrevealed future state. Yet man is aided by his sense of sharing the historical experience of all civilized men of the past, and that is an inexhaustible source of guidance and of validation when the creative intellectual or artistic individual chooses to use it. And in his cultural milieu he had no choice but to use it. He could acquire the authority and the confidence to do his own thing only by being immersed in an all-enfolding past.

1. *The Conservative Mind: From Burke to Santayana* (New York, 1953), p. 8.

THE LIBERATING PAST

The past (*ku*) was proper (*cheng*) because something had to be, and nothing else could acquire competitive validity. Since the proper was in the past, the present had to be a deviation (*bien*) from it. Yet the same human intelligence that has allowed man to achieve the proper in the past also guided his discriminating mind in judging the present to be deviant, and in providing him with the knowledge of how to correct the deviant and recover the past (*fu-ku*). As man honed his mind to perfect such discriminating capacities, he could also become an expert judge of technical and artistic achievements; when those were of high order, they virtually participated in the past, or brought past greatness again into men's present awareness. Idealist philosophies within the various Chinese traditions developed an awareness of the vast, even unlimited, capacities of the human mind to commune with the minds of men past, to incorporate their experience within present knowledge, and to reserve to individual knowing minds the ultimate judgment about all of man's acts.

So, the greater the aesthetic and technical achievement, the more the creative individual was thought to be in command of the past, or under command of the past—for they were the same thing.

This is the theorizing mode within which the creative impulse was analyzed in traditional China. Within the same theorizing mode were conducted the reflective, systematic thinking about human problems and the active engagement with political and social realities. The language is remarkably even (one might say "flat") throughout discussions of all, and the same men engaged in all, or felt themselves one organic elite with the men who engaged in all. Apprehending the past and realizing its value had different implications for the different areas of civilized man's activities, but a remarkable unity of cultural style resulted. How this conditioned the stylistic vocabulary of the great painters is for the art historians to tell us.[2] The painters' psychic awareness is another matter, and it too is one component of their art. Wang Hui, in his obsession with the past and his own sense of having synthesized and expressed it all again for the men of his generation, becomes one supremely revealing example of how the civilization creatively used the resource of its past to renew its life repeatedly in the recurrent present.

Fu-ku, or recovering the past, could be a self-deceiving slavishness in many minds, but

2. It is my impression, gained from reading through the collection *Hua-lun ts'ung k'an*, 2 vols. (Peking, 1958), that much pre-Sung theory was in fact explication of technique, and not general theory; there it did not dwell on justification or similar philosophical issues. But where it did, as in two of the earliest items included there—Tsung Ping's "Introduction to Landscape Painting" and Wang Wei's "Introduction to Painting" (both translated in W. T. de Bary et al., *Sources of Chinese Tradition* [New York, 1960], pp. 293ff.)—the obsession with the past, and even the incidental use of the word *ku*, are obvious. Moreover, these two writings were the fountainhead of all later painting theory. Yet Professor Soper has made a valuable point in his essay later in this volume when he notes that collections of paintings probably were not available for study by painters until Sung and later times, so that the comparison with past models took on a new meaning for painters in that age.

in other minds it could be a revolutionary archaism that spawned competing repudiations of the present, and that bolstered creative approaches to all of man's activities. One man's *cheng* could be another man's *pien*, and it was the individual artistic (or intellectual, or other) achievement that in the last analysis was the measure of *cheng*. The mode is different from our own. It provided one of the conditions within which the artist worked. Its implications are not simple or invariable; it suggested pattern, but did not impose rule. It was a way of linking the universality of human experience with the personal uniqueness of each man's inner experience.

Fu-ku, this mode of using the past, had little to do with the history of styles per se. In art history, "archaism" has a specific meaning vis-à-vis stylistic features. It also has the general meaning of relating expression to one's consciousness of past models. These two must not be confused; *fu-ku*, recovering the past, on another level of truth from such literal concepts as "style," provided the means of relating the artist to his work, to his audience, and to history. Understanding it, we can attempt to do the same.

'INNER EXPERIENCE':
THE BASIS OF CREATIVITY IN
NEO-CONFUCIAN THINKING

Wei-ming Tu

Writing in *Creative Fidelity*, Gabriel Marcel asserts:

> The problem now was not so much one of building as of digging; philosophical activity was now definable as a drilling rather than a construction. The further I went in the examination of *my experience*, and into the hidden meaning of these two words, the more unacceptable became the idea of a particular body of thoughts which was my system, one I could call my own; the presumption that the universe could be encapsuled in a more or less rigorously related set of formulas, seemed absurd.[1]

To be sure, Marcel's rebellion against the construction of a disinterestedly argued system of ideas as a legitimate form of philosophical inquiry must be understood in terms of his self-image as a "Neo-Socratic" and in the context of religious existentialism.[2] But his singleminded effort to underline the primacy of inner experience, as a challenge to the main stream of Western philosophy, has a profound meaning for our attempt to apprehend the Neo-Confucian mode of thinking. Indeed, the direction of his questioning, especially his declaration that "philosophy is experience *transmuted* into thought," will help us to appreciate more fully the "central datum" in the Neo-Confucian tradition. Since our immediate concern is not to raise an issue in comparative philosophy, the viewpoint of the brilliant Christian philosopher is mentioned here merely as a way of introducing the subject of the present study.

The need for the construction of a general theory of metaphysics or ethics for its own sake has never occurred to the Neo-Confucianist as a major concern in his quest for self-realization. Either by conscious choice or by default, he does not pose theoretical questions about the what and the why of man from an objective point of view. He neither

1. Trans. Robert Rosthal (New York, 1964), p. 14.
2. Although Marcel is better known in America as a leading Christian existentialist, he has repeatedly rejected such a label. He prefers to be called a "Neo-Socratic." In a broad sense, however, Marcel, together with Paul Tillich and Martin Buber, may be referred to as an important architect of religious existentialism in the twentieth century.

seeks nor establishes logical systems to demonstrate his philosophy of life. He resists the temptation to abstract a set of encapsuled formulas from his spiritual awareness. And he refuses to subject his moral feelings to an externalized pattern of intellectual argumentation. His focus is on the cultivation of the inner experience, both as a way of self-knowledge and as a method of true communion with the other.

The term "inner experience" is here employed to signify a cluster of Neo-Confucian ideas. For the sake of expediency, I shall limit this part of the discussion to only one of the several relevant key concepts, t'i, which literally means "to embody." Since t'i as a noun denotes the body in terms of both its form and substance, when it is used as a verb or an adjective it frequently conveys the meaning of involving the whole person. It should be pointed out that t'i in a derivative sense may also refer to the structure and essence of reality. But in the present context it has little connection with the highly controversial problem of the t'i-yung ("substance-function") dichotomy in Chinese philosophy. Rather, it forms into compounds with words such as ch'a ("examination"), wei ("taste"), jen ("comprehension"), hui ("understanding"), cheng ("confirmation"), and yen ("verification"). Sometimes it is simply used as a verb by being attached to the final particle chih.[3]

Underlying the meaning of these divergent compounds is the concerted theme of total commitment, involving the entire "body and mind." Thus t'i-cha in its original meaning refers to a deep examination of one's being rather than a thorough investigation of some external thing. Similarly t'i-wei in a strict sense is not applied to any sensory perception of a transient nature. Its usage is limited to the kind of "taste" or "flavor" that can be developed only through a long and strenuous process of self-cultivation. T'i-jen certainly entails the mental activity of cognition, but it involves more than the comprehension of something out there. Since the act of comprehending in this particular connection requires a continuous process of interiorization, it is inconceivable that one can have t'i-jen in the true sense of the term without undergoing a significant transformation of one's way of life.

T'i-hui is therefore to understand experientially, as if one has "encountered" or "met" in person, that which is to be understood. To know an objective truth in passing without deepening one's self-knowledge is certainly not to understand in the form of t'i-hui. Accordingly t'i-cheng is not to confirm the validity of a theorem by a set of empirically tested criteria. It points to a kind of "confirmation" in which the truthfulness of an idea cannot be demonstrated by logical argument but must be lived by concrete experience. However, such an experience is neither mysterious nor subjectivistic, although its meaning can be readily acknowledged only by those who have tuned their minds and bodies

3. Virtually all of the terms used in the present context have appeared in Neo-Confucian writings. In fact, this particular usage of t'i can also be found in the Doctrine of the Mean. Suggestively, Wing-tsit Chan has rendered the phrase t'i ch'ün-ch'en as "identifying oneself with the welfare of the whole body of officers." See his A Source Book in Chinese Philosophy (Princeton, N.J., 1963), p. 105. For the original source see the Doctrine of the Mean, trans. James Legge (London, 1895), ch. 20.

to appreciate it. In the same way, *t'i-yen* implies the willingness to devote one's whole being to an ideal or a truth. Indeed, the term connotes such a deep and lasting commitment that its usage is restricted to "great ideas" such as life, love, and beauty. As a result, when the Neo-Confucian master suggests to his students that the only way to take hold of a certain dimension of his teaching is to "embody it" (*t'i-chih*), he is absolutely serious. The absence of a clearly articulated position on such matters is not a result of the teacher's deliberate attempt to remain silent as a pedagogical device, but of his sincere determination to be truthful to the very nature of such a teaching.

In the consciousness of the Neo-Confucian thinker, the main task is neither to build an ethical system nor to analyze a metaphysical theory. To teach is a way of manifesting what he has learned through self-cultivation, and to learn is a method of crystallizing what he has taught by personal example. It is in this connection that "teaching and learning are mutually encouraging" (*chiao-hsüeh hsiang-chang*), and "exemplary teaching" (*shen-chiao*), as against teaching by word (*yen-chiao*), is considered a better avenue to learning. Consequently, the Neo-Confucian thinker characterizes his knowledge as the "learning of the body and mind" (*shen-hsin chih hsüeh*), which is also understood as the way of *how* to become a genuine person.

The decision to focus on the problem of *how* rather than the cognitive issues of *what* and *why* certainly has many far-reaching implications. The basic concern, however, is to refrain from converting issues of profound human significance into mere objects of speculation. Understandably, the majority of Neo-Confucian writings are neither expositions of ideas *qua* ideas nor treatises on purely contemplative issues; they are rather records of spiritual quests and events. They mainly take the form of dialogues, aphorisms, reflections, anecdotes, letters, and poetry. Even in some of the highly sophisticated essays on "humanity" (*jen*), the emphasis is still on experiential understanding rather than the art of argumentation. This emphasis on the personality behind the mode of articulation impels the Neo-Confucian to think not only with his head but with his entire "body and mind."

To think with one's whole being is not to cogitate on some external truth. It is a way of examining, tasting, comprehending, understanding, confirming, and verifying the quality of one's life. Underlying such kind of reflection is a process of digging and drilling that necessarily leads to an awareness of the self not as a mental construct but an experienced reality. Wang Yang-ming (1472–1529) states that his ideas become empty words if they are detached from the concrete experiential bases on which they are meaningfully organized:

> I have come to the realization of the teaching of *liang-chih* ... [innate knowledge] through a hundred deaths and a thousand hardships. It is with utmost reluctance that I have articulated [the totality of my inner experience] in a single breath. I strongly fear that the student might easily grasp [this simple formulation of] it, treat it as a circumstantial notion, and play with it, without solidly dwelling in it and strenuously

11

working at it. This would certainly turn his back upon [the real meaning of] such knowledge.[4]

To be sure, Yang-ming's "dynamic idealism" is not representative of the dominant trend of Sung learning. Nor is it necessarily in line with the philosophical orientation of the early Ming masters, who can be legitimately characterized as followers of the Chu Hsi (1130–1200) and Ch'eng I (1033–1107) school. But Yang-ming's concern in this particular connection seems to have been shared by virtually all major thinkers in the Neo-Confucian tradition. In fact, many less famous scholars in this period seem also to have internalized this aspect of exemplary teaching. Hsüeh Hsüan (1393–1464), the early Ming master, delineates his approach to knowledge as *shih* (literally, "solid").[5] For, as a process of self-fulfillment rather than an accumulation of empirical data, the knowledge obtained must be "solidly" sealed to one's whole existence. This emphasis on experiential learning is reminiscent of Ch'eng I's characterization of the entire tradition of Confucian teaching as *shih-hsüeh* ("solid learning").[6] Indeed, Ts'ao Tuan's (1376–1434) instruction on the cultivation of the *hsin* ("mind-heart"),[7] Wu Yü-pi's (1392–1469) insistence upon self-discipline,[8] and Hu Chü-jen's (1434–1484) devotion to the practice of reverence[9] all point to the central concern that inner experience is a prerequisite for appropriating the meaning of their teaching. They can well appreciate Lu Hsiang-shan's (1139–1193) command that his students make an existential decision as a precondition for taking up learning with him.[10]

We may tentatively define this approach to philosophical thinking as "concrete-universal."[11] It is commonly accepted that universal principles can only be obtained by transcending the particular. To achieve a high level of generality, thought has to be detached from the concrete. To construct a theorem that can have some universal claim necessitates a process of abstraction. In the present case, however, the inner experience of a concrete person serves as the real basis of generalization. And only through a total immersion in one's own being can the source of universality be reached. Mencius'

4. See his *Nien-p'u*, under 50 *sui*, first month, in *Yang-ming ch'üan-shu*, *Ssu-pu pei-yao* ed., xxxiii/16b.

5. The concept occurs quite frequently in Hsüeh Hsüan's writings. For example, see his *Tu-shu lu*, 1751 ed., ii/8, iv/7.

6. Ch'eng I's statement is quoted by Chu Hsi in his introductory note to the *Doctrine of the Mean* in his *Ssu-shu chi-chu*.

7. For an example of Ts'ao Tuan's emphasis on *hsin*, see the following statement: "In everything one must devote one's effort to the exercise of the mind, and that is the main road of entering into the gate of Confucian teaching." Huang Tsung-hsi, *Ming-ju hsüeh-an*, *Ssu-pu pei-yao* ed., xliv/1b.

8. His dedication to self-discipline is vividly demonstrated in his *Jih-lu*. See the first *chüan* of *K'ang-chai hsien-sheng chi*.

9. See his *Chü-yeh lu*, *Cheng-i t'ang* ed., viii/4–5.

10. Although Lu Hsiang-shan has been credited with the notion of *li-chih* (to establish one's will, or simply to make an existential decision), Chu Hsi has also put much emphasis on the importance of making up one's mind to become a sage as a precondition for Confucian learning. See Ch'ien Mu, *Chu Tzu hsin hsüeh-an* (Taipei, 1971), 2: 364–78.

11. In my opinion, the best analysis of this kind of approach to date is in Mou Tsung-san's *Hsin-t'i yü hsing-t'i* (Taipei, 1968), 1: 1–10.

statement that "he who has completely realized his mind knows his nature; knowing his nature, he knows Heaven"[12] is therefore a classical formulation of such an orientation. Commenting on this passage, Lu Hsiang-shan advances his idealistic thesis: "Mind is only one mind. My own mind, or that of my friend, or that of a sage of a thousand generations hence—their minds are all only [one] like this. The extent of the mind is very great. If I can completely realize my mind, I thereby become identified with Heaven. Study consists of nothing more than to apprehend this."[13]

Implicit in the above statement is the belief that one's inner experience is the real ground of communication. It is not only the ultimate basis of human relationships but also the foundation upon which man, according to the *Doctrine of the Mean*, "participates in the transforming and nourishing operations of Heaven and Earth."[14] Therefore, the "inner experience" we have been talking about is neither a kind of intuitionism nor a solipsistic state. It is not even a spark of inspiration. Actually, the apparent emphasis on "subjectivity" is not at all in conflict with the view that "to conquer oneself and return to propriety is humanity."[15] Indeed, the ego has to be transcended and sometimes even denied for the sake of realizing the genuine self. For self-control, overcoming the ego, is the authentic way to gain inner experience. This path is universally open to every human being, but it ought to be traveled concretely by each person.

The cultivation of an inner experience is consequently a search for self-identity. Yet in Neo-Confucian thinking this process of looking into oneself does not at all alienate one from society. It actually impels one to enter into what may be called "the community of the like-minded" or even "the community of selfhood." In such a community one not only befriends one's contemporaries, but one also establishes an immediate relationship with the ancients. Wang P'in (Hsin-po, 1082–1153), a relatively unknown thinker of the Sung dynasty, captures this spirit well in his remarkable statement:

> The former sages and the later sages are in perfect harmony. It is because they do not transmit the Tao of the sage but the mind of the sage. Actually they do not transmit the mind of the sage but their own minds. Indeed my mind is not different from that of the sage. It is vast and infinite. It embraces myriad goods. To expand this mind is thus the way to transmit the Tao of the sages.[16]

To appreciate the Way of the Sages is not only to study its external manifestations,

12. *Mencius* 7A.1.

13. *Hsiang-shan ch'üan-chi, Ssu-pu pei-yao* ed., xxxv/10a. For this translation, see Chan, *Source Book*, p. 585.

14. Ch. 22.

15. *Analects* 12.1.

16. The statement is found in Wang P'in's memorial to Emperor Kao Tsung, which is included in the "Chen-che hsüeh-an" section of the *Sung-Yüan hsüeh-an, Ssu-pu pei-yao* ed., xix/1b. This statement has been wrongly attributed to the famous Sung thinker Ch'eng Hao (1032–1085) ever since Huang Tsung-hsi mistakenly identified the statement as contained in Ch'eng Hao's memorial to Emperor Shen Tsung, in his contribution to the *Sung-Yüan hsüeh-an* (see xiii/15). Several important anthologies of Neo-Confucian sayings have also attributed the statement to Ch'eng Hao. For a general discussion on this issue, see Ch'ien Mu, *Chu Tzu hsin hsüeh-an*, 3: 300–301 and 540–42.

such as in the Classics, but to understand the "intentionality" (*i*) behind the spoken word. Actually, the intentionality of the Sages can never be grasped as merely an external phenomenon. It must be savored in one's own mind. Indeed, only in cultivating an inner experience of the mind can the Way of the Sages be fully "compassed." When one establishes a "spiritual communion"(*shen-hui*) with the ancients, one emerges as their spokesman and delegate. One bridges the gap between one's spiritual contemporaries and one's temporal contemporaries in performing the creative act of a living transmitter.

What one tries to transmit is of course not the form or even the content of the ancients but their minds. To imitate their form would be to behave like Wang Ken (1483–1540), whose effort to dress like an ancient sage merely credited him with the reputation of being *ku-kuai*, "archaic and weird."[17] Only through a constantly active process of "internalization"—in the present context tantamount to self-realization—is one capable of transmitting the intentionality of the ancients. In a deeper sense, the intentionality of the ancients is really an experienced reality of one's inner self, but with the challenge of the ancients, one can more fully "witness" the subtle meaning of it.

Since the mind of the ancients can never be reproduced, transmission in a real sense always implies an act of creativity—not creating something out of nothing, to be sure, but deepening one's self-awareness to the extent that its quality is comparable to that of the ancients. Each transmission, in this connection, is itself a unique event that can be located in a specific spatial-temporal sequence. It is the cumulative achievement of these events that constitutes the so-called Great Tradition. To be an integral part of such a tradition requires creative adaptation and spiritual metamorphosis, which in the Neo-Confucian terminology is commonly known as *pien-hua ch'i-chih*, "transforming one's concrete being."[18]

When "inner experience" is conceived as the basis of creativity, the art of constructing some philosophical system *ex nihilo*, no matter how "ingenious" (*ch'iao*) it may be, cannot be accepted as profound. Great moments in thought are those in which some perennial concerns of man are perceptively articulated, not by a reflection on abstract principles but by an insightful grasp of concrete human situations. Profundity in thought is thus understood in terms of one's ability to penetrate the bedrock of one's given tradition, which necessarily involves a strong sense of history. However, far from being bound to the past as a fixed entity, to have a historical consciousness is to develop the power of creativity not in isolation but in a dialogue with those great historical personalities by whom one's own work is meaningfully judged and properly appreciated. To the Neo-Confucian thinker, what happens here and now is more than the demonstra-

17. *Ming-ju hsüeh-an*, xxxii/6.
18. *Ch'i-chih* is a difficult concept to translate. In the Neo-Confucian literature, it is frequently used in conjunction with *i-li*. For example, *i-li chih-hsing* refers to man's moral nature, whereas *ch'i-chih chih hsing* refers to his physical nature. According to Chu Hsi, Chang Tsai (1020–1077), an uncle of the Ch'eng brothers, made a great contribution to Confucian learning by stressing the importance of understanding man's *ch'i-chih chih-hsing*.

tion of a single individual genius; it is the fulfillment of a historical mission and the vivification of an accumulative tradition. The success of a creative act does not signify a departure from the past. Rather it is a new realization of what has long been intended by the seminal minds of one's chosen transmission. The pursuit of antiquity therefore means to dig and drill into that historicity which symbolizes the most significant landmarks of human achievement in the past. The individual talent does not go through a process of depersonalization in order to become an integral part of his tradition, for the basis upon which he can embody the essence of the ancients and generate his source of creativity is his true self.

TRADITION AND CREATIVITY IN EARLY CH'ING POETICS

James J. Y. Liu

The relative importance of tradition and creativity was one of the controversial issues among early Ch'ing critics of poetry. Broadly speaking, we may group together, on the one hand, those who advocated imitation of ancient poets and observance of rules of composition, didacticism, and book learning, and, on the other, those who emphasized natural talent, individuality, intuition, inspiration, spontaneity, and genuineness of emotion. However, critics were by no means divided into two clear-cut opposing camps. On the contrary, many of them were "pluralists" who held several views, some of which may be considered "traditionalist" and others "individualist." In my previous writings, I have classified the Ch'ing critics under four headings: Moralists, Individualists (or Expressionists), Technicians (or Formalists), and Intuitionalists.[1] To correct any misleading impression I may have created, I now wish to make clear that this classification is not meant to suggest the existence of four distinct schools of critics holding mutually exclusive views, but only to draw attention to certain tendencies in critical thinking.

In discussing Chinese poetics, we constantly encounter difficulties in terminology. The same term, even when used by the same critic, often denotes several different concepts, whereas different terms sometimes, on analysis, turn out to denote similar, if not identical, concepts. This is bad enough with monosyllabic words, but when we come to binomes the situation becomes worse: it is often difficult to decide whether the two syllables denote one concept or two concepts and, if the latter, what their relation is, since the syntactic relation between the two syllables is often ambiguous. Take the term *shen-yün*. The first syllable, *shen*, can be a noun meaning "spirit," "mental vitality," or "essence," or an adjective meaning "spiritual," "inspired," "divine," or "miraculous"; the second syllable, *yün*, can mean "rhyme," "rhythm," "resonance," "tone," or "style." Together, *shen-yün* can mean "spirit and tone" or "the tone of the spirit" or "spiritual

1. See *The Art of Chinese Poetry* (Chicago and London, 1962; Phoenix Books ed., Chicago, 1966), pp. 63–87; "*Ch'ing-tai shih-shuo lun-yao*," in *Symposium on Chinese Studies Commemorating the Golden Jubilee of the University of Hong Kong* (Hong Kong, 1964), 1: 321–42.

tone or resonance" or "miraculous, inspired style," etc. On the other hand, some other words like *ch'i* often appear to mean the same thing as *shen*. Our difficulties are further compounded when we are discussing Chinese poetics in English, for it is obvious that one cannot hope to find an English word that has all the different meanings of a Chinese word or to find English words all meaning the same thing. The best we can do is to try to sort out which Chinese terms denote the same concept and use an ad hoc translation suited to the context. At the same time, we have to distinguish different concepts covered by the same term and use different English words for them or add qualifying adjectives.

Keeping in mind the reservations implied in the above preamble, we may nevertheless proceed to glance at a few critical views. On the side of tradition, we find both the Moralists and the Technicians, with differences in emphasis and their understanding of tradition. For instance, Feng Pan (1614–1671), Chao Chih-hsin (1662–1744), and Shen Te-ch'ien (1673–1769) all stressed the moral purpose of poetry,[2] but differed in other respects. Feng disapproved of imitating the style and prosody of ancient poetry, although he did approve of imitating ancient poetry in its didactic purpose.[3] Chao and Shen, on the other hand, both paid considerable attention to imitating ancient poetry and to prosodic rules.[4] The latter two may therefore be called Technicians as well as Moralists. Now, what I have referred to as "style" is often denoted by the term *ko-tiao* in Chinese. By itself, *ko* can mean the verse form, or the style, or both, while *tiao* by itself means literally "tune" and can be applied to the prosodic features of poetry or to "style" in a more general sense. The binome *ko-tiao* usually denotes a partly formal and partly periodic conception of style. In other words, style was conceived of as something external which consisted of certain formal elements and which was the hallmark of the poetry of a period. Those who advocated imitation of ancient poetry differed in their choice of the period to be imitated, but they all implicitly believe in an ideal style as exemplified by the poetry of a particular period. Thus, the term *ko-tiao* is seen to have the additional implication of "model" or "standard." If one adopted this conception of style, then following tradition would mean imitating the style of a period, and if one further believed that there were permanent rules or methods (*lü* or *fa*) of poetic composition embodied in the works of the ancients, the term *ko-tiao* would become almost synonymous with *ko-lü*, or "standard forms and rules." In this way, the Moralist and the Technical views of poetry were combined.

Those on the side of individual creativity include both the Individualists and the Intuitionalists. The Individualists, such as Chin Jen-jui (better known as Chin Sheng-t'an, d. 1661), Yüan Mei (1716–1798), and Chao I (1727–1814), emphasized the spontaneous expression of one's nature and emotion (*hsing-ch'ing*) or native sensibility (*hsing-ling*), and

2. See Feng Pan, *Tun-yin tsa-lu*, in Ting Fu-pao, ed., *Ch'ing Shih-hua* (Shanghai, 1927; hereafter cited as *CSH*), p. 5a; Chao Chih-hsin, *T'an-lung lu*, *CSH*, p. 2a; Shen Te-ch'ien, *Shuo-shih tsui-yü*, *CSH*, passim, and prefaces to *T'ang-shih pieh-ts'ai* (Shanghai, 1961) and *Ch'ing-shih pieh-ts'ai* (Basic Sinological Series). Also cf. Kuo Shao-yü, *Chung-kuo wen-hsüeh-p'i-p'ing shih* (rev. ed., Shanghai, 1956), pp. 446–47, 474–75.
3. *Tun-yin tsa-lu*, p. 3b; Kuo, *Chung-kuo wen-hsüeh-p'i-p'ing shih*, p. 474.
4. Chao, *T'an-lung lu* and *Sheng-tiao p'u*, *CSH*, passim; Shen, *Shuo-shih tsui-yü*.

the independent creation of new forms and styles (*tu-ch'uang* or *ch'uang-t'i*).[5] The Intuitionalists like Wang Fu-chih (1619–1692) and Wang Shih-chen (also known as Wang Yü-yang, 1634–1711) advocated intuitive apprehension (*miao-wu*) of reality and of poetry, inspiration occasioned by the mind's intuitive encounter with reality (*hsing-tao shen-hui*), and encountering the spirit or essence (*shen*) of external things with one's own mental vitality (*shen*) so as to embody this essence in one's poetry. At the same time, one must cultivate a personal tone or style (*yün*); otherwise one's poetry would not have an "inspired style" or "spiritual resonance" (*shen-yün*).[6] It is interesting to observe that the concept of *shen* as the essence of an object bears some resemblance to Gerard Manley Hopkins' "inscape," while the concept of *yün* as resonance between the object and the mind of the perceiver resembles his "instress."[7] Since Hopkins also believed in intuition, this resemblance between his poetic theory and that of the Chinese Intuitionalists is not as startling as it may seem at first sight.

Both the Individualists and the Intuitionalists rejected slavish imitation of ancient poetry, pedantry, and mechanical observance of prosodic rules, but neither repudiated tradition itself. Both schools conceived of style as something personal, but the former regarded poetry as an expression of one's personality, whereas the latter regarded it as the embodiment of an individual mode of consciousness. The difference is subtle but real. The former focused attention on the poet, the latter on poetry. Critics of the former school were concerned with the immediate emotional appeal of poetry among all readers; those of the latter school were inclined to indulge in esoteric aestheticism.

As suggested above, many critics were "pluralists," but the one who effected the most complete reconciliation between the claims of tradition and those of individual creativity was Yeh Hsieh (1627–1703). His view of poetry is historical and evolutionary; he compared the growth of Chinese poetry to that of a tree and to the stages of development of material civilization.[8] This view implies the importance of tradition but also recognizes the necessity for change. To him, "orthodoxy" (*cheng*) and "change" (*pien*) were descriptive rather than normative terms, and he writes, "We cannot say that 'orthodoxy' is the source and that which always flourishes, and 'change' is the stream and that which starts to decline. It is precisely because 'orthodoxy' gradually declines that 'change' can initiate a new phase of flourishing."[9] Indeed, one may develop his ideas further and say that successive changes constitute tradition.

5. Chin Sheng-t'an, letters, in Shen Ch'i-wu, ed., *Chin-tai san-wen ch'ao* (Hong Kong, 1957), pp. 290–96; Yüan Mei, letters, in *Hsiao-ts'ang shan-fang wen chi, Sui-yüan san-shih-liu chung* ed. (Shanghai, 1913), *chüan* 17; *Sui-yüan shih-hua* (Peking, 1960), pp. 2, 3, 10, 20, 35, 39, 73, 74, 80, 87, 565, 626; Chao I, *Ou-pei shih-hua* (Peking, 1963), pp. 19, 31, 32, 38, 39, 57, 63, 80, 184–86.

6. Wang Fu-chih, *Chiang-chai shih-hua*, CSH, *chüan shang*, p. 3b, *chüan hsia*, pp. 3a–b, 5a–b; Wang Shih-chen, *Tai-ching-t'ang shih-hua* (Shanghai, n.d.), *chüan* 3. Cf. Kuo, *Chung-kuo wen-hsüeh-p'i-p'ing shih*, pp. 447–54, 459–72.

7. W. H. Gardener and N. H. Mackenzie, eds., *The Poems of Gerard Manley Hopkins*, 4th ed. (London, 1967), pp. xx–xxii.

8. Yeh Hsieh, *Yüan-shih*, CSH, pp. 2b–3a, 19a, 29a.

9. *Ibid.*, p. 4b. Cf. Kuo, *Chung-kuo wen-hsüeh-p'i-p'ing shih*, pp. 430–46.

None of the critics discussed would admit to being unorthodox, though they might be accused of being such by their opponents, for they could all cite the Confucian Classics as their authority with some justification. Moreover, in Chinese literary history we may discern two kinds of orthodoxy: an ideological orthodoxy identified with Confucian didacticism and a purely literary one that consisted of the acknowledged masters and masterpieces of literature. Poets like Juan Chi or Li Po were far from orthodox in thought or behavior, but no one would dream of denying either a place in the orthodox literary tradition. Orthodoxy in the second sense seems to rest mainly on the use of accepted poetic diction, forms, and styles. By contrast, a poet like Han-shan would be considered unorthodox, not because he was a Buddhist monk but because he used colloquial language.

Ultimately, there is no real conflict between tradition and creativity, for, on the one hand, as T. S. Eliot observed, there is no poetry which owes nothing to the past,[10] and, on the other, newly created expressions, forms, and styles in time become part of the Great Tradition, modifying it, enriching it, and renewing it, so that it will not die.

10. *Notes toward the Definition of Culture* (New York, 1949), p. 118.

THE RELATIONSHIP
OF EARLY CHINESE PAINTING
TO ITS OWN PAST

Alexander C. Soper

In the Princeton colloquium, most of the contributions from art historians dealt with the ways in which painters from the Yüan dynasty on showed their acute awareness of earlier achievements in their art: some by imitating its great masters, some by stubbornly rejecting its rules, others by attempting to fuse the elements of past greatness with the interests of their own time. My paper was designed to serve as a very brief historical introduction, to stress the fact that this weight of the past was a relatively late phenomenon, built up gradually from the T'ang dynasty on, and long resisted.

In its present form my essay has been considerably expanded, chiefly through the addition of a comparison with the early history of calligraphy. The material used is almost entirely textual because it is only through the choice of key words by early theorists and historians—above all the character *ku*—that the process can be demonstrated with any hope of a convincing conclusion.

Of all the Chinese fine arts, painting was the last to develop and the slowest in reaching maturity. This statement requires a proviso: our first sight of the possibilities of brush and pigments in Chinese hands is early, and at a precociously high level. The Neolithic painted pottery of central and western North China is, by any standard of comparison, astonishing. Its execution at best is wonderfully clean and strong and its themes are richly varied. Since the vocabulary of forms is almost entirely abstract, designed to convey symbolic meanings with a high degree of visual effectiveness, it may be thought of as a form of calligraphy, worked out long before the invention of a true script.

Archaeological finds have made it clear, however, that the painted pottery cultures of the north were everywhere submerged by the great changes that came with the dynastic age. The royal tombs at Anyang show that painting was then used to supplement and accentuate carvings on wood, to embellish the life and death of the Shang ruling class. Though the evidence is very meager, it has been argued that much of the repertory of animal and bird forms used in various Shang media had been formulated earlier in paintings on wood or leather. The all-important material of the time was, of course, bronze, and it remained so throughout the Chou kingdom and the feudal age. Almost

21

all the artifacts of high quality found in the tombs of the feudal lords are of bronze. Lest this evidence should be discounted as reflecting no more than the relative indestructibility of metal, we have corroborative testimony for the Ch'un-ch'iu period in the *Tso chuan*; there the great works of art that are cited as bribes or war prizes are all bronze vessels or jades.

By the fifth century the ornamental repertory of the bronze masters was expanded to take in a radically new element, the depiction of figures in action. When fully exploited this came to include illustrations of many of the typical aspects of aristocratic life: hunting, archery contests, music-making, formal ceremonies and war for the men, and mulberry-tree culture for the ladies. The more complex such scenes became, the more clearly were they unsuited to bronze decoration. The prototypes imitated in miniature in the bronze workshops must have been paintings, very likely executed on walls at much larger scale. There are, however, no descriptions of such picture cycles in late Chou texts; and the immediate sequel to the fashion for "pictorial bronzes" was their disappearance after a few decades, not the further emergence of painting. Only toward the end of the period and in the Western Han, in encyclopedic works like the *Chuang-tzu*, the *Han Fei-tzu*, and the *Huai-nan-tzu*, do we meet as a newcomer the painter whose art is remarkable.[1] An incidental result of this late arrival is that there are no painters among the legendary paragons of skill like the horse-judge Po Lo, the musician Po-Ya, and Lu Pan the carpenter and maker of contraptions.

In the Han, painting acquired a new seriousness and broader application as an instrument of state. Its story-telling function was exploited for moral instruction, useful at every level of the ruling class from the emperor down. Its newly acquired realism made possible a novel reward for distinguished services, the official portrait placed in a hall of fame. With this recognition, the art and those who practiced it entered official records. The first comprehensive history of painting, the *Li-tai ming hua chi*, compiled in 847 by Chang Yen-yüan, begins to be a factual account of the past with the Han.[2] Chang's sources permitted him to name a group of six court painters for the late Western Han, with a place of origin given and a speciality noted for each. One was expert with human figures, two were particularly good at coloring, and the other three did oxen and horses. For the Eastern Han there are also six, but only two were mere painters-in-attendance. One of the others was made grand master of ceremonies at court in 201; another became a grand warden in Szechwan; and the remaining two were the celebrated Chang Heng and Ts'ai Yung, who between them had mastered almost every cultural achievement open to a Han scholar.[3]

This new attractiveness of painting as a gentleman's avocation is a clear sign of progress,

1. Several such passages have been collected by Yü Chien-hua for his *Chung-kuo hui-hua shih*, 2d ed. (Shanghai, 1955), 1: 11–12, and for his *Chung-kuo hua lun lei-pien* (Peking, 1956), 1: 4, 6. See also Soper, "Life-Motion and the Sense of Space in Early Chinese Representational Art," *Art Bulletin* 30 (1948): 170, n. 21.

2. Soper, "Life-Motion," pp. 171–72.

3. Chang Yen-yüan, *Li-tai ming hua chi* (hereafter cited as *LTMHC*), iv.

a long stride toward the climax reached in the third and fourth centuries, when two emperors practiced the art. It must be stressed, however, that the Han was still a period of preparation. In later centuries its masters seemed too primitive to be taken seriously, and virtually none of their works survived in collectors' hands. The earliest systematic critic of painting, Hsieh Ho, who composed his *Ku hua p'in lu* around 500, classifies no master earlier than the Three Kingdoms. His first comment, on one of the five men in his topmost class, Wei Hsieh of the Eastern Chin, is that "he was the first to do finely detailed work, replacing the sketchiness of earlier painting."[4] His top ranking, "beyond the highest of the high," is awarded to a painter no more than a generation before his own time, Lu T'an-wei of Liu Sung.[5]

Later critics quarreled with this opinion and proposed instead the later fourth-century Ku K'ai-chih, but no earlier name was ever taken seriously. Chang Yen-yüan, looking back from his long perspective, saw this "age of Ku and Lu" as so important a beginning, and yet so far from his own in terms of style, that he made it the key phase in discussing the Three Antiquities of painting, as we shall see below.

At this point a comparison with the early literature of calligraphy becomes highly instructive. Chang Yen-yüan reappears there as a compiler, since his long *Fa shu yao lu* consists mainly of earlier treatises.[6] One of its major components is a *Shu tuan* by Chang Huai-kuan, written in the early eighth century.[7] There we find a scheme of Three Antiquities for writing: high for the *ku wen*, the ancient script, whose invention is ascribed to the age of Huang Ti; middle for the earlier seal character, said to have been worked out in the reign of King Hsüan of Chou (orthodox 827–782); and low for the lesser seal form, designed by the prime minister of the Ch'in, Li Ssu.[8] Chang Huai-kuan epitomizes these three stages and sets all later developments against them by borrowing Lao-tzu's *shih* and *hua*—literally, "the fruit" and "the flowers." It is hard to know precisely what he meant by this, since in his time the two could be treated as necessary complements, standing merely for the subject matter and its artistic embellishment. In Lao-tzu's original antithesis, however, there is an inescapable preference. The thirty-eighth stanza of the *Tao te ching*, describing the step-by-step descent from the Tao to the Confucian Li, from the best to the barely acceptable, concludes (in Duyvendak's transla-

4. Translated by W. R. B. Acker, *Some T'ang and Pre-T'ang Texts on Chinese Painting* (Leiden, 1954), p. 9: "With (Wei) Hsieh the summariness of the ancient painters was for the first time (replaced by) elaboration."

5. *Ibid.*, pp. 6, 7.

6. I have used the version reprinted in the mid-sixteenth-century anthology *Wang shih shu yüan* (hereafter cited as WSSY), in which *Fa shu yao lu* (hereafter cited as FSYL), takes up the first five volumes in the standard Shanghai reprint of 1922.

7. FSYL, vii–ix. Data on Chang Huai-kuan and his book are assembled in Yü Shao-sung, *Shu hua shu lu chieh-t'i* (Taipei, 1968), iv/2a, 2b. A comprehensive account is given by Nakamura Shigeo in *Chūgoku garon no tenkai* (Kyoto, 1965), pp. 231ff. In the WSSY edition of FSYL, the *Shu tuan* occupies vol. 4 and part of 5. The concluding section dates the work to 724–727. The same author's lost work on painting, *Hua tuan*, has been partially preserved in quotations, especially in the LTMHC.

8. FSYL, viii, in WSSY, 4:26a.

tion): "C'est pourquoi le grand 'adulte' s'en tient à ce qui est épais et ne s'arrête pas à ce qui est mince; il s'en tient au noyau et ne s'arrête pas à la fleur."[9]

Since Chang presents his *shih* and *hua* in a temporal sequence, it seems to me likely that he intended at least a reminder of Lao-tzu's severity, if only as a sop to the philosophers. He continues:

> The three styles of antiquity are the fruit, while the *ts'ao* and *li* forms are the flower. The peak of excellence [in dealing with] the flower was reached by [Wang Hsi-chih and his son Hsien-chih] Hsi and Hsien. The possibilities of refinement [in dealing with] the fruit were exhausted by Shih and Ssu (Shih Chou, the legendary inventor of the earlier seal form, and Li Ssu].[10]

A number of early writers on calligraphy tried their hands at sifting out the masters of the past and their own present into qualitative groups. The most ambitious system, found in the *Fa shu yao lu*, takes up two-thirds of Chang Huai-kuan's treatise.[11] He uses a conventional tripartite division into categories called *shen*, *miao*, and *neng*—roughly translated as "inspired," "excellent," and "competent." The first two names in the inspired class are the two seal character inventors. In an earlier list by Li Ssu-chen, active in the later seventh century, Shih Chou's name is lacking, presumably because he was too remote a figure and was represented by no known remains.[12] Li Ssu, on the other hand, heads a special group of five at the head of Li Ssu-chen's list, designated as *i*: a term hard to render by any one English equivalent, which I have chosen to call "untrammeled."

Both lists are instructive in respect to the values attached by their compilers to the masters of Han and post-Han times. Li gives the other four places in his *i* group to Chang Chih and Chung Yu of the Eastern Han and to the two Wangs of the Eastern Chin. His more conventional top category begins with two upper names, both from the Eastern Han. The next step down, to the middle upper, brings in two names from the Eastern Han, three from the Three Kingdoms, and two from the Chin.

In Chang Huai-kuan's grouping, the twelve inspired entries divide between the two seal-character inventors, representing Chou and Ch'in; four names from the Eastern Han; two from the Three Kingdoms; and four from the Chin.

We have seen that the first age of greatness in painting history opened only with the fourth century, in the Eastern Chin, and reached its first climax either at that same time

9. J. H. L. Duyvendak, *Tao Tö King, Le livre de la voie et de vertu* (Paris, 1953), pp. 88–89.

10. *FSYL*, viii, in *WSSY*, 4:26a.

11. *FSYL*, viii–ix, in *WSSY*, 4:21a and ff.

12. *FSYL*, iii, in *WSSY*, 2:11b and ff. For data on Li Ssu-chen's treatise, see Yü, *Shu hua shu lu chieh-t'i*, iv/1b. Li also wrote a treatise on poetry and one on painting, which survive in quoted fragments; the latter is frequently cited in *LTMHC*. The painting treatise has been studied by Shimada Shūjirō, "Ri Shishin no ga ronshu," in *Kanda hakase kanreki kinen shoshi gaku ronshu* (Kyoto, 1957), pp. 381–96, a collection of studies published in honor of Professor Kanda. Li's official biography appears in the old *T'ang History*, cxci, and in the new, xci. He was appointed a state librarian in 666 and died in 696.

with Ku K'ai-chih or in the fifth with Lu T'an-wei, depending on the critic's preference. In calligraphy—although the two arts were at approximately the same stage at the outset of the Han—the first summits of fine writing were reached much more rapidly, by the second century. Both types of artist needed first to master the same implements, the brush and the pigment. The case of Ts'ai Yung shows that one man could still turn his skill in either direction. He is said to have painted five generations of the noble Yang family, by order of the Emperor Ling (reigned 168–189), composing for each portrait a eulogy and then writing the inscriptions, and so achieving a triple masterpiece. In Li Ssu-chen's list of famous calligraphers Ts'ai is at the head of the middle upper category; in Chang Huai-kuan's he is ranked as inspired in two forms, the *pa fen* and the *fei-pai*, and as excellent in three others. For the historians of painting, however, he was a primitive, and so *hors de concours*.

Beyond question, the factor that so delayed the maturity of "red and blue"—to use the traditional euphemism—was the painter's obligation to satisfy a rising standard of realism. Late in the Western Han it was noted admiringly of the figure specialist Mao Yen-shou that "whatever sort of person he painted, old or young, beautiful or ugly, was always rendered true to nature."[13] It was four hundred years or more later, however, before Ku K'ai-chih reached such a sense of actuality that he acquired the reputation of a magician. The qualifications for a high ranking involved, of course, much more than a mere fidelity to nature, as Hsieh Ho's comments make clear. His supreme genius, Lu T'an-wei, was not only a consummate portraitist but a master of all the Six Elements, *liu fa*. On the other hand, the ability to solve representational problems with increasing skill, to suggest space and solidity more and more convincingly, to give a more natural freedom to the positions of the body, to combine figures in more complex groups, to catch not only the features of an individual but also his mood, to present the figures in a story or a religious assemblage with both ethos and pathos—all this required a gradual accumulation of experience, and so provided the historian with something like a yardstick by which to measure progress out of the archaic past into a bountiful present.

In comparison, the writers on calligraphy found only subjective criteria, open to endless argument. The most striking illustration is furnished by the long uncertainty as to the proper status of the Two Wangs. Their reputations, particularly that of the father, eventually overshadowed all others far more completely and permanently than was the case with their contemporaries Ku and Lu. Chang Yen-yüan, for example, in discussing Wang Hsi-chih as a middling good painter, calls him "the crowning glory of all time" as a calligrapher.[14]

Closer to their own time, however, the achievements of the two Wangs were much harder to evaluate, above all in relation to those of their famous predecessors. The Liang dynasty calligrapher-critic Yü Chien-wu attempted to sum up the essential requirements for greatness in two complementary terms, demanding that the best writing be both

13. *LTMHC*, iv, in the *Ts'ung-shu chi-ch'eng* ed. (hereafter cited as *TSCC*), p. 151.
14. *LTMHC*, v, *TSCC* ed., p. 175.

25

kung-fu ("accomplished") and *t'ien-jan* ("natural").[15] On this scale the elder Wang was lodged unheroically between his two most famous rivals. His works were judged less accomplished than those of Chang Chih, but more so than those of Chung Yu. At the same time they were more natural than those of Chang, while less so than those of Chung. It seems to have been his consistently high level of performance, rather than a spectacular specialization, that counted most in his favor when the final evaluation was made by Chang Huai-kuan in the eighth century.[16] Of the six styles of writing on which he was judged, Wang Hsi-chih was given "inspired" status in five, *li, hsing, chang ts'ao, fei pai,* and *ts'ao* proper. In the sixth, *pa fen,* his ranking was "excellent." No one else appears so often at this high bracket except his son. Wang Hsien-chih was also "inspired" in the same five, but in *pa fen* was merely "competent," and so was inferior by one degree.[17]

In another treatise, the *I shu,* Chang Huai-kuan evaluates Wang Senior in a different way, with a sharper critical focus. There the classification is four-fold, formed about the *chen, hsing, chang ts'ao,* and *ts'ao* hands. The father is placed first in the first two, but only fifth in the third, and eighth—at the very bottom—in the *ts'ao* hand. The author explains:

> I may be asked why in this category all the other masters are placed ahead of I-shao. My answer is that ... each of them had in the *ts'ao* mode his individual form of aware-ness, a soaring spirit or an arrestingly personal note. I-shao's standards were not high, nor is his work very accomplished. For all its opulence and beauty, it lacks any vital spirit. There are no sharp-pointed axes and halberds in it to inspire fear, nor is there any sense of things astir with life at which to marvel. In all this he is inferior to the others.[18]

The early T'ang age produced one authoritative defender of modernity in hand-writing, Sun Kuo-t'ing. In his *Shu p'u,* dated 687,[19] he argues eloquently against the common verdict that the "Four Worthies" were the supreme masters for all time and yet among themselves forever unequal. He quotes the dogma: "The present does not equal the past. The past has the plain substance, *chih,* the present has charm, *yen.* The plain substance keeps its greatness from age to age, while charm alters with fashion. ... Furthermore Tzu-ching [the son] was not the equal of I-shao, nor was I-shao the equal of Chung and Chang."[20]

15. *FSYL,* ii, in *WSSY,* 1:47a.

16. *FSYL,* viii, in *WSSY,* 4:21b–22a.

17. *Ibid.,* pp. 21b, 22b.

18. *FSYL,* iv, in *WSSY,* 2:49b.

19. Not included in *FSYL.* Reprinted in *WSSY,* suppl. vol. 1; also in the modern anthology *Mei shu ts'ung-k'an* (Taipei, 1965), 4:1ff. The English translation by Sun Ta-yü in *T'ien Hsia Monthly,* September, 1935, is much too free to permit any close study of the contents. See also Yü, *Shu hua shu lu chieh-t'i,* iii/1a–2a; Nakamura, *Chūgoku garon no tenkai,* pp. 227ff.

20. *WSSY,* suppl. vol. 1, i/1b; *Mei shu ts'ung-k'an,* 4:1.

Part of Sun's counterargument runs:

> The three phases in the development of *chih* and *wen* must pass in succession, for such is the eternal order of things. That antiquity should pay honor to skill did not run counter to the times, nor is it a sign of corruption today. It has been said that an equal blend of the ornamental and the substantial marks the *chün-tzu*. Who would change his sculptured palace for a cave dwelling, or his jade chariot of state for a clumsy cart?[21]

Sun uses this sensible argument wholly for the benefit of Wang Hsi-chih, however, whom he favors first because of his versatility, as opposed to his predecessors' narrow specialization, and then on the grounds of his "high position and lofty talents, the purity of his taste and the courtliness of his diction."[22] Any comparable claim for the son, Sun rejects, primarily because Hsien-chih is said to have intimated that his own hand might be even better than his father's. Beyond this unfilial arrogance, the whole tenor of his life as a scholar-recluse is held against him: "He posed as an Immortal, ashamed to honor family ties; and to complete his studies, found nothing better than facing a wall [in meditation]."[23]

In summarizing what happened after the Two Wangs, Sun lapses into the carping tones of a routine historian surveying his own time. Though the period involved was nearly three centuries, he gives no names and describes only shortcomings.

The cult of the past is immediately visible in the two long lists of calligraphers arranged by Li Ssu-chen and Chang Huai-kuan. Their common preferences are shown both by quantity and by ranking. Li's entries comprise thirty-seven names for the pre-Liu Sung period, as against forty-five from the Sung on into the early T'ang. Chang Huai-kuan, writing in the 720s, names sixty-four for pre-Sung and thirty-three from the Sung into the K'ai-yüan period. In Li's ten-step system—an initial group of "untrammeled" geniuses, followed by three tripartite classes—the only names of post-Chin men to appear above the middle class are four at the end of the bottom-upper (his fourth step). These include the greatly admired seventh-century masters Ou-yang Hsün, Yü Shih-nan, and Ch'u Sui-liang. Post-Chin names preponderate only from the middle-middle rank on down.

In Chang Huai-kuan's *shen-miao-neng* system there are no post-Chin names in the inspired category and only fourteen out of thirty-nine in the excellent. Ou-yang, Yü, and Ch'u fall at the end of the latter.

The standards used in evaluating early calligraphy and early painting met in the person of one celebrated T'ang authority, Chang Yen-yüan, the mid-ninth-century compiler of the *Fa shu yao lu* and author of the *Li-tai ming hua chi*. His family had collected works of high quality in both fields from his great-grandfather's time on, and he himself dabbled

21. *Ibid.*
22. *WSSY*, suppl. vol. 1, i/1b, 5a.
23. *Ibid.*, p. 2a.

in both as an amateur. Signs of this double interest are plentiful in the *Li-tai ming hua chi.* Its first section proclaims the common, supernatural origin of the two arts. Many of the author's interests and much of his aesthetic terminology occur with equal emphasis in both books; and he was capable of summing up the relationship in a sonorous truism: "The ultimate subtleties, *chen miao,* of painting are the same as in calligraphy."[24]

With so much granted, the differences between the two works are all the more revealing. To begin with, the time factor is conspicuously later in the painting history. There also we find four geniuses for all time—Ku, Lu, Chang, and Wu (Ku K'ai-chih, Lu T'an-wei, Chang Seng-yu of Liang, and Wu Tao-tzu of T'ang)—to match the calligraphic quartet Chang, Chung, Wang Senior, and Wang Junior. The calligraphers span the period from the second to the fourth centuries, as we have seen; the painters begin at the late fourth and continue into the eighth. As a historian of painting, Chang Yen-yüan also uses the concept of three stages of antiquity, *san ku,* but with a much more recent connotation than Chang Huai-kuan's. The *Li-tai ming hua chi* is in this respect confusing, since the theme is twice referred to, with conflicting dates. Both versions, however, begin and end much later than the calligraphic scheme. The differences may be tabulated thus:

ANTIQUITY	CHANG HUAI-KUAN	LTMHC, i/4	LTMHC, ii/4
high	age of Huang Ti	Chin-Sung	Han-Wei
middle	Hsüan Wang of Chou	Sui	Chin-Sung
low	Ch'in dynasty	—	later sixth dynasty
recent times	—	seventh–eighth	Sui-early T'ang
modern men	—	ninth	—

The second *Li-tai ming hua chi* passage is the more orderly of the two and the more chronologically plausible. Only the first two stages are described, briefly, and we meet there the two contrasting terms that had been used in a similar evolutionary context by Sun Kuo-t'ing. The lost paintings of high antiquity were *chih* and *lüeh,* plain and summary. The works of middle antiquity, exemplified by Ku and Lu, show a blend of *yen* and *chih,* "charm" and "plainness."[25]

Chang Yen-yüan's other summary of the past in painting, though perhaps chronologically garbled, is much more interesting from the standpoint of stylistic criticism. In it he seems to show both pride and wariness. The pride was that of a T'ang historian and connoisseur who could enumerate all the spectacular technical advances that had reached a climax in his dynasty. The wariness—if I am right in this interpretation—would have come from his suspicion, as a respectable reader of the early philosophers, that something important had been sacrificed in the process. This is how he puts it:

In the High Antiquity of painting, workmanship was summary while the themes were at once tranquil and noble. Such was the school of Ku and Lu. In Middle Antiquity

24. *LTMHC,* ii/4; quoted from Acker's translation, *T'ang and Pre-T'ang Texts,* p. 202.
25. Acker, *T'ang and Pre-T'ang Texts,* p. 198. Acker renders the four attributes as primitive and summary vs. grace and primitive force.

paintings were fine-scaled, exquisitely finished, and exceedingly beautiful. Such was the school of Chan [Tzu-ch'ien] and Cheng [Fa-shih]. In recent times paintings have been a blaze of splendor, with completeness as their goal. The paintings of modern men are chaotic and without meaning, the work of mere craftsmen.[26]

Chang's last sentence is more justifiable than the usual Chinese diatribe against the present; he lived in an awkward interregnum, a century past one great age and a century too soon for the next. What he has to say about high T'ang is the crux of my suspicion that he vacillated between two sets of values, one forward-looking and positive, the other retrospective and regretful. He was probably using his phrase about the search for completeness, *ch'iu pei*, in the relatively unfavorable sense that had been given it in the *Lieh-tzu*, iv.[27] There the Taoist contrasted two kinds of mental experience of journeying (*yu*). Those who busy themselves with journeying in the external world seek completeness through material things. Those who prefer inward contemplation find their sufficiency in the self, a higher mode of experience.

The sense of what might have been lost in the exchange stands out more clearly in a quotation from Chang Huai-kuan's lost history of painting, in which he evaluates the three great pre-T'ang portraitists. Ku had caught the spirit of his sitter, Lu the bones, and Chang Seng-yu the flesh. In this difference the three painters were in correspondence with the calligraphic masters Chung, Chang, and I-shao. Because "the subtleties of the spirit are boundless," Ku K'ai-chih the earliest had been the greatest.[28]

The most unequivocal demonstration of pride in the *progress* of painting, on the other hand, appears in the section on landscape. Chang Yen-yüan traces the growth of the landscape painter's capacities from the almost infantile state of the Wei and Chin beginners to the great innovator five centuries later who brought the art to maturity, Wu Tao-tzu. Though Chang has in general no better than faint praise for the artists of the ninth century, in this section he carries his account well past Wu to describe—at greater length and with more enthusiasm than anywhere else in his book—the dramatic suggestiveness of a wall painting of trees and rocks, done by a monk-painter of the South.[29]

26. *LTMHC*, i/4, translated in *ibid.*, p. 149. Acker has: "Simple in technique yet adequate in [their expression of] thought, and had a classic orthodoxy . . . delicate and precise, refined and closely knit, and exceedingly charming . . . gorgeous and brilliant and aimed at [technical] perfection . . . confused and messy and altogether meaningless; such are the works of the mass of artisans."
27. Translated by L. Wieger in *Les pères du systeme Taoiste* (Paris and Leiden, 1950), p. 123.
28. In the *Lun shu* by the mid-T'ang calligrapher Hsü Hao, included in *FSYL*, iii, a comparable three-part analysis names the qualities that the three early T'ang master calligraphers got from tradition: "Yü [Shih-nan] got the muscle, Ch'u [Sui-liang] got the flesh, and Ou-yang [Hsün] got the bones." See *WSSY*, 2:22b. In the order muscle-bones-flesh this is applied once to three other masters, and in the order bones-flesh-muscle to three more, in Chang Huai-kuan's *Hua tuan*, ii. See *FSYL*, viii, in *WSSY*, 4:29b, 35b. Apparently, the original calligraphic triad lacked spirit, which would have been considered in a separate category, while the original painting triad lacked muscle. The two systems are merged in the *Pi fa chi*, attributed to the tenth-century landscapist Ching Hao; for him the four aspects of brushwork are muscles, flesh, bones, and spirit.
29. *LTMHC*, i/5; see Acker, *T'ang and Pre-T'ang Texts*, pp. 154–59.

The process of change is discussed again in Chang's account of the two great styles of brushwork developed for painting: the continuous, unvarying hair-thin lines of Ku and Lu, as against the dynamic, interrupted strokes and dabs of Chang and Wu. The section culminates in unstinted praise of Wu: "He walks alone for all time. He totally over-shadows his predecessors Ku and Lu. . . . He may well be called the Painter Sage; some god must have loaned him the creative powers of Heaven; his genius is inexhaustible."[30]

To make this claim more believable, Chang draws in the story, or legend, that Wu ripened his brush technique under the turbulent master of the *ts'ao* hand Chang Hsü the Madman. He reaches a familiar conclusion: "Thus we learn once more that in calli-graphy and in painting the use of the brush is the same."[31]

No support outside the realm of painting is sought for a second eulogy of Wu that comes at the end of the section on Hsieh Ho's Six Elements:

> Only when we gaze on the works of Wu Tao-tzu may we say that all Six Elements have been fulfilled, and the myriad phenomena have been wholly expressed. Some god must have loaned him his hand, to allow him to fathom so completely the power of Creation itself. So heroic was his *ch'i-yün* that it could scarcely be contained within the silk. His brushstrokes came with so tumultuous a freedom that he was constrained to use the walls of buildings to embody his ideas.[32]

The *Li-tai ming hua chi* reveals its freedom from any cult of the past by its very sparing use of the character *ku* in stylistic evaluation; he uses it only four times, if my count is correct, and all in nonlaudatory contexts. Two are compounds completed by *cho*, "awkward," and so imply "archaic" or "antiquated" in a pejorative sense. One of these is applied to the female figures done by the Liu Sung artist Yüan Ch'ien,[33] and the other to the landscapes of a minor mid-T'ang man, Wei Luan.[34] The interval between these two, around three centuries, corresponds roughly to the different rates of development of the two genres.

A four-character phrase containing *ku* and *cho* in a different combination is used to describe the dissatisfaction felt by the great innovator in early Chinese Buddhist art Tai K'uei, of the Chin, for the images current in his time: "He found the ancient models plain and clumsy."[35] Finally, the mid-T'ang landscapist Pi Hung, celebrated for his trees and rocks, is said to have been the first whose rendering of trees "was advanced by changing the old [formula]."[36]

The fact that the sweeping changes made between the third and eighth centuries

30. *LTMHC*, ii/2; Acker, *T'ang and Pre-T'ang Texts*, p. 179. The translation varies slightly.

31. *Ibid.*

32. *LTMHC*, i/4; Acker, *T'ang and Pre-T'ang Texts*, pp. 151–52. Acker's translation ends: "Such was the rugged freedom of his brush work that he had to give free expression to his ideas on the partitions and walls of buildings."

33. *LTMHC*, vi. Acker has not translated the entire work. See the *TSCC* ed., p. 215.

34. *LTMHC*, x, *TSCC* ed., p. 317.

35. *LTMHC*, v, *TSCC* ed., p. 198.

36. *LTMHC*, x, *TSCC* ed., p. 315.

encouraged a frequent reevaluation of artists is suggested by twelve uses in the *Li-tai ming hua chi* of *ku chin*, in claims that one artist or another was peerless for all time. As one would expect, these paragons begin with Ku and Lu, linked naturally to the unique Wang Hsi-chih in calligraphy. For modern counterparts, Chang Yen-yüan names Wu for figures and Han Kan[37] for horses. Presumably in a different sense he also speaks of the figure specialists Yen Li-te and his brother Li-pen as "the crowning glory of all time."[38] In connection with scenes of nomad life he names the Middle T'ang Li Chien as "without peer in past or present."[39] In addition, the opinions quoted by Chang from earlier writers occasionally praise the peerless celebrities of *their* times. The claim of uniqueness is made for Tien Seng-liang of the Northern Ch'i and Tung Po-jen of Sui,[40] and even for a long-forgotten wonderworker of early T'ang landscape art, Wang T'o-tzu. The mid-eighth-century critic who proposed this last name, Tou Meng, did so with as much fervor as any of the others: "His landscapes were unique. He created a school of his own, un-challenged in ancient or modern times [in rendering] untrodden and gloomy haunts."[41]

The pride taken by T'ang art lovers in the painters of their dynasty materialized in a second quasi-history, devoted exclusively to the T'ang: Chu Ching-hsüan's *T'ang ch'ao ming hua lu*, completed around the middle of the ninth century.[42] Chu was an unusually matter-of-fact writer for such a theme, not given to rhetoric or fine-drawn distinctions. His attitude toward the relationship of present and past was a sensible one, emphasizing the many-sidedness of painting rather than an ideal consistency. So it seemed to him proper that Lu T'an-wei should have been "beyond the highest of the high" as a por-traitist, four centuries earlier. Any attempt that he might have made to cope with the world of nature would have been naively primitive by T'ang standards.[43]

Two important Northern Sung histories continue the two types of record developed in the ninth century. The earlier, the *Sheng ch'ao ming hua p'ing* by Liu Tao-ch'un, is devoted to early Sung alone. Though a much more sophisticated and literary work than its T'ang counterpart, it conveys a similar sense of confidence and pride in the recent past. *Ku* is still a neutral term, or it may be used to indicate a refreshing independence. Thus we are told of the figure specialist Wang Kuan, who is ranked at the head of the *shen* class, that he knew Wu Tao-tzu's monumental style so intimately that he was able to correct that master's errors of proportioning: "He discarded the shortcomings of the men of old, and created a new excellence for the future."[44] Again, the author says of the

37. *LTMHC*, ix, *TSCC* ed., p. 305.
38. *LTMHC*, ix, *TSCC* ed., p. 275.
39. *LTMHC*, x, *TSCC* ed., p. 325.
40. *LTMHC*, viii, *TSCC* ed., pp. 252, 260.
41. *LTMHC*, ix, *TSCC* ed., p. 284.
42. A revised translation by A. C. Soper appeared as "Celebrated Painters of the T'ang Dynasty," *Artibus Asiae* 31 (1958): 204–30. For an earlier translation see "The Famous Painters of the T'ang Dynasty," *Archives of the Chinese Art Society of America* 4 (1950): 5–28.
43. Soper, "Celebrated Painters," p. 206.
44. Liu Tao-ch'un, *Sheng ch'ao ming hua p'ing*, i; see the companion anthology to *WSSY*, *Wang shih hua yüan* (hereafter cited as *WSHY*), 5:1b.

great landscapist Fan K'uan: "Antiquity gave him no rules. His creative ideas were his own: his achievements were like those of Creation itself."[45] Another landscape master, Yen Wen-kuei, is said to have "followed the lead of no one in the past when formulating his ideas."[46]

The section on the inspired bird and flower specialist Hsü Hsi says that "in sketching from imagination he went beyond the men of old, to create subtleties all his own."[47]

Of the "inspired" landscapist Li Ch'eng, finally, we read (in ii) that "antiquity had not his like for purity of thought and ripeness of style."[48]

The sequel to the *Li-tai ming hua chi* was Kuo Jo-hsü's *T'u-hua chien-wen chih*, completed around 1075.[49] Like its predecessor, this contains both historical and biographical material and theoretical essays. Among the latter is a section entitled "On the Relative Superiority of Past and Present," Kuo's answer to what was probably a common question in his day. His stand is essentially an amplification of Chu Ching-hsüan's: "If it is a question of Buddhist and Taoist icons, secular figure themes, gentlewomen, or cattle and horses, then the modern works do not measure up to the ancient. In the case of landscapes, trees and rocks, flowers and bamboo, birds and fish, then the ancient works do not equal the modern."[50] This is the same sort of rule of thumb that a realistic art historian would use today. In applying it to individual cases, Kuo makes a statement that may have seemed bold to his readers. If the famous T'ang landscapists, Li Ssu-hsün, Li Chao-tao, Wang Wei, Wang Hsiung, and Wang Tsai, or the celebrated bird and flower specialists, Pien Luan and Ch'en Shu, were to be reborn now, at the end of the first century of the Sung, no one would pay any attention to them, so far-reaching have been the advances since their time.

The *T'u-hua chien-wen chih* contains almost no examples of *ku* used either to praise or to blame. Since there was little likelihood that a recognized Sung artist would show any technical immaturity, it is not surprising that this implication occurs only once, in the term *ch'un ku*, used to describe fish paintings by an obscure army official called Lu the Ya-t'ui. The sense seems to be "archaic" or "primitive."[51]

On the side of praise, there is one instance of a binome that was soon to become more popular, *ku ya*. In writings on calligraphy this had been known at least since the T'ang in a highly favorable sense. Chang Huai-kuan uses it twice to characterize a basic quality in the art of the Eastern Han paragon Chung Yu. One passage culminates in the sentence: "There were no limits to his profundities, and he had a superabundance of antique

45. Liu Tao-ch'un, *Sheng ch'ao ming hua p'ing*, ii; *WSHY*, 5:20b.
46. *Ibid.*, p. 21b.
47. Liu Tao-ch'un, *Sheng ch'ao ming hua p'ing*, iii; *WSHY*, 5:30a.
48. Liu Tao-ch'un, *Sheng ch'ao ming hua p'ing*, ii; *WSHY*, 5:29b.
49. *T'u-hua chien-wen chih* (hereafter cited as *THCWC*) was translated by A. C. Soper as *Kuo Jo-hsü's Experiences in Painting* (Washington, D.C., 1951; hereafter cited as *Experiences*).
50. *Experiences*, pp. 21–22.
51. *THCWC*, iv; *Experiences*, p. 70.

nobility.[52] Again he says, in comparing Chung with Wang Hsi-chih, that the latter's "technique heightened sensuous beauty, but fell behind in antique nobility."[53]

Kuo Jo-hsü applies the term only to the architectural features, the "terraces and pavilions" placed by the landscapist Fan K'uan among his mountains.[54] His choice was perhaps quite apt. During the Northern Sung, formal architecture evolved a long way from the large-scale boldness with which it began—as an inheritance from T'ang— toward the almost dainty intricacy of the Southern Sung. Fan was active during the dynasty's first two generations; he may well have continued to favor as an old man the sturdy building of his youth, which suited his huge rock masses, and so preserved for a while the monumental nobility that was disappearing in practice.

Kuo's single use of *ch'ing ku* is mildly regretful; he applies it to the idealized female figures in old pictures. In his own time the degeneration of this theme was unmistakable since instead of dignity nothing was required except a surface prettiness.[55] Another new term whose implications are not developed is *ch'i ku*, applied only to the icons painted in the late ninth and early tenth centuries by the Szechwan master Chang Su-ch'ing. This was probably Kuo's way of summarizing what he had read in one of his earlier sources, the *I-chou ming hua lu*: the fact that Chang had enjoyed the (very rare) privilege of studying an extensive collection of Sui and T'ang masterpieces, which gave his own style a "uniquely antique" look.[56]

Kuo's pride in the present, however, was already falling out of date when he wrote, doubtless as an old man, in the 1070s. The great names that he recites in the modern fields of landscape and flower and bird painting are in almost every case those of men who had been active during the Five Dynasties. Of his three landscape geniuses—Kuan T'ung, Li Ch'eng, and Fan K'uan—only the last had a lengthy career at the outset of the Sung. The landscape section names some twenty-four masters, but only one, Hsü Tao-ning, is suggested as a close successor to Fan K'uan, and only one more, Kuo Hsi, had appeared when Kuo Jo-hsü wrote, forty years or so later.[57] The others were all praise-worthy in one way or another, but clearly owed much more to the momentum built up by their great predecessors than to their own capacities. Kuo Hsi, in writing his own "Essay on Landscape Painting" a little later, refers to the "artists of today" with a new note of complaint, speaking of their immaturity, the narrowness of their training and experience, and their preference for small themes rather than great ones.[58]

Kuo Jo-hsü's flower and bird section is even more crowded, but again the only peerless masters had painted in the tenth century, Huang Ch'üan at the Shu court and Hsü Hsi at Nanking. Those who practiced at the Sung capital were their descendants or followers,

52. *FSYL*, viii; *WSSY*, 4:29a.
53. *Ibid.*, p. 30b.
54. *THCWC*, i; *Experiences*, p. 19.
55. *Ibid.*, p. 18.
56. *THCWC*, ii; *Experiences*, p. 25.
57. *THCWC*, iii; *Experiences*, p. 58, 60.
58. Translated by Shio Sakanishi, *An Essay on Landscape Painting* (London, 1935), pp. 33, 41–43, 50.

with a sprinkling of innovators whose work was by some greatly admired and by others dismissed with contempt.[59]

For all of his assurance, Kuo had formally signed over half of the great fields of painting to the dominance of the past. In the histories and treatises on painting that fall in the next three generations, this drift becomes increasingly marked. Toward the turn of the century, to begin with, the heightened reverence for antiquity seen in so many other aspects of Sung life was epitomized for painting in the careers of the two most famous artists of the conservative coterie at the capital, Li Kung-lin and Mi Fu. Both were fervent collectors, specialists in antiquarian lore, and tireless copyists of old paintings and specimens of fine writing. In his own paintings of figures and animals, Li carried out a more serious search for great models than had been known before outside calligraphy.[60] Throughout the Northern Sung the well-schooled artists who worked in this time-honored area had been following one or the other of two contrasting traditions, the styles of Wu and of Ts'ao. The first certainly looked back to Wu Tao-tzu, and the other probably commemorated the sixth-century Buddhist painter Ts'ao Chung-ta.[61] It is noteworthy that these identifications were not universally accepted; the ties with the past must have been very loose. The major original works by "Wu and Ts'ao"—whomever they may have been—had certainly been wall paintings, destroyed centuries earlier.

Li Kung-lin may have seen one or two surviving frescoes attributed to Wu Tao-tzu, along with the small-scale works, sketchbooks, and careful copies on which he must have placed a greater reliance. From this material, and from what he had read in the histories of painting about Wu's indifference to colors, he set a new fashion for drawing in outlines only, *pai hua*. For the type of subject in which Wu's *terribilitá* would have been incongruous, he found more elegantly modest authorities in Ku K'ai-chih and Lu T'an-wei. Since he liked to paint fine horses, he went inevitably to the mid-T'ang master Han Kan. Hui Tsung's painting catalogue, the *Hsüan-ho hua p'u*, in which these connections with past painters are drawn, sums up the emperor's admiration for the subtle simplicities of his style by comparing him to the poet Tu Fu.[62] The later *Hua chi*, completed by Teng Ch'un in 1167 after the near-destruction of the dynasty and so perhaps less accurate a source, also links Li with the mid-T'ang ox specialist Han Huang, and in landscapes with Li Ssu-hsün. It is clear that he was a brilliant draftsman in any kind of traditional line, hair-thin, iron-wire, or boldly accented. With his great talents, high social standing, and the access he enjoyed to the masterpieces in great collections, he was able to bring about a kind of neoclassic revival in the very fields that Kuo Jo-hsü had relinquished to the past.

The extraordinary whims and fits of temper that punctuated Mi Fu's everyday life

59. *THCWC*, i. iii; *Experiences*, pp. 33–34, 61–62.

60. Well covered by Agnes E. Meyer, *Chinese Painting as Reflected in the Life and Thought of Li Lung-mien* (New York, 1923); and in O. Sirén, *Chinese Painting: Leading Masters and Principles*, 7 vols. (New York and London, 1956–58), 2:39ff. See also Richard Barnhart's essay later in this volume.

61. *THCWC*, i; *Experiences*, pp. 16–17.

62. *Hsüan-ho hua p'u* (hereafter cited as *Hua p'u*), vii, see also Sirén, *Chinese Painting*, 2:39–40.

make him a witness to be used with more than usual caution.[63] As a collector of treasures from the past, he could be possessive to the point of mania; as a critic of art, he could be both sensitive in his judgments and reckless in stating them. Nothing in the present or past of painting and calligraphy was safe from his arrogance and spite. In one anecdote we find him revealing his jealousy of Li Kung-lin through an attack on Li's great model, Wu Tao-tzu. He himself preferred Ku K'ai-chih, he said, and took not one single brushstroke from Master Wu.[64] Another story, perhaps too outrageous and told too late to be fully credible, appears in the *Ku chin hua chien* of the Yüan connoisseur T'ang Hou. Mi is said to have written on a screen in the presence of Hui Tsung (in hiding), and at his command. When he had finished he threw down his brush, crying, "I have washed away all the ugliness of the Two Wangs' style, and have brought glory to the imperial Sung for a myriad ages to come!"[65]

Mi's "history" of painting, *Hua shih*, contains several instances of such impudence, chiefly directed toward the fashionable artists of the recent past or of his own time who specialized in birds and flowers, a field that he placed next to the bottom, outdone in triviality only by pictures of fine ladies and animals. The famous Five Dynasties master Huang Ch'üan he found "for all his opulence and beauty, invariably vulgar."[66] Of the Sung experts he pronounced one group fit only for decorations for wedding receptions.[67] Another, he said, "should be hung in tea shops and wine parlors; they will only deface the walls of [a gentleman's house]."[68] He describes lovingly the studio in which he kept his oldest and rarest art objects from the Chin age, his Pao-chin-chai. One of these passages terminates in a surprising way, with a reference to the paintings from his own brush that he hangs in pairs in the studio. He does "no large pictures," he says, "and not one brushstroke has the commonplace spirit of Li Ch'eng and Kuan T'ung."[69]

In contrast to this sort of wayward snobbery, Mi's approval must have been genuine and carefully phrased. In the use of *ku* he introduces two more binomes, destined to flourish greatly in the future. His *kao ku* was the quality of "lofty antiquity" in Ku K'ai-chih that made him preferable to the more easily accessible Wu.[70] To judge from the entries in the *P'ei wen yün fu* and the exhaustive Japanese dictionary *Dai Kanwa jiten*, this term was adopted in Sung poetic circles: Mi's friends Su Shih and Huang T'ing-chien are said to have composed in a style marked by an extreme of *kao ku*.[71] (It is in this context that it

63. Nicole Vandier-Nicolas has discussed Mi's personality and career in *Art et sagesse en Chine, Mi Fou (1051–1107)* (Paris, 1963) and has translated his treatise on painting, *Hua shih*, as *Le Houa-che de Mi Fou* (Paris, 1964).

64. *Houa-che*, p. 59; see also *Hua chi*, iii.

65. For this text I have used the modern reprint in *Mei-shu ts'ung-k'an*, 1:175

66. *Houa-che*, p. 39.

67. *Ibid.*, pp. 90–91.

68. *Ibid.*, pp. 68–69.

69. *Ibid.*, p. 74.

70. *Ibid.*, p. 59.

71. See *Dai Kanwa jiten*, vol. 12, no. 45313/308 (the opinion is taken from the *Men-se hsin hua* by Ch'en Shan, a partisan of Wang An-shih's): "The poems of Lord Ou-yang [Hsiu] are still in the style, *feng-ch'i*, of

is used once by Kuo Jo-hsü, characterizing a poetic eulogy composed at the Shu court in honor of a painting by Chang Su-ch'ing.[72]) Mi Fu shows an awareness of its further possibilities by applying it to a landscape painted by one of his favorite masters, Tung Yüan, the southerner who worked at the Five Dynasties Nanking court. The picture was in Mi's own collection, and so must have been especially dear to him. He says of it: "The framework of the mountains is now hidden, now revealed; the forest treetops appear and disappear. The conception has a flavor of lofty antiquity."[73] In Mi's companion treatise on calligraphy, *Shu shih*, the single instance of *kao ku* has a fairly literal sense: he speaks of "the lofty antiquity prior to the Two Wangs."[74] How the term could be applied to a tenth-century landscape is suggested in the *Hua shih* in connection with a T'ang copy of Ku K'ai-chih's celebrated "portrait" of the sage Vimalakīrti:

> On the folding screen [behind the sage is painted] a landscape whose woods and trees are strange and archaic *ch'i ku*. The "wrinkles," *ts'un*, on its banks and hillsides are like Tung Yüan's. One realizes why men say of the South that from Ku K'ai-chih on it has always been given the same look; through Sui, T'ang, and down to [Tung's pupil] Chü-jan there has been no change.[75]

Mi's second *ku* binome is *ku i*, which we shall meet at the end of this essay as the foremost requirement for fine painting, proclaimed as a new dogma by the Yüan master Chao Meng-fu. With Mi the implication is still unpretentious; to him the Sung painter Wu Yüeh, a student of Wu (Tao-tzu), "conveys the sense of antiquity."[76] In his *Shu shih* he is equally matter-of-fact in speaking of a ninth-century court calligrapher who codified the accepted ways of writing into ten styles: "T'ang Hsüan-tu in his various styles gives a rough sense of antiquity."[77] *Ch'i ku* is used descriptively several times in the two books with a sense something like "singularly oldfashioned," all in reference to works of the T'ang or earlier.[78]

the T'ang men who were followed at the beginning of this dynasty. He succeeded in changing Sung prose style, but not poetic style. Then there appeared such men as the Duke of Ching [Wang An-shih], Su [Tung-p'o], and Huang [T'ing-chien]; and thereafter the style of poetry reached an extreme of *kao ku*."

72. *THCWC*, vi; *Experiences*, p. 99: "Scanning the eulogy he would admire its elevated and antique phraseology; and as he examined the handwriting he would cherish the sturdy virility of its dots and strokes."

73. Vandier-Nicolas' version in *Houa-che*, p. 49, is: "C'est une conception qui remonte à la plus haute antiquité."

74. Text reprinted in *Mei-shu ts'ung-k'an*, 1:81; and in *WSSY*, 6:34a.

75. *Houa-che*, pp. 153–54.

76. *Ibid.*, p. 70.

77. *Mei-shu ts'ung-k'an*, p. 79; *WSSY*, p. 31b.

78. *Hua-shih* uses it of a picture of Lao-tzu crossing the western frontier (p. 48), of a tree and rock composition by Pi Hung of the T'ang (p. 157), of a landscape by the same Pi Hung (p. 108), of an anonymous T'ang landscape (pp. 148–49), and of a portrait of the fifth-century poet Hsieh Ling-yün (pp. 156–57). All these are in addition to the screen in the Vimalakīrti picture mentioned above. In Mi's *Shu shih* the term refers to a piece in the *ts'ao* hand by Yüan Yen of Liang, and again in referring to the Liang virtuoso Hsiao Tzu-yün. See *Mei-shu ts'ung-k'an*, 1:62, 82; or *WSSY*, 6:9a, 36a.

Mi's calligraphy treatise has two other laudatory compounds, *ching ku* and *chien ku*. The first is used to describe a specimen from the hand of the high T'ang *ts'ao shu* expert Chang Hsü: "A genuine work in which the layout of the characters was vigorous and antique, not like the other writings by him that one sees in collectors' hands, the very best of all his works."[79] *Chien ku* is applied to a writing by Chang's eccentric monk pupil Huai-su, in which "the effect of the brush was simple and antique, for this was a work of his maturity."[80]

Perhaps it was still more natural in Mi's time to associate such virtues with the past in calligraphy than in painting. In handwriting the best models had always been the oldest, dating from the fourth century or earlier. Paintings of such a vintage were extremely rare, and the usual pre-T'ang survivors were likely to be neither very simple nor very vigorous.

There is an apt confirmation of the distance that still separated the aesthetics of the two brush arts in the case of Mi himself, who was admired for his performances in both. As a landscape painter he opened up a quite new direction and was granted the status of an inventor. Teng Ch'un praises a picture by him that seems to have been an experiment in the direction of *wen-jen hua*:

> Plum tree, orchid, and chrysanthemum were set in sequence on the paper, their branches and stalks crossing and the foliage intermingled but without confusion. In terms of [actual] complexity it was almost simple, yet in that simplicity there was nothing loose. It was very lofty, very original, truly a masterpiece for the ages.[81]

Mi's calligraphy, on the other hand, prompted his friend and fellow amateur Su Tung-p'o to make an all too familiar comment: "In our own time there is the cursive style of Mi Fu and the small *ts'ao* hand of Wang Kung. Both have a good deal of loftiness of tone [?], but do not measure up to the men of old."[82] In Hui Tsung's calligraphy catalogue a good deal of admiration for Mi is expressed, but only one specimen of his work is listed.[83] The remnant of the Ch'ien-lung emperor's collection, now in the National Palace Museum, Taipei, includes five. By way of contrast, Hui Tsung owned seventy-seven pieces from the brush of his favorite, the "bad minister" Ts'ai Ching.

The reign of Hui Tsung (1101–1125) must have greatly increased the authority of the past over the minds of artists, critics, and patrons. His prolonged effort to collect in quantity the finest paintings of all periods brought together in the Pien-ching palace an unprecedented number of works by old masters. The imperial *Hsüan-ho hua p'u* claims 1,257 paintings by named artists between the third century and the fall of the T'ang. (There were, of course, far more for later periods; the collection totaled 6,396.) Hui Tsung's concurrent interest in his painting academy—in raising the level of court art

79. *Mei-shu ts'ung-k'an*, 1:68; WSSY, 6:36a.
80. *Ibid.*, pp. 78 or 30b.
81. *Hua chi*, iii; WSHY, 7:17b.
82. See *Tung-p'o t'i-pa*, iv/39a in the Chi-ku-ko ed.
83. *Hsüan-ho shu p'u* (hereafter cited as *Shu p'u*), xii, TSCC ed., pp. 282–85.

through reforms in the training of candidates and close supervision of their work—must have given this treasure house a double value. From it, by systematic examination and criticism on the part of experts, could be selected the best models for every use, to train modern eyes and hands and to enrich modern imaginations.

It is not likely that the emperor thought of this as a confrontation with only one desirable outcome. As a ruler he gave his support to what was left of the innovating faction at court. One of his early educational reforms was the establishment of a school for budding painters at the capital (along with others for calligraphy, ciphering, and medicine), in which the curriculum was designed to substitute working from nature for copying of earlier masters.[84] It is hard to believe that this preference was stringently enforced, at least for very long, since the independent art school to which it presumably applied was in existence only from 1104 to 1106. The description of Hui Tsung's personal visits to the studios where his future academicians were in training, however, make it clear that a very close observation of nature was one of his deepest concerns.[85]

As an expert calligrapher the emperor perfected a highly original style, so far from normal influences that later critics tried to explain it as writing affected by his habits as a painter. In painting he worked chiefly in the most recently matured field, flowers and birds, where history provided very little prior to the mid-tenth century. Pictures of that sort comprised about 40 percent of the Hsüan-ho collection, a total of 2,786. All the well-known recent names were heavily represented, from the 349 works claimed for Huang Ch'üan to the 189 contributed by one of Hui Tsung's own academicians, Wu Yüan-yü. Out of the same academy there emerged one landscape painter, Li T'ang, whose powers of assimilation and re-creation were so great that he almost singlehandedly built up a new vocabulary of forms for the next century and a half of the Southern Sung.

Unquestionably, the *Hsüan-ho hua p'u* is more deeply permeated by respect for the past than any previous work on painting. It shows this first by its frequent references to the *ku jen*, the men of old, not in sweeping comparisons with their modern heirs but in individual cases. Almost none of these references, surprisingly enough, lapses into the despairing formulas applied to calligraphers: "he does not reach . . . ," "he is not close to . . . ," "modern times do not equal. . . ." There were certainly many artists represented in Hui Tsung's collection of whom this might have been said. Instead, what is emphasized are the cases in which the past *was* mastered, or even surpassed, by men whose creative strength permitted them to study and love without sacrificing their independence.

Thus it was said of Li Kung-lin that his father, an honorary councilor at court, "loved to collect specimens of fine handwriting and celebrated paintings. Kung-lin as a boy scrutinized these until he understood the brushwork and ideas of the ancients."[86] And it was said of the Five Dynasties dragon specialist Priest Ch'uan-ku: "In his most untram-

84. *Sung shih*, clvii.
85. *Hua chi*, x; Sirén, *Chinese Painting*, pp. 76–78.
86. *Hua p'u*, vii, TSCC ed., p. 197.

meled passages he sometimes achieved more than had been possible for the ancients."[87]

Of the grandee Wang Shen, friend and patron of Mi, Li Kung-lin, and Su Tung-p'o, a great collector in the generation before Hui Tsung and a fine landscapist in his own right: "When he brought down his brush with his mind made up, he would go on to reach those regions in which the ancients had been pre-eminent."[88]

Of the Sung imperial prince Chao Tsung-han, another landscapist: "His *ch'i yün* was carefree, and he conveyed the flavor of lonely distances in the river and lake [country]. Critics held that he was not inferior to the ancients."[89]

Of the Sung deer and ape specialist I Yüan-chi: "He began as a painter of flowers and birds, until he saw a picture by [the fashionable master] Chao Ch'ang. Thereupon he said: 'There is no lack of [talented] men in this age; I must abandon my old habits, so as to rise to the top in those directions which the ancients did not enter.'"[90]

Of the Sung flower and bird specialist Ts'ui Po: "His finest passages were not inferior to the ancients.... Had he not been a lover of the past and broadly cultivated, so that he could master what the men of the past conveyed from mind to brushpoint, this would not have been possible for him."[91] (Two or three decades earlier the calligrapher-critic Huang T'ing-chien had said of Ts'ui more cautiously: "In brush and ink he almost reaches areas to which the men of old paid little attention."[92])

In the *Hsüan-ho hua p'u* the binome *kao ku*, "lofty antiquity," is applied more frequently than before and for more varied purposes. It describes the style (*ko*) of the tenth-century Shih K'o, a specialist in grotesque and fantastic figures;[93] the palace architecture rendered in great detail by the eleventh-century expert Kuo Chung-shu;[94] the simplifications in dragon painting devised by Priest Ch'uan-ku;[95] the *ch'i yün* of the eleventh-century landscapist Sun K'o-yüan,[96] and the paintings by famous masters in the palace collection itself that were copied by one of Hui Tsung's eunuch attendants, Liang K'uei.[97] Though the links with the past are clear in the second and last instances, the others suggest that the term might now be used with poetic vagueness, as little more than fashionable compliment. A half century later Teng Ch'un was to apply *kao ku* with this new looseness to the early twelfth-century landscapist Ch'ien Chih-ch'eng: "His ideas were fashioned with refinement and profundity; his brushwork was lofty and antique."[98]

The fact that calligraphy in Hui Tsung's time was still more overshadowed by the

87. *Hua p'u*, preface to ix, *TSCC* ed., p. 236.
88. *Hua p'u*, xii, *TSCC* ed., p. 329.
89. *Hua p'u*, xvi, *TSCC* ed., p. 445.
90. *Hua p'u*, xvii, *TSCC* ed., p. 509.
91. *Hua p'u*, xviii, *TSCC* ed., p. 519.
92. See *Shan-ku t'i-pa*, iii, a colophon to an ink bamboo painting by Li Han-chü, *TSCC* ed., p. 28.
93. *Hua p'u*, vii, *TSCC* ed., p. 190.
94. *Hua p'u*, preface to viii, *TSCC* ed., p. 214.
95. *Hua p'u*, ix, *TSCC* ed., p. 239.
96. *Hua p'u*, xi, *TSCC* ed., p. 306.
97. *Hua p'u*, xii, *TSCC* ed., p. 336.
98. *Hua chi*, vi, *WSHY*, 8:16a.

past is made clear first by the contrast in curriculum between the schools of writing and painting established in 1104. In both, the students were required to familiarize themselves with the earliest dictionaries—presumably to make their knowledge of the remote past more concrete—and to study at least one Confucian Classic. Thereafter the divergence was complete. The student-painters "were not to imitate their predecessors, but to give their subjects sentiments and physical characteristics fully in accordance with nature. Skill was to lie in a lofty simplicity of brush tone."[99] When they studied the regular hand, the young calligraphers were to base themselves on the formal and cursive styles of the Two Wangs, Ou-[yang Hsün], Yü [Shih-nan], Yen [Chen-ch'ing], and Liu [Kung-ch'üan]. For the *ts'ao* hand their model was to be the nine variations devised by Chang Chih of Han. The greatest success was to write so that "the strokes were vigorous, the vital force pure, the tone antique and ripe, without any trace of vulgarity." The bottom category of students would be those who "could copy the brushstrokes of the ancients without mastering their intentions."[100]

The simplest statistics show the much greater hold of the past on Hui Tsung's calligraphy collection and its catalogue. Old paintings dated prior to the Five Dynasties accounted for about 20 percent of that total, as we have seen. Old specimens of writing for the same period were about 80 percent of the whole. In contrast to the emperor's predilection for modern landscapists and flower and bird experts, he owned no more than a handful by any but two late calligraphers—his ministers Ts'ai Ching (77 items), and the last prince of the Southern T'ang regime, on whose style his own writing was said to have been based (24). Instead, he concentrated on old masters. No less than 243 were claimed for Wang Senior and 89 for Wang Junior. The T'ang paragons Ou-yang, Yü, Yen, and Liu were represented by 40, 13, 28, and 11, respectively; and the famous drunken *ts'ao* experts of the mid-T'ang, Chang Hsü and Huai-su, by 24 and 101.

The *Hsüan-ho shu p'u*, again, is much more heavily laced with *ku* than its counterpart. There are about three times as many references to the ancients, taken collectively, or to the masters of Chin and Liu Sung, against whom all later men must pit themselves. Here also individual achievements may be singled out as successful, and there are not many out-and-out failures; like any other major collector, Hui Tsung probably preferred such frankness in small doses. At one point, however, the classical standard is revealed in its starkest form. The discussion is of a ninth-century *ts'ao shu* specialist, P'ei Su, a student of the Two Wangs:

> Looking at [the specimen by him in the collection], one may say that while he aimed at strength there is not much muscle and too much surface charm; i.e., he failed to capture the subtleties of the ancients' brushwork. . . . But the excellence of the characters drawn by Hsi-[chih] and Hsien-[chih] went far beyond their own Eastern Chin period, to become the eternal prototype for brush and ink. Considering

99. Recorded in the dynastic history *Sung shih* near the end of ch. clvii, dealing with the educational system, *Po-na-pen* ed., p. 35b.

100. *Ibid.*, p. 34b.

those who later studied them, who cannot be said to have "mounted to the hall" or to have "entered the apartment,"[101] who indeed were hardly able to peer through the hedge and yet with that alone won celebrity—in comparison, Su's study of the characters is almost impressive.[102]

The antiquarian zeal of Hui Tsung's age, continued at Hang-chou by his son Kao Tsung, encouraged the imitation not only of the accepted classical models, but also of styles that had fallen out of fashion long before or had been superseded in the process of stylistic evolution. To Kuo Jo-hsü, the T'ang landscapists from Li Ssu-hsün on had seemed completely out of date. Now they were revived in the small and intimate landscapes contrived by two prince-painters at the turn of the century, Chao Ling-jang and Chao Yung-nien. At Hang-chou a more pronounced archaic note was added when Chao Po-chü standardized the use of blue, green, and gold. To an unabashed eclectic it now seemed profitable to handle both modern and revived styles, depending on the commission. The Szechwan master Chou Shun adopted Li Ssu-hsün as his model for landscapes and looked back to Ku K'ai-chih for figure themes; but when he painted Buddhist icons he was satisfied with his near contemporary Li Kung-lin.[103] We know from the same source that another late Northern Sung figure, Ch'ao Pu-chih, listed no less than twelve different authorities, ranging in time from Wu Tao-tzu and Chou Fang to Ts'ui Po, from whom he borrowed the various parts of his repertory.[104]

We know that Hui Tsung himself was a meticulous copyist from the classical past in the two handscrolls still extant that claim to derive from lost works by the eighth-century master of court ladies and their pleasures Chang Hsüan.[105] The emperor is also said to have reproduced by his own hand a (now lost) painting by the fourth-century Wei Hsieh, showing a *kao shih*, a gentleman cultivating lofty pleasures. Since the earliest description of this replica appears only in the last generation of Ming, its value is not very high,[106] but at least we know that Hui Tsung's collection included a "Wei Hsieh" with that same title.[107]

It is of incidental interest that a conspicuously large number of painters from the Five Dynasties on into the Southern Sung had names in which *ku* appeared either in the *ming* or the *tzu*. These were: for the tenth century, Priest Ch'uan-ku; for the early eleventh, Sun Chih-wei, called T'ai-ku; for the later Northern Sung, Sung Ti, called Fu-ku, Chang Tsung-ku, and Hou Tsung-ku; and for the Southern Sung, Cheng Hsi-ku, Liu Tsung-ku,

101. These quotations are from the *Analects* xi, 14, in which Confucius is speaking of his disciple Tzu-lu's progress. Legge in his *Chinese Classics* (London, 1865–95), 1:242, makes it: "Yu has ascended into the hall, though he has not yet passed into the inner apartments."

102. *Shu p'u*, xviii, *TSCC* ed. p. 407.

103. *Hua chi*, iii, *WSHY*, 7:246.

104. *Ibid.*, pp. 18a–18b.

105. Sirén, *Chinese Painting*, 1:144, describes the Boston *Ladies Preparing Silk* and on p. 145 what he calls the *Spring Party of Lady Kuo-kuo.*

106. See Wang K'o-yü, *Shan-hu wang hua lu*, iii.

107. *Hua p'u*, v, *TSCC* ed., pp. 150–51.

Li T'ang called Hsi-ku, Chia Shih-ku, Sung Min called Hao-ku, Wu Ku-sung, Liu Ku-hsin, and Priest Wei-han, called Ku-ch'ing.[108] In contrast, the *Li-tai ming hua chi* lists only one artist with such a name throughout its entire period, an early eighth-century portraitist, Chou Ku-yen.[109]

The Southern Sung period offers much less information about changes of taste in painting than the late Northern Sung. Its one ambitious history, the *Hua chi*, has little to say or suggest about the shifting balance between ancient and modern. The most representative painting of the time, the "academy style" favored at court, carried on for generations a discreet compromise between the two, in which recent achievements usually played the major role. Figure painters, recorders of the human scene, were encouraged to practice a descriptive realism more pronounced than ever before. The landscape style initiated by Li T'ang and carried to its conclusion by Ma Yüan and Hsia Kuei is clearly a late product, derived from Northern Sung precedents but strikingly independent of any earlier master's style. Its designs and forms show no signs of a return to the more distant past. On the contrary, its characteristic blending of light and mist, its habit of setting strong solid forms against others half dissolved or barely hinted, implies a study of atmospheric effects for which no previous period was equipped.

Two very important documents from the early Yüan, written by connoisseurs in the South whose early life had been spent under Sung rule, give a very different impression. The earlier is by the well-known littérateur Chou Mi, who was already serving as a magistrate in Chekiang in the 1250s. His works include a series of notes on the contents of art collections that he saw, chiefly in the 1290s. The broadest coverage is given these in his *Yün yen kuo yen lu* (the title borrowed from a famous confession by Su Tung-p'o and the point of view and much of the vocabulary from Mi Fu).[110] More detailed information recurs in his *Chih-ya-t'ang tsa-ch'ao*.[111] Out of a great many scraps of information one remarkable generalization may be made: the paintings treasured by these Southern collectors in the generation after the conquest included not one single representative of the Southern Sung academy style. This sweeping rejection of the immediate past was true even of the largest collection listed by Chou, that of a member of the old imperial clan who had been governor of the capital district as early as the 1230s, Chao Yü-ch'in. The only important masters still in favor who had worked at Hang-chou were all atypical: Li T'ang, most of whose career had been spent in the North; the mid-twelfth-century Ma Ho-chih, who painted as a gentleman amateur with scholarly inclinations; and the best-

108. These names have been accumulated from earlier sources in the Yüan dynasty painting history *T'u-hui pao chien*, by Hsia Wen-yen, preface dated 1365. In the modern anthology *Hua shih ts'ung shu*, edited by Yü An-lan (Shanghai, 1962), see 3:34, 43, 50, 67, 86, 95, 100 (two references), 103, 130, 132, 150, and 153.
109. *LTMHC*, x, *TSCC* ed., p. 311.
110. Accessible in *Mei-shu ts'ung-shu*. In the Shanghai edition of 1928, see vol. 2, ii/1–2; in the recent Taipei reprint, see xii. For the author's close relationship to Chao Meng-fu, see Chu-tsing Li, *Autumn Colors on the Ch'iao and Hua Mountains* (Ascona, 1965).
111. In the same two editions of *Mei-shu ts'ung-shu* see 3, iii, p. 4, or xxiii.

known archaizer of the same period, Chao Po-chü, who specialized in colorful, T'ang-style landscapes.

The other document, also divided between two titles, is a series of critical notes on well-known painters of the past by T'ang Hou, a southerner who spent some time at Peking, where he was able to talk about paintings with an artist-connoisseur attached to the imperial library, K'o Chiu-ssu. The longer, more summary work is his *Ku chin hua chien*, said to have been published posthumously around 1330.[112] The shorter and more detailed is the *Hua lun*.[113]

T'ang says flatly: "Collectors of painting nowadays mostly prize the old and care little for what is recent."[114] He is disdainful of the Southern Sung official style:

> After the Sung moved southward, many gentleman-officials appeared who were good at painting. Men such as Chu Tun-ju, called Hsi-chen, Pi Liang-shih, called Shao-tung, and Chiang Shen, called Tao-kuan, were all capable painters of landscapes, trees and rocks, and the like. Then there were various men who won names for themselves in the painting academy, such as Li T'ang, Chou Ts'eng, and Ma Fen, continuing down to Ma Yüan, Hsia Kuei, Li Ti, Li An-chung, Lou Kuan, and Liang K'ai. I make an exception of Li T'ang, who is worth looking at, but the others I cannot tell apart.[115]

In T'ang Hou's vocabulary, *ku* has finally come into its own as an index of value applicable everywhere. Most bluntly, it may be used alone: thus we are told of the Northern Sung water buffalo specialist P'ei Wen-ni that "he was a skillful painter who made a name for himself; but though he could get a likeness, he had too little *ku*."[116]

A colophon by T'ang's near-contemporary Chao Meng-fu is quoted, praising a horse picture by the T'ang master Ts'ao Pa: "There were a good many T'ang men who were expert horse painters, but Ts'ao and Han [Kan] were the best; the reason being that their control over their ideas was lofty and antique [*kao ku*], and they did not strive for [mere] likeness."[117]

In connection with a pupil of Han's, Tai Sung, who became a water buffalo expert, T'ang remarks: "The men of old held that domestic animals are unsuitable for the pure pleasures of the library. But if the brush scheme is clear and lush, so that when the scroll is opened its sense of the past, *ku i*, is suddenly manifest, and there is an atmosphere of peasants and fields, I will take [Tai] Sung."[118]

Ku i is an important compound. T'ang holds it against the archaizer Chao Po-chü that

112. Reprinted in *Mei-shu ts'ung-k'an*, 1:159–78. The statement about his relationship with K'o Chiu-ssu (who was given the post referred to in 1330) is made briefly by a friend, Chang Yü, in a preface apparently written after T'ang's death. Further details are lacking; it seems likely that Chang put the existing work together from T'ang's notes, and perhaps made additions of his own.

113. *Mei-shu ts'ung-k'an*, 1:153–57.

114. *Ibid.*, p. 156.

115. *Ibid.*, p. 176.

116. *Ibid.*, p. 173.

117. *Ibid.*, p. 163.

118. *Ibid.*, p. 164.

although his colorful, gold-lit landscapes resembled their T'ang models enough to be "charming, he lacked *ku i*."[119] Again, the Sung figure master Hao Ch'eng "was extremely vulgar in his horse paintings. I once saw a picture by him of men and horses which was no better than hack-work; it particularly lacked *ku i*."[120]

Kao ku recurs in a discussion of the eleventh-century landscapist Kao K'o-ming, who specialized in miniatures for fans and decorative panels: "Although his landscapes are skillfully done, they are not free of the clichés of professional painters; they convey no spirit of deep understanding, of lofty antiquity."[121] Of Ma Ho-chih, on the other hand, we find: "Very good at secular figures, with a running brush that seems to whirl and fly. His contemporaries called him Master Wu Junior, because he was able to rid himself of vulgar clichés and fix his mind on what was lofty and antique."[122]

T'ang records a verdict on the Ch'an painter-monk Mu-ch'i that has pained and mystified the modern devotees of his work in Japan: "His ink-play is coarse and ugly, [governed by] none of the rules of the past."[123] In contrast, he praises the almost-forgotten Ch'en Lin, a southerner who survived the fall of the Sung:

> A professional painter who was able to model himself on the past. His landscapes, bamboo and flowers, and birds and beasts were all highly acclaimed. He looked at the copies of old masters that were made by the academicians, and Chao Tzu-ang [i.e., Meng-fu] used to explain things to him in a way that he found very helpful. His painting was not vulgar; in all the two centuries of Sung in the South, there was no other professional like him.[124]

It would be a very interesting document for the formation of new standards of taste in an unsettled age if a record of Chao's conversations with Ch'en Lin were ever found. Under the circumstances described, his success was phenomenal. The listener was a painter for hire, all of whose experience must have consisted of what the new arbiters called vulgar clichés. The visual material used to open his eyes to the greatness of earlier ages was a series of routine copies, made by the academicians whose own work was now thought beneath notice. We must reconstruct what Chao may have said from his preserved writings in other contexts. In 1301, for example, he composed an often-quoted colophon:

> What is precious in a painting is the spirit of antiquity, *ku i*; without it, skill is wasted. Nowadays men who know how to draw at fine scale and lay on rich and brilliant colors consider themselves competent. They quite ignore the fact that a lack of the spirit of antiquity will create so many faults that the result will not be worth looking at. My

119. *Ibid.*, p. 163.
120. *Ibid.*, p. 169.
121. *Ibid.*, p. 173.
122. *Ibid.*, p. 177.
123. *Ibid.*, p. 177.
124. *Ibid.*, p. 178.

own paintings will seem to be quite simply and carelessly done, but connoisseurs will realize that they are superior because of their closeness to the past."[125]

On the handscroll by Chao of *Sheep and Goat* in the Freer Gallery, as Chu-tsing Li has recently pointed out, he wrote a brief note that concludes: "Although this painting cannot approach those of the ancients, it seems to have caught something of their *ch'i yün*."[126] Whether this humility was real or assumed—Chao badly needed a blameless self-image—it makes a nice terminal contrast with the mood of a comment by Su Tung-p'o, written two centuries earlier: "My own writing is not very good, but when some new idea comes to me spontaneously and I cease to tread in the footsteps of the ancients, I am delighted."[127]

It may be of interest to conclude with a postscript comparing the chronologies of painting and calligraphy with what is observable in a third great art. Literature reached what was later to be considered its golden age—through its involvement with Confucian and Taoist teachings—centuries earlier than calligraphy and a millennium or more before painting. Its evolution thereafter toward complexity, richness, and superficiality provoked the first deliberate rejection of the immediate past as early as the outset of the T'ang. Six hundred years or so before the critics and connoisseurs of the Yüan repudiated the paintings of the Southern Sung, the early T'ang writer Ch'en Tzu-ang complained: "The way of letters has been in decay for five hundred years; the frame and temper of Han and Wei were not handed on to Chin and Sung."[128]

In an essay on poetry Li Po took up the same theme: "Since Liang and Ch'en times, sensuous beauty and triviality have reached a climax. If there is to be a revival of the Way of Antiquity, who is there but I [to undertake it]?"[129]

In the middle T'ang, when Han Yü and Liu Tsung-yüan began to preach the need for a more fundamental return to the ideals of the past, and developed the *ku wen* as a means of conveying their moral teaching most effectively, the most correct and inspiring models for prose style were chosen from Chou and Han: several of the Confucian Classics, the *Chuang-tzu*, the *Li-sao*, the *Shih chi*, Yang Hsiung, and Ssu-ma Hsiang-ju. In the second and more successful wave of purification that rose in the Northern Sung with the backing of Ou-yang Hsiu, the two T'ang reformers, or Han Yü alone, were added to the list. A leading antiquarian poet, Yin Shu, wrote:

In the T'ang belles-lettres were at first not wholly rid of the aura of [Northern] Chou, Sui, and the five [Nanking] dynasties. In mid-course there appeared the talents

125. Quoted by Chu-tsing Li, "The Freer *Sheep and Goat* and Chao Meng-fu's Horse Paintings," *Artibus Asiae* 30 (1968): 303.

126. *Ibid.*, p. 281.

127. *Tung-p'o t'i-pa*, iv/16b–17a in the Chi-ku-ko ed., from a note titled "P'ing ts'ao shu."

128. See Aoki Seiji, *Shina bungaku shisō-shi* (Tokyo, 1943), p. 88; or Kuo Shao-yü, *Chung-kuo wen-hsüeh p'i-p'ing shih* (Shanghai, 1956), p. 98.

129. Aoki, *Shina bungaku shisō-shi*, p. 91; Kuo, *Chung-kuo wen-hsüeh p'i-p'ing shih*, p. 100.

of Li [Po] and Tu [Fu] . . . but the Way did not yet attain its fullest expression. Then with the rise of Han and Liu there came a great blossoming of the literature of the ancients. In their phrases [the moral qualities] *jen* and *i* met in inseparable union with [the aesthetic], *hua* and *shih*. . . . Everywhere their expressions are dignified, and the moral code is admirable; they are composed like the Classics. In a trice they elevated the virtue of T'ang beyond that of Han at its height.[130]

For those who supported the revivalist *fu-ku* movement in literature in the Northern Sung, what was admirable in the past could be summed up in a small group of antique writings, supplemented by their T'ang champions. Su Hsün spoke of five: Confucius, Mencius, Hsün-tzu, Yang Hsiung, plus Han Yü a millennium later.[131] As we have seen, the classicists in calligraphy proposed Chang Chih of Han, the Two Wangs, plus "Ou, Yü, Yen, and Liu" of the T'ang. For the traditional side of painting the same sort of distribution would necessarily have been set a stage later: the classic paragons "Ku, Lu, Chang, and Wu" covering the fourth to eighth centuries, with Li Kung-lin following as a reviver of humanistic themes in the eleventh.

It is tempting to see in all three of these series the Chinese historian's faith in the recurrence of a phase of recovery and renewed greatness, *chung hsing*, midway in the course of a historic cycle. In only one case, however, was the parallel at all close. Only in literature was it possible to speak of a prolonged period of decadence and an urgent need to repudiate the existing style, on both aesthetic and moral grounds. In calligraphy there was no such devaluation of the masters who had practiced between the Two Wangs and the early T'ang. Of the ten calligraphers of the period whom Chang Huai-kuan ranked as excellent, *miao*, the six ranging from the Liu Sung to the Ch'en regimes were given as high ratings, in as many different ways of writing, as the four from the seventh century. Nothing that he says indicates that the six exhibited an undesirable drift or that the T'ang men revived anything that had been lost.

In figure painting the directions of change are clearer. There was indeed a prolonged period of obsolescence of ancient themes and a once-classic style of drawing, traceable from the T'ang through most of the eleventh century. But the revival that Li Kung-lin epitomized was grounded in little more than aesthetic preference. It was a shallow nostalgia, without any strong moralizing anchor; no one really believed that the salvation of painting lay in a return to pictorial sermons and portraiture. What was truly important for the art lay elsewhere, in subjects drawn from the nonhuman world and in new, more calligraphic uses of ink. These were too novel, and their relationships were too unclear, to fit into any historian's evolutionary sequence. What made it possible at last to create a convincing pattern along familiar lines was first, the long domination of the academy style in the Southern Sung, and then its thoroughgoing rejection by the Yüan reformers.

130. Kuo, *Chung-kuo wen-hsüeh p'i-p'ing shih*, p. 142.
131. *Ibid.*, pp. 148–49; see also p. 166.

For Chao Meng-fu and those he taught, the art of the previous two centuries was both aesthetically and morally unbearable. On the one hand, being so uniformly expert and superficially attractive, it represented the most dangerously disguised vulgarity. On more general grounds, it offended a code much more complex and subtle than the Confucian idealism of the past. Its chief offense, perhaps, had been not so much against mankind, or society, or the state as against the artist's newly prized individuality, the freedom he deserved to paint or not as he pleased and in whatever manner suited his mood. Here again the threat was more dangerous because it was disguised by the appearance of good treatment, the dignities and prizes of the academy system.

In none of this was there a need to appeal to the past which went beyond the normal Chinese instinct to look backward toward better times. For Yüan painting the gulf between the old and the new was necessarily much wider—to take in an enormous accumulation of experience—than in the cases of calligraphy and literature. Thus for the Yüan masters who were to fulfil the *chung-hsing* function in painting the natural world— Chao Meng-fu and his four celebrated successors—whatever "antique" quality they might achieve was much more impalpable—or even fictional—than in the case of the *ku wen* practitioners in the T'ang and Sung literature or the perennial new students of old masters in calligraphy.

PART II
MODES OF ARCHAISM
IN PAINTING

LI KUNG-LIN'S USE OF PAST STYLES

Richard Barnhart

INTRODUCTION

In various Sung sources the following painters are cited as Li Kung-lin's masters:[1]

> Ku K'ai-chih (ca. 344–ca. 406)
> Lu T'an-wei (ca. 440–ca. 500)
> Chang Seng-yu (active ca. 500–550)
> Wu Tao-tzu (ca. 680–after 755?)
> Li Ssu-hsün (651–716)
> Wang Wei (died 761)
> Lu Hung (eighth century)
> Han Kan (eighth century)
> Han Huang (723–787)

Under any circumstances such a glittering array of models would be unusual; in the late eleventh century it is astonishing. No earlier painter in Chinese history is cited as having emulated more than two predecessors, and even two is very rare.[2] The mere citation of so many sources is in itself indication of a fundamental historical change.

1. These names are found in Li's biographies in *Hsüan-ho hua-p'u* (Peking, 1964; hereafter cited as *HHHP*), 7/130–33; in Chang Cheng's *Hua-lu kuang-i* of 1139, *Mei-shu ts'ung shu* ed. (hereafter cited as *MSTS*), pp. 175–76; in Teng Ch'un's *Hua chi* of 1167, 1963 ed., pp. 18–20; and in Mi Fu's *Hua shih* of ca. 1104, *MSTS* ed., p. 19. Additional comments by Su Shih, Huang T'ing-chien, and others are referred to in the text.
2. Tung Yüan (d. 963) is said by Kuo Jo-hsü (ca. 1080) to have followed Li Ssu-hsün and Wang Wei in landscape painting. See A. C. Soper, trans., *Kuo Jo-hsü's Experiences in Painting* (Washington, D.C., 1951), (hereafter cited as Kuo Jo-hsü, *THCWC*), p. 46. Figure painters are said by the same writer, pp. 16–17, to have employed the twin styles of Ts'ao Chung-ta and Wu Tao-tzu in Buddhist figure painting. In his biography of the tenth-century figure Kao Wen-chin, for example, he notes that Kao "handled both the Ts'ao and Wu styles perfectly" (p. 51). While stylistic duality in figure painting was thus quite common through the tenth and eleventh centuries, certainly in the Northern Sung period no fundamental dichotomy between the landscape masters Li Ssu-hsün and Wang Wei of the kind later proposed by Tung Ch'i-ch'ang was conceived. They are indeed often spoken of together as comparable early masters, so that the significance of Kuo Jo-hsü's discussion of styles in Tung Yüan's art is unclear. The major point at issue may be simply the use of color. Mi Fu notes of his friend Wang Shen, for example, that both his "gold-and-green" and "ink wash" styles are "based upon Li Ch'eng." See *Hua shih*, *MSTS* ed., p. 25.

If distinguished by subject matter and joined by common stylistic tradition, the seemingly random list of Li's masters can be put into a less amorphous sequence:

Secular figure painting: the style of Ku K'ai-chih, subsequently continued by Lu T'an-wei and Han Huang[3]

Religious and martial figure painting: the style of Chang Seng-yu and Wu Tao-tzu[4]

Horse painting: Han Kan

Landscape: Li Ssu-hsün, Wang Wei, Lu Hung[5]

Several observations should be made of these groups. The Chang Seng-yu–Wu Tao-tzu tradition of religious and, in general, dramatic figure painting was the dominant formal ideal of the Northern Sung period.[6] Han Kan was equally renowned and is characteristically cited, often with Ts'ao Pa, as the epitome of excellence in the painting of horses.[7] In choosing to emulate these masters in their respective subjects, therefore, Li Kung-lin selected his most admired predecessors, to that extent departing not at all from the standards of many generations.

The Ku K'ai-chih tradition of secular figure painting, in contrast, was virtually moribund in the eleventh century. No figure painter since Han Huang of the eighth century had been regarded as heir to this legacy.[8] Similarly, Li Ssu-hsün, Wang Wei, and Lu Hung are rarely mentioned in the long interval between Ching Hao of circa 900 and the late eleventh century.[9] Their relatively primitive landscape art had been thoroughly overshadowed by the great masters of the tenth and eleventh centuries, just as the Ku K'ai-chih style of figure painting had been supplanted by the vigorous and dramatic styles of T'ang and the realism of the Five Dynasties. Wang Wei's reputation began to rise only with Su Shih's famous poem of 1060;[10] Li Ssu-hsün's rose in the late Northern Sung period when interest in the colorful "blue-and-green" style revived after the long dominance

3. Chang Yen-yüan, *Li-tai ming-hua-chi*, is the *locus classicus* of early figure styles. See W. R. B. Acker, trans., *Some T'ang and Pre-T'ang Texts on Chinese Painting* (Leiden, 1954), pp. 177–84. Han Huang is called a follower of Lu T'an-wei by the T'ang historian Chu Ching-hsüan in *T'ang-ch'ao ming-hua lu*. See A. C. Soper, trans., *Artibus Asiae* 21 (1958): 220–21.

4. Chang Yen-yüan, *Li-tai ming-hua-chi*, discusses the style and the historical relationship between the two masters. See also Richard Barnhart, "Survivals, Revivals, and the Classical Tradition of Chinese Figure Painting," in *Proceedings of the International Symposium on Chinese Painting* (Taipei, 1972), for a summary of the continuing Ku K'ai-chih–Wu Tao-tzu formal dichotomy.

5. As noted above (n. 2), Sung writers evidently regarded Li and Wang as similar rather than contrasting masters, both representing the early, archaic phase of landscape representation, although they are of different generations. See, for example, Su Shih's colophon to a landscape by Sung Han-chieh in *Tung-p'o t'i-pa, I-shu ts'ung-pien* ed., 5/99. Lu Hung, or Lu Hung-i, is generally associated with Wang Wei, as in his biography in *HHHP*, p. 168.

6. Kuo Jo-hsü, *THCWC*, pp. 21–22; Barnhart, "Classical Tradition," pp. 4–5.

7. Kuo Jo-hsü, *THCWC*. See also Chu-tsing Li, "The Freer *Sheep and Goat* and Chao Meng-fu's Horse Painting," *Artibus Asiae* 30 (1968): 297–301.

8. Barnhart, "Classical Tradition," pp. 1–4.

9. Chu-tsing Li, *Autumn Colors on the Ch'iao and Hua Mountains* (Ascona, 1965), pp. 36–37.

10. Barnhart, "Classical Tradition," p. 6.

of monochrome.[11] In both the Ku K'ai-chih and T'ang landscape revivals, Li Kung-lin was a central figure.

Li thus drew upon arts that bridged the span of historical cycles. Ku K'ai-chih and the T'ang landscape masters represented the relatively primitive beginnings of figure painting and landscape, while Wu Tao-tzu and Han Kan were widely held to have achieved the ultimate in religious art and in the painting of horses, respectively. Each of these models formed a single aspect of the multiple stylistic structure which, in Li Kung-lin's work, was elaborated on so broad a scale for the first time in the history of Chinese painting—a structure in which the most appropriate style from among the great masters was chosen by the artist for each of the subjects he attempted. Each style had its own history, philosophical-aesthetic connotations, expressive purpose, and artistic effect, and each was a clearly defined entity in itself. All were orchestrated by Li Kung-lin in such a way that his painting appears to sweep over the entire past history of the art.

FOUR COMPOSITIONS BY LI KUNG-LIN

There is every reason to believe that Li Kung-lin painted four subjects that can be related to extant works: *Five Tribute Horses*, in the style of Han Kan;[12] *The Classic of Filial Piety*, in the style of Ku K'ai-chih; *Kuo Tzu-i Receiving the Homage of the Uighurs*, in the style of Wu Tao-tzu; and *Dwelling in the Lung-mien Mountains*, in the style of Wang Wei and Lu Hung. The question of the authenticity of extant versions of these subjects may be argued. What it is not reasonable to doubt is that he once painted them, and that surviving versions reflect his prototypes.

Five Tribute Horses (fig. 1)
Painted between 1089 and 1090, the identifying inscriptions and colophon by Huang T'ing-chien were written in 1090; a second colophon by Tseng Yü was written in 1131. The seals begin with the Shao-hsing era (1131–1162). The painting was first recorded in Chou Mi, *Yün-yen kuo-yen lu*.[13] Han Kan is mentioned by Tseng Yü in his colophon; elsewhere Su Shih,[14] Huang T'ing-chien,[15] *Hsüan-ho hua-p'u*,[16] Teng Ch'un,[17] Chao Meng-fu,[18]

11. *HHHP* 10/166, biography of Li Ssu-hsün: "When modern men paint coloured landscapes, they generally imitate [Li]." See also my *"Marriage of the Lord of the River": A Lost Landscape by Tung Yüan* (Ascona, 1970), pp. 22–26.

12. Extensively discussed in *Kokka*, nos. 380–81; Chu-tsing Li, "Chao Meng-fu's Horse Painting," pp. 300–302; and my doctoral dissertation, "Li Kung-lin's *Hsiao Ching t'u*" (Princeton University, 1967), pp. 150–75.

13. *MSTS* ed., pp. 40–42.

14. *Su Tung-p'o ch'üan-chi*, World Book Co. ed., p. 228: "Rhyming Tzu-yu's colophon to the Han Kan horses owned by Li Po-shih."

15. *Shan-ku shih chu, Ts'ung-shu chi-ch'eng* ed., *nei-chi*, pp. 120–21: "In praise of Li Po-shih's copy of Han Kan's *Three Horses*." See also pp. 121–23.

16. *HHHP*, p. 131.

17. *Hua chi*, p. 18.

18. See Chu-tsing Li, "Chao Meng-fu's Horse Painting," p. 302.

and T'ang Hou[19] all cite Li's relationship to the Han Kan tradition. Li himself is quoted by Huang T'ing-chien as admiring Han above all other horse specialists,[20] and a painting in Liao-ning purports to be a copy of a famous Han Kan model by Li.[21] Several versions of the same subject, tribute horses, are attributed to Han Kan.[22] Extant copies suggest that Li used Han's compositional program in his work—each horse separately portrayed

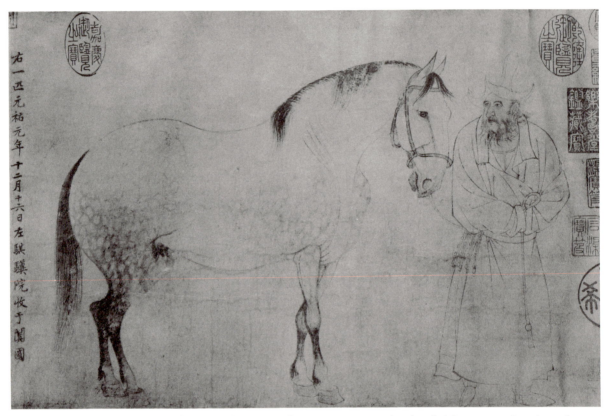

Figure 1. Li Kung-lin, *Five Tribute Horses* (first section), 1089–90, handscroll, ink on paper. Location unknown, reported destroyed. Reproduced from a Japanese collotype facsimile scroll (n.p., n.d.) at the Department of Art and Archaeology, Princeton University.

in simple profile, each accompanied by a groom, without setting or background.

Li's brushwork in the drapery is strong and incisive, done slowly and deliberately, with relatively little modulation but considerable freedom. Each stroke is round and firm, as in the best T'ang painting. Undoubtedly Li's own contribution is the brilliant portraiture of horses and grooms and the subtle physical and psychological relationship he has discerned between each animal and its attendant. Only one other horse painting speaks so insistently and effectively of inner spirit, and that is Han Kan's *Chao-yeh-pai* (fig. 6),

19. *Hua chien* (Peking, 1959), p. 11.
20. *Shan-ku shih chu, Ts'ung-shu chi-ch'eng* ed., pp. 121–23.
21. Ho Lo-chih, *Han Kan Tai Sung* (Shangai, 1961), pl. 6.
22. See, e.g., *ibid.*, pls. 4–5.

suggesting that Li perceived the essence of the T'ang master's style, its directness, descriptive simplicity and clarity, and immanent life, and re-created it in those terms.

The Classic of Filial Piety (fig. 2)
Painted in 1085, the handscroll was originally accompanied by an inscription by Li Kung-

Figure 2. Li Kung-lin, *The Classic of Filial Piety* (detail from the illustration to chapter 5), 1085, handscroll, ink on silk. Wen C. Fong collection, Princeton.

lin and a colophon by Su Shih; the present version has the fragmentary signature and seal of Li Kung-lin and colophons by Han-man-weng (thirteenth-century?), Tung Ch'i-ch'ang, and later men. It was first recorded in Chou Mi, *Yün-yen kuo-yen lu*.[23] Ku K'ai-chih and Lu T'an-wei are mentioned as the artist's models by Su Shih in his now-lost colophon.[24] Ku and the Six Dynasties tradition are cited elsewhere by Huang T'ing-chien,[25]

23. *MSTS* ed., p. 37.
24. Quoted in *P'ei-wen-chai shu-hua-p'u*, 1883 reduced size ed. (hereafter cited as *PWC*), 83/1a. Su even saw evidence of the Six Dynasties in Li's religious subjects. See Barnhart, "Classical Tradition," p. 14.
25. Quoted by Han-man-weng (thirteenth century?) in his colophon to *The Classic of Filial Piety*.

in the *Hsüan-ho hua-p'u*,[26] and by Teng Ch'un,[27] Ho Liang-chün,[28] and Tung Ch'i-ch'ang[29] as Li's standard in secular figure painting. While there appears to be no record of any T'ang version of this·subject, it was painted by several Six Dynasties artists, including Ku K'ai-chih's contemporary Hsieh Chih.[30] Among extant works, *The Classic of Filial Piety* and the several fourteenth-century copies and paraphrases of Li's *Nine Songs* best illustrate his Six Dynasties manner.[31]

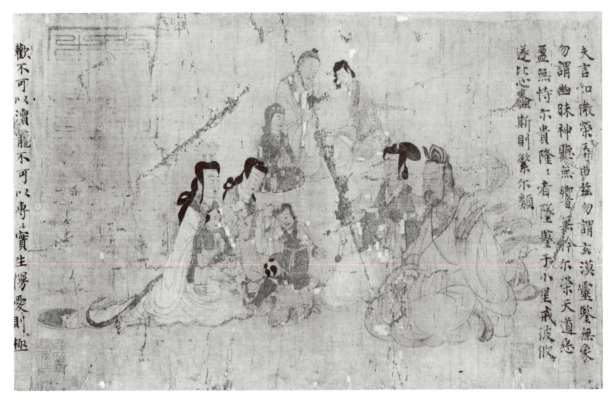

Figure 3. Attributed to Ku K'ai-chih, *Admonitions of the Instructress to the Ladies of the Court* (sixth section), Six Dynasties, handscroll, ink and colors on silk. British Museum, London, reproduced by permission of the Trustees.

Compositional principles are identical with those of Ku's *Admonitions* handscroll (fig. 3). The main figures provide formal structure, supported by screens and furniture, but with no additional setting. The structure plays upon human interaction, confrontations, encounters, and family gatherings, in the development of which the artist effectively

26. *HHHP*, 7/132.
27. *Hua chi*, p. 18.
28. Quoted in Barnhart, "Classical Tradition," pp. 2–3.
29. In his colophon to *The Classic of Filial Piety*.
30. P'ei Hsiao-yüan, *Chen-kuan kung-ssu hua-shih*, *Mei-shu ts'ung-k'an* ed., p. 40. A version attributed since the seventeenth century to Yen Li-pen has recently been identified as a Southern Sung academic work. See *Wen Wu* 10 (1963): 34.

31. The *Nine Songs* are discussed in my "Classical Tradition," pp. 21–23 and n. 99.

uses pictorial concepts of emptiness and fullness, always suggesting slowly unfolding activity. Most human expressions are restrained and delicate; there are few extremes of either emotion or gesture, and the figures seem to combine humanness and a certain ethereal quality. The subtle, silk-like brushwork is also derived from the Six Dynasties tradition, far different from the bold strength of T'ang.

Aside from the *Admonitions* and related Ku K'ai-chih attributions, among the few earlier paintings to share some of these characteristics are *Scholars of the Northern Ch'i Dynasty Collating the Classical Texts*,[32] which reflects the early T'ang legacy of Ku K'ai-chih, and the portrait of Fu Sheng attributed to Wang Wei.[33] It is evident that Li Kung-lin perceived in the art of Ku K'ai-chih and the Six Dynasties an appropriateness to the depiction of humanistic subjects that had to do with its naiveté, its air of grace, its restraint, and its humanistic spirit, not only in itself, but through the personality of Ku K'ai-chih and the Six Dynasties as a whole.

Kuo Tzu-i Receiving the Homage of the Uighurs (fig. 4)

The purported signature of Li Kung-lin is a later addition. In the seventeenth century fourteen colophons were attached, including one by Chao Meng-fu. Only one from the seventeenth-century sequence, by Han Chün and dated 1367, is still attached. It was first recorded (?) in Chang Ch'ou, *Ch'ing-ho shu-hua-fang*.[34] The second half of the present scroll, from the outstretched hand of Kuo Tzu-i on, is a replacement, evidently a tracing copy of the highest order. It predates Chang Ch'ou's record of 1632, while the signature was added later.

Of all the paintings in the Wu Tao-tzu manner attributed to Li Kung-lin, this is the finest and most plausible. It is in the same style as several other famous and well-documented compositions which without doubt were originally painted by Li in the Wu manner and which remain today in varying states of preservation: *The Hua-yen Sutra*, British Museum,[35] a dull but early copy of a work described in *Hsüan-ho hua-p'u* as the Sung equivalent of Wu's famed *Hell Scenes*;[36] *The White Lotus Society*, many versions extant, the earliest perhaps Chang Chi's twelfth-century copy;[37] and *Chi-jang t'u*, or *People of Yao Dancing*, an impressively documented Sung painting in the Wu style, attributed to Li Kung-lin in the colophons and perhaps originally a copy by him of a T'ang picture.[38]

Li is called a follower of Wu by his friend Mi Fu,[39] in the *Hsüan-ho hua-p'u*,[40] in the

32. K. Tomita, "Scholars of the Northern Ch'i Dynasty Collating the Classics," *Bulletin of the Museum of Fine Arts, Boston* 29 (1931): 58–63.

33. Discussed in this context in Barnhart, "Classical Tradition," pp. 6–11.

34. Vol. 8, pp. 28b–29a. See also *Ku-kung shu-hua lu*, 4-vol. ed., 1: 4/22–24.

35. Basil Gray, "A Great Taoist Painting," *Oriental Art*, n.s., 11 (1965): 85–94.

36. P. 131.

37. *Liao-ning-sheng po-wu-kuan ts'ang-hua chi* (Peking, 1962), vol. 1, pls. 24–35.

38. Osvald Sirén, *Chinese Painting: Leading Masters and Principles*, 7 vols. (New York, 1956–58), vol. 3, pl. 194. Recorded in full in *Sheng-ching Ku-kung shu-hua lu*, MSTS ed., 2/20–22.

39. *Hua shih*, MSTS ed., p. 19.

40. HHHP, p. 131; the reference is to religious subjects.

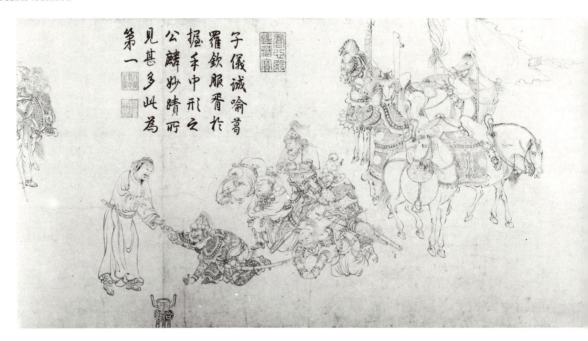

Hua chi,[41] and by T'ang Hou.[42] Huang T'ing-chien's well-known discussion of *yün*, which he understood from Li Kung-lin to be a sense of continuing movement involving the viewer in its structure and completion, was written on a painting of Kuo Tzu-i, which may be related to the present work.[43]

The brushwork in this tradition is fluid and fluctuating, constantly thickening and thinning "like scudding clouds and flowing water."[44] Facial expressions are broadly varied and vividly exaggerated, sometimes grotesque. Postures and gestures are artificially emphasized, as in a stage performance. The style is calculated to convey the excitement and/or mysterious power of the subject most dramatically and directly.

Dwelling in the Lung-mien Mountains

At least four copies of this, the most famous of Li's landscape paintings, are extant: one in the Palace Museum,[45] one in Peking,[46] one in the Berenson collection (fig. 5), and a fourth, whereabouts unknown, published some years ago in Japan.[47] They are composi-

41. *Hua chi*, p. 18; the reference is to Buddhist figures.

42. *Hua chien*, pp. 39–40.

43. Huang T'ing-chien, *Yü-yang Huang hsien-sheng wen-chi, Ssu-pu ts'ung-k'an* ed., 8:27/66, trans. in Barnhart, "Classical Tradition," p. 16.

44. The traditional description of Wu Tao-tzu's brushwork, as used, for example, by T'ang Hou in *Hua chien*, pp. 39–40.

45. Sirén, *Chinese Painting*, vol. 3, pl. 195.

46. *Wen Wu* 6 (1961): 39.

47. Otsuka Kogeisha, n.d. A detail is reproduced in R. H. van Gulik, *Chinese Pictorial Art as Viewed by the Connoisseur* (Rome, 1958), pl. 76. An excellent analysis of the composition and its tradition by Harada Bizan accompanies the Otsuka Kogeisha album.

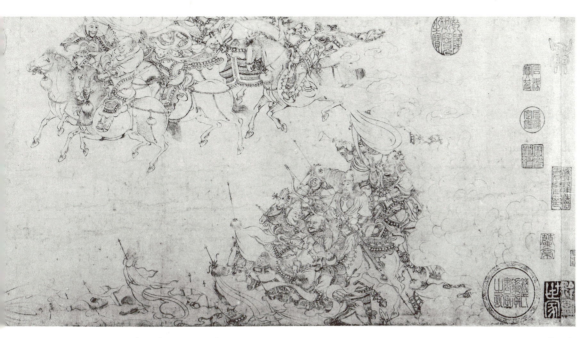

Figure 4. Attributed to Li Kung-lin, *Kuo Tzu-i Receiving the Homage of the Uighurs* (first section), 11th century, handscroll, ink on paper. National Palace Museum, Taiwan.

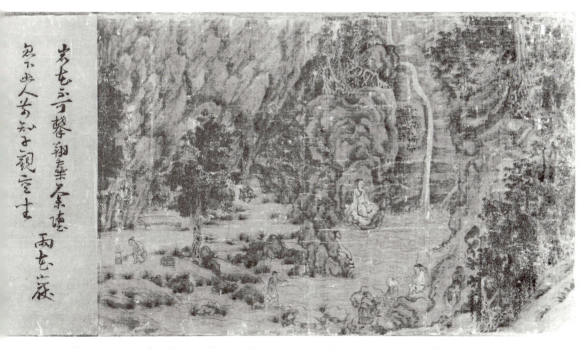

Figure 5. Copy after Li Kung-lin, possibly by Ma Ho-chih (12th century), *Dwelling in the Lung-mien Mountains* (section), handscroll, ink and colors on silk. Berenson collection, Florence, reproduced by permission of the President and Fellows of Harvard College.

tionally identical but of two distinct formats. The Palace Museum and Peking copies are continuous handscrolls on paper in the *pai-miao* technique; the Berenson and Japanese versions are on silk in color, and are presented as a series of compositions originally separated by poetic texts. The two recensions may reflect an original sketch and a final, finished version. The Berenson copy appears to have been done by Ma Ho-chih and is clearly the earliest and finest of the three published copies.

Su Shih wrote a famous colophon for Li's original in which he refers to Wang Wei.[48] Su Ch'e, who originally wrote poems to accompany each of the fifteen scenes, cites the parallel with Wang Wei's *Wang-ch'uan t'u* (fig. 6).[49] There is even a "signature" of Wang Wei on the Japanese album version and evidence of confusion with Wang Wei in the history of transmission of Li's composition.[50]

Figure 6. Wang Wei, *Wang-ch'uan t'u* (section), 8th century, rubbing of 1617 engraving, based on the Kuo Chung-shu copy? The Art Museum, Princeton University (formerly George Rowley collection); location of engraving unknown.

Lu Hung, a painter contemporary with Wang Wei whose art was similarly regarded, is also cited as a predecessor of Li Kung-lin, no doubt because of a relationship between *Dwelling in the Lung-mien Mountains* and Lu's famed *Ten Views from a Thatched Cottage*. Li's copy of the composition was greatly admired in the twelfth and thirteenth centuries.[51]

The primitive, archaic qualities of both T'ang painters had long been ignored, as a succession of brilliant landscape masters created the richly spacious and naturalistic styles of the tenth and eleventh centuries. In the late Northern Sung period, however, as the styles and theories of literati painting were formulated, the poetic simplicity of T'ang landscape won renewed appreciation. Li Kung-lin, Chao Ta-nien, and Mi Fu all drew upon T'ang conventions.[52] In *Dwelling in the Lung-mien Mountains*, map-like conceptual-

48. Quoted in *PWC*, 83/4a.
49. Wu Sheng, *Ta-kuan lu* 12/32ff., records the original poems and colophons.
50. Discussed by Harada Bizan; see n. 47.
51. A detailed description of Li's copy and a copy of the former owned by Mi Yu-jen are found in Chou Mi, *Yün-yen kuo-yen lu*, *MSTS* ed., hsia, pp. 73–81.
52. Chao Ta-nien's *River Village in Clear Summer* of 1100 is the major original monument of this late

izations alternate with dramatic closeups—minutely descriptive scenes of tangled roots and moss-grown rocks. There is little space, apart from the space-cell pockets conventional in the T'ang. Although it is now faded and worn away, in the Berenson copy rich green and red colors, in the T'ang manner, were once present. All of these elements must have vividly recalled Wang Wei and Lu Hung to the minds of the Sung scholars who saw the original painting. Li evidently drew directly upon his study of the *Wang-ch'uan t'u* and *Ten Views from a Thatched Cottage*, ignoring most of the intervening landscape art.

The following chart summarizes the four discrete stylistic traditions followed by Li Kung-lin in the works here discussed:

INDIVIDUAL MANNER	BRUSHWORK	COMPOSITION	FIGURE MORPHOLOGY
Han Kan	bold, straight, little modulation	large, clean individual forms against a plain background; relatively little interrelationship	subtle, naturalistic description of faces and gestures
Ku K'ai-chih	delicate, silk-like, little modulation	circular groups of figures and accessories, without other setting; continuous elaboration of human interaction within closed compositional structures	restrained expressions and gestures; essential human types rather than descriptions; ethereality
Wu Tao-tzu	flowing, richly modulated, curvilinear	flowing, horizontal movement, open and dramatic	melodramatic exaggeration of gesture and expression, as if in a stage performance
Wang Wei	tangled, hemp-fiber strokes and massed ink dots used with wash and color	dense, richly tactual forms closing off space: map-like conceptualizations	

THE STYLE OF LI KUNG-LIN

We have, then, four distinctive styles in the work of a single master, which is precisely what the Sung texts would lead us to expect. The scanty available evidence of dates—

Northern Sung Wang Wei revival. See Robert J. Maeda, "The Chao Ta-nien Tradition," *Ars Orientalis* 8 (1970): 243–53. I am also inclined to see Mi Fu's *Auspicious Pines in Spring Mountains* (*Chinese Art Treasures* [Geneva, 1961], no. 28) as significant evidence of his archaic landscape style, although most authorities regard it as a later work.

Figure 7. Li Kung-lin, *Five Tribute Horses*, detail from the second section (see figure 1).

Figure 8. Li Kung-lin, *The Classic of Filial Piety*, detail from the illustration to chapter 8 (see figure 2).

1085 for *The Classic of Filial Piety*, 1089–1090 for *Five Tribute Horses*—suggests that this variety of modes may not be related to Li's personal stylistic chronology. While it would be simplistic to seek a style, as style is generally defined, in the work of a painter so complex—a painter, moreover, whose œuvre is substantially preserved in copies—there are nonetheless common elements and evidence of a single artistic personality among the several works discussed.

A single male figure drawn from each of the three figure paintings, for example (figs. 7–9), is the same morphological type described in three distinctive brush manners, much

Figure 9. Attributed to Li Kung-lin, *Kuo Tzu-i Receiving the Homage of the Uighurs*, detail from the first section (see figure 4).

as the same character might be written in a *li*, *k'ai*, and *hsing* script.[53] In the *Hsiao-ching* figure (fig. 8), the brushwork is fine, even, delicate, the "silken thread" of Ku K'ai-chih. The *Five Tribute Horses* groom (fig. 7) is very similar, but is drawn in a heavier, straighter line, more T'ang-like in character. The Kuo Tzu-i (fig. 9), while related in general configuration to the others, is a pure Wu Tao-tzu-style image, drawn in flowing thickening and thinning line and continuous curves.

53. Compare my article on calligraphy in the Metropolitan Museum of Art *Bulletin*, April/May 1972; and a preliminary examination of the nature of style in painting as it may be related to the earlier history of calligraphy: "Li T'ang and the Koto-in Landscapes," *Burlington Magazine*, May 1972, pp. 305–14.

The three figures correspond to three of the primary stylistic traditions of early Chinese painting, each of which is readily identifiable as a discrete historical tradition. At the same time, each style is an essential ingredient in Li Kung-lin's style, and all are invested by him with a degree of uniformity. This uniformity is in part a function of the physical type of male figure common to all three examples, but it has to do also with the specific representational mode. It is noticeable that in the Kuo Tzu-i and *Hsiao-ching* figures there is a closely similar placement of brush lines in defining the fall of the robe across the legs, for example, and in the direction of the sleeves. Only the character of the line itself differs.

Another sort of uniformity can be seen in the composition as a whole, that is, in the balance between overt and incomplete action which requires the participation of the viewer in the realization of its structure. All of the paintings plausibly attributed to Li Kung-lin share this quality of *yün*, and many other contemporary works lack it.

In the *Kuo Tzu-i*, for example, the entire scroll is focused on the two central figures. From the dynamic Uighur horsemen bursting from the dust at the right to the still dignity of Chinese subordinates to the left, every element acts to intensify the drama of the encounter between a gracious, heroic Kuo Tzu-i and the kneeling Uighur chieftain and to convey a continuously evolving psychological-moral narrative.

Most of *The Classic of Filial Piety* illustrations employ a similar pictorial structure, but in more intimate terms, closed rather than open. In chapter five, which discusses the filiality of a minor official (fig. 2), the artist depicts a young man serving and entertaining his mother and father (in strict accordance with the text), kneeling before them as his wife stands to the right holding a tray. They are linked pictorially by their tight circle and psychologically by the network of interaction between father and mother, son and parents, daughter and the three figures she attends. All implied and described activity is ongoing, and the sensation of participation remains in the mind when the painting is gone.

In *Five Tribute Horses*, *yün* is achieved principally by the subtle impression of identification between each utterly individual horse and its groom, as if a crystallization of the concept itself.

Also unifying all the works in the style of Kung-lin is their denial of all naturalistic spatial effect and their presentation of form on an imaginary shallow stage just behind the picture surface. Whenever appropriate, as in *The Classic of Filial Piety* and *Dwelling in the Lung-mien Mountains*, supporting elements—landscape, architecture, screens, furniture—establish a tight, closed stage upon which the figures act out their rituals. And in both *Kuo Tzu-i* and *Five Tribute Horses* there is no background; figures and animals are isolated in an implied closeness with our space.

Point-by-point comparison of details in these works will extend the stylistic similarities far beyond these three examples. Additional mention is made here only of the soft ink-dotting technique used in the sketchy landscape closing *The Classic of Filial Piety* and in many sections of *Dwelling in the Lung-mien Mountains*. Such subtleties rarely survive the process of copying, however, and thus the definition of individual style in any early

master is seriously hampered. Even under the best of circumstances, it is no easy task to describe so broad a stylistic range in the terms we are accustomed to use. When an artist takes as his scope the history of his art (as literati artists hereafter did), we must expect to encounter a comparable breadth of vision in his style.

LI KUNG-LIN AND SOME PREDECESSORS

Perhaps the most significant qualities of Li Kung-lin's art, in terms of both its historical position and its individuality, can be most clearly defined by examining its relationship to and contrast with the art that immediately preceded his own. Whether working in an

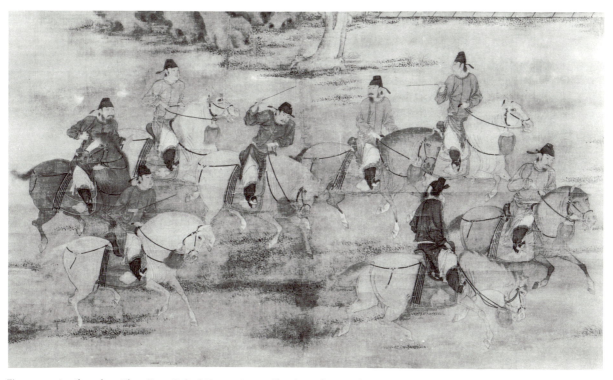

Figure 10. Attributed to Chao Yen, *Eight Riders in Spring* (detail), 10th or 11th century, hanging scroll, ink and colors on silk. National Palace Museum, Taiwan.

archaic or a more recent style, his painting appears restrained, inward, easy and natural. Its denial of the common attributes and standards of his contemporaries (those beyond his immediate circle) is consistent no matter which historical manner is employed for a specific expressive purpose.

Comparable in subject to *Five Tribute Horses* is Chao Yen's *Eight Riders in Spring* (fig. 10), a brilliant and dramatic example of horse painting from the tenth or eleventh century. The animals are prancing vigorously, heads thrown back, mouths agape, hooves flying; their riders are smiling gaily, gesturing among themselves. All are seen from a distance,

65

galloping across a broad field. The impression is grand, colorful, outgoing; together with the precise, hard brushwork and color, the image preserves the high drama of T'ang art but joins to it subtle descriptive and spatial advances.

Li's tribute horses and grooms are, in contrast, almost totally inward, conceived and portrayed on what approaches a mystical level of existential absolutes. As only in Han Kan's *Chao-yeh-pai* before him (fig. 11), his work seems to convey not only the form of horses but also their inner character and spirit. The contrast between the haunted,

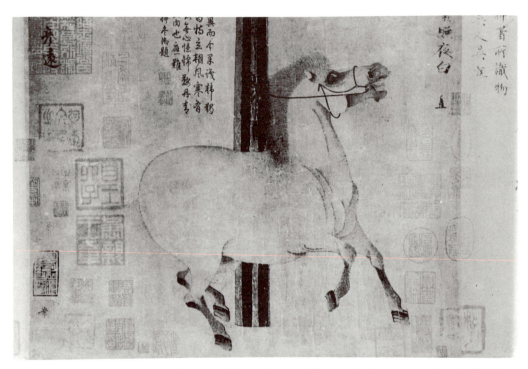

Figure 11. Attributed to Han Kan, *Chao-yeh-pai* (*The Night-Shining White Steed*), T'ang dynasty, handscroll, ink on paper. Collection of Mrs. John D. Riddell, London.

melancholy power of the T'ang work and the restrained grace and contemplative spirit of *Five Tribute Horses*, however, may be the essence of the aesthetic identities of the High T'ang and Northern Sung periods, respectively. Despite the fact, therefore, that both Chao Yen and Li Kung-lin may be said to have honored Han Kan equally in the classical tradition of horse painting, the contrast between their arts could scarcely be greater. Chao continued the T'ang tradition; Li redefined and reformed it.

The popular traditions of secular figure painting throughout the tenth and eleventh centuries also grew from T'ang achievements. A fine, courtly manner related to Yen Li-pen, Chang Hsüan, Chou Fang, Chou Wen-chü, Ku Hung-chung, and others was perhaps most common, although a highly realistic genre style also had great popularity through the Five Dynasties and Northern Sung. With the establishment of the Sung empire came also a vigorous Wu Tao-tzu revival, principally in Buddhist and Taoist figure painting,

but presumably extending into the secular realm, though examples of the latter are rare.[54] For purposes of comparison, Ku Hung-chung's *Night Revels of Han Hsi-tsai* (fig. 12) may be considered representative of the highest standard of this secular painting. Many authorities regard the present scroll as a twelfth-century replica of a tenth-century work;[55] a version of *The Women's Classic of Filial Piety* in Peking suggests that the style continued to be popular in secular subjects in the Sung imperial painting academies and was favored not only in profane subjects but in illustration of the Confucian Classics as well.[56]

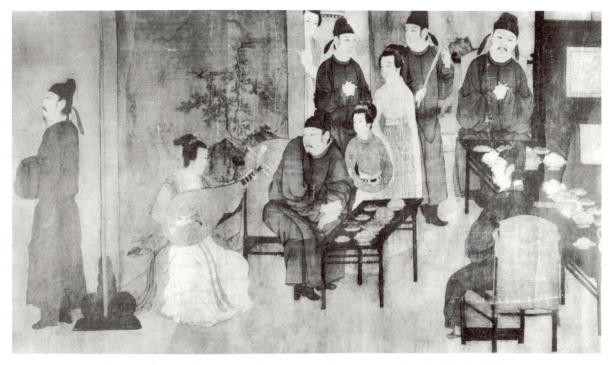

Figure 12. Ku Hung-chung, *Night Revels of Han Hsi-tsai* (first section), 12th-century copy?, handscroll, ink and colors on silk. Palace Museum, Peking.

In comparison with *The Classic of Filial Piety*, the Ku Hung-chung style appears brilliantly descriptive and literal, the brushwork, like Chao Yen's, sharp and precise, the color rich and lovely. Throughout, the artist reveals his mastery of the art and craft of painting. Descriptive realism of this kind was at its peak in the tenth and eleventh centuries, though, as ever, it is combined with the exquisite linear flourish of the T'ang decorative mode. The faces in the scroll explain the admiration of Sung scholars for Ku's portraiture,[57] while the painstaking description and total absence of spontaneity explain

54. A rubbing of the popular cult figure Pu-tai after Ts'ui Po (reproduced as the frontispiece in Soper, *Kuo Jo-hsü's Experiences in Painting*) is an example of the style.
55. *Chugoku bijutsu*, vol. 3: *Sekai bijutsu taikei*, 1965, vol. 10, color pls. 3–4 and fig. 1, notes p. 182.
56. Reproduced and discussed in comparison with *Night Revels of Han Hsi-tsai* in *Gugong bowuyuan yuankan*, no. 2 (Peking, 1960), pp. 182–83.
57. For example, Mi Fu, *Hua shih*, MSTS ed., p. 57.

their disdain for such art as a vehicle for anything more than academic display.[58] Its inappropriateness for the elucidation of ideas is made clear by comparison with Li's *Classic of Filial Piety*.

The illustrations to the Confucian classics are wholly concerned with the moralistic concept of filiality. It was apparently conceived by the painter as an almost tangible entity that could be seen to emerge from the ordered and correct interactions among men. Like the structure of each picture itself, however, which is a reduction of human interaction to archaic formal principles of pictorial interaction, these are not specific men but universal symbols. Except in rare instances, specific individuals would in fact be distracting. The purpose of the illustrations is thus quite different from either the *Night Revels of Han Hsi-tsai* or Li's own *Five Tribute Horses*, which at least begin from the standpoint of straightforward naturalistic description. Many of Su Shih's well-known comments on the art of painting could be applied to the precise contrast between the Ku Hung-chung scroll and *The Classic of Filial Piety*. The two paintings give concrete visual corroboration to the surviving textual evidence for the beginnings of literati theory.[59]

Because he drew upon the formal and expressive vocabulary of Ku K'ai-chih, the first master of figure painting, with which to illustrate the idea of filial piety, Li's painting appears archaic in the context of Sung art. Simultaneously, however, his calligraphically spontaneous brush, freed from the necessity of specific description, speaks a scholarly language unlike that of any earlier master. Joining the most advanced and sophisticated brush techniques of his age to lofty, primitive form and the pursuit of concepts lying beyond form itself, Li turns away from almost every goal that preoccupied his immediate predecessors. That *The Classic of Filial Piety* and *Five Tribute Horses* draw upon vastly different historical sources is perhaps less significant than that their aesthetic stance toward the recent past is generally uniform and that both defined the classical ideals of the future.

This role is reinforced in a comparison of Li's *Kuo Tzu-i* with the Wu Tao-tzu style as it was popularly continued in the earlier eleventh century. Wu Tsung-yüan's *Ch'ao-yüan hsien-chang t'u* (fig. 13), a dramatic procession of Taoist deities and their retinues, represents the grand wall painting tradition of T'ang in the process of being transformed into the handscroll format. The result is somewhat disconcerting because of the disparity between the style and technique suited to large-scale public design and the intimate scale of the format. There is no such contradiction in Li Kung-lin's essay in the Wu manner. His brushwork, infinitely more subtle and intrinsically rewarding, unconsciously harmonizes with the handscroll form and, like the carefully constructed composition, begins, develops, and concludes a controlled, limited flow in the idiom of the great T'ang master. Again, too, the painter subordinates the style to an idea: the ultimate triumph of Confucian morality and the drama of that victory.[60] The harmony between the struc-

58. For these attitudes, see Susan Bush, *The Chinese Literati on Painting* (Cambridge, Mass., 1971), pp. 29–74.
59. *Ibid.*, pp. 29–43.
60. The story of Kuo Tzu-i, one of the heroes in the reconstruction of the empire following the An Lu-shan

ture and the exposition of a central idea is fascinating. If the early Ming version of Wu Tao-tzu's *Sung-tzu t'ien-wang* in Osaka is evidence of the T'ang master's compositional modes, it is likely that Li Kung-lin acquired most of the expositional principles revealed in dramatic works of this kind from the Wu tradition.[61]

Figure 13. Wu Tsung-yüan, *Ch'ao-yüan hsien-chang t'u* (section), early 11th century, handscroll, ink on silk. C. C. Wang collection, New York.

While Li's formative role in the traditions of Han Kan, Ku K'ai-chih, and Wu Tao-tzu is becoming known, his importance in the transmission of the Wang Wei landscape ideal has been little observed. Here too an archaistic revival is at the heart of the issue. At a time when the T'ang landscape pioneer had receded into the position of primitive forerunner to the great Five Dynasties and Northern Sung masters of cosmological landscape painting, it is quite astonishing to find Li referred to as "the reincarnation of Wang Wei."[62] Unlike almost any other picture of the time, *Dwelling in the Lung-mien Mountains* takes its departure directly from the eighth-century master, returning to the pristine

rebellion, is told by Agnes E. Meyer, *Chinese Painting as Reflected in the Thought and Art of Li Lung-mien* (New York, 1923), pp. 381–83.

61. Sirén, *Chinese Painting*, vol. 3, pls. 86–87. Although now fragmentary and disjointed, the composition consists of a sequence of melodramatic encounters of precisely the kind on which Li's *Kuo Tzu-i* focuses.

62. Chang Cheng, *Hua-lu kuang-i*, dated 1139, *MSTS* ed., pp. 175–76.

inception of an art while rejecting the "vulgar habits"[63] of the brilliant masters of his own age. Beside the glowing, spacious vistas of the Northern Sung followers of Li Ch'eng (fig. 14), it is schematic, primitive, nonillusionistic, and without space. It is also as tactually inviting as landscape itself.

There is in this archaic, calligraphic landscape an interesting prefiguration of such later archaistic landscapes as Chao Meng-fu's *Autumn Colors on the Ch'iao and Hua Mountains* and the *Lion Grove Garden* of Ni Tsan and Chao Yüan,[64] providing a parallel in the history of landscape painting to Li's position as a painter of figure and animal subjects. And when Su Shih and Su Ch'e wrote their inscriptions and colophons for Li's composition, they were as keenly aware of the relationship with Wang Wei as was Yang Tsai two centuries later in inscribing Chao Meng-fu's seemingly revolutionary *Autumn Colors*.

SUMMARY

It is evident that Li Kung-lin was consciously acting as arbiter of history. Into the substance of his art he drew those variant strands of past achievement which appeared most suited to a new art of scholarly communication, re-created and re-formed them, and bequeathed an enduring tradition of classical ideals to later centuries. The evidence of Sung texts and extant attributions to Li Kung-lin appears to be in full agreement in suggesting that the painter employed separate and identifiable manners for different subjects. The subject matter in painting of this kind thus appears to correspond roughly to the script forms of calligraphy, although this analogy must be carefully explored.

In the work of a later but closely related painter, Chao Meng-fu, a similar stylistic structure is more certainly identified. In pine and rock subjects he followed the Li Ch'eng-Kuo Hsi tradition;[65] in landscapes, the Wang Wei-Tung Yüan manner;[66] in humanistic figure subjects, the Li Kung-lin *pai-miao* manner;[67] in Buddhist figures, an archaic Kuan-hsiu style;[68] in animal painting, usually a T'ang-like archaic style, but in horses the Han Kan-Li Kung-lin classical tradition;[69] and in old trees, bamboo, and rock, the Wen T'ung-Su Shih-Wang T'ing-yün style.[70] In each subject Chao achieved an individuality that goes far beyond whatever limitations such a heritage of received ideals may seem to imply; that is, one has no difficulty in recognizing the personality of Chao Meng-fu throughout the complex stylistic range of his art.

63. Mi Fu's term, a favorite pejorative used by him to describe the superficial mannerisms eventually attendant upon every popular stylistic tradition. See *Hua shih*, passim.

64. See, respectively, Chu-tsing Li, *Autumn Colors on the Ch'iao and Hua Mountains* (Ascona, 1965); and Sherman E. Lee, *A History of Far Eastern Art* (New York, n.d.), fig. 546.

65. Discussed in my *Wintry Forests, Old Trees: Some Landscape Themes in Chinese Painting* (New York, 1972), no. 6.

66. Chu-tsing Li, *Autumn Colors*; Barnhart, "*Marriage of the Lord of the River*."

67. Barnhart, "Classical Tradition," pp. 27–30.

68. As suggested by his *Priest from the Western Regions in a Red Robe* of 1304. *Liao-ning-sheng po-wu-kuan ts'ang-hua chi*, 1:82.

69. Both analyzed in Chu-tsing Li, "Chao Meng-fu's Horse Painting."

70. *Wintry Forests, Old Trees*, no. 7.

So too with Li Kung-lin. The evidence of his art is scantier and conclusions more hazard-ous, but it appears inescapable that style in his art is a far more complex phenomenon than we have encountered in any earlier artists except calligraphers. In this stylistic variety his art evidently anticipates the later history of literati painting. It may be ob-served, therefore, that the histories of calligraphy and painting meet and join in the figure of Li Kung-lin.

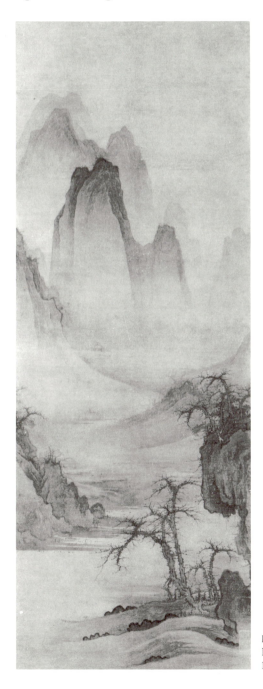

Figure 14. Li Kung-nien, *Landscape*, late 11th century, hanging scroll, ink and slight color on silk. The Art Museum, Princeton University (46-191).

THE USES OF THE PAST
IN YÜAN LANDSCAPE PAINTING

Chu-tsing Li

The forming of an orthodoxy in a culture is often a long process. A well-established tradition, a solid body of theories, one or more strong personalities, some kind of official approval or sanction, and many special circumstances are necessary. In the history of Chinese painting, although there were some rather orthodox practices in earlier periods, such as the academy of Emperor Hui-tsung in the Sung and similar developments in the early Ming, they never had the extensive influence and domination achieved by the orthodox school of the Four Wangs and Wu (Li) and Yün (Shou-p'ing) of the early Ch'ing. It is not the purpose of this essay to discuss the ideas and practices of this orthodox school of early Ch'ing painting. Rather, this study attempts to examine one aspect of the orthodox approach, namely, its uses of the past. While studying the theories and ideas of the early Ch'ing, which followed closely those of Tung Ch'i-ch'ang (1555–1636), one cannot help noticing that Tung derived many ideas from the Yüan period. He seems to have been particularly interested in the ideas of Chao Meng-fu (1254–1322).[1] One of the most important notions that he took from the early Yüan was that the past was an essential part of an artist's preparation and creation. It is thus worth while for us to look into the early Yüan period and its artistic development as a means of understanding the uses of the past in early Ch'ing orthodoxy.

In terms of new ideas and theories of painting, the early Yüan was a particularly important period. We can see from written and pictorial sources that there was a sharp break and a great change in Chinese painting and other cultural expressions between the Southern Sung and the Yüan. Of course, many of the artistic trends in the Southern Sung lingered on, but the most important development, in the eyes of later Chinese artists and critics, was the fact that a small group of painters living in the Chiang-nan area boldly departed from the Southern Sung in form and content. In artistic achievement,

1. Tung Ch'i-ch'ang's attitude toward Chao Meng-fu was discussed by this writer in *Autumn Colors on the Ch'iao and Hua Mountains* (Ascona, 1965), p. 84. Cf. Nelson I. Wu, "Tung Ch'i-ch'ang (1555–1636): Apathy in Government and Fervor in Art," in *Confucian Personalities*, ed. A. F. Wright and D. Twitchett (Stanford, Calif., 1962), p. 264.

novelty of ideas, and influence, they ranked far above the more Southern Sung-oriented painters. In a study of this group of painters, we can more or less see how they made use of the past and opened up new possibilities for the future.

Most of the new ideas originated in many cities of the Chiang-nan area, such as Hang-chow, Wu-hsing, Sung-chiang, Soochow, and Nanking, where the Southern Sung culture had flourished.² Of these, Wu-hsing was the city where some of the most influential ideas on painting developed. It is not entirely clear why it held such a position, but there were at least three factors at work. First, Wu-hsing was close to Hangchow, which had been the capital of the Southern Sung, the center of Chinese culture in that period. At the beginning of the Yüan, though Hangchow was no longer the capital, it was still where many of the former Sung officials and intellectuals lived in retirement. Because of this, Hangchow was the place where the late Sung culture continued to be dominant, where people looked back to the past and lamented their fate. In art, it was still the stronghold of the late Sung academic approaches, such as the landscape of the Ma-Hsia school, represented by Sun Chün-tse, a native of Hangchow;³ flower and bird paintings and animal paintings, such as those by Sung Ju-chih, who served in the academy;⁴ the free expression connected with some Ch'an monks, such as Mu-ch'i and Jih-kuan, who were still working in Hangchow at that time;⁵ and some of the Buddhist and Taoist painting in the more traditional style, which still prevailed in the area around the former capital. However, because of the new situation, Hangchow would soon be exposed to some new ideas. In the early Yüan period, many Northerners, such as Kao K'o-kung, Li K'an, Hsien-yü Shu, and some others, came to live in Hangchow.⁶ Wu-hsing was close to Hangchow and thus could absorb many of the ideas there, but it was also far enough away (about forty miles) to maintain its individuality and to develop some ideas of its own.

2. The importance of geography in the development of Yüan painting is a subject being undertaken by this writer. For the importance of Sung-chiang, see my study, "Rocks and Trees and the Art of Ts'ao Chih-po," *Artibus Asiae* 23 (1960): 153–92. A paper on the importance of Soochow in Yüan painting was presented by this author in the Palace Museum symposium in Taipei in June 1970. See *Proceedings of the International Symposium on Chinese Painting* (Taipei, 1972), pp. 483–525.

3. Sun Chün-tse's paintings have all but disappeared in China, but a number of them have been found in Japan. The best known is a pair of landscapes in the Ma-Hsia manner in the Seikado, Tokyo. Several more are scattered through other collections in Japan, and one has recently been found in San Francisco. In spite of his obscurity in China, his name can still be found in the Yüan section of Hsia Wen-yen's *T'u-hui pao chien*.

4. Like those of Sun Chün-tse, the only works attributed to Sung Ju-chih are now found in Japan, and the only record about him is also found in *T'u-hui pao chien*. According to this source, after the fall of the Sung, he became a Taoist in a temple in the Hangchow area.

5. Both Mu-ch'i (Fa-ch'ang) and Jih-kuan (Tzu-wen) were Ch'an monks whose works are now largely preserved in Japan. Contrary to earlier belief, recent materials show that Mu-ch'i lived almost into the Yüan period. Jih-kuan was known to be a friend of Chao Meng-fu.

6. Kao K'o-kung (1240–1310), from Ta-t'ung, Shansi, Li K'an (1245–1320), from Chi-ch'iu, near Peking, and Hsien-yü Shu (1257–1302), from Yü-yang, also near Peking, were the three Northerners best known in the south as painters and calligraphers of the early Yüan. They were closely associated with Southern intellectuals and became quite well known.

Another important factor is that Wu-hsing was a district with great literary and artistic traditions, which went back to the great Chin geniuses such as Ts'ao Pu-hsing and the father and son Wang Hsi-chih and Hsien-chih, the T'ang calligrapher Yen Chen-ch'ing, the Northern Sung literati painters Wen T'ung and Su Tung-p'o, and the noted landscape painters Yen Wen-kuei and Chiang Shen.[7] All these famous names provided a great inspiration for the people of Wu-hsing. Its cultural importance can be measured by the famous libraries in that district, some of which numbered tens of thousands of volumes, as recorded in the writings of Chou Mi and other writers of the early Yüan. Collections of paintings and calligraphy, as well as bronzes and other objects, were also quite well-known.[8] However, many of these libraries and collections suffered great damage during the fighting between the Mongol and Sung armies just before the collapse of Hangchow to the Mongols in 1276.[9] Still, the tradition must have persisted in this area. Indeed, some of the leading people of the district must have returned after the collapse of Hangchow, making Wu-hsing a breeding ground for new ideas. A third factor was the group of literati called the "Eight Talents of Wu-hsing," of which Chao Meng-fu and Ch'ien Hsüan were the leading painters and Ao Shan, teacher of Chao, the famous scholar.[10] They were responsible for the development of some of the most important ideas on painting in the Yüan.

It was the crisis created by the downfall of the Southern Sung that prepared the way for the formation of a new set of ideas. Many of its leading intellectuals, including Chao and Ch'ien, who had served as officials in the Sung, realized that it was not possible for them to pursue an official career further and turned to self-cultivation through learning and the arts. They seem to have moved away from the artistic and literary directions of the Southern Sung, searched into the early periods of Chinese painting and calligraphy for formal elements and ideas, and re-evaluated the major ideas of the past in order to find a new way. This cultural redirection was a necessary step in surmounting the crisis of the intellectuals.

Most important in this redirection in Wu-hsing were Chao Meng-fu and Ch'ien Hsüan. Although the relationship between the two has been much discussed recently, with different conclusions,[11] major differences between them are not difficult to see. Ch'ien

7. For a short discussion of Wu-hsing's cultural heritage, see my *Autumn Colors*, pp. 78–79, and Chang Hsia-chou, *Wu-hsing chih*, ii/11ff.

8. See Cheng Yüan-ch'ing, *Wu-hsing ts'ang shu lu* (Shanghai, 1957; original ed. dated ca. 1800).

9. See *ibid.*, esp. the entry by Chou Mi, pp. 10–11.

10. In his letter of farewell to Wu Ch'eng, who wanted to leave Peking to return to his home in Lin-ch'üan, Kiangsi, not long after his arrival in Peking upon the call of Emperor Kublai Khan, Chao Meng-fu recommended a number of people in his native district, Wu-hsing, for Wu to meet. They included Ao Shan, his teacher, and Ch'ien Hsüan, Hsiao Ho (Tzu-chung), Chang Fu-heng (Kang-fu), Ch'en Ch'ueh (Hsin-chung), Yao Shih (Tzu-ching), and Ch'en K'ang-tsu (Wu-i), all his friends. Together with himself, they were probably the Eight Talents of Wu-hsing. See Chao Meng-fu, *Sung-hsüeh-chai wen chi*, SPTK ed., 6–6b.

11. See James Cahill's "Ch'ien Hsüan and His Figure Paintings," *Archives of the Chinese Art Society of America* 12 (1958): 11–29; Wen Fong, "The Problem of Ch'ien Hsüan," *Art Bulletin* 42 (1960): 173–89; Li

Hsüan was the older of the two, already well over forty when the Sung dynasty came to an end.[12] As an official during the Sung he must have traveled around, but after the collapse of the Sung he seems to have confined himself to his native district, where he is said to have spent his last years writing poetry and painting,[13] and thus his experience was limited. While there were many well-known collections of old paintings in the Chiang-nan area,[14] it is unlikely that he saw many of them. Few famous recorded scrolls of the T'ang and Sung carry his colophons. Very little about his theories and ideas on painting is noted by critics and connoisseurs of that time. On the other hand, Chao Meng-fu, a much younger and more versatile man from the same district, who did accept Yüan appointments, absorbed a great number of ideas after traveling extensively in North China. The foremost member of the group first invited by Emperor Kublai Khan to become Yüan officials in 1286, Chao served under five emperors successfully and achieved distinction as a high official and an outstanding calligrapher and painter. In painting, his approach and range were very broad, and he found new solutions to his figure, bird, horse, and landscape subjects. Undoubtedly the large areas he visited in both northern and southern China and the great numbers of paintings he saw in many famous collections, as evidenced in the many colophons he wrote on old paintings, offered him ideas for his own paintings.

One of the main problems connected with the relationship between these two Wu-hsing painters of the early Yüan is whether Chao Meng-fu was a pupil of Ch'ien Hsüan. The major references to this relationship are the colophons, particularly those by Chang Yü and Huang Kung-wang, on one of Ch'ien Hsüan's landscape handscrolls, *Dwelling on Floating Jade Mountain (Fou-yü-shan chü t'u)*.[15] The whereabouts of this painting is unknown, although photographs of it are in the files of the Freer Gallery of Art.[16] Both writers

Ya-nung, "On Ch'ien Hsüan's Position in Chinese Art History," in *Chung-hua wen shih lun ts'ung* (Shanghai, 1962), pp. 1–30; and Sherman E. Lee and Wai-kam Ho, *Chinese Art under the Mongols: The Yüan Dynasty (1279–1368)* (Cleveland, 1968), esp. the section by Sherman Lee, pp. 1–62. The article written by Li Ya-nung, a historian, is particularly critical of Chao Meng-fu, reflecting the typical Chinese Confucian moralistic viewpoint.

12. Ch'ien's date of birth is generally set at around 1235 by various modern scholars (see Cahill, "Ch'ien Hsüan," n. 4). According to Hsia Wen-yen, he became a *chin-shih* during the Ching-ting era (1260–1265). Chao was born in 1254 and was exactly one generation younger than Ch'ien.

13. The main reference to this episode is an account by Chang Yü (1333–1385) in his *Ching-chü chi*, SPTK ed., iii/7b. During the late Yüan Chang lived for some time in Wu-hsing and thus must have become familiar with some of the episodes of that district.

14. Early Yüan collections of paintings and calligraphy were recorded by Chou Mi (1232–1398) in his *Yün yen kuo yen lu*, MSTS ed., ii/2. Chou lived in Wu-hsing but moved to Hangchow after the collapse of the Sung.

15. This scroll is recorded, among other catalogues, in the *Shih-ku-t'ang shu hua hui kao*, compiled by Pien Yung-yü (Taipei, 1958), 4: 159–65. Chang Yü's poem for this scroll is found in his collected works, *Chü-ch'ü-wai-shih Chen-chü hsien-sheng shih-chi*, SPTK reduced size ed., ii/22. This Chang Yü (1275–1348) is not the man mentioned in n. 13 above.

16. This painting has never been reproduced in its entirety, but the Freer Gallery has photographs of the painting section of the scroll. A part of the painting was recently reproduced in Max Loehr, "Chinese Painting after Sung," Yale Art Gallery Ryerson Lecture, Mar. 2, 1967, fig. 2. Chu Sheng-chai, in his *Hua*

indicate that Chao learned painting from Ch'ien. In particular, Huang Kung-wang seems to have pointed out the importance of Ch'ien Hsüan:

> Cha-ch'i-weng [referring to Ch'ien] of Wu-hsing was a man of great learning, storing in his bosom all the ideas from the classics and histories. People in his own time did not seem to know about this. But he was particularly well-acquainted with Ao Shan. They discussed and exchanged, and ate and drank together, and they fathomed the deepest principles of things. Chao Wen-min [Meng-fu] studied under him, not only in painting, but also in all the matters ancient and modern. Ch'ien was also well-versed in the study of music. This shows how lofty his character was, but the world often regarded him only as a professional artist. His hobby thus overshadowed his learning.[17]

Cahill points out that Chao Meng-fu never acknowledged this relationship.[18] One of the clearest evidences of Chao's attitude toward Ch'ien, as this writer has noted, was his letter to Wu Ch'eng (1249–1331), a philosopher who went with him to Peking in answer to Kublai Khan's call, upon Wu's departure from the capital city. In it Chao referred to Ao Shan as "my teacher," while he called Ch'ien Hsüan and other literati in Wu-hsing "my friends."[19] This contradicts the statements of both Chang Yü and Huang Kung-wang in this painting. Another often-quoted statement, first found in Ts'ao Chao's *Ko ku yao lun* of 1387, which describes a conversation between these two people, has also been considered to refer to this relationship:

> Chao Tzu-ang asked Ch'ien Shun-chü, "What sort of thing is scholar-gentlemen's painting?" Shun-chü answered, "It is the painting of the *li-chia* [amateurs]." Tzu-ang said, "But look at Wang Wei, Li Ch'eng, Hsü Hsi, Li Po-shih (Kung-lin)—they were all lofty and respected scholars, yet their paintings transmit the spirit of the [depicted] object, completely capture its wonderful qualities. As for people of recent times who do scholar-painting, how very misguided they are!"[20]

This conversation has been interpreted as another indication of the teacher-pupil relationship of these two painters of Wu-hsing. However, in essence, it reflects the difference in the two men's outlooks and approaches. It must be borne in mind that the two were more friends talking as equals than teacher talking to pupil. Their concepts of *wen-jen-hua* seem to have been quite different from each other.

It is possible that Chao Meng-fu, a generation younger than Ch'ien Hsüan, did learn

jen hua shih (Hong Kong, 1962), p. 124, mentions a painting by Ch'ien Hsüan called *Shan-chü t'u*, during his visit in that year to the Hui-hua-kuan of the Palace Museum in Peking. This is probably the one reproduced in *Chung-kuo ku-tai hui-hua hsüan chi* (Peking, 1963), pl 58. If so, it is not identical with the *Fou-yü-shan chü t'u*, the whereabouts of which remains unknown today. Recently, the whole painting section was reproduced by Richard Barnhart in "*Marriage of the Lord of the River*": *A Lost Landscape by Tung Yüan* (Ascona, 1970), fig. 23.

17. *Shih-ku-t'ang shu hua hui k'ao*, p. 160.
18. Cahill, "Ch'ien Hsüan," p. 16.
19. See Chao Meng-fu, *Sung-hsüeh-chai wen chi*, and my *Autumn Colors*, p.18, n. 17.
20. Cahill, "Ch'ien Hsüan," p. 14.

some painting techniques from Ch'ien.[21] If so, it was most likely in the ten years after the fall of the capital city of Hangchow to the Mongols, when both men must have returned to their own district to live the retired lives of Sung officials. At that time, Ch'ien was in his early forties, while Chao was about twenty years younger, and was already well known for his painting, especially that of bird and flower subjects; Chao was probably better known as a calligrapher. In this period, like most of the intellectuals whose official careers had come to an abrupt end following the Mongol conquest, Chao and Ch'ien doubtless devoted their time to the pursuit of learning and literary and artistic expression. Literary gatherings in the Hangchow area were particularly popular during those days.[22] The most famous scholar in the district of Wu-hsing was probably Ao Shan, under whom Chao studied and distinguished himself. Soon Chao became known as the leader of the so-called Eight Talents of Wu-hsing.[23] It is then quite possible that both Chao and Ch'ien, both regarded as "Talents" in their native city, together with the others met regularly in their literary gatherings, as implied in Chao's famous letter to Wu Ch'eng mentioned above, and together formed some of the ideas that later shaped the development of Yüan painting. This is probably why Chao never acknowledged any special indebtedness to Ch'ien. In the same way, in the two major Yüan art-historical sources, T'ang Hou's *Hua Chien* and Hsia Wen-yen's *T'u hui pao chien*, which reflect some of Chao's new ideas on painting, there was no indication of such a debt.

The emphasis on Chao's being a pupil of Ch'ien probably partly reflected the Confucian attitude toward loyalty to the Sung. Ch'ien, a middle-aged man, decided not to serve under the Mongols. As such he was respected as a loyalist, in the same group as Wen T'ien-hsiang (1236–1282) or Hsieh Fang-te (1226–1289) or the painters Cheng Ssu-hsiao and Kung K'ai, all of whom commanded tremendous respect at that time. On the other hand, Chao, though a member of the Sung imperial clan, could not resist the great opportunity offered him by Emperor Kublai Khan in 1286, when he was still in his early thirties. Because of this "betrayal," he was criticized and condemned by many writers even during the Yüan period, although he was also very much respected by a considerable number of other intellectuals.[24] Many of the stories concerning Chao's humiliation have recently been shown to be complete fabrications, such as the one about his being slighted by his relative Chao Meng-chien.[25] The story of their teacher-pupil relationship

21. In this connection, there is a colophon written by Ni Tsan for Ch'ien Hsüan's handscroll *Peony*, which says, in addition to recording a poem concerning the relationship between the two, "Chao Yung-lu [Meng-fu], in his early years, studied flower and bird painting in color under the Venerable Ch'ien." See *Ku-kung shu hua lu* (Taipei, 1965), 4:75.

22. The most famous of these is the one recorded by Tai Yen-yüan, "Yang-shih ch'ih-t'ang yen chi shih hsü," in *Yen-yüan Tai Hsien-sheng wen chi*, SPTK reduced size ed., x/91–92.

23. The earliest reference to this term seems to be Chang Yü's *Ching-chü chi*, which was written in the late Yüan or early Ming. However, Chao probably was already referring to them in his letter of 1287 (see n. 10 above), although he did not use the term.

24. Cf., for example, the admiration shown toward Chao by the young Kuo Pi in his diary written during 1308–9, recorded in *Kuo T'ien-hsi shou shu jih-chi* (Shanghai, 1958).

25. See Chiang T'ien-ke, "On the Relationship between Chao Meng-chien and Chao Meng-fu," *Wen Wu* 12 (1962): 26–31.

is possibly also one of the exaggerations. It is interesting that contemporary writings by various people close to Chao and the Wu-hsing group never mentioned this relationship, and neither Chao nor his sons and grandsons ever acknowledged it in their colophon writings. The only major piece of evidence for it is the colophons of the *Dwelling on Floating Jade Mountain* scroll, which unfortunately is no longer available for examination. Even if the painting and the colophons are genuine, the date of Chang Yü's and Huang Kung-wang's colophons, 1348, still puts them twenty-six years after Chao's death. By that time Chao's fame must have been at its highest, and any story about him, either laudatory or critical, could have been exaggerated out of all proportion. Interestingly enough, both colophons seem to have been written in the city of Soochow, for most of the other colophons were by intellectuals of that city, where Sung loyalist sentiment was very strong,[26] and the relationship between the two Wu-hsing leaders may have been a story circulated in Soochow more or less to play up the importance of Ch'ien Hsüan the Sung loyalist.

Perhaps the most convincing evidences are the paintings themselves. The majority of Ch'ien Hsüan's works, both extant and recorded, fall into three major groups: bird and flower, figure, and landscape. By far the largest number are bird and flower paintings, next figures, and then landscapes. Unfortunately, very few of Ch'ien's paintings are dated, making it difficult to reconstruct his development. The most reliable short reference to him as an artist seems to come from Hsia Wen-yen, also a native of Wu-hsing, who wrote of him in 1365: "He was skillful in figures, landscapes, flowers and plants. His birds followed Chao Ch'ang, and his blue-and-green landscapes followed Chao Chien-li [Po-chü]. He was especially skillful in [painting] cut branches. When he was pleased with these paintings, he would inscribe his own poems on them."[27] There is no indication that he went back to the T'ang or earlier for his models. The only possibility is that in following Chao Po-chü he would naturally become interested in the works of Li Ssu-hsün and Li Chao-tao of the T'ang, whom Chao was believed to have imitated. Among the extant landscape paintings attributed to Ch'ien Hsüan, a number seem to fall into this category.[28] One which does not, unique among his landscape attributions, is his *Dwelling on Floating Jade Mountain*, mentioned above. The scroll is said to follow Wang Wei of the T'ang. However, since Ch'ien is thought to have lived until 1300 or after, some of these paintings, if they are indeed his, may be works of his last years. Thus, in spite of the difference in their ages, both Chao and Ch'ien might have developed their ideas in the decade when they were together in their home district.

26. This idea is discussed in this author's paper on Soochow mentioned in n. 2 above. Both Cheng Ssu-hsiao, a Fukienese who had lived in Hangchow, and Kung K'ai, from the Huai River area, chose Soochow as their residence after the fall of the Sung.

27. *T'u-hui pao chien* (Taipei, 1956), p. 97.

28. Two of these are included in Lee and Ho's *Chinese Art under the Mongols*, nos. 184–85. Two others are in the National Palace Museum, Taipei; see *Ku-kung shu hua lu*, 1965 ed., 4:69–73. Another is reproduced in *Chung-kuo kui-tai hui-hua hsüan chi*, pl. 58, and still another is in Osvald Sirén, *Chinese Paintings: Leading Masters and Principles*, 7 vols. (New York, 1956–58), vol. 6, pl. 34.

The area where Ch'ien Hsüan seems to have made a greater contribution is figure painting. His main surviving attributions in this area seem to show an indebtedness to T'ang models, but by way of the Sung literati artist Li Kung-lin. In one of his poems, Chao Meng-fu indicates that Ch'ien made an imitation of Li Kung-lin's horse paintings.[29] This is an important reference, for Ch'ien's interest in the literati theory of the Northern Sung lies mainly in the figure paintings of Li Kung-lin, whose approach was quite different from that of either Wen T'ung and Su Tung-p'o or Mi Fu and Mi Yu-jen, all leading literati painters with whom he is usually grouped.[30] It was Li Kung-lin's idea of archaism to which Ch'ien seems to have wholeheartedly subscribed, and the extant attribution of his figure paintings certainly bears this out.[31] Again, this source was common to both Ch'ien and Chao, for the latter did follow Li in his figure and horse paintings. It seems likely that both Chao and Ch'ien worked together and developed further, each in his own direction.

It is possible that because of his great prestige and broad influence Chao Meng-fu received all the credit for ideas that he and Ch'ien developed together, and, in a way, Chao deserved it. All the contemporary accounts describe Chao as a leader in art theory and practice. Furthermore, the materials available reveal a consistency in his ideas and his painting. Most important, each major idea was worked out by Chao to its logical conclusion, quite an achievement. Especially fortunate is the fact that in this case we have enough materials now available to reconstruct his development.

Although Chao did not leave a complete set of artistic theories to us, it is possible to trace his major ideas.[32] For example, his dissatisfaction with the late Sung culture is seen in his statement concerning the literature of that period: "During the last years of the Sung literary writing was a great disaster. Classical scholars were not wary of departing from the basic tenets of the classics, but expended their major efforts on establishing strange and dangerous theories. Writers of *fu* poetry were not troubled by the fragmentary, minute, and luxurious nature of their work but tried to be satisfied with ornamental novelty."[33] This statement is very much in line with some of the ideas concerning late Southern Sung art in T'ang Hou's treatise on painting, as noted above.[34] The strong dislike of the major Southern Sung artists, including Ma Yüan and Hsia Kuei, and the severe attack on the paintings of monk artists, especially those of the Ch'an

29. For Li Lung-mien's influence on Chao Meng-fu, see my "The Freer *Sheep and Goat* and Chao Meng-fu's Horse Paintings," *Artibus Asiae* 30 (1968): 279–326; and Richard Barnhart, "Li Kung-lin's *Hsiao Ching t'u*" (Ph.D. diss., Princeton University, 1967). Ch'ien's relationship to Li can be seen in a poem written by Chao Meng-fu, "Written for Shun-chü's [Ch'ien Hsüan] Imitation of Po-shih's [Li Kung-lin] *Two Horses*," in *Sung-hsüeh-chai wen chi*, SPTK ed., iii/19a.

30. This aspect of Ch'ien Hsüan is discussed in Richard Barnhart's thesis mentioned in n. 29.

31. Cf., for example, his *The Joy of Writing Poetry on the West Lake* (in Hsieh Chih-liu, *T'ang Wu-tai Sung Yüan ming-chi* [Shanghai, 1957], pl. 23) and *Portrait of T'ao Yüan-ming* (in J. Harada, *Pageant of Chinese Painting* [Tokyo, 1936], pl. 278). Cf. also Cahill, "Ch'ien Hsüan."

32. This is discussed in my *Autumn Colors*, pp. 70–80.

33. "Ti-i-shan-jen wen chi hsü," *Sung-hsüeh-chai wen chi*, SPTK ed., vi/11a.

34. This was discussed also in *Autumn Colors*, pp. 70–80.

monks like Mu-ch'i, were all part of the same attitude. It seems to be partly this attitude which led to Chao's development of new ideas in early Yüan literature and art. To a certain extent, it may be one of his reasons for accepting the call of Kublai Khan to serve in the Yüan court in Peking.

From the writings of T'ang Hou and Hsia Wen-yen and some of Chao's colophons on other paintings and his own works, we see that his ideas were foremost in reviving and consolidating the ideas of the *wen-jen-hua* group in the late eleventh century. Following Su Tung-p'o, Mi Fu, and other literati painters of the Northern Sung, he insisted that painting was a means for expressing the inner feeling of the artist and emphasized the close relationship between painting and calligraphy. But most important he held that the form and spirit of ancient masters must be studied in order to develop new ideas. Although sometimes this theory was misunderstood to mean a conservative imitation of ancient models, in actual practice, as so well reflected in Chao's works, it transferred the classical spirit of Chinese painting to his own time.

In fact, Chao Meng-fu's uses of the past were among the most interesting and creative in the Yüan period. To almost every genre of painting he brought something new, but it is his paintings of landscape that offer the greatest insight into his ideas of classicism. Unlike Ch'ien Hsüan's landscapes, Chao's extant works on this subject allow us to reconstruct the pattern of his development in his search for classical elements. From his extant landscape works we can take four well-documented handscrolls as a guide to his development, best described as a series of syntheses. The first is *Mind Landscape of Hsieh Yu-yü* (*Yu-yü chiu-ho t'u*), (fig. 1), a handscroll on silk in colors. Though undated, it is, according to a colophon by his son Chao Yung (b. 1289), an early work, probably done after the fall of Hangchow to the Mongols and while he was in retreat at Wu-hsing and closely associated with Ch'ien Hsüan.[35] In this scroll, several colophon writers mention that the *Mind Landscape* follows Ku K'ai-chih of the fourth century. Comparisons between this painting and the landscape scene *Admonitions of the Instructress*, in the British Museum, do show similarity in brushwork, landscape details, and handling of space. The total conception and composition, on the other hand, are somewhat close to the *Four Hoary Heads* of the Teng-hsien tiles of the Six Dynasties. However, as far as we can see, Chao did not directly imitate or copy Ku K'ai-chih or some other Chin master, but followed the demands of his subject, the superior character of the Chin hermit Hsieh Yu-yü (280–322), drawing on certain stylistic features of Chin paintings to express his desire to live like the man in the "mind landscape." As a Yüan painting derived from Chin style, *Mind Landscape* is thoroughly convincing as an early work of Chao Meng-fu. The use of iron-wire lines, blue-and-green rocks and mountains, the spacing of the trees, the space-cell idea shutting out the distance in most of the scroll, and the sudden opening at the very

35. Two scrolls of this subject by Chao Meng-fu were recorded, both with a colophon by his son Chao Yung, which refers to them as works of his father's early years. However, the two have considerable differences; one lacks Chao Meng-fu's inscription and the other carries two of his. The version under discussion is the former; the latter does not seem to have survived. See *Shih-ku-t'ang shu hua hui k'ao*, pp. 119–20.

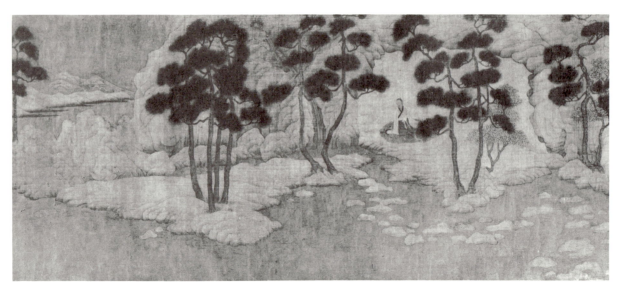

Figure 1. Chao Meng-fu, *Mind Landscape of Hsieh Yu-yü* (section), Yüan dynasty, handscroll, ink and colors on silk. Anonymous long-term loan, The Art Museum, Princeton University (L216.69).

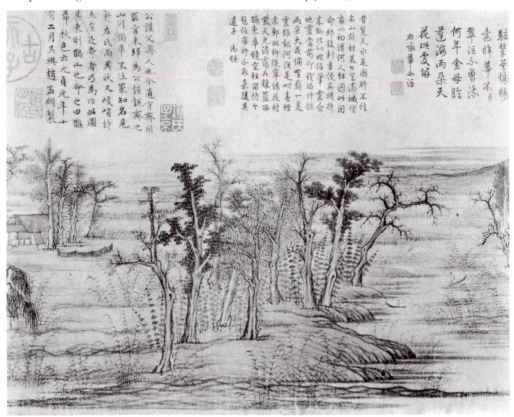

Figure 2. Chao Meng-fu, *Autumn Colors on the Ch'iao and Hua Mountains* (section), 1296, handscroll, ink and colors on paper. National Palace Museum, Taiwan. Reproduced from Chu-tsing Li, "The *Autumn Colors on the Ch'iao and Hua Mountains*: A Landscape by Chao Meng-fu," *Artibus Asiae* (Ascona, Switzerland, 1965), supp. 21.

end of the scroll—all are elements characteristic of Chin and Six Dynasties painting. In fact, this is the kind of approach that should have been found in Ch'ien Hsüan's archaistic landscape, but Chi'en's extant paintings indicate quite a different direction, even though the ideas they express might be similar to those of Chao Meng-fu.

The second painting we will consider is *Autumn Colors on the Ch'iao and Hua Mountains* (fig. 2), a work on paper in colors, now in the National Palace Museum, Taiwan, dated in the early days of 1296, after Chao's extensive ten-year travels in North China. This painting has features in common with some of Ch'ien Hsüan's landscapes in color, indicating that both artists had been working on similar ideas earlier. At the same time, the painting exemplifies Chao Meng-fu's absorption of T'ang and Northern Sung elements. As has been shown elsewhere, the stylistic principles of this painting came from T'ang landscapes, such as those generally attributed to Wang Wei.[36] Similarly, as shown in my earlier study of *Autumn Colors* and in Richard Barnhart's more recent comments,[37] Chao also absorbed some of the Tung Yüan elements from some of the scrolls available to him around that time, such as *Hsiao-Hsiang t'u*, now in Peking, which was probably known as *Marriage of the Lord of the River* at that time; *Summer Scene: Waiting for the Ferry at Mountain's Opening*, now at the Liaoning Museum; and *Wintry Trees by a Lake*, now at the Kurokawa Institute of Ancient Culture, Hyogo. Again, it was the creative use of the past that led Chao to achieve another synthesis in his development.

The third painting is *Water Village* (fig. 3), a short handscroll in ink on paper, dated 1302, now in Peking, which has also been discussed elsewhere.[38] While both the Wang Wei and Tung Yüan elements used in *Autumn Colors* persist in this later work, the emphasis here is more Northern Sung than T'ang, as indicated in the stress on ink rather than colors and the more unified space and scale. The same style can be seen in another short handscroll, whereabouts unknown, entitled *Poetic Feeling of an Autumnal Mood*, which was painted for Chao's good friend Teng Wen-yüan.[39] Since this work is undated and Teng outlived Chao by six years, there is no way to give a definite date to the scroll. However, from the stylistic point of view, it must have been painted around 1300, about the time of *Water Village*.

While this absorption of the Wang Wei and Tung Yüan traditions into his own style must have continued throughout the rest of Chao's life, he also started in another direction, drawing on the Li Ch'eng and Kuo Hsi elements in the Northern Sung, exemplified in the fourth painting, *Rivers and Mountains* (fig. 4), a handscroll in ink on paper, dated 1303, now also at the National Palace Museum, Taiwan.[40] The Li-Kuo

36. This painting has been thoroughly discussed in my *Autumn Colors*. In my translation of this book into Chinese published in *National Palace Museum Quarterly*, vols 3–4 (1969), I made revisions, some of which are based on the recent study of Tung Yüan by Richard Barnhart ("*Marriage of the Lord of the River*").
37. See n. 36 above.
38. See *Autumn Colors*, pp. 53–59.
39. This painting is reproduced in *Chung-kuo ming hua chi* (Shanghai, 1909), 1:98.
40. This painting is reproduced in several publications of the National Palace Museum, the best of which is *Three Hundred Masterpieces of Chinese Painting in the Palace Museum* (Taipei, 1959), p. 149. In *National Palace Museum Bulletin* 3 (1968): 12–13, 4 (1969), fig. 5, it is also reproduced.

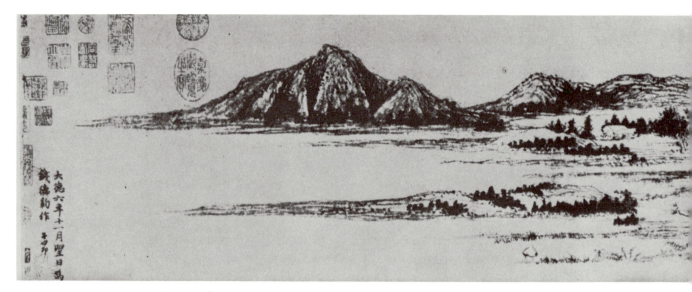

Figure 3. Chao Meng-fu, *Water Village*, 1302, handscroll, ink on paper. Palace Museum, Peking. Reproduced from *Chung-kuo hua* monthly, Peking, 1959/9.

tradition was undoubtedly well-known to him, for, according to contemporary literary sources, he did paint in this stylistic tradition. Perhaps he became acquainted with it during his travels in the north, where the works of both Li and Kuo and their followers must have survived in considerable numbers after the collapse of the Northern Sung into the Chin and early Yüan periods. Chao was probably also responsible for starting this new trend in his native district, Wu-hsing, where two of the famous painters in the Li-Kuo tradition, T'ang Ti (1296–1365) and Yao Yen-ching (early fourteenth century), lived and worked. *Rivers and Mountains*, in its use of wash technique in the mountains, in the absence of *ts'un*, in its emphasis on the tree motif on the left, and in the strictly symmetrical composition, is a typical product of the Li-Kuo influence. But again, unlike so many Yüan painters in this tradition, Chao combined these elements with his own ideas to achieve a new synthesis.

In these four handscrolls it is easy to see the stages of development in Chao's uses of the past. Starting from the Chin and Six Dynasties, whose works were still available in his own time even though some of them must have been copies, he moved through the T'ang and Five Dynasties, and finally to the Northern Sung. Within the last period, when landscape achieved great heights, he sought out two of the three traditions, the Tung Yüan and the Li Ch'eng, leaving out the Fan K'uan, for his experiments in transforming the past. This two-pronged interest, which probably occupied the last twenty years of his artistic life, was an innovation of his own, which later became typical in the Yüan period, as indicated at the beginning of Huang Kung-wang's treatise on landscape.

Yet in spite of all the differences among these four scrolls, there are some common characteristics that tie them together as works of Chao Meng-fu. There is a strong

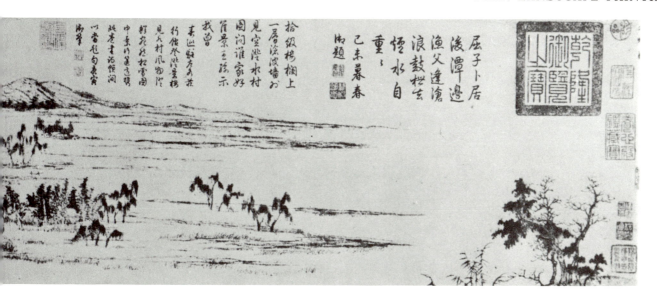

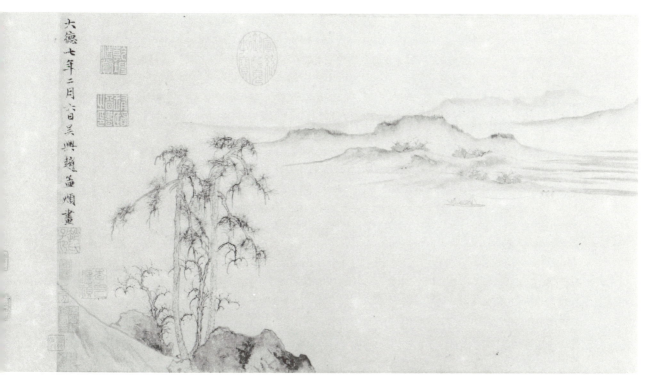

Figure 4. Chao Meng-fu, *Rivers and Mountains* (section), 1303, handscroll, ink on paper. National Palace Museum, Taiwan.

emphasis on formal elements: a simple structure based on verticals and horizontals; a repetition of major motifs; a clear indication of the three grounds; and a strong interest in symmetry, order, and restraint. These are, in fact, characteristics of Chao Meng-fu's personal style. There is also a turning away from the more emotional approach of the Southern Sung to a more formal and intellectual one. Yet his style was formed from his intense interest in and study of paintings of old masters. It was the crystallization of his contacts with the past rather than direct imitation of any one master or his work. Chao grasped the classical spirit and developed a classical style. In the generic sense, this is his classicism, and in the course of achieving it he made painting into a humanistic discipline.

In this creative use of the past, Chao Meng-fu not only stood out among his contemporaries as a great master but also pointed the way toward all the major directions that Yüan landscape painting would take. He attempted to absorb the entire early development of Chinese painting, from Chin to Northern Sung, distilled what he considered to be its most valuable elements, and passed them on to the following generations. Thus Chao's achievement can be considered the classical stage of Yüan landscape painting. It ran from the beginning of the Yüan to around 1320, about the time of Chao's death.

The rest of the development of Yüan landscape can be described as taking place in three stages. From Wu-hsing Chao's ideas spread to various places in the intellectual community of Chiang-nan. In a way, these three stages seem to be only elaborations and refinements of Chao's experiments. From his interest in the Li-Kuo tradition the second stage develops, which can be called the Li-Kuo stage, from around 1320 to 1350. Under the influence of Li Ch'eng and Kuo Hsi and their followers, the most creative Yüan painters in this period seem to have been attracted to a tree-dominated composition that must have come from those masters. Actually, this type of painting probably had its origin in the pine and rock painting tradition of Chang Tsao and Wei Yen of the T'ang dynasty, whose works survived in considerable numbers in the Yüan period. Chao Meng-fu himself was known to be interested in the works of Chang Tsao.[41] Among the many works from this period we can mention Wu Chen's *Two Pines* of 1328, Ts'ao Chih-po's *Two Pines* of 1329, Wang Yüan's *Meeting of Friends in a Pine-Shaded Pavilion* of 1347, Chang Shun-tzu's *Old Trees and Flying Waterfall* of the same year, and even Ni Tsan's early work, *A Pavilion among Pines* of 1354. Of course, the standardbearers of the Li-Kuo tradition in the Yüan, such as Yao Yen-ching, T'ang Ti, and Chu Te-jun, must also be considered as part of this stage, although some of their works might overlap other stages. All three were closely associated with Chao Meng-fu in one way or another.

The third stage, from about 1340 to 1370, is dominated by river and lake scenes, and was also anticipated by Chao Meng-fu, especially in his *Water Village* of 1302 and *Rivers and Mountains* of 1303 and in his hanging scroll, *The Eastern Mountain of Tung-t'ing*, which, though undated, seems to belong to the period of *Autumn Colors*. In a way, this is also the result of a combination of both the Tung Yüan and Li-Kuo traditions. While the tree group of the Li-Kuo type is retained, it has given way in importance to the river or lake.

41. See T'ang Hou, *Hua chien* (Peking, 1959), p. 16, which quotes Chao's statement on Chang Tsao.

Both Wu Chen and Ni Tsan brought this new development to its height, as exemplified by most of the attributions of these two masters: Wu Chen's *Hermit Fisherman at Lake Tung-t'ing* of 1341 and Ni Tsan's *Jung-hsi Studio* of 1372 are the most typical examples. To a certain extent, Huang Kung-wang's *Dwelling on the Fu-ch'un Mountains* of 1347–1350 can also be considered as a work of this group.

Toward the end of the Yüan and well into the reign of Emperor Hung-wu, a new kind of composition, now dominated by mountains that fill the whole picture, became typical among painters of Soochow. This fourth stage of development might not have come from Chao Meng-fu, though there are some indications of his work in this direction. The main inspirations were probably some of the works of Tung Yüan and Chü-jan found at that time. The artist who took the lead in this new development was Wang Meng, who did inherit some ideas from his grandfather, Chao Meng-fu, and whose many attributed works bear witness to his exploration of the potentials of the new concept. Other painters, such as Chao Yüan, Hsü Pen, Lu Kuang, and even Wang Fu later, brought various personal expressions to it.[42]

In all these three later stages of Yüan landscape development, Chao's blending of old ideas with new ones to achieve new syntheses as expressions of personal outlook in a time of great changes still persisted. Each stage still drew its main inspiration from the past: the Li-Kuo, the combination of Li-Kuo and Tung Yüan, and the Tung-Chü approaches. Creative artists explored these possibilities and transformed them into an expression of their own inner yearnings in their changing world. Thus each stage represents a new synthesis, the sum of a number of small syntheses in individual artists.

The development of landscape is the most exciting aspect of Yüan painting; other subjects, some of which were also recommended by Chao Meng-fu, did not seem to be equally successful. A good example is the painting of birds and flowers. Several painters, including Ch'en Lin, Wang Yüan, and some others, are recorded as skillful artists who, following Chao's persuasion, turned to the ink style. Chao himself seems to have done the same in his horse paintings and figure compositions.[43] However, because of the inherent quality of these paintings, the attempt to bring new life to old traditions by transforming skill into ink technique had only limited success. As a result, there was a sharp decline in the popularity of these subjects in the Yüan period, while landscape became a favorite from then on.

In landscape, because of the creative efforts of the great painters, each step in the Yüan development, as seen in Chao Meng-fu and later painters, was an exciting experience. The past was taken as a guide: its form and style were not to be copied, but its spirit and expression were to be absorbed. Throughout the Yüan there was a general nostalgia for

42. The development of Yüan landscape painting is the subject of another paper, "Stages of Development in Yüan Dynasty Landscape Painting," *National Palace Museum Bulletin*, vol. 4, nos. 2–3 (1969). The discussion of these stages is more detailed in that two-part paper, and major paintings mentioned in the text, especially those in the Museum, are reproduced there. Readers are urged to consult the reproductions in that article.

43. A discussion of Chao Meng-fu's horse paintings can be found in my "The Freer *Sheep and Goat*."

the ancient past, but each creative artist constantly searched for a more personal and individual expression as a vehicle for his feelings in his own world. Thus the process took place without the formation of an orthodoxy.

What is interesting is that all these new developments in Yüan landscape, with all the strong personalities and solid theories they involved, could have created a kind of orthodoxy if the first emperor of the Ming, Hung-wu, had been more sympathetic to the arts. However, Hung-wu was suspicious of the literati painters who were mostly active in Soochow and ruthlessly executed a number of outstanding artists.[44] By the middle of his reign, the great development of landscape painting seems to have come to a complete standstill. It was only after his death that some artists began to pick up the pieces. Wang Fu, from the Soochow area, survived his exile to Shansi and after the death of Hung-wu returned to continue the tradition. Throughout the fifteenth century such men as Yao Shou, Tu Ch'iung, Liu Chüeh, and eventually Shen Chou gradually re-established the tradition. In the sixteenth and the early seventeenth centuries, this literati tradition continued to develop, independent of official support. It is ironic that during the seventeenth century, first through a strong personality, Tung Ch'i-ch'ang, whose great prestige and influence again brought all the scholarly innovations into sharp focus, then through a strong body of theories formed by Tung and his friends, and eventually through the official endorsement of two of Tung's followers, Wang Hui and Wang Yüan-ch'i, an orthodoxy was finally formed, which lasted into the twentieth century.

44. For a discussion of the persecutions of intellectuals during the reign of Emperor Hung-wu, see Frederick W. Mote, *The Poet Kao Ch'i (1336–1374)* (Princeton, 1962).

ARCHAISM AS A 'PRIMITIVE' STYLE

Wen C. Fong

Throughout the history of Chinese art, the notion of *fu-ku*, "return to the archaic," has dominated the artist's imagination.[1] A brief survey of the histories of figure painting, landscape painting, calligraphy, and thought in China will show that they shared a common pattern of development: after a primary evolutionary phase, they each went through successive *fu-ku* or "return to the archaic" movements.

DIFFERENT CYCLES OF *FU-KU* MOVEMENTS

Writing in the middle of the ninth century, Chang Yen-yüan (ca. 847) noted, on the one hand, progress in representational skill in the history of painting, and on the other hand, a decline in painting in his own time. He remarked: "In paintings of High Antiquity, though the drawing is simple the expression is tranquil and noble.... Paintings of Middle Antiquity are fine-scaled, exquisitely finished and exceedingly beautiful.... Paintings of more recent times, brilliantly executed, excel in [representational] completeness. But contemporary paintings are chaotic and meaningless."[2]

When Chang wrote, figure painting had already passed the zenith of its glory with Wu

1. F. W. Mote, in the first essay in this volume, suggests the notion of an "inexorable past" in Chinese thought, pointing out that "in Chinese civilization ... the defining criteria for value were inescapably governed by past models." A. C. Soper, on the other hand, in his essay, "The Relationship of Early Chinese Painting to Its Own Past," observes that painting theory did not become obsessed with the notion of *ku* or archaic until the Sung and later times; he stresses "the fact that this weight of the past was a relatively late phenomenon, built up gradually from the T'ang dynasty on, and long resisted." These two seemingly divergent statements, in my opinion, are both valid historical "theorizing modes." As a cultural historian attempting to penetrate a special mode of thought—or "the theorizing mode of the civilization"—Mote sees *fu-ku* as a peculiarly Chinese formula "for explaining change [and] assigning values." As a historian of art, however, Soper is more concerned with concrete evidence of specific uses of past models in painting. Since "of all the Chinese fine arts, painting was the last to develop and the slowest in reaching maturity," it is understandable that painters and critics of painting were relatively free from the "cult of the past" until the Sung period.

2. *Li-tai-ming-hua-chi*, 1/6; see William Acker, *Some T'ang and Pre-T'ang Texts on Chinese Painting* (Leiden, 1954), p. 149.

Tao-tzu's generation (ca. 700–770) about a century earlier, while landscape painting was just gathering the momentum that was to culminate in the spectacular visions of Ching Hao, Kuan T'ung, and Li Ch'eng a century later. The fact that, even in the nadir of painting during the ninth and early tenth centuries, Chang and his colleagues did not conceive of a cyclical return to greatness through a *fu-ku* movement of studying ancient models supports Alexander Soper's view that, in painting, the weight of the past was not yet sufficient at that time to cause such a movement.[3]

From the representational point of view, Chinese figural art before the ninth century underwent a complete course of development, from an archaic phase of linear, essentially frontal and two-dimensional representation (late Chou through early Six Dynasties, ca. fifth century B.C.–A.D. 550), through a transitional phase of cylindrical forms with developing organic relationships between parts of a figure (late Six Dynasties through early T'ang, ca. A.D. 550–700), to a fully developed state of well-articulated, three-dimensional bodies with increasingly naturalistic, almost transparent, drapery folds toward the end of this development. Figure painting after the ninth century continued mostly in the traditions of the mid-T'ang masters. But Li Kung-lin (1040–1106) of the late Northern Sung, in a climate of antiquarianism and the "scholar-painting" aesthetics of that period, set a neoclassic standard by returning to a more archaic model, Ku K'ai-chih (A.D. 344–406), adapting Ku's manner to his own *pai-miao* or "plain outline drawing" style.[4] A second *fu-ku* movement was carried out at the beginning of the Yüan period by Chao Meng-fu (1254–1322), who imitated Li Kung-lin as well as Ku K'ai-chih.[5] Thereafter, having acquired an established stock of form types, drapery patterns, and brush methods, culled and reduced from ancient models, the Chinese figure painter sought success mostly in the vitality of his brushwork and in expressive (descriptive or calligraphic) elegance—in short, in the sudden coming to life of the oldest methods and forms.

In landscape painting, the development from ideographic mountain-and-tree motifs to the creation of illusionistic space spanned a time period from the late Han to the early Yüan (ca. third century–late thirteenth century).[6] Toward the end of the thirteenth century, a full-fledged *fu-ku* movement was realized by Chao Meng-fu, who, after studying a whole range of ancient models—the archaic "blue-and-green," the descriptive Li-Kuo, and the calligraphically expressive Tung-Chü—set the course of a major painting revival with the Tung-Chü idiom, which he preferred.[7] Through calligraphic brushwork, Chao's celebrated followers, the so-called Four Great Masters of the Late Yüan, stressed *hsieh-i*, the "writing of ideas," in painting. The more painting emphasized inner experi-

3. See his essay in Part I of this volume.
4. See Richard M. Barnhart, "Li Kung-lin's *Hsiao-ching-t'u*" (Ph.D. diss., Princeton University, 1967), especially pp. 175ff.
5. See Chu-tsing Li, "The Freer *Sheep and Goat* and Chao Meng-fu's Horse Paintings," *Artibus Asiae* 30 (1968): 279–306, especially pp. 301ff.
6. See Wen Fong, "Toward a Structural Analysis of Chinese Landscape Painting," *Art Journal* 28 (1969): 388–97.
7. See Chu-tsing Li, *Autumn Colors on the Ch'iao and Hua Mountains* (Ascona, 1965).

ence and resembled calligraphy, the more it devalued the representational content in favor of the purely aesthetic. By the early Ming (ca. 1400), and throughout subsequent periods, all painters worked happily within the established idioms, the best of them proving to be capable of creating infinite variations on and renewals of the oldest of the themes.

This pattern of a primary evolutionary development followed by successive renewals through *fu-ku* movements in the history of painting was closely paralleled—in fact, anticipated—by the history of calligraphy. The historical evolution of the Chinese script, from the "seal" (*chuan*) through the "clerical" (*li*) to the "regular" (*cheng*), was complete by the third century. During the third century, archaism and eclectic mixing of ancient styles became prevalent in writing: for instance, *T'ien-fa-shen-ch'an pei*, dated 276, affects the "seal" style;[8] *Ta-chiang-chün Ts'ao Chen ts'an-pei*, dated 235–236, shows a "clerical" style mixed with "seal" elements;[9] *Chiu-chen-t'ai-shou Ku Lang pei*, dated 272, combines "clerical" elements with the "regular" style.[10] Wang Hsi-chih, the "calligraphic Sage" (307–365), by achieving a *ta-ch'eng* or Great Synthesis of various currents at calligraphy's historic moment of gestation, became the classic model for all future calligraphers. The history of calligraphy since Wang Hsi-chih sees branches of Wang's followers successively multiply and, when their strengths waned, be periodically pruned and reinvigorated by *fu-ku* movements which restudied Wang's oeuvre. Thus in the seventh century, under the auspices of the T'ai-tsung emperor of the T'ang, Ch'u Sui-liang compiled a catalogue of more than two thousand specimens of Wang's writings, and in 672 the priest Huai-jen painstakingly composed the *Shen-chiao hsü* with characters culled from Wang's writing.[11] The rigorous analysis of Wang's methods (*fa*) was the basis of the renascence of calligraphy during the early T'ang. Later on, in the late Northern Sung, serious studies of archaic models again brought glory to calligraphy: Li Kung-lin was inspired by Chung Yu (A.D. 151–230), Huang T'ing-chien (1045–1105) by *I-ho ming* (early sixth century), and Mi Fu (1051–1107) by Wang Hsi-chih.[12] At the end of the thirteenth century, Chao Meng-fu once again brought the diverse early Yüan efforts for renewal back to the main track, so to speak, by a thorough study of Wang Hsi-chih's writings. The next major *fu-ku* leader was Tung Ch'i-ch'ang (1555–1636), who, though unable to discard Chao Meng-fu's influence entirely, nonetheless succeeded in establishing a new direction for his time through a rigorous study of Wang Hsi-chih.

If we now consider the history of thought, we shall see, as F. W. Mote points out, that "artistic activities possessing identity and status within the Great Tradition . . . [merely] conform[ed] to the already well-established ways of that tradition."[13] At the end of the

8. *Shodō zenshū* (Heibonsha, Tokyo) 3 (1959), pls. 77–82.
9. *Ibid.*, pls. 61–62.
10. *Ibid.*, pls. 75–76.
11. *Ibid.*, 7:12, 33ff.
12. For Chung Yu, see *ibid.*, 3:24ff.; for *I-ho ming*, see *ibid.*, 5:19ff.; for Li Kung-lin, Huang T'ing-chien, and Mi Fu, see Barnhart, "Li Kung-lin's *Hsiao-ching-t'u*," pp. 140ff., and *Shodō zenshū* 10:21–36 and plates.
13. See his essay in this volume.

Figure 1. *Bodhisattva*, 9th century, stone. T'ien-lung-shan (cave 14), Shansi. Reproduced from Osvald Sirén, *Chinese Sculpture from the Fifth to the Fourteenth Century* (New York: Charles Scribner's Sons, 1925), vol. 4, pl. 495.

Figure 2. *Seated Lohan*, 12th century, white marble. Private collection, New York. Reproduced from Osvald Sirén, *Chinese Sculpture from the Fifth to the Fourteenth Century* (New York: Charles Scribner's Sons, 1925), vol. 4, pl. 582.

Eastern Chou period, Confucius (551–479 B.C.) is said to have achieved a *ta-ch'eng* or Great Synthesis of ancient thoughts. In the *Analects* the Master states: "I am a transmitter and not a creator. I believe in and have a passion for the ancients" (7/21). Fung Yu-lan divided his history of Chinese philosophy into only two main periods: "The Period of the Philosophers" began with Confucius in the sixth century B.C. and lasted until about 100 B.C., when Confucianism gained acceptance as the official orthodoxy; "The Period of Classical Learning" extended from about 199 B.C. until recent times.[14] Such a division appears to suggest, at first sight, that all original thinkers lived in the four hundred years of the first period; yet Fung argued vigorously that "such [later] men as Tung Chung-shu and Wang Yang-ming are not merely commentators, and that their philosophic works represent their own philosophy and not that preceding them."[15] Fung

14. *A History of Chinese Philosophy*, trans. Derk Bodde, 2 vols. (Princeton, N.J., 1952).
15. *Ibid.*, 1:5.

explained that "Chinese philosophy, in short, has always laid stress upon what man is (i.e., his moral qualities), rather than what he has (i.e., his intellectual and material capacities). . . . Because of its emphasis upon the way of the 'Inner Sage,' [Chinese philosophy] has delved deeply into the methods of self-cultivation, that is, what it calls 'the method of conducting study.'"[16]

This method of study placed emphasis on how rather than what one studied; it stressed not knowledge per se, but rather one's own inner response to it. Since it was believed that the voice of the ancients was heard only by one who had found it in himself, it followed that fidelity to the ancients meant fidelity to one's inner self. Thus to be a good imitator, one can only create. In copying ancient models, Tung Ch'i-ch'ang explained, true correspondence (ho) could come about only through individual departure, or metamorphosis (pien).[17] He wrote: "The calligraphic styles of Wang Hsi-chih and his son were exhausted by the Ch'i and Liang dynasties. In the early T'ang, when Yü Shih-nan, Ch'u Sui-liang, and others brought a new metamorphosis [pien] to the [Two Wangs'] methods, a new correspondence [with the ancient models] was discovered through the change. Wang Hsi-chih and his son were alive again."[18]

Thus in fu-ku the Chinese saw history not as a long fall from grace, but as an enduring crusade to restore life and truth to art. Ancient models were seen in a non-historical continuum, in which the later man, should he succeed in achieving an inner response (shen-hui, or "spiritual correspondence") to his model, suddenly emerged as an equal rather than a follower.

ARCHAISM AS A "PRIMITIVE" STYLE

As we noted above, Chinese figure style reached a peak of naturalism in the early ninth century. When we compare a late T'ien-lung-shan figure of the ninth century with a twelfth-century sculpture (figs. 1–2),[19] we see the clinging "wet" drapery with sharp arises and undercutting give way to flat, schematized bands. In the woodblock prints found inside the Sakyamuni statue at the Seiryōji, Kyoto, dated in the tenth century (figs. 3–4),[20] we see the simultaneous existence of a natural and a schematic style. But at Tun-huang, figure as well as landscape paintings of the tenth century, when compared with those of the eighth and ninth centuries, show a predominant taste for schematized forms with flat bands of colors (figs. 5–6).[21] In Pelliot Cave 76 at Tun-huang, there are sixteen seated lohan figures, datable to the early Sung (fig. 7), which show a schematic

16. Ibid., pp. 2–3.
17. See Wen Fong, "Tung Ch'i-ch'ang and the Orthodox Theory of Painting," National Palace Museum Quarterly 2 (1968): 19ff.
18. Hua-ch'an-shih sui-pi, ii/17a.
19. See Osvald Sirén, Chinese Sculpture (New York, 1925), vol. 4, pls. 495, 582A, and vol. 1, pp. 134, 156.
20. See Nihon chōkoku shi kiso shiryō shūsei: Heian-jidai, ed. Maruo Shozaburō et al. (Tokyo, 1966), 1: 65, 66, and pl. 1.
21. Paul Pelliot, Les Grottes de Touen Houang (Paris, 1914), pl. 222.

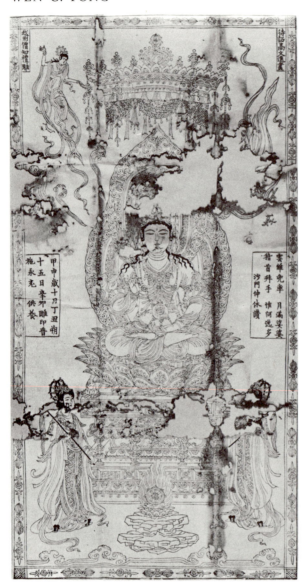

Figure 3. Kao Wen-chin, *Maitreya Enthroned*, A.D. 984, woodblock print. Seiryōji, Kyoto.

Figure 4. Anonymous, *Manjusri*, before A.D. 984, woodblock print. Seiryōji, Kyoto.

treatment of facial features, drapery folds, and landscape elements.[22] This schematic style is seen also in the tenth-century reliefs at the Ch'i-hsia-ssu near Nanking (fig. 8) and the carvings of the tomb of Emperor Jen-tsung (died 1063) in Honan (fig. 9).[23]

The lohan figures at Tun-huang reflect Kuan-hsiu's (832–912) famous images, the best copies of which are now preserved in the Imperial Household Museum in Tokyo (fig. 10).[24] Born in Teng-kao (Lan-ch'i), Chekiang, in 832, Kuan-hsiu became a Buddhist

22. *Ibid.*, pl. 151.
23. Sirén, *Chinese Sculpture*, pls. 599, 558.
24. See Tajima Shiichi, *Zengetsu-daishi juroku-rakan* (Tokyo, 1914).

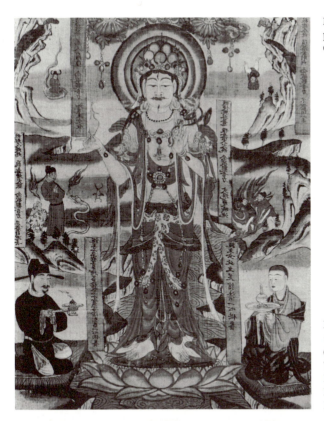

Figure 5. *Kuan-yin with Donors*, 10th century, painting on silk, from Tun-huang. Musée Guimet, Paris (MG-17665).

Figure 6. *Wu-t'ai-shan* (landscape detail), 10th century, wall painting, Tun-huang (Pelliot Cave 117). Photograph from the Tun-huang photographic archive at the Department of Art and Archaeology, Princeton University, courtesy of Mr. and Mrs. James C. Lo.

95

Figure 7. *Sixteen Seated Lohans* (detail), 10th century, wall painting, Tun-huang (Pelliot Cave 76). Photograph from the Tun-huang photographic archive at the Department of Art and Archaeology, Princeton University, courtesy of Mr. and Mrs. James C. Lo.

Figure 8. Relief, 10th century, stone. Ch'i-hsia-ssu, near Nanking. Reproduced from Osvald Sirén, *Chinese Sculpture from the Fifth to the Fourteenth Century* (New York: Charles Scribner's Sons, 1925), pl. 599.

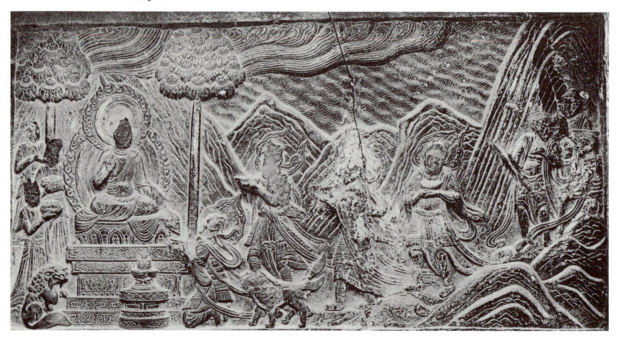

novice in 838 and was ordained a priest around 851. He was said to have painted his images of the sixteen lohans (in Sanskrit *Arhat*, in Japanese *Rakan*) according to his visions. The set now in Tokyo was painted for the Huai-yü-shan monastery in Kiangsi; he executed ten of the figures in 880 in Teng-kao and the remaining six in 894 in Ching-lin

Figure 9. Relief, tomb of Emperor Jen-tsung (died 1063), gray limestone. Yung-ch'ao-ling, Honan. Reproduced from Osvald Sirén, *Chinese Sculpture from the Fifth to the Fourteenth Century* (New York: Charles Scribner's Sons, 1925), pl. 558.

Figure 10. Attributed to Kuan-hsiu, *Sixteen Lohans* (detail), 880–894, one of a set of hanging scrolls, ink and color on silk. Imperial Household collection, Tokyo. Reproduced from Tajima Shiichi, *Zengetsu-daishi juroku-rakan* (Tokyo: Shimbi Shoin, 1914), pl. 16.

in Hupei.[25] The years between 851, when he was ordained, and 894, when he completed these images, were ones of great political turmoil in China; a series of rebellions led by Ch'iu Fu, Wang Hsien-chih, Huang Ch'ao, and Ch'in Tsung-ch'üan devastated central China, bringing about the downfall of the T'ang empire in 904. In 875 a salt smuggler from Hangchow named Ch'ien Liu enlisted to fight against the bandits. Soon he controlled Chekiang Province, and in 907 he was proclaimed the prince of Wu-yüeh. This marked the beginning of the so-called Five Dynasties and Ten Principalities period. In 894 Kuan-hsiu, a distinguished artist-priest seeking patronage among the new princes,

25. See Wen Fong, "Five Hundred Lohans at the Daitokuji" (Ph.D. diss., Princeton University, 1956), 1: 30–76, especially 53–55.

embarked on a long journey which took him through five of the ten principalities. In the T'ien-fu period (901–4), he arrived at Shu (Szechuan), where Prince Wang Chien honored him with the title "Ch'an-yüeh ta-shih." He died there in 912.

Kuan-hsiu's highly stylized grotesqueries represented something new and unusual in the portrayal of the lohan images. The *Sung kao-seng-chuan* (completed in 988) described them as "different from all ordinary images";[26] the *I-chou-ming-hua-lu* (preface dated 1006), noting their "thick eyebrows, huge eyes, hanging cheeks, and peaked noses," pointed out that "the beholders were startled by them."[27] The *Hsüan-ho-hua-p'u* of 1120 described Kuan-hsiu's images as *ku-yeh*, "archaic and rustic."[28] A variant of the term *ku-yeh* is *ku-kuai*, "archaic and weird," which, like its antithetical term *hsin-ch'i*, "new and strange," describes something unfamiliar and exotic.

Thus in Kuan-hsiu's paintings we encounter one set of qualities associated with the term *ku*, "archaic": the rustic, strange, and weird—in other words, archaism as a "primitive" style. This archaizing, primitive quality in late ninth- and early tenth-century paintings accords well with Soper's observation that "the idealization of the past for its own sake" did not become an important concern in painting until "the generation that included Li Kung-lin, Mi Fu, and Hui-tsung" in the late eleventh and early twelfth century. In renouncing the highly naturalistic style of the early ninth century and reducing forms to flat, schematic, and consciously exaggerated patterns, Kuan-hsiu had no interest in imitating, or re-creating, ancient models. Ou-yang Chiung, an admirer of Kuan-hsiu's at the Shu court, indeed praised Hsiu's art as surpassing that of Ku K'ai-chih and Wu Tao-tzu.[29] Kuan-hsiu's primitivism—his *ku-yeh* ("archaic and rustic") style—was modern rather than classical in spirit; his intensely stylized forms were concerned more with self-expression than with an idealistic reconstruction of the past.

In landscape painting, the schematic style of the early tenth century reverted to the use of triangular mountain motifs with parallel sections rendered in unmodulated outlines and solid bands of colors. The prototypical mountain motif is the ideographic form *shan* (see list of Chinese names and terms), which shows three peaks, a "host" flanked by two "guests." On a Han tile (second century B.C.) (fig. 11a), mountain motifs are represented by triangles set in one another, with bands of decorative lines. On a tile excavated at Puyō, Korea, dated in the seventh century (fig. 11b), mountain motifs in groups of three are shown with rows of trees above them; the bands of schematic modeling or decorative lines remain.[30] At Lung-men in central China, in the early sixth century, there appears an effort to model the sides of the mountain through undercutting (fig. 11c).[31] At the Shōsōin in Nara, Japan, one of the landscapes on a biwa, *Tiger Hunt*, dated

26. *Taisho daizōkyō*, l/2061, xxx/897 a–b.
27. *Wang-shih shu-hua-yüan* ed., ix/36a.
28. iii/10a.
29. *Ibid.*, ix/37a.
30. See Evelyn McCune, *The Arts of Korea* (Toyko, 1962), p. 102.
31. Pin-yang cave; see Mizuno Seiichi and Nagahiro Toshio, *Ryu-mon seki kutsu no kenkyū* (Tokyo, 1941), fig. 19.

from the late seventh century (fig. 11*d*), shows a further development of this mountain motif: the overlapping triangles are seen in alternating bands of green and orange, the whole resembling the cross-section of an artichoke.[32] In another landscape on a biwa at

(a) (b) (c) (d)

Figure 11. Development of the mountain motif: *a*, Han tile, 2nd century B.C.; *b*, tile from Puyō, Korea, 7th century A.D.; *c*, Lung-men, Honan, early 6th century A.D.; *d*, *Tiger Hunt*, Shōsōin, Nara, Japan, late 7th century.

Shōsōin, *Musicians Riding on an Elephant*, dated in the early eighth century (fig. 12), the mountain form is more naturalistically treated; its irregular crevices are modeled by graduated shading and softly rubbed texture strokes.[33] Finally, a ninth-century banner from Tun-huang, now in the British Museum, shows the developed mountain form: the tops of the triangles are open to suggest the receding ridge, or "spine," of a mountain mass, the crevices are modeled by texture strokes, and the colors are modulated, greens for the exposed grass-covered surfaces and browns and blacks for earth and shaded areas (fig. 13).[34]

The reversion to schematic mountain forms in late ninth- and early tenth-century landscape painting (fig. 6) is thus an important stylistic phenomenon that needs to be explained. As we noted above, Chang Yen-yüan said that "in paintings of High Antiquity ... the drawing is simple ... [but] paintings of more recent times ... excel in [representational] completeness."[35] The retreat from naturalistic description in late ninth-century painting can be viewed either as a mannerist degeneration or as a cyclical return to archaic simplicity. Still a third possibility exists: the archaic schematic style was never completely replaced by naturalism during the eighth century; the flat, unmodulated mountain motif which survived as a *retardataire* style during the eighth simply reasserted itself toward the end of the ninth century.

Whatever the formal explanation for the early tenth-century schematic landscape style, the important fact is that the schematic mountain form with unmodulated, "iron-wire" outlines and solid bands of colors, known either as the "gold-and-green" (*chin-pi*) or the "blue-and-green" (*ch'ing-lü*) style, became a fixed archaistic and "primitive" idiom in subsequent centuries. Without referring to any specific ancient model, the schematic mountain motif denoted a primitive, archaic style. At the same time, in more

32. See Imperial Household Agency, *Treasures of the Shōsōin: The South Section* (Tokyo, 1961), no. 99.
33. *Ibid.*, no. 98.
34. See Matsumoto Eiichi, *Tonkō-ga no kenkyū* (Tokyo, 1937), pl. 79a.
35. See n. 2 above.

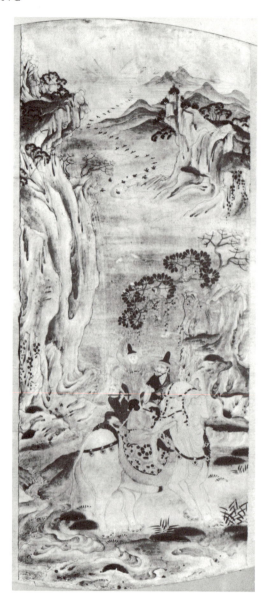

Figure 12. *Musicians Riding on an Elephant*, early 8th century, biwa plectrum guard, color on leather. Shōsōin, Nara, Japan. Reproduced from *Treasures of the Shōsōin: The South Section* (Tokyo: Asahi Publishing Company, 1961), pl. 98.

Figure 13. *Life of Buddha* (section), 9th century, color on silk banner, from Tun-huang. British Museum, London, reproduced by permission of the Trustees.

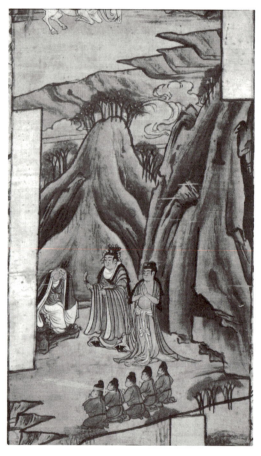

conservative media such as bas-relief or woodcut designs (figs. 9 and 14), it also served as a decorative idiom.[36] At the end of the Northern Sung period, in the early twelfth century, Chao Po-chü was known for his "blue-and-green" paintings, and at the end of the Southern Sung, in the late thirteenth century, Ch'ien Hsüan painted in a flat, schematic style (fig. 15).[37] In the Shōkokuji in Kyoto, a set of sixteen lohans by Lu Hsin-chung, a contemporary of Ch'ien Hsüan, also shows an exaggerated fondness for linear

36. For fig. 14, see Max Loehr, *Chinese Landscape Woodcuts* (Cambridge, Mass., 1968), pl. 2.

37. See Sherman Lee and Wai-Kam Ho, *Chinese Art under the Mongols* (Cleveland, 1968), no. 185.

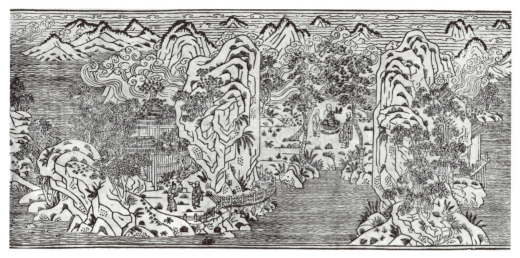

Figure 14. Detail of woodblock print from Sung Imperial commentary on the Chinese Tripitaka, edition of the late 10th century. Fogg Art Museum, Cambridge, Mass.; purchase, Daly, Higginson, and Hyatt Fund (1962.11 1–4).

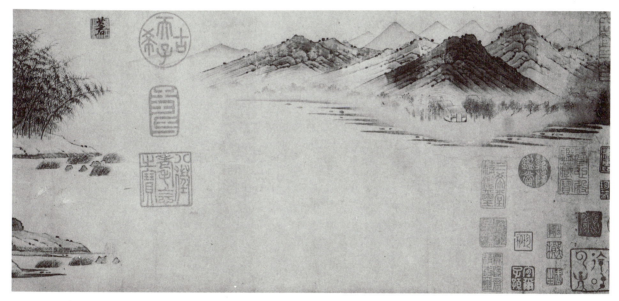

Figure 15. Ch'ien Hsüan, *Wang Hsi-chih Watching Geese* (detail), late 13th century, handscroll; ink, gold, and colors on paper. Metropolitan Museum of Art, New York, gift of the Dillon Fund (1973.120.6).

and schematic patterns (fig. 16).[38] Finally, at the end of the Ming dynasty, in the early seventeenth century, Ch'en Hung-shou (1598–1652) worked in a schematic archaistic idiom that strongly recalled Kuan-hsiu's figures (fig. 17).

A native of Chu-chi (near Shao-hsing), Chekiang, Ch'en Hung-shou was born into a distinguished family: his grandfather served as governor in both Kwangtung and Shensi. A child prodigy who, according to one biographer, painted a giant portrait on a wall at

38. See *Kokka*, vol. 22 (Tokyo, 1911), no. 255.

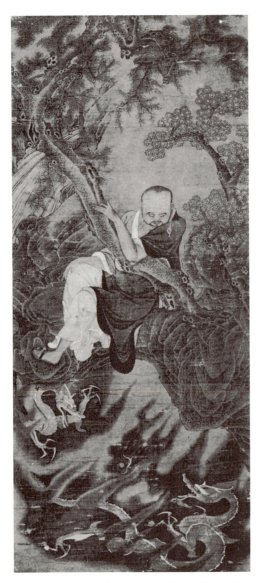

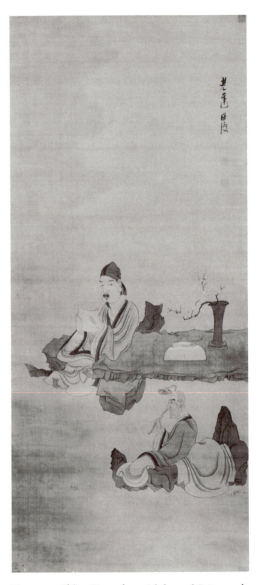

Figure 16. Lu Hsin-chung, *Sixteen Lohans*, late 13th century, one of a set of hanging scrolls, ink and colors on silk. Shōkokuji, Kyoto.

Figure 17. Ch'en Hung-shou, *Scholar and Priest*, early 17th century, hanging scroll, ink and color on silk. Anonymous loan, The Art Museum, Princeton University (L34.65).

the age of four, Ch'en's later life was marked by tragedies and disappointments.[39] He left home at an early age and eked out a meager living as a painter. Soon after his first wife died in 1623, he went north to the capital, Peking, to try his fortune, but he fell seriously ill and had to return south to Hangchow after a year. A failure at his secondary degree examination in 1630 left his life permanently scarred. He occupied the next ten

39. See Huang Yung-ch'üan, *Ch'en Hung-shou, Chung-kuo hua-chia ts'ung-shu* ser. (Shanghai, 1958), pp. 1–48, especially pp. 2–26; Tseng Yu-ho, "A Report on Ch'en Hung-shou," *Archives of the Chinese Art Society of America* 13 (1959): 75–88.

years mostly with wine, women, and his painting. In a final try at an official career, he went back to Peking in 1640 and joined the Imperial Academy (*kuo-tzu-chien*). Instead of receiving a government appointment, however, he was invited to the palace to make copies of old imperial portraits. When the position of a *kung-feng* (painter-in-waiting) was offered him, he declined it and returned south in 1643. When Peking fell to the bandits in 1644, the Ming pretenders in the south offered him various honorific titles, which he also refused. In 1646, after narrowly escaping capture by the Manchu army, he became a Buddhist monk. He died in 1652.

After the fall of the Ming dynasty in 1644, Ch'en Hung-shou styled himself Hui-ch'ih ("regret too late"). Lao-ch'ih ("the old belated"), Hui-seng ("the repentant monk"), or Fu-ch'ih ("do not be late"). Having been passed over by life—or so he felt—he knew only regrets and repentance. Before 1644, he regretted his career failures, his inability to contribute to the reform efforts at the court, and, having failed to achieve them, his ambitions to become a government official.[40] After 1644 he regretted that he had not died with the patriots at the time of dynastic catastrophe. He indulged in fits of weeping and drinking bouts in the company of courtesans, and behaved eccentrically.[41] But above all, he regretted that he had become, against his wishes, a professional painter—an occupation which in late Ming society was regarded as that of an artisan. He regretted being a painter at all.

The remarkable fact about Ch'en's art was indeed that it was able to draw from the traditions and forms of craft—woodblock illustrations, tapestries, lacquer and ceramic decorations—and, imbuing these forms with a new life and emotion, to turn them into a highly expressive style. A prolific book illustrator, Ch'en illustrated his first book at the age of eighteen, *The Nine Songs by Ch'ü Yüan*, which were published in Lai Ching-chih's *Ch'u-tz'u shu-chu* in 1638 (fig. 18).[42] The archaizing linear style showing figures and landscape elements in angular contours and parallel folds, which is well suited for woodblock cutting, became the hallmark of Ch'en's painting style. Unlike Wu Pin's (1573–1620) and Ting Yün-p'eng's (ca. 1584–1638) archaizing figures, which are more curious than powerful, Ch'en's are those of a superb cartoonist; they show not only a subtle eye for individual characterization but also an intense feeling for the subject. The tragic poet Ch'ü Yüan sauntering down the riverbank, a timeless portrait of the disappointed loyal minister, is a remarkable prefiguration of the future course of the young artist's own life. Around the age of ten, Ch'en studied flower and landscape painting with Lan Ying (1585–ca. 1600) in Hangchow. Although he generously acknowledged his debt not only to Lan Ying but also to Lu Chih (1496–1576), Ch'en was a major style-setter of his time.[43] His flower painting style was widely imitated in decorative carvings, lacquer, ceramic, and embroidery designs of the early Ch'ing period, and his figure and landscape paintings profoundly influenced the works of many leading Ch'ing "individualist" and "eccentric"

40. Huang, *Ch'en Hung-shou*, pp. 7–19.
41. *Ibid.*, pp. 20–24.
42. *Ibid.*, pp. 37–38.
43. *Ibid.*, pp. 43–44.

painters—Tao-chi (1641–ca. 1717), Chin Nung (1687–1764), Lo P'ing (1733–1799), and Jen I (1840–1896), to name only a few.

In theory, Ch'en Hung-shou openly disagreed with Ch'en Chi-ju (1558–1639) and Tung Ch'i-ch'ang (1555–1636), who preferred the free, kinesthetic brushwork of the Yüan painters to the more rigid outline drawings of the Sung period.[44] Tung Ch'i-ch'ang's

Figure 18. Ch'en Hung-shou, *The Poet Ch'ü Yüan*, 1638, woodblock print published in Lai Ching-chih's *Ch'u-tz'u shu-chu*. Reproduced from Cheng Chen-to, *Ch'u tz'u t'u* (Peking, 1953), p. 27b.

approach to painting, in the words of Wang Hui (1632–1717), was to "use the brushwork of the Yüan to move the peaks and valleys of the Sung."[45] Tung had divided the history of painting into "Northern" and "Southern" schools, insisting that the Northern school of Li Ssu-hsün's and Chao Po-chü's blue-and-green styles, executed in a fine and detailed manner, was followed only by academicians and professional painters, and that these

44. See Tseng Yu-ho, "Ch'en Hung-shou," p. 80.
45. See Wen Fong, "The Orthodox Master," *Art News Annual* 33 (1967): 133–39.

styles "were anything but what we [scholar-]painters should emulate."[46] To this Ch'en Hung-shou countered firmly: "In the painting of the Great and Small General Li [Ssu-hsün and Chao-tao], Li Ch'eng and Chao Po-chü, and others, even though there may be a thousand details of houses and people, a thousand peaks and ten thousand waters, every detail must have resonance and finesse. Only some people are unwilling to observe [their merits] and learn from them!"[47]

In life as well as in art, Ch'en Hung-shou and Tung Ch'i-ch'ang followed divergent courses. A successful scholar-official, Tung was a classical scholar, a learned calligrapher, and a great connoisseur and collector before he became a painter. As a calligrapher, he followed the orthodox manners of Chao Meng-fu and Yen Chen-ch'ing, which he improved by applying himself diligently to the study of the ultimate classic, Wang Hsi-chih. Through collecting and authenticating ancient paintings, he achieved profound insights into historical painting styles. His learned approach to ancient models amounted to what Mote calls a "revolutionary archaism"; it enabled him to make a clean break from the more recent past. In reaching back into the ancient roots of the Great Tradition, Tung Ch'i-ch'ang was able to mold its formal and spiritual components into a new creative synthesis (ta-ch'eng).

Ch'en Hung-shou, on the other hand, who failed as a scholar-official, refused to be an orthodox scholar. His prose and poetry, though poignant and bluntly expressive, were not considered refined in style.[48] His calligraphy was highly individualistic.[49] As a youth he once declared: "every student [of calligraphy] speaks of Chung Yu and Wang Hsi-chih. But whom did these ancient masters imitate?"[50] In Hangchow, young Ch'en Hung-shou copied many times the engraved designs, *Confucius and His Seventy-Two Disciples*, attributed to Li Kung-lin (fig. 19).[51] At Hangchow also were Kuan-hsiu's version of the lohans kept at the Sheng-yin-ssu (fig. 20), which undoubtedly also influenced him.[52] Likewise, he expressed a great admiration for Chou Fang and other T'ang figure painters. Yet unlike Tung, who studied ancient paintings analytically, Ch'en treated his models—many were engraved designs—merely as linear patterns which he amplified and transformed into new, expressive images (fig. 17). A true primitive, Ch'en had no scholarly interest in re-creating ancient models. His schematic archaistic style, employing an iron-wire technique that had a powerful rhythm of its own, was in fact a highly personal vocabulary for creating his unique images. His pupil Lu Hsin described his manner of painting as follows:

As he moves his brush to create a "plain outline drawing" [pai-miao], he does not use any preliminary sketch [fen-pen]. From top to bottom, with drapery folds wrapping

46. See Fong, "Tung Ch'i-ch'ang," p. 1.

47. Huang, *Ch'en Hung-shou*, p. 31.

48. *Ibid.*, p. 27.

49. See Tseng Yu-ho Ecke, *Chinese Calligraphy* (Philadelphia, 1971), no. 73.

50. Huang, *Ch'en Hung-shou*, p. 27.

51. *Ibid.*, p. 5.

52. *Ibid.*, p. 29. For Kuan-hsiu's *Lohans* at the Sheng-yin-ssu, see Fong, "Five Hundred Lohans," pp. 3off.

around [the figures], and frequently [in a scroll of] several tens of feet long, the painting is sketched in one long continuous brush movement without the slightest pause or hesitation. It is like the sea monster suddenly taking off by the wind, traveling for ten thousand miles. No one else can lay a hand on it.[53]

Above all, Ch'en Hung-shou was a consummate draftsman whose seemingly automatic and irrepressible iron-wire lines, while producing strangely distorted forms, never

Figure 19. Attributed to Li Kung-lin (probably Ma Ho-chih), *Confucius and His Seventy-Two Disciples*, 12th century, rubbing of stone engraving, Hangchow. Reproduced from Huang Yung-ch'üan, *Li Kung-lin sheng hsien t'u shih k'o* (Peking, 1963), pl. 60.

fail to endow these forms with a life and emotion of their own. Indeed, this great archaizing stylizer was ultimately a realist at heart. One observer has written the following:

> Around the long bridge at the [southern] bend of the Western Lake [in Hangchow], there are masses of morning glories. Every year, between late summer and early fall, when they are moist and overflowing, there is an especially mysterious flavor about them. When Ch'en Hung-shou was at Hangchow, he loved these flowers. Every morning at dawn, he would walk slowly along the long bridge, murmuring poetry and amusing himself around the bamboo fences [looking at these flowers], returning home only at sundown. I have seen an album of his paintings of morning glories, which are exquisitely beautiful. In particular, the colors are incomparable. Because of his true interest in these flowers, he was able to achieve a divine likeness [*shen-ssu*] in his paintings.[54]

53. Huang, *Ch'en Hung-shou*, p. 34.
54. *Ibid.*, p. 30.

"PRIMITIVISM" VS. "CLASSICISM"

In Tung Ch'i-ch'ang and Ch'en Hung-shou we find two contiguous modes of *fu-ku* or using the past, a "classical" and a "primitive" style. A classicist, Tung Ch'i-ch'ang successfully sought for a renewal in painting through a learned revival of ancient models: styles that had succeeded in the past were made to live again through the artist's personal *pien* or metamorphosis. Ch'en Hung-shou, on the other hand, adopted a consciously

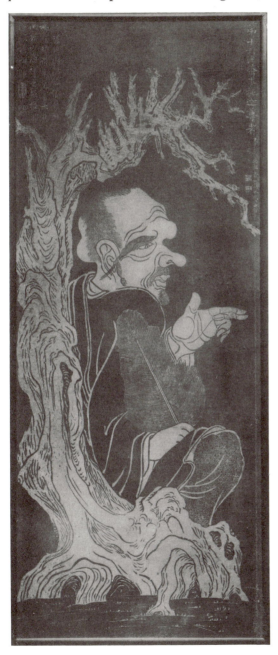

Figure 20. Attributed to Kuan-hsiu, *Sixteen Lohans* (detail), 880–894, rubbing of stone engraving, Sheng-yin-ssu, Hangchow. Reproduced from Tajima Shiichi, *Zengetsu-daishi juroku-rakan* (Tokyo: Shimbi Shoin, 1914), text p. 17.

exotic, primitive manner. His paintings were whimsical and iconoclastic; like Kuan-hsiu's, they were "new and strange" (*hsin-ch'i*) because they were "archaic and weird" (*ku-kuai*). Ch'en's strange figures with flowing beards and billowing costumes remind us of the early Ch'ing patriots who donned ancient fashions in order to escape wearing the Manchu dress and the hated Manchu queue. The linear, schematic idiom in painting, like an ancient costume, was donned to repudiate the present—to shock and amuse—and to evoke a nostalgia for the past without seriously trying to re-create it.

Throughout the history of Chinese painting primitive archaism has appeared as a counter-movement to classical reconstructions of the past, both recurring periodically as concurrent *fu-ku* impulses. Ch'en Hung-shou's relationship to Tung Ch'i-ch'ang seems comparable to Ch'ien Hsüan's to Chao Meng-fu, or Chao Po-chü's to Li Kung-lin. During times of change, while the more charismatic leaders such as Chao Meng-fu and Tung Ch'i-ch'ang re-created greatness through a critical study of the past, more reticent and introverted men such as Kuan-hsiu, Ch'ien Hsüan, and Ch'en Hung-shou retrenched, and escaped into a schematic, ideographic idiom. Psychologically, the schematic idiom seems to represent, for these painters, something primeval, archetypal, and permanent. It is perhaps no accident that schematic archaism flourished during almost every period of dynastic change since the T'ang—between the T'ang and the Sung, around 900, between the Northern and Southern Sung, around 1100, between the Southern Sung and the Yüan, around 1300, and between the Ming and the Ch'ing, around 1600.[55] These were times of national disaster in Chinese history, and while the great orthodox masters rallied to re-establish the Great Tradition, more retiring souls chose schematic archaism as a personal retreat or protest.

While it is interesting, on the one hand, to contrast Ch'en Hung-shou's primitive archaism with Tung Ch'i-ch'ang's classicism, and on the other, to compare Ch'en's paintings with Kuan-hsiu's, it is important that we are also able to describe the differences between Kuan-hsiu's and Ch'en Hung-shou's works (figs. 10 and 17). We must therefore come back to the problem of periodization of style. In a narrow sense, "period style" refers to formal features characterized within a developmental framework. Structurally, like all late Ming paintings Ch'en's stress surface pattern and two-dimensional movement; the features of his figures are deliberately distorted and exaggerated, and their flowing robes follow a calligraphic rhythm unrelated to the body underneath. This disregard for organic reality must distinguish Ch'en's figures from Kuan-hsiu's. In Kuan-hsiu's *Sixteen Lohans* in Tokyo (fig. 10) there are structurally ambiguous passages in the drawing, but these are explained by the fact that the present paintings are most certainly copies, perhaps several times removed from the original. Except for these confused areas, all these Kuan-hsiu figures are perfectly conceived from the representational point of

55. Only in the period of dynastic change between the Yüan and the Ming in the late fourteenth century did some form of schematic archaism not flourish. Perhaps this had to do with the feeling that the fall of the alien Mongol dynasty should be viewed as a moment of cultural restoration rather than disintegration.

view. They agree structurally with the early Sung lohan images at Tun-huang (fig. 7), which, despite their schematic styles, show organically well-conceived features typical of their time.

But in a broader sense, period styles must be seen in terms of a cultural history.[56] In order to understand Tung Ch'i-ch'ang and Ch'en Hung-shou, we must not only study their stylistic developments but also reconstruct their cultural contexts. If Tung's and Ch'en's new styles were results of their free choices, rather than inevitable products of their time, they were nevertheless based on certain familiar modes of thought, as well as on well-established stylistic conventions.

While repudiating the present was the strong emotion they shared, Tung's and Ch'en's different ways of drawing on the past were mutually intelligible to both. In copying ancient models, each in his own way, Tung and Ch'en articulated new meanings and uses of the past for their time. Understanding these uses of the past will enable us to gain important insights into the cultural history of the late Ming period.

56. Because of its Hegelian associations, the term *Kulturgeschichte* has fallen into disrepute in recent years. Yet the rejection of a holistic approach to cultural styles still leaves unresolved the very questions which the *Kulturgeschichter* and *Geistesgeschichter* sought to answer. If no culture can be described in its entirety, it remains clear that no aspect of culture can be understood in isolation. See E. H. Gombrich, *In Search of a Cultural History* (Oxford, 1969).

PART III
ORTHODOXY AND INDIVIDUALISM

TUNG CH'I-CH'ANG'S NEW ORTHODOXY AND THE SOUTHERN SCHOOL THEORY

Wai-kam Ho

The theory of the Southern and Northern schools is not a new topic in the history of Chinese painting. Its early definitions, the subsequent refinement of its content, and the significance of its far-reaching implications—all these have been well known to students. There remain, however, a number of questions which are either still unsettled or relatively unexplored. One of these is the problem of authorship, which we shall touch upon only briefly in this paper. The other, to be discussed in greater detail, is the historical background for the formulation of this theory in the early seventeenth century, and how it represented the triumphant emergence of a new orthodoxy in art that was partly built on the same theoretical foundation, with more or less the same material and tools, as the old authority it tore down and replaced.

There has been a near-consensus of opinion that the writings of Mo Shih-lung (1540?–1587?) and Tung Ch'i-ch'ang (1555–1636) on this issue had been intermingled—that the elder scholar with his *Hua-shuo* was the true originator of the theory, with Tung Ch'i-ch'ang merely amplifying it and molding it into a forceful and sophisticated system. Since Yü Shao-sung expressed this view in 1931, most scholars, from T'eng Ku in China to Yoshizawa Tadashi in Japan and Victoria Contag in Europe, seem to have accepted it. In recent years a few skeptics on the mainland like Ch'i-kung and Cheng Ping-shan have tried to reverse the verdict but have been unable to present decisive arguments. What is most amazing about this controversy is that the partisans of Mo Shih-lung never did really offer any evidence which is more than circumstantial, and they are truly not convincing.

To begin with, the *Pao-yen-t'ang pi-chi*, the collection in which Mo Shih-lung's *Hua-shuo* was supposedly first published, is a highly unreliable work. Although Ch'en Chi-ju (1558–1639), a close associate of Tung Ch'i-ch'ang, was nominally its editor, the compilation was actually done by a number of hired scholars and personal friends. Material for the collection came from many sources, the authenticity of attribution of some of which had never been tested. These included fragmentary manuscripts or handwritten copies contributed by private collectors from remote provinces, and possibly also works which

113

were added to the later printings after 1620 but which are taken as part of the original assemblage.

Without going into textual criticism at unwelcome length, it may be sufficient to call attention to an anthology of late Ming prose writings, *Mei-yu-ko wen-yü*, a work completed in 1627 by Cheng Ch'ao-tsung with express approval and encouragement from both Ch'en Chi-ju and Tung Ch'i-ch'ang. In this an essay of twelve (or thirteen) paragraphs, including all the crucial passages on the Southern and Northern school theory identical with Mo Shih-lung's *Hua-shuo*, was published under the authorship of Tung Ch'i-ch'ang with the title *Lun-hua so-yen* (*Miscellaneous Notes on Painting*)—a title given in a post-script to the essay by Tung Ch'i-ch'ang himself, who also recorded the occasion, possibly between 1593 and 1598, in which he discussed this essay with the famous connoisseur Wu Hung-yü.

It may be suggested that this essay might have been part of a larger collection of Tung Ch'i-ch'ang's notes on calligraphy and painting known as *Lai-chung-lou sui-pi*, which in turn constitutes one of the major sources for all other later compilations on the subject of art, including those incorporated in Tung Ch'i-ch'ang's collected works, the *Jung-t'ai-chi*. It should be pointed out that the three works mentioned above, the *Mei-yu-ko wen-yü*, the *Lai-chung-lou sui-pi*, and the *Collected Works* of Tung Ch'i-ch'ang, were all prefaced, and presumably read, by Ch'en Chi-ju. It would be rather fantastic to imply that Tung Ch'i-ch'ang, the undisputed dean of late Ming artists and critics, would have allowed himself to commit plagiarism knowingly and repeatedly, and that at least three times Ch'en Chi-ju would have chosen to ignore all these editorial oversights. What is more, this latter-day case of mistaken identity never seemed to have created a problem in Tung Ch'i-ch'ang's own time. Passages from *Lun-hua so-yen* and related works were freely cited as Tung Ch'i-ch'ang's by his late Ming contemporaries, such as Chou Liang-kung in his *Shu-ying* (*Shadow of Books*) or Ch'en Hung-hsü in his *Han-yeh-lu* (*Cold Evening's Notes*) or Wang K'o-yü in his *Shan-hu-wang hua-lu* (*The Coral Nets*). In these citations the name of Mo Shih-lung is not once mentioned or hinted at.

In short, I am inclined to take the other alternative offered by Yü Shao-sung for this problem. That is, Mo Shih-lung may (or may not) actually have written a treatise called *Hua-shuo*. If the treatise did exist, Ming scholars seemed to know nothing about it. In any case, the lost (or nonexistent) text was restored with Tung Ch'i-ch'ang's writing some-time in the early seventeenth century. This fooled even the very learned editors of the *Ssu-ku ch'üan-shu*, the imperial collection of the K'ang-hsi period, who happened to be less well informed in the field of painting. Thus, after three hundred years we still have a "headless" case in art history, as well as an injustice done to the founder of later Chinese art criticism.

The problem of authorship, if it may seem a trifle academic to some people, is historic-ally significant in that it not only testifies to the process of fermentation of a momen-tous theory but also helps to trace the origin and development of the thought of its creator. It is my conjecture that the theory of the Southern and Northern schools was

developed relatively late in Tung Ch'i-ch'ang's career—probably not earlier than 1588. At the beginning, and perhaps during most of his life, Tung Ch'i-ch'ang was correctly more concerned with the larger problem of the literati and the academic (amateur and professional, *li-chia* and *hang-chia*, etc.) rather than with Southern and Northern paintings. He apparently had difficulties in justifying the Southern and Northern distinction and made it amply clear that in his theory the geographical origin of the artists was not taken into account. This was, in effect, a reiteration of the Southern Sung concept: "The division of south and north is applicable only to geography but not to people, nor should it be applied to the 'legitimate line of succession in Confucian thought' [*tao-t'ung*] or to 'the lineage in literature' [*wen-mo*]."

But geographical diversities did count in Chinese history in such matters as religious schisms or art traditions. The Southern and Northern schools of Ch'an Buddhism and Taoism were based originally on geographical divisions. The same geographical factor had an important role in the development of Sung painting, as most Sung critics (Kuo Hsi, Han Cho, Li Ch'eng-sou) recognized the significant differences between the Southern and Northern landscapes. Indeed, the Southern and Northern concept had been so deeply rooted in Chinese cultural history since the Six Dynasties that Tung Ch'i-ch'ang could hardly claim to be the first critic who made the distinction. In art history, Yüan Hao-wen (1190–1257), the great poet of the Chin dynasty, probably should be credited with the earliest adaptation of this term when he spoke of the nine masters of cursive script in the Northern school of calligraphy. In the early Ming, almost two centuries before the time of Tung Ch'i-ch'ang, the poet-painter Tu Ch'iung (1396–1474), a teacher of Shen Chou, classified landscape painting in two opposing traditions, the ink monochrome school of Wang Wei and the "gold-and-blue" school of Li Ssu-hsün, a scheme so remarkably reminiscent of Tung Ch'i-ch'ang's that one cannot help wondering whether the resemblance is more than coincidental.

Indeed, in choosing Wang Wei to be the founder of the Southern and literati school, Tung Ch'i-ch'ang had his own good reasons, and most later critics, including some modern Japanese scholars, seem to have missed most of his points. Admittedly the designation is an entirely arbitrary one from a purely art-historical point of view. It does, nevertheless, reveal a deep historical insight that goes beyond mere considerations of style and technique to reach the very heart of a cultural ideal inseparable from aesthetic and moral criteria for later Chinese art and art criticism. The middle of the eighth century was a turning point in Chinese social history, as the new literati class coming from the landed gentry gradually began to displace the aristocratic families from their dominant hereditary position. In the person of Wang Wei, Tung Ch'i-ch'ang found a man who combined the best qualities of both groups: a gentleman of high birth and social as well as political eminence, a great creative genius foremost in both painting and poetry, and a retiring intellectual able to reconcile Confucian principles with Buddhist philosophy. Even more important, the middle T'ang was an age of literary and artistic renaissance, in the sense that the Southern tradition of the Six Dynasties was being

revived, and Wang Wei symbolized this nostalgic spiritual return to a medieval national heritage amid an influx of alien influences. This renaissance was partly a result of the success of the Chinese in integrating Ch'an Buddhism with the immediacy and sensitivity of their aesthetic of daily life; and Wang Wei, again, was deemed best qualified to represent this transition. In other words, to elevate Wang Wei, who did not enjoy his exalted position among literati until the twelfth century, was to uphold the literary ideal of the middle and late T'ang against the tyrannical early and high T'ang style, the Southern culture of the Six Dynasties against the stiffer, formalistic Northern tradition, and the spontaneous Southern school against the Northern school of Ch'an Buddhism and all that which it implied. It was part of a grand design with which Tung Ch'i-ch'ang was able to establish his new orthodoxy in art, a common scheme used by both revivalists and anti-revivalists in the Ming period, as we shall see.

But Wang Wei and many of his alleged followers, like Kuan T'ung and Li Ch'eng, still posed a tricky problem: they were not Southerners. In order to identify and combine his literati school with the Southern school, Tung Ch'i-ch'ang had to resolve this geographical dilemma. He found the solution outside the realm of formal art, in the basic difference of approach toward enlightenment which separates the Southern and Northern traditions of Ch'an Buddhism. It was on the basis of these seemingly opposing doctrines of *tun-wu* ("sudden awakening") and *chien-wu* ("gradual awakening") that he was able to develop a logically defensible thesis of the Southern and Northern schools of Chinese painting. It must be remembered that this concept of *tun-wu* was nothing new in the seventeenth century but that it was indeed fundamental to and inseparable from the evolution of literary criticism throughout the Ming period. It directly derived from the celebrated "Primary Principle" (*ti-i i*) trumpeted by the Southern Sung critic Yen Yü, and the Primary Principle was, beyond any doubt, the most important, the most universally revered critical criterion for the whole orthodox movement of the "classical revival" in the Ming period. This must be fully understood before it is possible to trace the establishment and development of orthodoxy in Ming literature and art.

One may well wonder at this point why the problem of *cheng-t'ung* ("legitimate line of succession") should have been so stressed among the Ming people. It was of course originally a historical problem of dynastic legitimacy, which became particularly sensitive during a period of foreign rule (e.g., the Yüan) or after the restoration of a Chinese state (e.g., the Ming). At such times the issue of orthodoxy was broadened and sharpened by similar obsessions with religious and ideological matters, from the lineage of doctrinal transmission in Ch'an Buddhism to the ideological rivalry in Neo-Confucianism. This clannish spirit seems to be strangely consistent with the Ming temperament, which manifested an uncompromising attitude whenever the question of sectarianism was involved. This dogmatic tendency was especially conspicuous in the writings of the chief advocates of the classical revival, who were collectively known as the Former Seven Masters and the Later Seven Masters. Most of these people, in contrast to many of their unofficial critics, had been successful in government service and were joined together

not only ideologically but also more or less politically. One interesting fact hitherto unnoticed that could be of some significance is that these partisans of restorationism were concentrated in one single government department, the Ministry of Justice. Under the leadership and the great prestige of Wang Shih-chen (1526–1590), who was president of the Southern Board of Justice and at the same time the grand patriarch of the late Ming literary circle, the ministry had become, if one may be excused for a slight exaggeration, the official arbiter of taste, a sort of high court for literary orthodoxy in the second half of the sixteenth century.

As has been demonstrated time and again, art criticism in China has always been closely linked to its sister disciplines, music, calligraphy, and literature in particular. In Ming literature, historians often spoke of two crucial turning points which fall in, respectively, the second half of the Chia-ching reign (ca. 1540) and the second half of the Wan-li reign (ca. 1600). Ming literature is thus roughly divided into three major periods. In the early Ming, up to the end of Ch'eng-hua (1465–1487), when the Wu and Che schools of painting were in the prime of their youth and Shen Chou (1427–1509) and Wu Wei (1458–1508) were still active, the trend in literature was primarily a continuation of Sung and Yüan traditions, without any set orientation. No single authority was universally accepted. The first wave of the classical revival swept the country around 1500: some of its basic principles were firmly established by Li Meng-yang (1427–1529) and his sometime supporter Ho Ching-ming (1483–1521), both precursors of the Later Seven Masters. In Neo-Confucianism, the philosophy of Ch'eng I and Chu Hsi had been securely enshrined as the officially sanctioned interpretation for classical studies. In literature, the Ch'in-Han period was singled out as the only acceptable model for prose writing, and the high T'ang (*sheng-T'ang*) style was revered as the summit of achievement in poetry. With little modification these remained the basic standards for orthodox literature before the Lung-ch'ing–Wan-li period.

It is to be noted that whenever the topic of orthodoxy is in question, one is expected to be specific with his identification of the historical context. A principle of authority does not stand forever, or remain always the same. It changes in accordance with the needs and aspirations of a given age or society. That is why a full recognition of the factor of "change" has been a prerequisite for the rise of any revivalism. In the case of the Ming, the evolutionary view of literary styles was shared by most major critics and was strongly reflected in art criticism, from Sung Lien to Tung Ch'i-ch'ang. According to this view, the emphasis must be placed first on the periodic preference for genres. A certain period excels in a certain genre (*t'i-chih*). When most of its possibilities have been exhausted or the best of its pattern has been fulfilled, a change is called for. The same rule is applied to the changes of styles within a genre, such as Tu Fu's "regulated verse" or Li Ch'eng's wintry landscape. This having been granted, the natural next step is to move directly to the problem of periodization. Kao T'ing-li (1350–1423), an early Ming poet from Fukien, made the first important attempt at a critical periodization of T'ang poetry and laid down a chronological framework for the revivalist theories of the next

117

centuries. On the basis of his sequence, the high T'ang style, the second stage of a four-staged evolution, had now come to be considered the "orthodox tradition" (cheng-tsung) in poetry, while the others (the middle and late T'ang styles) became merely "lingering echoes" (yü-hsiang). With the supreme level of attainment generally accepted, it was now possible to identify high T'ang poetry or its equivalent—Sung painting, for instance—with Yen Yü's Primary Principle, which means a spontaneous and complete enlightenment. This was *tun-wu* ("sudden awakening") or *miao-wu* ("wondrous awakening"), achieved only through innate gifts and intuition, as compared to the "lesser vehicles" (*hsia-ch'eng*) that must depend on accumulated knowledge, skills, and efforts. Students therefore must "model after the highest so as to attain at least the intermediate." Without this direct penetration into the Primary Principle, the "correct Dharma Eye," one would be able to achieve only the superficial, the secondary, and might possibly get lost in a "wild fox's meditation" (*yeh-hu shan*). It is interesting to note how this same Primary Principle of Yen Yü was used by the sixteenth-century revivalists to set a standard of excellence and a criterion for quality, while in the hands of Tung Ch'i-ch'ang and the followers of his new orthodoxy it became a way of approach, a creative attitude, and an artistic attitude leading to self-realization. This change in meaning also holds one of the keys for the problems of "form likeness" (*hsing-se*) against "spirit harmony" (*ch'i-yün*) or Sung painting against Yüan painting. One can hardly overstress its significance.

But an even more fundamental difference which set Tung Ch'i-ch'ang and the Seven Masters apart is found in the Masters' ideal of an artist in relation to his subjects, which leads to a polarity between self and "things," man and nature.

FA ("RULE") AND *YÜ* ("ENCOUNTER")

The revivalists of the sixteenth century encouraged imitation, believing in the omnipresence of rules in everything. Rules in literature were compared to the rulers and compass which produce all the variations of squares and circles. They were the self-regulating disciplines of all forms. To study the rules of the old masters, therefore, meant to study the self-governing rules of the objects properly represented. In such studies, the artist's sensibility is activated by the encounter with the object. They meet each other halfway. The resultant harmony seems to be compatible with the idea of wondrous awakening of the Primary Principle, and yet it remains dualistic.

I ("DISSIMILARITY") AND *T'UNG* ("SIMILARITY")

Since rules exist wherever there are things, similarities must also exist wherever there are dissimilarities. To be able to see only the importance of being different and to condemn all imitations as mere shadows of the old masters is no less mistaken than to depart from rules and reality ("form likeness") and boast of being the one "who abandons his raft and comes to land," an obvious allusion to the fantastic and eccentric school.

HO ("CONFORMITY") AND LI ("DETACHMENT")

Because the universal and the typical were emphasized ahead of the individual, the importance of method (or rule) was stressed. Originality had no conflict with method. Instead, it was the outgrowth of the mastery of method. Accordingly "even a great master of painting must start from imitation. In time there will come virtuosity, with virtuosity will come spontaneity. Once [the method] is mastered and digested by the painter, he can go in [ju] or out [ch'u] of the method at will with his own variations, and can be completely free from his models." This is the passage from conformity to detachment. An artist may depart from his model in style (t'i or ko) but conform in spirit (i), or vice versa. The ultimate is the subtle and unobstructed state which completely transcends all self-consciousness. It is described as "nonconformity and non-detachment" (pu-chi pu-li) and no longer seems to be distinguishable from Yen Yü's ideal of "inspired harmony"—the central thought of Wang Yü-yang's school of literary criticism, which dominated the second half of the seventeenth century.

CHENG ("ORTHODOXY") AND PIEN ("TRANSFORMATION")

This leads us to the final realization of the sixteenth-century orthodoxy. The Ming literati tried to introduce reforms through a "return to the past" (fu-ku). They argued that transformation and revival were the same thing, since either deviation from or conformity to the orthodox necessarily implies change, and that orthodoxy was no more than an organic synthesis embodying the self-regulating, self-renewing "laws" (fa) innate to all things. Hence one conforms only to the laws, and is transformed only upon the attainment of an intuitive understanding. In the words of Hu Ying-lin, a staunch follower of Wang Shih-chen, "Mere conformity to the laws without intuitive understanding is like the novice bound by monastic rules, and intuitive understanding not based on laws results in the false enlightenment of the heretics or the wild foxes." With this unification of laws and intuition, sixteenth-century orthodox artists found themselves moving from the theoretical ground of "formal regulation" (ko-tiao) ever closer to the concept of "inspired harmony" (shen-yün). Again, in a well-known metaphor of Hu Ying-lin, formal regulations are water and mirror, while inspired harmony is flower and moon: "The images of the flowers and moon can come out pure and brilliant only when the water and mirror are clear." In other words, formal regulations must come ahead of inspired harmony, method ahead of intuition, conformity ahead of deviation, and orthodoxy ahead of evolution.

As long as the sixteenth-century revivalists saw inner logic (fa) and rationality (li) in all existence in the real world, their conception of knowledge and ultimate enlightenment had to be based on the investigation of things (ko-wu). Similarly, since the supreme aesthetic quality of inspired harmony was to be found within the form likeness of reality and not outside it, the highest level of artistic achievement must be the "inspired" (shen-p'in) and not the "untrammeled" or "transcendental" class (i-p'in). When Chinese

painting was appraised from this standpoint as a parallel development of the Sung Neo-Confucianism of the Ch'eng-Chu school, the Sung tradition was logically and inevitably regarded as the orthodox; and the mantle was passed on to the Che school, which was considered the direct successor of the Southern Sung. This was the core of Wang Shih-chen's view of Chinese painting history, manifested explicitly in his many colophons and summed up in his early notes on the arts, the *I-yüan chih-yen*, and was that of his followers (e.g., Li K'ai-hsien).

After the death of Li P'an-lung (1514–1570), Wang Shih-chen became the un-contested leader of the Ming intelligentsia. He was said to have been at the helm of the literary circle for more than twenty years: no scholar in the land could hope to establish himself without Wang's sponsorship. While this position of domination commanded a tremendous nationwide following, it also provoked violent reactions from different directions. In the twilight of the sixteenth century, or toward the end of the Wan-li period, Wang Shih-chen and the Seven Masters came under the frontal attack of the Kung-an school, spearheaded by the three Yüan brothers from Hunan. The revivalist positions in literature and art were openly questioned and criticized. The better products of the movement were ridiculed for being constricted by rules and stereotypes, like "birds flying with broken wings"; its inferior works were simply dismissed as laughable imitations, "old women, heavily powdered and flirts." In this determined assault on the literary establishment, the middle T'ang style in poetry represented by Po Chü-i and Yüan Chen was raised from oblivion by Yüan Hung-tao (Chung-lang, 1568–1610) and his followers to challenge the authority of the high T'ang style, just as Yüan painting was brought forward to challenge the supremacy of Sung.

Before we return to the confrontation of Sung and Yüan, I must hasten to remark that the rise of Yüan painting in progressive stages represents a great transfiguration among the many-splendored faces of Ming art, especially in the domains of aesthetic judgement, art theory, and popular taste, for in the circle of Shen Chou and Wen Cheng-ming, Yüan painting was only a major part of the artistic heritage which they accepted, utilized, and developed. There was no implication of any historical and theoretical problems. Even to the anti-revivalists such as the three Yüan brothers, Yüan painting was no more than a reflection of their demand for an independent and honest self-expression, an emancipation of individual vision. But in the hands of the anti-orthodox, it became a means to realize a different kind of revival through change (*i pien wei fu*), a logical basis for the creation of a new orthodoxy through the process of assimilation and metamorphosis. It was at this critical point of transition, in this historical moment, that Tung Ch'i-ch'ang entered the picture with his remarkable insight and creative genius to begin his historical journey to a new chapter of Chinese painting.

One must remember first of all that Tung Ch'i-ch'ang, unlike the Kung-an school, never opposed the idea of a return to the past. But at the same time he was deeply influenced by the leading figures of the anti-revivalism in the Kung-an school. This crucial fact seems to have been so far neglected by most historians. It might also be

pointed out in passing that the undeniable impact of the Kung-an school and its immediate offshoot, the Ching-ling school, upon the individualist painters of the late Ming period is another important topic that has so far escaped our attention. In discussing the ideological background of Tung Ch'i-ch'ang, therefore, it is necessary to emphasize his close personal relationship with the Yüan brothers as well as the common interest which brought them together. These binding factors include, first, the study and practice of Ch'an Buddhism, and second, the admiration for Li Chih as an individualistic freethinker and for the T'ai-chou school of Neo-Confucianism as a whole.

In the Wan-li period, philosophical eclecticism was prevalent. The rejuvenation of Ch'an Buddhism and the new direction given by Wang Yang-ming (1472–1528) to Neo-Confucian thinking had brought a breath of fresh air to the late Ming society. Tung Ch'i-ch'ang and the Yüan brothers were typical products of this age. According to Ch'en Chi-ju's prefaces to the *Lai-chung-lou sui-pi* and *Jung-t'ai chi*, Tung Ch'i-ch'ang seems to have cultivated a historical sense of mission early in his life. Despite the advice of some of his close friends, he had doggedly refused to climb aboard the bandwagon of Wang Shih-chen, that center of power and prestige. He seems to have always cherished the ambition to carry on the great local art tradition of Sung-chiang (where he lived as a youth) so splendidly established by Chao Meng-fu, Huang Kung-wang, Ni Tsan, and Ts'ao Chih-po, and to follow in their footsteps to bring about great changes in calligraphy and painting. He began to study calligraphy at the early age of seventeen (1572) and painting at twenty-two (1577). It was in these years, when he was still a young student at the prefectural school, that he came under the spell of the teaching of the Ch'an priest Ta-kuan (Tzu-pai Chen-k'o, 1543–1603) and began to study Ch'an Buddhism seriously.

From 1588 on, his friendship with the Yüan brothers appears to have been based on their shared enthusiasm for literature, art, and religion. During the years from 1594 to 1598, when Tung Ch'i-ch'ang was serving in the Peking government, they had regular meetings in the Grape Club (*P'u-t'ao she*), which was almost entirely devoted to Ch'an meditation and discussion. In these meetings not only the problem of sudden enlightenment of the Southern school but also the thinking of their mutual friend Li Chih must have been frequent topics for discussion. The members of this very exclusive club never tried to hide their admiration for Li Chih, the outspoken arch-iconoclast of the Ming period. There can be little doubt that Li Chih, with his public defiance of the Confucian Classics, his repudiation of most traditional standards of value, his equal acceptance of "three religions," and his belief in the innate perfection of an individual's "child-mind," had been largely responsible for the rebellious and uncompromising attitude of the Yüan brothers toward established authority in literature and art; and this in turn must have impressed Tung Ch'i-ch'ang profoundly.

The main thesis of the Kung-an school can be summed up in a few words: for intrinsic quality, truthfulness (*chen*) was demanded against the false and the insincere; hence imitation was to be detested. For external expression, eccentricity (*ch'i*) was preferred over the familiar and the conventional; therefore any fixed formula was to be avoided.

An artist was obligated to be truthful to his object, to his own time and surroundings, and above all to his own "mind." In the words of Yüan Hung-tao, "A good painter learns from his object and not from people; a good scholar learns from his own mind and not from the 'Tao'; a good poet learns from the myriad forms of nature and not from the ancient masters." This essentially agrees with the views of Tung Ch'i-ch'ang, who put them in a milder way: "A painter who models after the ancient masters is on the right track. But to advance himself he must model after the heaven and earth."

"To model after the heaven and earth"—does this not mean imitation of nature? Evidently the answer is not so simple. Superficially Tung Ch'i-ch'ang may look as if he had merely revised the method of Wang Shih-chen and his fellow revivalists, moving a step forward from the "the imitation of old masters" to "the imitation of nature." In actuality Tung Ch'i-ch'ang's proposal suggested a clear break from the dualistic thinking of the sixteenth century. One must trace his idea from Li Chih to the philosophical fountainhead of the whole T'ai-chou school, the metaphysics of Lu Hsiang-shan and Wang Yang-ming. According to this school of Neo-Confucianism, the universe exists only in one's mind, and since there is no reality outside the mind, to learn from nature means to learn from one's own mind. Similarly, all the truth in the classics exists only in one's mind, and since there is no law or method outside the mind, to return to the past is to return to one's own mind. Realism in art had no meaning whatsoever unless it was understood as a projection of the artist's own mind-image. Consequently, one did not simply imitate nature or the old masters. One reconstructed or remodeled the laws of nature or the old masters in accordance with one's own free will (shuo-i). This leads us to the differentiation between two types of art suggested by Tung Ch'i-ch'ang. As he said, "the Way of painting is to be found in the painter who controls the universe in his own hands. Wherever he looks he sees life, or the motivation for life." And "as for those who meticulously and carefully delineate, they can only be the slaves of nature." The distinction, obviously, is one between the master and the slave. The only way to win complete freedom from the bondage of objective phenomena or the limitation of tradition was to become the master of their laws. Once this was achieved through the "sudden awakening" to one's innate perception and sensibility, the barrier between imitation and originality disappeared. This process is described in a Ch'an metaphor: "to break up the bones and to return them to one's father or to cut off the flesh and to return it to one's mother." In this way the artist was free from all dependence and, above all, from derivations.

When painting was approached with such a subjective, transcendental attitude, the creative process itself, and not the end product, became first in importance. Art was a form of self-realization; and since brush and ink work were the most direct and effective intermediaries for self-expression, they were accorded primacy over other formal and pictorial elements such as composition. This was explained in a pragmatic way by Tung Ch'i-ch'ang: "painting is no equal to mountains and water for the wonder of scenery; but mountain and water are no equal to painting for the sheer

marvels of brush and ink." A painter does not and need not compete with nature for grandeur of design, but he should surpass nature with the expressive and structural power of his brush and ink work. Following the same line of reasoning, Tung Ch'i-ch'ang arrived at another inevitable conclusion that the basic purpose of literati painting, a precedent for which he credited Huang Kung-wang, was to "take refuge in painting, and to take pleasure in painting." And a large part of the pleasure, let us repeat, came from the creative process, not the finished work.

The assignment of such unusual significance to the process of expression and communication also had its philosophical basis in the T'ai-chou school of Neo-Confucianism. Ho Hsin-yin (alias Liang Ju-yüan, 1517–1579), another famous rebel from that school, provided an eloquent major premise for the expressionistic aspect of literati painting. From his somewhat mystic point of departure, Ho Hsin-yin started out by rejecting all distinctions among the so-called five categories of *Hung-fan* (*Hung-fan wu-shih*), namely, appearance (form), utterance (sound), seeing, hearing, and thinking (*mao, yen, shih, t'ing, ssu*). He came to the conclusion that these evolved simultaneously and existed concurrently. Their relationships, such as those between forms and the sense of sight or sounds and the sense of hearing, was one of concomitant happening which excludes any sequence of time or events. As there was no form before we see it, it followed that a form would emerge only in the way that we see it. By extension, reality as such in the visual arts had no meaning whatsoever unless it was conceived exactly as we perceive it. The moment of truth, in other words, came at the instant of communication and interaction between the painter and his subject, or, to be more precise, at the instant of the formation and projection of the painter's mind-image. A painter was thus completely free to do whatever he pleased with nature or the old masters. The process of his creation or reconstruction was theoretically identified with the process of his self-expression. A painter like Huang Kung-wang was thus able to "take pleasure" in his life- and form-giving power and to "take refuge" in his unbounded spiritual freedom. This, according to Tung Ch'i-ch'ang, was the literati's approach to painting. It was one of the key arguments with which the advocate of Yüan orthodoxy could claim independence and even superiority over Sung painting. It was in this way, and in other ways we have already outlined, that the Lu Hsiang-shan, Wang Yang-ming, Ho Hsin-yin, and Li Chih school was able to sidestep the pitfalls of the dualistic thinking of the Ming revivalists and to show their critics a direct, workable shortcut to the Primary Principle for a wondrous awakening.

But this is also about as far as Tung Ch'i-ch'ang and his friends the three Yüan brothers and their Kung-an followers could go together. Once this point was passed, when the problem of the actual execution of an art work was involved, their paths had to diverge. Why? Because the Kung-an school had a vision of a new horizon but lacked the ability to move toward it. In their zealous struggle against the main force of the revivalist movement, the worst of its partisans tended to be extreme and excessive. They in turn were labeled the decadent and the misled, artists who "had mistaken vulgarity for lucidity, and artificiality for ingenuity." One familiar line of criticism is epitomized in the words

of the late Ming–early Ch'ing scholar Ch'ien Ch'ien-i (1582–1644): "In the past everybody was discerning enough to disdain the epidemic of literacy piracy and burglary. Since then scholars seem to have been groping in the dark and going backward in a turn for the worse. They could be compared with people who, disgusted by the false look of funerary statues, took phantoms and ghosts for real." Phantoms and ghosts (*wang-liang kuei-mei*)—this was probably the evaluation of some avant-garde painters, the fantastics and eccentrics, by the orthodox of the late Ming. These individualist painters were well aware of the precariousness of their position, however. They used to apologize that "the tendency toward caricature is the result of over-reaction against the other extreme; to achieve a new form of balance, one has to go along with the slanting and the asymmetrical. Just as one cannot expect a smooth surface on a wide river, so there must be superfluous branches in a deep forest." Unfortunately, being few in number, these gifted individualists were like "the water in a bowl, which is hardly sufficient to churn up a wave of any respectable height and only becomes a laughing stock to the god of the river."

Decadent (*mo-hsüeh*), vulgar (*pi-li*), artificial (*tu-chuan*), shallow (*pi-tse*), and prejudiced (*p'i-chien*)—such were some of the most common derogatory words heaped upon the Kung-an–Ching-ling schools, and by association also upon some of the individualist painters. These criticisms, however severe, were in fact not nearly as hard-hitting and devastating as one remark made by Yüan Hung-tao himself, which may well be the best self-appraisal of the anti-revivalist movement: "to imitate and lose is certainly not as good as to do the opposite and win; one does the opposite so as to imitate!" Now the notion of two facets of imitation, the positive and the negative, is nothing really new in Western literary criticism. To cite just a few of the definitions quoted by Ch'ien Chung-shu in his *T'an-i-lu*, "the most fatal plagiarism" is that "whose originality consists of reversing well-known models" (Dobell) or "to do the opposite is also a mode of imitation" (Lichtenberg). One has the curious feeling that this same issue of "contra-imitation" is perfectly applicable to the situation in the late Ming period.

Tung Ch'i-ch'ang must have realized that his best way out of the conflict between the revivalists and the anti-revivalists would be to steer a middle course combining the best of the two traditions. After all, as we have emphasized before, he had never opposed the idea of a "return to the past." Nor had he opposed imitation, except that his idea of imitation was somewhat comparable to that of Chou Liang-kung or Ch'en Hung-shou: "the imitation of the ancients is like the longing for a good friend who is far away—one can meet him in a dream [i.e., in spirit] but one should not make him appear in broad daylight [i.e., in the flesh]." If Tung Ch'i-ch'ang had shown disapproval of the Southern Sung and the Che school, his purpose was to upgrade Yüan painting and its spiritual and stylistic mentors Tung Yüan and Chü-jan. If he lent his reputation to the rebellion against the orthodoxy of Wang Shih-chen and Li P'an-lung, his purpose was not to be destructive, but to establish a new orthodoxy of his own. When he began to construct his own painting theory, his original concern was with the distinction between the literati

and the professional, or, on the highest level, between "paintings by intuition" (*shuo-i*; "to follow the idea wherever it goes") and "paintings by design" (*tso-i*; "to make up and build up an idea from without"). Although admittedly the paths leading to these two goals often crossed, he somehow succeeded in giving his basic outlook a logical and conceptual unity by the subjective idealism of Wang Yang-ming and Ho Hsin-yin. On the other hand, in order to bridge the arbitrary chasm between Sung and Yüan, and to give historical continuity and credentials to his literati and Southern school theory, Tung Ch'i-ch'ang simply took over Yen Yü's Primary Principle from the hands of the Seven Masters and reinforced it with his own considerable perception of the *tun-wu* thesis of Ch'an Buddhism. But sudden attainment is, after all, like playing a "lute with no strings" (*wu-hsüan ch'in*)—one could perhaps reach musical heights occasionally in a flight of fantasy, but to translate this into tangible artistic reality is an entirely different matter. What then, could possibly be the answer to this theory-and-practice question?

One of the most plausible clues is found in Tung Ch'i-ch'ang's high esteem for the artistic value of *shih-wen*, "contemporary-style prose writing," better known as the "eight-legged essay," the relative mastery of which determined to a large extent a scholar's success or failure in the civil service examination. This was again one of the important views shared by Tung Ch'i-Ch'ang and the three Yüan brothers. It is indeed fascinating that the most vigorous defense of *shih-wen* should have come from the most unlikely source, the most rebellious faction of late Ming society—the anti-revivalists and the individualists, who somehow saw in *shih-wen* true aesthetic merits despite its admitted fallacies and defects. In a candid criticism of Wang Shih-chen's negative view of the interrelation between poetry and *shih-wen*, Tung Ch'i-ch'ang made this thought-provoking comment: "the secret of the art of prose writing was never revealed until our times. All its major principles, such as the striving for emancipation from attachment and restrictions, opposition to the conventional and the commonplace, alertness against falling into the trap of language, are nothing but the same as the art of poetry." Now it is well known that the eight-legged essay was one of the most tightly regulated literary forms ever devised by the Chinese. Within its extremely rigid, elaborate, and modified triadic form, the artistic skill and ingenuity of the writer were taxed to the utmost as he developed his theme on some of the most repetitious and trivial Confucian subjects. "A lion jumping on a rabbit with all his might"—the eight-legged essay was indeed an ironic repudiation of the aesthetic principle of minimum consumption of energy. Then why, of all possibilities, was it singled out to provide the cue for a solution to the "theory and practice" problem in painting? Could it be that as early as the seventeenth century a generation of the new orthodox had anticipated the neo-classicist declaration, "art is born in bondage, lives in struggle, and dies in freedom"?

The answer seems to lie in the fact that the basic literary value of *shih-wen* derived not from its substance but from its methodology, its unification of the two seemingly opposite concepts of "rule" (*fa*) and "change" (*pien*). *Shih-wen* was born in rules, un-changeable rules, and was reborn in stylistic changes, self-renewing changes. The

vitality of *shih-wen* depended almost entirely on the constant transfiguration of its style. One therefore always spoke of *shih-wen* in terms of the prevailing style of a certain individual or the prevailing style of a certain reign, a certain decade, or even a certain year—hence the name, "contemporary-style" or "period-style" prose writing. If we return to landscape painting and say that the rule of the mountain is its unchangeable status quo and the rule of the water its ever-changing fluidity, and if we say that the static principle is to be completed by the dynamic principle, then the ultimate rule of *shih-wen* was similarly to be understood in terms of the perpetual transformation of its style. In a mock confession of his inability to espouse one single style and his irrepressible desire for changes, Tung Ch'i-ch'ang quoted the celebrated line from Lu Chi's *Wen fu* (a rhymed-prose essay on literature) as the guiding principle for the art of his calligraphy: "He spurns the morning blossom, now full-blown; he plucks the evening buds, which have yet to open." This uniting of the concepts of rules and changes again suggests a reconciliation of "formal regulation" and "inspired harmony" which is comparable to the goal of the classical revivalists. But while these remained abstract criteria in the sixteenth century, they were made tangible and accessible in the seventeenth. The key to the difference lies in the choice of models.

As we have discussed in the foregoing, the sixteenth-century revivalists emphasized the omnipresence and importance of rules. And yet, in the case of prose writing, these were the rules of the Ch'in-Han period, rules that had been obscured and rendered unintelligible because they were expressed in obsolete ancient language. The practical remedy, obviously was to look for literary models of a later period whose languages were more modern and whose styles were better suited for formal analysis. These models were handy in the prose works of the T'ang-Sung period, and their structural and rhythmical patterns were studied, abstracted, and refined by such master essayists as T'ang Shun-chih and Kuei Yu-kuang, who successfully applied them in creating their personal styles in *shih-wen*. The situation was similar in painting. It can be said that formal analysis was a relative latecomer to Chinese painting literature. Its emergence was closely related to the increasingly popular taste for and understanding of Yüan painting.

The explanation that I will venture to give is a simple one. That Sung painting had its own laws is beyond doubt. But since these laws, whether they be the principles for spatial organization or formulas for brush and ink work, had not been as neatly crystallized and conventionalized as in Yüan painting, they were difficult to grasp, at least for seventeenth-century critics. In comparison, with pictorial idioms such as Ni Tsan's composition or Huang Kung-wang's hemp-fiber modeling strokes firmly established, the laws of Yüan painting appeared to be much more readily amenable to formal analysis. And the mastery of any ancient method was possible only when it could be subjected to such analysis. That was perhaps why, logically and inevitably, the Yüan tradition was looked upon as the unique basis for the creation of a new orthodoxy in painting. With this in mind, it also becomes clear why Tung Ch'i-ch'ang should make the claim that

the secret of the art of prose writing has only now been revealed. Just as it was possible now for literary critics to speak of the compositional principles of "rise and fall" (ch'i-fu), "suspension and continuation" (tuan-chi), "thesis and antithesis" (cheng-fan), "reflections and echoes" (chao-hsiang), etc., in the art of shih-wen, so it was also possible for art historians to speak of the compositional principles of "opening and closing" (k'ai-ho), "void and solidity" (hsü-shih), "guest and host" (pin-chu), "frontality and reverse" (hsiang-pei), etc., in the art of painting. In short, methods and rules were no longer unattainable abstractions. They could now be imitated, mastered, changed, and discarded with a freedom secured by greater understanding of the old masters.

Not only were "formal regulations" visualized and translated into practical schemes, but even "inspired harmony" was given a certain perceptible substance or frame of reference for its measurement. This was almost unthinkable before the seventeenth century. To earlier writers and artists "inspired harmony" was a lofty and ecstatic aesthetic state, the most abstract of poetic essences. Like the "pavilions in the dharma-world of the Avatamsaka manifested in a snap of the finger," it was a revelation, absolutely indescribable in words. But the late Ming-early Ch'ing critics seemed to think that they had finally succeeded in identifying it through intuitive understanding of phonic patterns and poetic dictions. In an important statement by Liu Hai-feng, one of the major figures in the T'ung-ch'eng school of prose writing, the idea was explained in this way: "many modern commentators on prose literature do not seem to know that there is such a thing as phonic pattern [yin-chieh]. If one brings out the problem of diction and phrasing, they will invariably laugh at them as being trivial. Such an attitude may look sophisticated but is actually erroneous," for "phonic pattern is the vestige of spirit-breath [shen-ch'i]; spirit-breath is invisible, but can be made visible through phonic pattern. Diction and phrasing are the matrix of phonic patterns; phonic pattern is difficult to measure, but can be made measurable through diction and phrasing." The use of geographical or personal names, phonetically selected and woven into the poetic fabric, had been a favorite device to give color and atmosphere to imagery, for example, in the following lines by a late Ming poet-painter, Ch'eng Chia-sui (1565–1643): "The river at Kua-pu is empty, lightly it has been raining; the sky over Mo-ling being far away, is not suitable for autumn." The effective use of these two seemingly unrelated and irrelevant geographical names in a poem is comparable to the use of a certain carefully conceived and strategically placed motif to open, so to speak, the "eyes" of a painting. In the opinion of Li P'an-lung, "they are the words of Samadhi which definitely require sudden awakening."

In the final analysis, however, the most revealing and dependable yardstick for measuring the presence of "inspired harmony" is still the musical quality in a prose or poetic work. Here we must first point out two parallel concepts in Chinese literary and art criticism, ch'i ("breath") in literature and shih ("momentum" or "force") in painting. Just as phonic pattern was considered the tell-tale mark of "spirit-breath" in literature, so brush movement and spatial dynamics were taken as the visible traces of the "breath-

momentum" in painting. The expressive and technical demands for *ch'i* and *shih* correspond precisely to the philosophical and aesthetic quest for "life" (*sheng*) and "motion" (*tung*) in traditional Chinese art. This is again better explained in music. In his preface to the collected works of Tung Chung-feng, T'ang Shun-chih, the Ming essayist mentioned previously in connection with the practical structural schemes in *shih-wen*, elucidated the problems of "one breath" (*i-ch'i*) and "one tone" (*i-sheng*):

> A breath will run out and then flow again; a tone will fall into cadence and then rise again. To draw out a breath so as to prepare for the next, or to terminate a tone so as to lead to another new enunciation—these are the natural methods designed by our creator and practiced by most singers. But not the best singers. For the best singers, a breath should be changed before it runs out, so that regardless of any changes from exhaustion to renewal of the breath it always goes like "one breath." Similarly, a tone should glide into the next before it tapers off, so that regardless of any shift from falling to rising of the tone it always sounds like "one tone."

"One breath" and "one tone," in the sense of their being the basis for all variations and methods, are the forerunners of Tao-chi's theory of the "one stroke" (*i-hua*); in the sense of their representing a subtle but vigorous control of an inner rhythm and movement, they are the physical embodiments of the principle of "life-motion." "Life-motion" is thus made perceptible through "breath." As the breath is induced to flow along with the brush, so the "spirit" (*shen*) is induced to move along with the breath. The motivating force which generates and sustains this operation is the potential and materialized "momentum" (*shih*).

By all odds *shih* was probably the most significant technical term in the new orthodox theory which Tung Ch'i-ch'ang used repeatedly in most emphatic terms in his discussions of calligraphy and painting. It can be applied equally to composition and brushwork. In composition, its importance may be illustrated by an observation of Wang Fu-chih in his *Hsi-t'ang yung-jih hsü-lun*: "the painting critics used to say, 'within the space of one square foot the momentum of ten thousand *li* is represented.' Our attention must be focused on the word 'momentum.' If painting is not discussed in terms of 'momentum,' then the reduction of ten thousand *li* to one square foot will be nothing more than a map of the world, a frontispiece illustration for a book of geography." In brushwork, the representation of *shih* is best demonstrated by Tung Ch'i-ch'ang's own calligraphic strokes. In the words of a modern scholar, "the new principle 'breath-movement life-motion' is a perfect description of Tung Ch'i-ch'ang's kinesthetic landscape, whose vigorously turning and twisting brushstrokes and compositional movement physically embodies the 'breath-forces' or 'breath-movements' which, in turn, represent 'life' and 'motion' in seventeenth-century landscape painting."[1]

I have tried in the foregoing to outline the historical and ideological background for

1. Wen Fong, "Tung Ch'i-ch'ang and the Orthodox Theory of Painting," *National Palace Museum Quarterly* 2, no. 3 (1967–68):18.

the formulation of Tung Ch'i-ch'ang's literati and Southern school theories and the establishment of his new orthodoxy on the basis of these theories. He resolved the geographical problem in his Southern school theory by introducing the thesis of *tun-wu* ("sudden awakening") from Ch'an Buddhism. He took over Yen Yü's Primary Principle from the hands of Wang Shih-chen, Li P'an-lung, and the Seven Masters to define the literati approach to painting. On the one hand, by possible inspiration from the Neo-Confucian philosophy of the T'ai-chou school, he was able to bypass the obstacles of the dualistic thinking of the sixteenth-century revivalists and to eliminate the differentiation between an artist and his subject, man and nature. He accordingly proposed the distinction of *shuo-i* and *tso-i* as the line of demarcation between the literati and the professional painters (*tso-chia*). An ideological foundation was laid in this way for literati painting. On the other hand, he had endeavored to avoid the confrontations of Sung and Yüan, of revivalists and anti-revivalists, of imitation and originality. His solution appears to have rested on the discovery of some workable shortcuts from the methodologies of the *shih-wen* and the classical prose of the T'ang-Sung periods that helped to transform the abstract principles of "formal regulation" and "inspired harmony" into something more perceptible, accessible, and practical. In this respect, he bears major responsibility for guiding Chinese art criticism from the pavilions of the dharma-world of the *Avatamsaka* to the mustard-seed garden of everyday aesthetics, or, in other words, from theory to practice. He was certainly the first art historian to lay the groundwork for formal analysis in Chinese painting. With this last achievement his theory for the new orthodoxy in painting was largely completed. As for other important issues he raised, such as the relationship between calligraphic structure and the so-called modeling strokes in painting, or the relationship between the quality of *p'ing-tan t'ien-chen* and the ideal of "inspired harmony," these are problems better discussed in a different historical perspective and consequently have been omitted from this present paper.

In all fairness, one must concede that Tung Ch'i-ch'ang had never been a professed enthusiast of orthodoxy of any kind. Nevertheless, the system he proposed for Chinese painting history, the system of the Southern school beginning with Wang Wei and coming down to Tung-Chü, the two Mis, the Four Yüan Masters (especially Huang Kung-wang), and finally himself (by implication), has been respectfully regarded by most later critics as the orthodox. In any case, most thinkers, writers, and artists since the seventeenth century who embraced and propagated the middle course of a Great Synthesis (*chi-ta-ch'eng*) may be justly considered as orthodox. A Great Synthesis was a summary of history, of past experiences achieved through relinquishment and selection. Its definition is deducible from the well-known lines of Tu Fu: "To discriminate against all the false styles—this will lead us to embrace the true classics. To benefit from many teachers—that alone is your teacher."

ENDING LINES IN WANG SHIH-CHEN'S 'CH'I-CHÜEH': CONVENTION AND CREATIVITY IN THE CH'ING

Yu-kung Kao and Tsu-lin Mei

One remarkable achievement of the Chinese poetic tradition is that for centuries after the T'ang dynasty (618–907) poems in the Regulated Style of commendable quality, though often of little originality, continued to be mass-produced. Literary historians may be seriously disheartened by this lack of innovation, since their touchstone of quality is inventiveness. Literary critics, however, frequently have to admit that these poems are more than simple imitations and that this comparatively rigid and limited form of art permitted people the pleasure of being poets even when they lacked genius. The temptation to write poetry proved to be irresistible, and yielding to it could even be beneficial to the spiritual well-being of citizens. It attracts our attention because the artists involved were both crippled and supported by the conventions. Regulated Verse may have lost its spontaneity, but its creative possibilities were never exhausted. Precisely because the conventions were never fully understood, a fresh understanding of the old materials often occurred—a new insight which generally modified and broadened the conventions and revivified worn-out forms.

In the early Ch'ing, Regulated Verse miraculously enjoyed a degree of revival. One of the much-acclaimed leaders of this renascence was Wang Shih-chen (1634–1711), who was a poet, teacher, critic, and anthologist. As a poet, he achieved eminence through his poetry modeled on T'ang masters. His critical writings and the criteria he established in the selection of poems for his anthology indicate that he was unequivocally committed to the tradition of the past and eager to search for some guiding principles to determine what constituted excellence in Regulated Verse, particularly that of the T'ang period. As a teacher he tirelessly propagated the conventions he derived from T'ang poetry. To be sure, all poets after the T'ang directed themselves to the search for the "secret methods of poetry composition," but usually they concentrated on imitating the more obvious characteristics of the poetry, such as phonic and structural patterns, subject matter, and vocabulary (diction and allusion).

Even the most creative poets could not abandon these basic conventions; Wang Shih-chen himself contributed to the understanding of phonic patterns, and his poetic theory

131

relies heavily on poetic diction. But for us it is most significant to demonstrate that his emulation of T'ang Regulated Verse went far beyond its superficial aspects. His life-long contact with this form enabled him to reach a profound intuitive understanding of certain stylistic characteristics and to utilize them to his own advantage. His critical doctrine based on the concept of "spiritual tone" (shen-yün), especially the maxim of "ideas beyond the words" in a poem (i tsai yen wai), may be partly explained by a formal analysis of the stylistic characteristics of his poetry. We propose to examine some concluding lines in Wang Shih-chen's septasyllabic quatrains (ch'i-chüeh), his favorite form and one which adequately illustrates his critical doctrine.

It is generally agreed that the quatrain form is called "cut-off form" (chüeh-chü) because it is cut off from an octave (eight-line) form (lü-shih). The critical implication of this interpretation cannot be overemphasized. The octave form is often viewed as a perfect embodiment of the ideal lyric poetry developed since the Six Dynasties. In its formal composition, the four couplets are comfortably distributed to serve the functions of introduction, development, reversal, and conclusion. In practice, the central four lines (two couplets) are primarily responsible for image-building. They are composed of isolated and fragmentary images, discontinuous and lacking structural organization though tightly woven in texture. The last two lines (the ending couplet), in contrast with the middle four, are continuous and sequential in development and consist of a single complex proposition which sums up the idea of the whole poem and, through underlying connections, cements together the seemingly diffuse images of earlier lines.

Though the quatrain follows the phonic and structural principles of an octave form, it has some fundamental differences. The lack of space to build images in the middle four lines of an octave form shifts the whole burden to the remaining opening and concluding lines, usually most of all to the last two lines. The dilemma a quatrain poet has to face is how to reconcile imagery with theme—how to present one or more images and to state an idea, either a feeling or a thought. Paradoxically, the octave form often suffers from its perfect balance and lack of dynamism. In a quatrain the tension resulting from saying so much in such a short space adds considerably to the interest of the ending. Most important, for Wang Shih-chen, is that the ending should not be an ending after all; it is an ending which doesn't end. To achieve this result, he tended to use frequently two devices which we shall call the "image in suspension" and the "solution unresolved."

We hope to demonstrate the kinship between these two devices and some of his critical concepts.

The "image in suspension" type of ending leaves an arrested image hanging in mid-air. Such an ending seems close to the mood of the central couplets in an octave form because of its appeal to perception-sensation. One might think that poets would use an antithetical couplet to end a quatrain, but this is seldom the case. For instance, only two or three examples out of Li Po's nearly eighty septasyllabic quatrains end in antithetical couplets (see example 1). Wang Shih-chen, who is more prolific in this sub-genre, has more, but they are hardly typical (example 2). Obviously the main

concern in the last couplet is still the principle of continuity; the two lines are frequently united either as one sentence (example 3) or as two parts of a compound sentence (example 4). All components in these two lines focus upon a dominant imagery: they are either qualitative or temporal-spatial modifications (example 5). Rather than proceeding in leisurely fashion to state a theme as in a traditional ending, the poem is suddenly arrested; it ends not on a full cadence, a summing up of the whole poem, but on a discord, an image suspended. This discord, if successfully contrived, precipitates the reader's search for the underlying meaning. Li and Wang Ch'ang-ling were certainly two of the great exponents of this device in quatrain form (example 6).

Wang Shih-chen's practice was largely slanted toward a variation further limiting the image to the last line only. The third line is used to present a situation related to the image in the last line, but the definite relationship between the two lines is not made apparent (example 7); that is, it is not conveyed syntactically or logically, as in the endings discussed earlier. The continuity seems to be interrupted; an image is abruptly thrust at the reader without preparation, and consequently the progression of the poem is interrupted and moved in a different direction. The image comes and goes all of a sudden. In a sense, such images in the final line are really in suspension; the compactness of the last line certainly intensifies this impression. This phenomenon is often compared by critics with the sudden illumination of self-cultivation in Zen. However, the image in the last line is by no means isolated; not merely one of many fragmented and diffuse images, it is the dominant one, firmly woven together with the previous line and underlining the theme of the whole poem. The third line indirectly defines the last line in terms of time, location, and other details; the fourth line is frequently an image perceived by one who is in a situation described in the third line. But the act and agent of perception which provide a link between the two lines are purposely omitted. Furthermore, the theme underlined by the suspended image will serve as a unifying factor behind the scene. The poem in example 8 is an impressionistic picture of the shrine of a chaste virgin. The objective image of "outside the door, the wild wind opens up white lotus" in the fourth line was presented to Wang, the poet, after "the traveler moors his boat, the moon begins to go down" stated in the third line without transition. The feeling of purity, aloofness, and loneliness in the middle of the wilderness all converge in this image. The feeling and the image are unmistakably related, but the relationship is never explicitly stated so as not to violate the delicate, subtle association. The understated and even ambiguous relationship between the external world which we all perceive and the inner world about which we can only surmise may express the poetic mood better than any clear statement of theme.

Any poem ending with a satisfactory problem-solving statement of thought or feeling lacks the subtle interplay of complex relationship and the mimesis of the sudden illumination mentioned above. But many of Wang's quatrains, following the examples of Li Po, Wang Ch'ang-ling, and Tu Mu, to name only three T'ang masters of this septasyllabic quatrain, often end with this kind of direct statement. It is worthwhile to

look into the device Wang learned and frequently used to add dimension to a flat statement. It is obvious that poets like to end poems by depicting a large-scale scene and shifting our attention gradually to the far distance. The use of allusion, either to facts of public knowledge or to private memory, is also a well-known feature of Chinese poetry. These devices, which create a sense of complexity and uncertainty, are part of the study of diction, which we cannot investigate in detail here. But when a poem ends with a juxtaposition of past and present events, it immediately forms a contrasting background to the present situation and adds a new dimension to the world directly perceived in the poem (example 9). It expands the horizon of the world within the poem to include some unspoken relationship between the present and the event alluded to, leaving the reader to wander along in this new direction. The relationship is not that of metaphorical identification, but of simile and contrast. The contrast is often more pronounced because of the similarity. Therefore in example 10 the comparison between the autumn and the spring reminds the poet and the reader of spring; it never is the spring. This device we call the "solution unresolved"; it in fact hinges on the unexpressed affinity and divergence between the two events.

This device is used by far most effectively in the case of hypothetical, negative, or interrogative modal aspects. All these three aspects, used either alone or jointly, not only suggest a new dimension but also do this with the fewest possible words, which is important in a short lyric of only twenty-eight characters. The hypothetical statement, subjunctive for the past or future, for retrospection or anticipation, always underlines the bitter fact that the present is not as desired (example 11). Although a negative controverts a fact, it imprints on the reader's mind, as if inadvertently, the very fact the poet intends, at least on the surface, to erase (example 12). The joint use of these two patterns gives us a forceful and highly complex statement with many levels of meaning (example 13). An interrogative can be rhetorical, really a negative in the form of an interrogative (example 14). More interesting is the true interrogative which goes far beyond the boundary of a poem to propose some juxtaposed underlying statements to the reader among which he can choose (example 15). If we quickly glance through the "Fourteen Occasional Poems of Ch'in-huai" and some other poems of this kind by Wang Shih-chen, we will see the abundant use of these three modal aspects in different combinations (example 16). Phrases such as "not like," "don't ask," "how many?," "don't see," "hope that some day" are there both to evoke the mood of infiniteness at the end of a poem and to open up the interpretive potential of the themes or images it contains.

Many consider poetry the verbal reconstruction of some inner experience of a poet. If so, we face a problem: when one believes his inner experience is indescribable, he is forever suffering from his stubborn attempt to communicate with and relate to others. The effort to depict a present situation then either takes the form of externalizing it as a world of images so shaped as to correspond to the inaccessible world within or overwhelming it by some contrasting experience in the past, in the future, in nonexistence, in the unknown or wished-for world. Both ways are approximations and maybe even

circumlocutions, leaving out or diverting attention from the real subject, namely, the inner experience. But in traditional Chinese poetry there were some technical conventions used to attain "spirit" or "spiritual tone" in poetry. These conventions had been established long before Wang Shih-chen's time. He may not have understood them fully and explicitly, but he creatively used them to revitalize Regulated Verse for a new era. Whether his relationship with the heritage of literary conventions may be considered analogous to that of any given artist with the heritage of artistic models or whether some general mode of interaction with the past common to all types of traditional Chinese cultural activity may be hypothesized are broader questions beyond the scope of this short essay.

APPENDIX

All examples given here are the last two lines of septasyllabic quatrains. Numbers in parentheses after Wang Shih-chen's poems are the page numbers on which they appear in *Yü-yang shan-jen ching-hua lu* (*Ssu-pu ts'ung-k'an*, ser. 1). Numbers in parentheses after the other poems are the page numbers on which they appear in *Ch'üan T'ang Shih* (*Complete T'ang Poems*) (Peking, 1960). Most of the notes are based on Chin Yung's *Yü-yang ching-hua-lu chien-chu* (Chung-hua shu-chü rpt.; Taipei, 1968).

Example 1

Li Po, "Spring Feeling"
 The falling moon, reaching low to the window, peeks at the guttering candle.
 Flying petals, entering the gate, laugh at the bed left empty.　　　　　(1880)

李 白 ，春 怨
　落 月 低 軒 窺 燭 盡
　飛 花 入 戶 笑 牀 空

Li Po, "Marching Song"
 From city tower, steel drums still echo.
 In the case, the golden dagger's blood stain is not yet dry.　　　　　(1876)

李 白 ，軍 行
　城 頭 鐵 鼓 聲 猶 震
　匣 裡 金 刀 血 未 乾

Li Po, "Seeing Azalea in Hsüan-ch'eng"
 For each cry, each look backward, the heart is broken once more.
 The third spring, the third month, recall the Three Pa [districts].　　　　　(1877)

李 白 ，宣 城 見 杜 鵑 花
　一 叫 一 廻 腸 一 斷
　三 春 三 月 憶 三 巴

136

Example 2

Wang Shih-chen, "Crossing the River at Kua-chou"
 Layers of distant trees like floating green shepherd's-purse.
 Light sails, one by one, stir up white gulls. (62)

王 士 禎 ， 瓜 洲 渡 江
層 層 遠 樹 浮 青 薺
葉 葉 輕 帆 起 白 鷗

Wang Shih-chen, "On the last day of the third month . . . at the River Tower, I composed
 five quatrains."
 [We were] already delighted that green rushes hid the sleeping ducks.
 Further [we] burned red candles to shoot the playing fish. (79)

王 士 禎 ， 三 月 晦 日 • • • 河 樓 得 絕 句 五 首
已 喜 綠 蒲 藏 睡 鴨
更 燒 紅 燭 射 遊 魚

Example 3

Li Po, "Poem Sent to Wang Ch'ang-ling on Hearing of His Exile to Lung-piao"
 I send you my melancholy heart and bright moon;
 Following the wind [they] will reach all the way west of Yeh-lang. (1769)

李 白 ， 聞 王 昌 齡 左 遷 龍 標 遙 寄 北 詩
我 寄 愁 心 與 明 月
隨 風 直 到 夜 郎 西

Li Po, "Ruins at Su Balcony"[1]
 Today there is only the West River moon
 Which once shone upon the beauty in the palace of King Wu. (1846)

李 白 ， 蘇 臺 覽 古
只 今 唯 有 西 江 月
曾 照 吳 王 宮 裡 人

Li Po, "To a Beauty Met on the Path"
 This beautiful lady, with a smile, lifts the pearl curtain,
 Points at the distant Red Tower: "That is my home." (1880)

李 白 ， 陌 上 贈 美 人
美 人 一 笑 褰 珠 箔
遙 指 紅 樓 是 妾 家

137

Wang Shih-chen, "Two Poems Sent Home from Pa Bridge, #1"
 On both banks of Pa Bridge, a thousand willow branches
 Have seen off everyone ferried from east and from west. (84)

王 士 禎 ， 灞 橋 寄 內 二 首 ， 其 一
 灞 橋 兩 岸 千 條 柳
 送 盡 東 西 渡 水 人

Example 4

Li Po, "Leaving White Emperor City in the Morning"
 On the banks the monkeys cry without end,
 The light boat has already passed thousand layered mountains. (1844)

李 白 ， 早 發 白 帝 城
 兩 岸 猿 聲 啼 不 住
 輕 舟 已 過 萬 重 山

Wang Shih-chen, "Four Bamboo Songs from Hsi-ling, #1"
 Just past Hsi-ling, having come out from the Ching River,
 Listening to the endless apes' crying, this is Hsia-chou. (96)

王 士 禎 ， 西 陵 竹 枝 四 首 ， 其 一
 西 陵 才 過 荊 江 出
 聽 盡 猿 聲 是 峽 州

Example 5

Wang Shih-chen, "Five Quatrains from Chen-chou, #4"
 Beautiful is the time after the sun slants down and the wind calms,
 Half the river is covered by red leaves and someone sells *lu* fish. (68)

王 士 禎 ， 眞 州 絕 句 五 首 ， 其 四
 好 是 日 斜 風 定 後
 半 江 紅 樹 賣 鱸 魚

Example 6

Li Po, "Gazing at the Heaven Gate Mountains"
 Both banks of green mountains emerge face to face,
 One sheet of lonely sail—out of the sun appears. (1839)

李 白 ， 望 天 門 山
 兩 岸 青 山 相 對 出
 孤 帆 一 片 日 邊 來

Li Po, "Seeing Meng Hao-jan Off to Kuang-ling from Yellow Crane Pavilion"
 The lone sail, a distant shadow, the blue sky ends.
 [I] only see the Long River flowing at the border of the sky. (1785)

李白，黃鶴樓送孟浩然之廣陵
 孤帆遠影碧空盡
 唯見長江天際流

Example 7

Wang Ch'ang-ling, "Seeing Off Hsin Chien at Hibiscus Pavilion, #1"
 If relatives and friends in Lo-yang inquire after me,
 Simply answer—a piece of icy heart in a jade vase. (1448)

王昌齡，芙蓉樓送辛漸二首其一
 洛陽親友如相問
 一片冰心在玉壺

Wang Ch'ang-ling, "Seeing Off Hsin Chien at Hibiscus Pavilion, #2"
 High tower, seeing a friend off, [I] cannot become drunk.
 Lonely the bright moon's heart in the cold river. (1448)

 其二
 高樓送客不能醉
 寂寂寒江明月心

Wang Shih-chen, "Six Bamboo Songs of Kuang-chou, #5"[2]
 Midnight, the hair is fragrant, man awakes from his dream.
 On silver silk thread everywhere bloom *su-hsing* flowers. (128)

王士禎，廣州竹枝六首，其五
 夜半髮香人夢醒
 銀絲開遍素馨花

Wang Shih-chen, "The Great Lone Mountain"[3]
 Misty pavilion, cloudy windows will not detain the traveler,
 Amid the fragrance of *p'in* flowers, [the boat] passes Lone Mountain. (130)

王士禎，大孤山
 霧閣雲窗不留客
 蘋花香裡過孤山

Example 8

Wang Shih-chen, "To Pass the Temple of Lu-chin Again"
 The traveller moors his boat, the moon begins to go down,
 Outside the door, the wild wind opens up white lotus. (61)

王 士 禎 ， 再 過 露 筋 祠
 行 人 繫 纜 月 初 墮
 門 外 野 風 開 白 蓮

Example 9

Li Po, "Ruins in the Central Yüeh District"
 Court girls like flowers once filled the spring palace.
 Today only nightjars are flying there. (1846)

李 白 ， 越 中 覽 古
 宮 女 如 花 滿 春 殿
 只 今 唯 有 鷓 鴣 飛

Wang Shih-chen, "Fourteen Occasional Poems of Ch'in-huai, #2"
 There only remains one strip of Green Stream water,
 Still sorrowing for the house of Lord Chiang. (64)

王 士 禎 ， 秦 淮 雜 詩 十 四 首 ， 其 二
 惟 餘 一 片 青 溪 水
 猶 傷 南 朝 江 令 居

Wang Shih-chen, "Three Bamboo Songs, #2"
 The Southerners sadly reminisce on the charm of the South.
 Bright mirrors embrace the city—in spring they begin to ripple. (80)

王 士 禎 ， 竹 枝 三 首 ， 其 二
 南 人 苦 憶 江 南 好
 明 鏡 夾 城 春 始 波

Example 10

Wang Shih-chen, "Fourteen Occasional Poems of Ch'in-huai, #1"
 For ten days, in the middle of fine rain, sheets of wind,
 In the dense spring, the misty scene is like late autumn. (64)

王 士 禎 ， 秦 淮 雜 詩 十 四 首 ， 其 一
 十 日 雨 絲 風 片 裡
 濃 春 烟 景 似 殘 秋

Example 11

Tu Mu, "Red Cliff"
 If the east wind had not helped General Chou,
 In the deep spring the Bronze Bird Balcony would lock up the two Ch'iao [beauties].
 (5980)

杜 牧 ， 赤 壁
 東 風 不 與 周 郎 便
 銅 雀 春 深 鎖 二 喬

Wang Shih-chen, "Poem for the Painting of the Old Gentleman of Sung-yüan"
 Should have a boat floating in the sky.
 Chi fish blow at the snow—the whole river becomes cold.
 (71)

王 士 禎 ， 題 松 園 老 人 畫
 應 有 扁 舟 天 上 坐
 魾 魚 吹 雪 一 江 寒

Example 12

Li Po, "Written Away from Home"
 Only if our host could make his guests drunk,
 [They] will not know any place as a strange land.
 (1842)

李 白 ， 客 中 行
 但 使 主 人 能 醉 客
 不 知 何 處 是 他 鄉

Wang Shih-chen, "Eight Poems on Ruins at Li Mountain, #3"[4]
 The Emperor loves the music of the Rainbow Skirt Prelude,
 Does not remember the liter of pearls east of the Tower.
 (84)

王 士 禎 ， 驪 山 懷 古 八 首 ， 其 三
 君 王 自 愛 霓 裳 序
 不 記 樓 東 一 斛 珠

Example 13

Wang Shih-chen, "Fourteen Occasional Poems of Ch'in-huai, #8"[5]
 The sobbing water of Ch'in-huai River after a thousand years
 Should not still complain of K'ung *Tu-kuan.*
 (64)

王 士 禎 ， 秦 淮 雜 詩 十 四 首 ， 其 八
 千 載 秦 淮 鳴 咽 水
 不 應 乃 恨 孔 都 官

Example 14

Wang Shih-chen, "Five Quatrains of Chen-chou, #5"[6]
 Fading moon, morning wind, road of Immortal's Palms,
 Who will pay respect to Liu *T'un-t'ien*? (68)

王 士 禎 ， 眞 州 絶 句 五 首 ， 其 五
 殘 月 曉 風 仙 掌 路
 何 人 爲 弔 柳 屯 田

Example 15

Tu Mu, "Quatrain on the Chiang-nan Spring"
 In the Southern Dynasties, four hundred eighty temples—
 How many towers and balconies in the middle of mist and rain? (5964)

杜 牧 ， 江 南 春 絶 句
 南 朝 四 百 八 十 寺
 多 少 樓 臺 烟 雨 中

Wang Shih-chen, "Two Poems on Night Rain, #1"
 Scattered bells, fires in the night, Cold Mountain Temple,
 [Do you] remember which bridge in the maple land of Wu? (63)

王 士 禎 ， 夜 雨 二 首 其 一
 疏 鐘 夜 火 寒 山 寺
 記 得 吳 楓 第 幾 橋

Example 16

Wang Shih-chen, "Fourteen Occasional Poems of Ch'in-huai, #3"
 Look at the ferry, the flowers bloom vainly,
 Who will row the boat to greet you? (64)

王 士 禎 ， 秦 淮 雜 詩 十 四 首 ， 其 三
 卽 看 渡 口 花 空 發
 更 有 何 人 打 槳 迎

Wang Shih-chen, "Fourteen Occasional Poems of Ch'in-huai, #4"[7]
 The pity is that the flower is the same as the species from West Szechwan,
 But she does not look like the time [when she bloomed] in the Ling-ho Palace. (64)

王 士 禎 ， 秦 淮 雜 詩 十 四 首 ， 其 四
 可 憐 一 樣 西 川 種
 不 似 靈 和 殿 裡 時

142

Wang Shih-chen, "Fourteen Occasional Poems of Ch'in-huai, #5"[8]
 In recent years, sorrow is overflowing like the spring tide,
 [I] do not believe that the lake still is named Without Sorrow. (64)

王 士 禎 ， 秦 淮 雜 詩 十 四 首 ， 其 五
 年 來 愁 與 春 潮 滿
 不 信 潮 名 尙 莫 愁

Wang Shih-chen, "Fourteen Occasional Poems of Ch'in-huai, #6"[9]
 However when I look for the house of Chiang Tsung,
 Cold mist already hides the mansion of Count Tuan. (64)

王 士 禎 ， 秦 淮 雜 詩 十 四 首 ， 其 六
 不 奈 更 尋 江 總 宅
 寒 烟 已 失 段 侯 家

Wang Shih-chen, "Fourteen Occasional Poems of Ch'in-huai, #7"[10]
 Don't ask about the past of Thousand-Spring Garden.
 Grass at the red gate has covered the Arch of Ta-kung. (64)

王 士 禎 ， 秦 淮 雜 詩 十 四 首 ， 其 七
 莫 問 萬 春 園 舊 事
 朱 門 草 沒 大 功 坊

Wang Shih-chen, "Fourteen Occasional Poems of Ch'in-huai, #10"[11]
 And today the bright moon is empty like water,
 [I] don't see the Long Wooden Bridge over Green Stream. (64)

王 士 禎 ， 秦 淮 雜 詩 十 四 首 ， 其 十
 而 今 明 月 空 如 水
 不 見 青 溪 長 板 橋

Wang Shih-chen, "Fourteen Occasional Poems of Ch'in-huai, #11"[12]
 Those young men at the street corner of Stone Bridge
 Still know how to sing the songs of White Silk Skirt of the old days. (64)

王 士 禎 ， 秦 淮 雜 詩 十 四 首 ， 其 十 一
 石 橋 巷 口 諸 年 少
 解 唱 當 年 白 練 裙

143

Wang Shih-chen, "Fourteen Occasional Poems of Ch'in-huai, #14"[13]
Perching ravens, flowing water, desolate and lonely.
[I] do not see Chi Ah-nan, who left the poem here. (64)

王 士 禎 ， 秦 淮 雜 詩 十 四 首 ， 其 十 四
栖 鴉 流 水 空 蕭 瑟
不 見 題 詩 絕 阿 男

1. Su Balcony is located at the ancient capital of Wu (modern Soochow) of the Warring States Period. The beauty referred to was Hsi Shih, the favorite consort of the Wu king, Fu-ch'ai.
2. In Canton, where Wang wrote this group of poems on folk themes, the custom was for women to wear fragrant flower petals strung together by wires in their hair.
3. Lone Mountain is a famous island in the middle of the Yangtze River.
4. When the Ming-huang (Brilliant Emperor) of the T'ang dynasty neglected his earlier favorite, Consort Mei, and favored Consort Yang, who composed the Rainbow Skirt Dance music, the dejected Consort Mei refused to accept a gift of pearls offered by the Emperor as a consolation.
5. The reference to K'ung Fan, an official of the Southern Ch'en dynasty who was one of the Emperor's entertaining companions, is intended in this poem to mean Juan Ta-ch'eng, the late Ming playwright and official, whose reputation was ruined by his political ties with the despised eunuch Wei Chung-hsien.
6. Liu Yung, the Northern Sung poet sometimes called by his official title, "T'un-t'ien (yüan-wai-lang)" (auxiliary secretary of the Bureau of Military Colonies), was buried at Hsien-jen-chang ("Immortal's Palms") near Chen-chou.
7. Ling-ho, one of the palaces of the Southern Dynasties in Chin-ling (modern Nanking), was famous for its willows transplanted from Szechwan.
8. Mo-ch'ou ("Without Sorrow") is a lake in Chin-ling named after a girl of the same name.
9. Chiang Tsung, like K'ung Fan an official of the Southern Ch'en dynasty, had a mansion which later became the home of Minister Tuan.
10. Both Wan-ch'un-yüan ("Thousand-Spring Garden") and Ta-kung-fang ("Arch of Ta-kung") are Chin-ling place names.
11. The Long Wooden Bridge refers to a particular bridge over the Ch'in-huai River.
12. *Po-lien-ch'ün* (White Silk Skirt) was the name of Northern-style drama.
13. Chi Ah-nan was a poetess who had written some poems about Ch'in-huai in her younger days. Her brother Chi Po-tsu was also a poet and a friend of Wang Shih-chen.

THE WAN-LI PERIOD VS.
THE K'ANG-HSI PERIOD:
FRAGMENTATION VS. REINTEGRATION?

Jonathan Spence

The Wan-li period and fragmentation: a weak and evasive emperor, eunuch power, squabbles among the princes and concubines, trouble on the northern frontiers, court extravagance, provincial deficits, virulent bureaucratic factionalism, and low morale. The K'ang-hsi period and reintegration: a strong and energetic emperor, eunuchs curbed, princes held in line (with an exception or two), frontiers expanded and consolidated, court economy, efficient provincial government, dedicated officials, and a new sense of purpose.

So the record can be read. And so the K'ang-hsi Emperor most emphatically wanted it read. Wang Hui was around the court in the 1690s, working on the Southern Tours project, so he must have known the current views on the state of the nation. Although we know nothing about his views on contemporary politics, which is not surprising, by one of those odd flukes that make history rewarding we can come very close to Wang Hui in the person of Wang Shan, who tumbled into the middle of the fragmentation-reintegration question at the end of the K'ang-hsi reign and nearly lost his life in consequence.

Wang Shan (1645–1728) was the eighth son of Wang Hui's friend and teacher Wang Shih-min and the uncle (though the younger by three years) of Wang Yüan-ch'i. After an impeccable official career, Wang Shan was made a grand secretary in 1712. But in 1717 he greatly displeased the K'ang-hsi Emperor by urging him to name a new heir-apparent in the place of Yin-jeng, the Emperor's second son, who had been permanently deposed in 1712 because of his gross immorality and political machinations.

Though warned off this dangerous ground by his emperor, Wang Shan nevertheless persisted. He finally went too far by invoking the name of his great-grandfather Wang Hsi-chüeh, claiming that this Ming statesman had rendered great service to the Wan-li Emperor by badgering him into naming T'ai-ch'ang as his heir-apparent.[1] "Treason,"

1. Wang Shan's memorial, quoting K'ang-hsi's angry verbal edict, is printed in *Wen-hsien ts'ung-pien* (rpt.; Taipei, 1964), p. 107.

said the K'ang-hsi Emperor, and the arguments that he used to justify this harsh judgment are illuminating. Ming T'ai-ch'ang, the K'ang-hsi Emperor pointed out, was an unfilial son and may have hastened his father's end—at least Heaven thought so, striking down T'ai-ch'ang before he had been three months on the throne. Wang Hsi-chüeh had rendered no service by his recommendations, had been indeed a disloyal official, and his grandson Wang Shih-min had been no better. Furthermore, the K'ang-hsi Emperor continued, the Wan-li reign had been the beginning of the end for the Ming, source of all later troubles, while the K'ang-hsi reign was a time of peace and prosperity. Therefore in drawing parallels between the Wan-li and K'ang-hsi reigns, Wang Shan was obviously part of a cabal seeking to undermine the Ch'ing dynasty by suggesting its imminent demise. Nor, it was clear, did Wang Shan want just any son named as heir-apparent; he wanted Yin-jeng, the deposed son whose crimes had been made manifest.

His argument completed, the K'ang-hsi Emperor handed the case over to his senior officials for final discussion. Death, they suggested sagely, was the only fitting penalty for such a man. The Emperor commuted the sentence to exile for life; and on account of Wang Shan's age and past service he graciously permitted Wang Shan's son to be exiled in his stead.[2]

There is something odd in all this. The K'ang-hsi Emperor was indubitably jumpy about the succession problem, but he also seems to have definitely feared that there were many Chinese who were not as emphatic on the differences between Wan-li fragmentation and K'ang-hsi reintegration as he would have liked. Could it be, he seems to have been asking, that the Wang Shans of China were returning an open verdict on the stability of his reign?

In his anger the K'ang-hsi Emperor was, I am convinced, very wide of the mark, for the man he was attacking was a member of the group that had good reason to be highly satisfied with the way things were going. With Wang Shan we are in the narrow world of the Chinese power elite (and Wang Hui was a part of that world). In an introduction to the catalogue for the 1967 Tao-chi exhibition at Michigan, I tried to depict a fragment of the Tao-chi circle. The central axis of my diagram was: Tao-chi—Po-erh-tu—Ts'ao Yin—Han T'an—Wang Hui.[3] We can continue this line to run: Wang Hui—Wang Shih-min—Wang Shan.

From Wang Shan, as from Han T'an, the lines extend in all directions to the holders of political power and wealth. These were the great men of early Ch'ing China. The people who praised and corresponded with Wang Hui were not mere scholars: they were at the center of the known universe. They were men such as Wang Hung-hsü, Board president and the Emperor's secret informant on the royal family and the bureaucracy; Sung Lao, the completely trusted long-term governor of Kiangsu; Kao Shih-ch'i, imperial confidant

2. Further comments by K'ang-hsi in 1717 and 1721 are in the *Ch'ing shih-lu* (rpt.; Taipei, 1964), pp. 3672–73, 3875–77.

3. *The Painting of Tao-chi: Catalogue of an Exhibition, August 13–September 17, 1967. Held at the Museum of Art, University of Michigan*, ed. Richard Edwards (Ann Arbor, 1967), p. 19.

and trusted cultural adviser; and Hsü Ch'ien-hsüeh, president of the Censorate.[4] Most of these men's families had not been greatly affected by the Manchu conquest. Even if their home towns had been sacked, they had been fortuitously absent at the time; and they had resumed under Manchu rulers the lucrative jobs that they had performed for the dying Ming. A startling amount of them came from a handful of *hsien* in the Yangtze delta, so that they added a shared locality to the ties of career and family. Their sons took high honors in the examinations and were duly promoted in their turn. Though they may have been nostalgic for the Ming at times, in the early Ch'ing, they had little to complain about and no incentive to rock the boat.

In public, these men would all have echoed the sentiments of Wang Shan in his defense to the K'ang-hsi Emperor: "These days are the peak of prosperity and magnificence, far surpassing the ancient dynasties . . . as good as the days of T'ang and Yü."[5] In private, of course, they may have mocked their emperor somewhat. What, for instance, did they think when they read in their friend Kao Shih-ch'i's published reminiscences that the K'ang-hsi Emperor had shown Kao two portraits of imperial concubines painted by a Westerner (probably Gherardini) and solemnly declared that "this Westerner paints as well as Ku K'ai-chih"?[6] Did they chuckle? Or nod their heads in agreement? The former reaction seems more likely than the latter, but the artistic taste of an emperor was less important than his or his hirclings' fiscal practices. Nothing could alter the basic fact that under the K'ang-hsi Emperor their estates were safe from the arbitrary exactions—and their persons from the arbitrary death—that had been a commonplace in the late Ming.

Wang Hui was firmly enmeshed in these circles of prestige and wealth. The Emperor commissioned him to record the imperial tours in central China, and the heir-apparent flattered him by writing out the four characters "Shan-shui ch'ing-hui"—"radiant landscapes"—which Wang Hui used in his *hao* "Ch'ing-hui."[7] His taste and his fame brought him money, as the top bureaucrats sought out his opinion on their purchases: Wang Hung-hsü, for example, worried in a letter to Wang Hui whether he should go higher than 120 *chin* for a Sung rubbing of the *Ta-kuan t'ieh* with one later interpolation and several pages torn. "If I don't buy it, then I'll miss the parts of it that are beautiful. If I do buy it, it's very expensive, and incomplete, and torn in many places. Please take a look at it for me, and tell me whether you think it's a Sung rubbing or not."[8]

From this and from other letters we can see that at one level Wang Hui was acting as an investment counselor. If an eighty-*chin* painting felt wrong despite the Tung Ch'i-ch'ang colophon that graced it, or if the signature on an alleged Chao Meng-fu horse

4. The names of all these men can be found in *Ch'ing-hui ko tseng-i ch'ih-tu (A Collection of the Letters Written to Wang Hui)*, 2 *chüan*, printed in *Feng-yü lou ts'ung-shu*.

5. *Wen-hsien ts'ung-pien*, p. 108.

6. Kao Shih-ch'i, *P'eng-shan mi-chi*, in *Ku-hsüeh hui-k'an*, 1st ser., no. 12 (Shanghai, 1912), p. 4.

7. For one version of the heir-apparent relationship by a contemporary observer, cf. Han T'an, *Yu-huai-t'ang shih-wen chi* (1703 ed.), ch. 22, p. 23.

8. *Ch'ing-hui ko tseng-i ch'ih-tu*, ch. 2, p. 6.

painting seemed somehow stilted, then Wang Hui was the man to turn to.[9] He also received requests to copy old masters in family collections and to paint portraits.[10] It was his stamp of approval that brought the final sense of security to scholar-officials who could never be quite sure that their judgment was good enough.

The historian can reach this point without much difficulty, but having reached it, he sticks. Before there can be further advance, it is clear that he must study reactions to the Manchu conquest in far greater depth than has been attempted hitherto, and also that he must accumulate the data that will enable him to write sophisticated *social* history. Only then will there be a chance for him to join the art historians in their quest to explain a spectrum that is as exciting as any a man could hope for—K'un-ts'an, Hung-jen, Kung Hsien, Chu Ta, Tao-chi, Fa Jo-chen, Kao Ch'i-p'ei, Wu Li, the Four Wangs. Pending the necessary advances, the historian can merely offer a hypothesis.

We know that many of Wang Hui's backers and friends were powerful men. They were probably also complacent, with the complacency born of wealth and success. Accepting the verdict of history—for history had done well by them—they found stimulation enough in the complex challenges offered by their own artistic heritage. Since social acceptability was a key criterion for life in this affluent world, a Wang Hui was well-advised to talk in the accepted language (with ink as with words). It is true that Wang Hui never sat for the civil service examinations, but we should consider the fact that he did not need to embark on that laborious route, as he already enjoyed most of the advantages that success there might bring. To maintain his position, he needed but to continue to please intelligently; or, to put it another way, he should dazzle but not bewilder.

The quality of *acceptance*—both historical and social—seems to me one of the concepts that we must pursue if we are ever to define "orthodox" and "individualist" to our satisfaction. Let me twist this paper's title and suggest a formulation: in Wang Hui's time, with Ming fragmentation a part of history, the orthodox were those who accepted the early Ch'ing as a period of reintegration; the individualists were the unconvinced, those who chose to pursue their personal reintegration in a still fragmented world.

9. *Ibid.*, pp. 5b–6.
10. *Ibid.*, pp. 3 (request by Sung Lao) and 6b (request by Kao Shih-ch'i).

THE STYLE OF SOME
SEVENTEENTH-CENTURY
CHINESE PAINTINGS

Harrie A. Vanderstappen

In recent years a number of exhibitions and catalogues have introduced paintings by the better-known artists of the seventeenth century. As a result, the problems of style in various schools and regional groups of painters of that time are now better known than ever before.[1] The tradition of dividing seventeenth-century painters into groups and classifying them as orthodox, individualist, or of the schools of Nanking, Anhui, Hsi-an, and others has been followed in nearly all of the studies of the late Ming and early Ch'ing painters. It would be unrealistic to ignore these classifications. However, aside from the fact that many of the minor artists of that time cannot be easily placed within any of the groups, there are, it seems, underlying features of style and attitude toward nature and a continuity of development which deserve more attention than they have received. In this discussion of a few paintings I hope to draw attention to these points.

In A.D. 1628 Wang Chien-chang (active ca. 1620–50) painted *Picking Mushrooms on the Way Home* (fig. 1). The inscription in the upper left of the painting suggests the artist's search for poetic inspiration.[2] He depicts his mountain retreat, with a new brushwood

1. James Cahill, *Fantastics and Eccentrics in Chinese Painting* (New York, 1967); Richard Edwards et al., *The Painting of Tao Chi: Catalogue of an Exhibition, August 13–September 17, 1967. Held at the Museum of Art, University of Michigan* (Ann Arbor, 1967); Marc Wilson, "Kung Hsien, Theorist and Technician in Painting," *The Nelson Gallery and Atkins Museum Bulletin* 4 (1969): 5–52; Martie W. Young, ed., *The Eccentric Painters of China* (Ithaca, N.Y., 1965); Roderick Whitfield, *In Pursuit of Antiquity* (Princeton, N.J., 1969); Hsio-yen Shih and Henry Trübner, *Individualists and Eccentrics* (Toronto, 1963); Hsien-ch'i Tseng, *Loan Exhibition of Chinese Paintings* (Toronto, 1956); Aschwin Lippe, *Kung Hsien and the Nanking School: Some Chinese Paintings of the Seventeenth Century* (New York, 1955); Sherman E. Lee, *Chinese Landscape Painting* (Cleveland, O., 1962). Since the writing of this essay, Wang Chien-chang's painting has been published by Elizabeth Fulder in James Cahill, ed., *The Restless Landscape: Chinese Painting of the Late Ming Period* (Berkeley, Calif., 1971), p. 105, pl. 48.

2. "In a mountain setting with trees, pockets of mist, and rapids in the river, I departed from the new brushwood gate in search of poetic inspiration. At dusk I returned home, picking mushrooms on my way. June 6, 1628, painted and inscribed by Wang Chien-chang." Most of the known biographical information on Wang Chien-chang can be found in Osvald Sirén, *Chinese Painting: Leading Masters and Principles*, 7 vols. (New York, 1956–58), 5:49–50. In a notice on a handscroll of flower paintings, Y. Yonezawa puts Wang Chien-chang together with Sung Hsü, Li Shih-ta, and Sheng Mao-yeh. He points out the import-

gate, beside rapids at the foot of cliffs and mountains, among which hover pockets of mist. The eye is first drawn to the large central mass of rocks and cliffs, the shapes of which resemble fungi struggling over and around each other in clustered layers on a tree trunk. The rocks seem to grow similar heads from twirling shapes and wrinkled bodies, and the contours and light surfaces of these heads guide the central part of the composition from the courtyard in the immediate foreground to the upper part of the painting, with its silhouetted trees and houses on a short mountain ridge. The view into the distance, with winding rapids, a boardwalk, and a bridge to the left, balanced on the right by a more limited view, thrusts the central rocky mass even more into focus. Timid and subordinate as these views to the left and the right may be, they are a concession to tradition; they help to link the painting with the style and composition of landscapes associated with Kuo Hsi (active second half of the eleventh century) and his later followers. A reference to Kuo Hsi in the inscription would come as no surprise, but this custom did not preoccupy Wang Chien-chang as much as it did some of his contemporaries.

It is obvious that the Kuo Hsi traditions are here interpreted through the somewhat laborious mannerisms of late Ming academic conventions; tonal ink patterns, atmosphere, the mingling of broad and crisp outlines, and the concentration on a setting, which includes a yard with a gate, the recession along the river with the bridge and the single sweeping curve of the mountain ridge into the background—all recall paintings by artists such as Hsieh Shih-ch'en, Li Shih-ta, Sheng Mao-yeh, Mi Wan-chung, and others.[3]

The strong, bold and bizarre form of the central mountain is the most imaginative part of this painting. That such a shocking feature could be absorbed by viewers at that time is certainly due to the influence of Tung Ch'i-ch'ang[4] or the visions in Wu Pin's paintings (active ca. 1568–1621).[5] Wu Pin transformed ancient landscape traditions into stretches of texture and elongated fantasies, recalling the precarious balancing act of a juggler. Understanding of Wang's work by his contemporaries was undoubtedly further facilitated by the strange pictorial explorations of other artists such as Ch'en Hung-shou (1599–1652). Ch'en enlivened his work with great subtlety, wit, and sarcasm and utilized all the possibilities of surprise and allusion. When, for instance, he mingles historical knowledge with his own response to visual imagery in a portrait of a solemn Confucian official, the viewer is left to decide for himself whether he is seeing a masquerade, a nostalgic disguise, or a quaint and amusing image of the past.[6] These "intricate inter-

ance of these painters for the Japanese Bunjin-ga (*Kokka*, no. 746 [1954], p. 132). A number of landscapes can be added to Sirén's list. Two are here reproduced (figs. 1, 4, and 5). Another painting, *Landscape with White Clouds and Clear Frost*, in colors on paper, belongs to the Cleveland Museum of Art.

3. For Hsieh Shih-ch'en, see *Kyuka Inshitsu Kanzō Garoku* (Koyto, 1920), vol. 1, pl. 20. For the others see *Minshin no kaiga* (Tokyo, 1967), pls. 53, 54, 47.

4. Cahill, *Fantastics*, figs. 1–2; see also Nelson I. Wu, "Tung Ch'i-ch'ang (1555–1636): Apathy in Government and Fervor in Art," in *Confucian Personalities*, ed. A. F. Wright and D. Twitchett (Stanford, Calif., 1962, pls. 1–2.

5. Cahill, *Fantastics*, figs. 6–7.

6. Huang Yung-ch'üan, *Ch'en Hung-shou* (Shanghai, 1958), fig. 12; Cahill, *Fantastics*, fig. 10*b*; Yu-ho Tseng, "A Report on Ch'en Hung-shou," *Archives of the Chinese Art Society of America* 13 (1959): 75–88. Even though

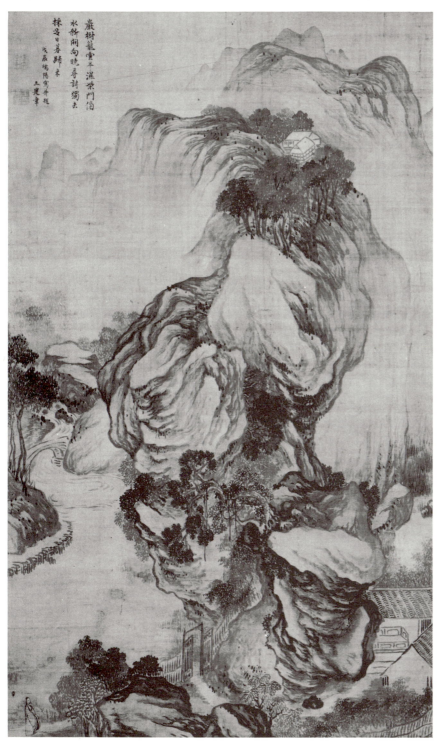

Figure 1. Wang Chien-chang, *Picking Mushrooms on the Way Home*, 1628, hanging scroll, ink and slight color on paper. Private collection, Chicago.

weavings of interpretations" in Ch'en Hung-shou have been aptly described by James Cahill, who also pointed out the lack of unity between the orderly recessions in one section of Tung Ch'i-ch'ang's *Dwelling in the Ch'ing-pien Mountains* of 1617 and the irrationality in other parts of the composition.[7] Wang Chien-chang's painting brings to mind similar juxtapositions of the eccentric and the traditional and serves as an example of the widespread penetration of the bizarre into the work of artists outside the mainstream of late Ming Chinese painting. However, Wang Chien-chang's painting differs from Tung Ch'i-ch'ang's in its emphasis on the eccentric shape; the image of nature has almost completely adopted itself to the willful, doughy forms grafted upon the rocks and mountains. Tung Ch'i-ch'ang's confidence in the eccentric form does not go that far. Wang Chien-chang's gentleman in the lower left corner seems to highlight his point: dressed in a quaintly colored ancient costume, he appears to step aside and pose next to this artifice of a mountain.

Some other paintings by Wang Chien-chang illustrate this concentration of eccentric forms and their new meaning and point to the development of style in landscape during the first half of the seventeenth century. Wang's Yü-hua mountain landscape (fig. 2)[8] recalls paintings in the tradition of the late-sixteenth-century Wen school in its proliferation of shapes. Although not as eccentric in its elongations as Wu Pin's *A Thousand Peaks and Myriad Rivers* of 1617,[9] the same tall and narrow format is filled with textured cliffs and trees. Moreover, the two paintings share the same reiteration of motifs, woven into shapes which are forever moving beyond the outline they have just established. The painting by Wang is not dated, but from its style and the content of his other work it seems safe to place it in the first quarter of the seventeenth century. In *Picking Mushrooms on the Way Home* Wang Chien-chang did not create an expansive view but emphasized a selected number of elements and boldly experimented with traditional motifs. The shapes of the objects selected and the uniformity of textures are stressed. This emphasis overshadows the composition. The rocks and mountains are traditional, but they are rocks transposed into the excitement of the unusual, and the transformation lends a new significance to the use of the eccentric. Wu Pin's fantastic elongations of the Sung landscape forms, Ch'en Hung-shou's vision of the flower petal trickling down at the feet of a solemn-looking official,[10] Tung Ch'i-ch'ang's realization that "what seems unorthodox and dangerous practice is actually the direct, sound and classical path to excellence"[11]—these have cleared the way for the late Ming artist, who sees that a thing in nature may best express itself by fully stating its own oddity. Wang Chien-chang's painting highlights this discovery. Through his pictorial language of strange, rolling shapes, the

Ch'en Hung-shou strongly criticizes artists who rely on their "examination knowledge" without solid training, his own paintings have much in common with those of the artists he chides.

7. Cahill, *Fantastics*, pp. 38–39, 18–19.

8. The painting is signed and titled *Spring Ravines in the Yü-hua Mountains*.

9. See Cahill, *Fantastics*, fig. 6.

10. Album leaf, Freer Gallery of Art, Washington, D.C.

11. In Wu, "Apathy in Government," p. 290.

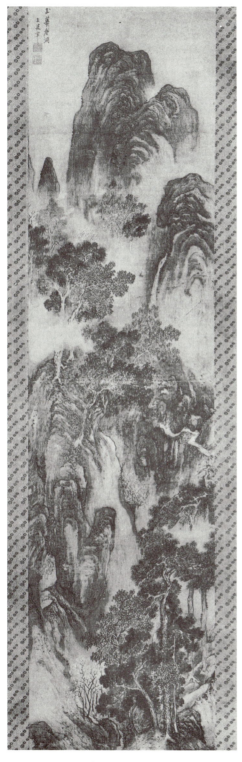

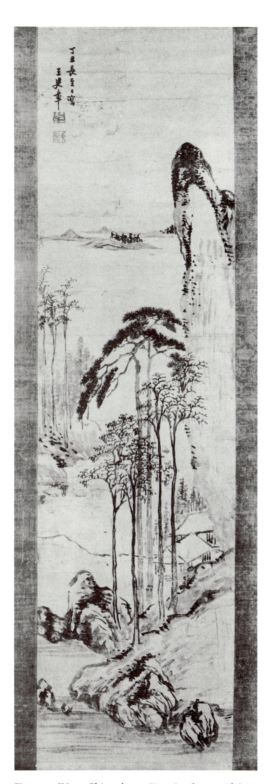

Figure 2. Wang Chien-chang, *Spring Ravines in the Yühua Mountains*, early 17th century, hanging scroll, ink on silk. Collection unknown. Reproduced from *Nanshū Meiga-en* (Tokyo, 1904), vol. 12.

Figure 3. Wang Chien-chang, *River Landscape with Steep Cliffs and Sparse Trees in the Foreground*, 1637, hanging scroll, ink on gold-flecked paper. Collection unknown. Reproduced from *Nanshū Meiga-en* (Tokyo, 1904), vol. 17.

153

physical qualities of the rock and mountain achieve their particular individuality. Their visual impact is heightened, and the eccentricity of the bizarre begins to become an accepted idiom.

In Wang Chien-chang's later painting, *River Landscape with Steep Cliffs and Sparse Trees in the Foreground*, dated 1637[12] (fig. 3), the individuality of the tall cluster of trees in the fore- and middleground has an added impact because they are placed in a very select composition, which is at once identified with the landscape formula of Ni Tsan (1301–1374). Notwithstanding the stereotyped setting, nature remains recognizable, if chastened. There is a clear independence and contrast of silhouettes: trees, rocks, and mountains still control the decision as to what shape their visual image should take, but the artist now is free to expand the upward direction of the trees, broaden the crowns of pine branches and needles, iron out the flatness of mountainsides, and sharpen the pinnacles of the cliffs. These elongations, these contrasts of light and dark shapes, of wet and dry, of rugged and smooth textures, these proportions of objects altered at will within the whole—all these only extend the particular physical properties of each part of nature. Without obscuring its generic origin, the idiosyncrasy of the individual object is described in its most telling shape.

The spatial relationship also conforms to this emphasis on the independence of the part within the total composition; buildings at the foot of the cliff speak of the mountain retreat, and a grove of trees surrounding the house completes the suggestion of intimacy. Such detail is physically acceptable, and the same may be said of the tall trees in the foreground. The ground space, however, is not measured by the same yardstick as the height of the trees, nor are the house and the cliff. Our common sense tells us that the time it takes the eye to travel the length of the trees and the distance between the houses and cliffs is not justified. Obviously, we are beginning to be drawn into a miniature orbit of expressiveness wherein each object is particularized and described by its most telling characteristic.

This painting is not an isolated phenomenon. In *Island of the Immortals*, dated 1638, Wang Chien-chang leans on the traditions of the sixteenth century, especially those of Lu Chih,[13] choosing a variety of squared-off shapes for his mountains (with an accent on the off-balance foreground cliffs) and parading them along the surface towards the dancing roofs of the Island of the Immortals, shrouded in clouds. The distinct and repeated mountain contours, all of comparable size, he peacefully coordinates like so many giants of nature. If one compares the repeated faceting of the mountainsides and the sharp-edged rocks with similar features in Lu Chih's landscape in the Nelson Gallery, the resemblance proves only superficial. Lu Chih has developed a mountain setting, spinning out a web of intricate forms which he builds into a unity of theme and physical

12. Inscribed on the day of the summer solstice, 1637.
13. *Island of the Immortals* is in the Seattle Art Museum, Seattle, Washington. For illustration, see *Kyuka Inshitsu Kanzō Garoku*, vol. 1, pl. 32; Sirén, *Chinese Painting*, vol. 6, pl. 308A. See S. Wilkinson, "Lu Chih's Views on Landscape," *Oriental Art* 15: 27–37, fig. 7, for Lu Chih's handscroll landscape in the William Rockhill Nelson Gallery of Art.

harmony. The oddity of the detail is still subordinated to the whole, although one is conscious of the artist and his peculiar vision. By contrast, Wang Chien-chang and many artists of his time feel free to use shapes and textures in such a way as to emphasize the sparkle of an object—its slightly mischievous behavior. It is obvious what element of nature is represented in each of the components, but the heightening of their characteristic shapes, together with their freshly acquired autonomy in a traditional setting, points to a new style.

Another late painting by Wang, *Solitary Colors of the Autumn Woods* (figs. 4–5), begins to point to later seventeenth-century landscape developments. In the inscription[14] Wang tells of the clear frost falling on the fence in a setting of gloomily colored mountain maples. Leisurely humming Chuang-tzu's "Ch'iu Shui Pien," he complains that, although he has long cherished this story, he has never before fully realized its meaning. In "Ch'iu Shui Pien" Chuang-tzu tells the story of the Spirit of the River, who was overjoyed by the swelling waters in the wake of the autumn floods. Glowing with the power of possessing the beauty of the earth, the Spirit entered the limitless expanse of the ocean. At that immense sight his face fell, and he sadly understood the truth of the proverb that he who has heard only part of the truth thinks no one equal to himself.

This story in pictorial language seems to say that as long as man's sense of space does not exceed the boundaries and relative proportions of his immediate surroundings, his understanding of his own measure is inadequate. Knowledge of one's own measure expands with each discovery of the size of one's neighbor. The viewer may speculate upon the degree to which these thoughts are expressed in the visual language of the painting. Wang uses the traditional motif of two gentlemen standing in front of a retreat, set back among tall trees in the foreground. Mountains with slanting tablelands are the setting for scattered pine trees. The abrupt break between the crowded trees in the foreground, arranged in pipe-organ fashion, and the small miniature trees in the mountains is a reference to pre-Sung traditions and may account in part for the allusion to Fan K'uan. The parallel strokes in the trees, the contrast between horizontal and vertical groups of lines and dots, and the striking irregularities of each form are but an extension of similar features in the paintings discussed earlier. In the use of parallel strokes, the distribution of shapes, and the heightened concentration on off-beat rhythms in each of the objects represented, Wang Chien-chang anticipates the style of Kung Hsien (ca. 1617–1689) and Mei Ch'ing (1623–1689).

The paintings by Wang Chien-chang referred to thus far belong to the second quarter of the seventeenth century; their style can be considered a reflection of the changes that took place then. The style of the following decades of the century finds its inception here. The second half of the century is usually discussed in terms of the Six Orthodox Masters

14. The inscription is unclear in the third character of the second line. The satin is repaired at that place and the character is rewritten. It should probably read *p'o,* "slope." The lower half of the character is on the original satin and would correspond with the writing of the lower half of *p'o.* This suggested change makes sense in meaning and rhyme. The suggestion for this change was made by Professor David Roy of the University of Chicago.

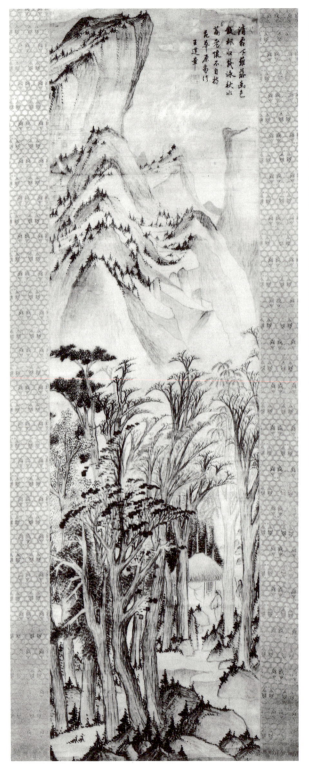

Figure 5. Wang Chien-chang, *Solitary Colors of the Autumn Woods*, detail of figure 4.

Figure 4. Wang Chien-chang, *Solitary Colors of the Autumn Woods*, mid-17th century, hanging scroll, ink and light color on paper. Cleveland Museum of Art, Purchase from the J. H. Wade Fund (72.68).

and the individualists, a useful division which establishes broad categories. A painting by Ch'i Chai-chia (1594–1682-?) offers an example of paintings by artists who cannot easily be placed within either of these major movements. Both Yonezawa and Kawakami have described a number of paintings by Ch'i Chai-chia, quoted the literature, and elucidated Ch'i's skills, his clever and sometimes whimsical talents.[15] The painting *Figures in a Mountainous Landscape* (fig. 6) is a good example of a very personal interpretation of the traditional style of the seventeenth century, uncommitted to strict orthodox or individualist movements. In addition, the historical importance of the inscription on the painting deserves attention; according to it, the work dates to 1680, when Ch'i Chai-chia was eighty-seven years old, information which establishes his birth date as 1594. The reference to Wang Meng is somewhat surprising; only a vague allusion to his full and luxuriant style is evident here, and the composition shows only the same kind of very general reference to Wang Meng. For example, the cluster of trees in the foreground, set on rocks in water fed by rapids and a waterfall in the background, is a familiar schema in paintings associated with Wang Meng. This scenery surrounds a pavilion where a gentleman awaits the arrival of friends. The intensity of the strokes and washes is individual and lively; the great variety of tones and the unerring certainty in putting the strokes on the paper with a minimum of weight creates a vivacious and lucid impression. A repetition of clearly defined cone-shaped rocks and cliffs recalls the earlier work by Wang Chien-chang. In the third quarter of the seventeenth century, Hung Jen (1610–1663) and Kung Hsien had arrived at final pictorial solutions of these definitions of shape, and Ch'i Chai-chia shows his dependence on these masters. The light touch of Ch'i's brush imbues the traditional motif with a feeling of rebirth not unlike the new look of a garment which has been turned and handsomely redesigned; one recognizes the old material but this recognition in no way vitiates one's pleasure in its lively new appearance.

The difficulty of placing Ch'i Chai-chia in one of the better-known groups of painters of that time is reflected in the remarks of Chou Liang-kung (1612–1672), Ch'in Tsu-yung

15. Y. Yonezawa discusses Ch'i Chai-chia in *Kokka*, no. 780 (1957), pp. 97–98; K. Kawakami adds new information in *Kokka*, no. 794 (1958), pp. 149–50. Both authors refer to earlier publications in *Kokka*. See also Sirén, *Chinese Painting*, 7: 304. Professor Kawakami refers to a painting that Ch'i Chai-chia did when he was eighty-nine years old. He was therefore still alive in 1682. Between the writing of this essay and its publication, Professor Kawakami has found the date of the birth of Ch'i Chai-chia on a scroll of calligraphy by Ch'i in the collection of Chang Chün-shih, containing Su Shih's poem "The Red Cliff," written in 1674 when Ch'i was eighty-three years old. From various records compiled over years of research, Professor Kawakami gives a list of important events in the life of Ch'i Chai-chia. Aside from the date of his birth the most important datable events are his passing of the *chü-jen* examination in 1627; his presence in Nanking in 1642; his capture by bandits on his way to the country in 1645 after the fall of Nanking; his appointment as inspection commissioner of the army in Taichou in Chekiang in 1646 (in that same year he is said to have lost all his possessions); his return north to Yangchou in 1654, when he met Chou Liang-kung and painted an album for him while traveling on a boat, and his visit in Chou's house that year in Nanking for one month. In 1682 he was still alive. In addition to the paintings listed by Sirén and E. J. Liang, Kawakami lists some nineteen other dated paintings by Ch'i Chai-chia. See Sirén, *Chinese Painting*, 7: 304; E. J. Liang, *Chinese Paintings in Chinese Publications* (Ann Arbor, Mich., 1969), p. 225; Kawakami Kei, "Ch'i Chai-chia no kenkyū," *Bijutsu kenkyū*, no. 269 (1970), pp. 36–39.

(active middle of the nineteenth century), and Huang Chih-chang. To put him into the family branch of Kuan T'ung and Ching Hao of the Five Dynasties seems only a figure of speech. Ch'in Tsu-yung has reservations when he describes Ch'i Chai-chia's relationship to Shen Chou, and then proceeds to criticize the firm lines of the brush, which create an effect of disquiet.[16] Huang Chih-chang goes even further, connecting Ch'i's style with that of the painters of Chekiang, his home province. The dreaded label of the Che school seems implied in this remark.[17] In his autumn landscape Ch'i demonstrated his independence and his individuality even though he was following a master revered and emulated by the painters of both the individualist and the orthodox schools. He seems to belong in neither school, but his paintings share aspects of both.

A brief description of the style of some paintings by better-known artists of the orthodox and individual schools will, I think, help us understand the main trends of landscape traditions of this time. The discussion will deal with four paintings by four artists. Wang Shih-min (1592–1680) and Wang Hui (1632–1717) will represent the orthodox movement, and Hung Jen (1610–1663) and Kung Hsien will represent the individualists; other artists might equally well have been chosen.

In 1669 Wang Shih-min, the oldest of the Four Wangs, had another look at his painting *Mountain View after Rain*, which he painted two years earlier (fig. 7).[18] Although he had seriously tried to imitate Huang Kung-wang, he felt that the effect was that of a maid who pretends to be a lady, and perspired with embarrassment. This large painting is an accumulation of hamlets, rivers, roads, and ranges of rocks and hills which terminate in a large central mountaintop above the clouds in the upper part, vaguely reflecting tenth-century landscape compositions. Only this large mountain and the trees in the foreground assert themselves, by virtue of their size, among the maze of traditional landscape elements. It takes effort to comprehend the painting visually, just as it took effort for the artist to penetrate the visual language of the past and to exhaust the possibilities of wavy gray and dark lines to describe mountains, of dots and short staccato strokes to describe tree trunks, and to arrange the whole like so many stepladders and stretches of barbed wire. Familiarity with Chinese landscape traditions of the past leads to the realization that Wang Shih-min did not invent the idea of the repeated cone-shaped mountains and hills, the placement of clustered rocks and trees at certain intervals, or even the panoramic view itself. Similarly, the strokes employed for dots and textures and the use of light and dark tones are well-established traditional patterns. In other words, the composition, subject matter, and pictorial language complement each other in reflecting Wang's interpretation of the history of Chinese painting. The assimilation of these traditions, the personal and sensitive use of textures, and the carefully controlled strokes are

16. Ch'in Tsu-yung, *T'ung-yin lun-hua*, *Se-yeh Shan-fang* ed., preface by Ch'in Hsiang-yeh, dated 1866 (Shanghai, 1918), 1st sec., *chüan* 2, p. 4.

17. Yonezawa, *Kokka*, p. 98.

18. The painting is dated winter of 1667. In addition to the second inscription by Wang Shih-min, Wang Tuan-kuo added a colophon in 1676, and another colophon was added by Wang Chien (1598–1677).

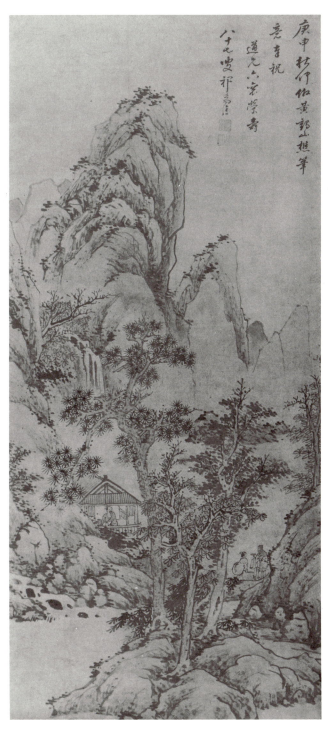

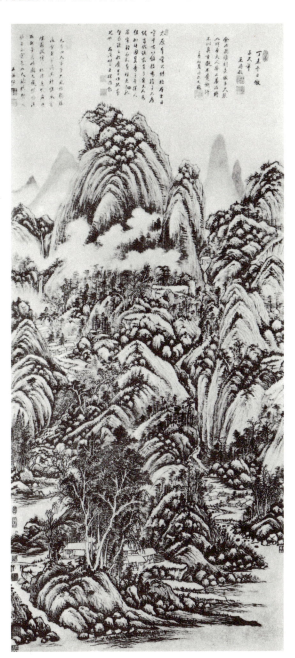

Figure 7. Wang Shih-min, *Mountain View after Rain*, 1667, hanging scroll, ink on paper. Collection unknown. Reproduced from Victoria Contag, *Die Sechs Berühmte Maler der Ch'ing-Dynastie* (Leipzig, 1940), pl. 6.

Figure 6. Ch'i Chai-chia, *Figures in a Mountainous Landscape*, 1680, hanging scroll, ink and light color on paper. Courtesy of the Art Institute of Chicago (1970.551).

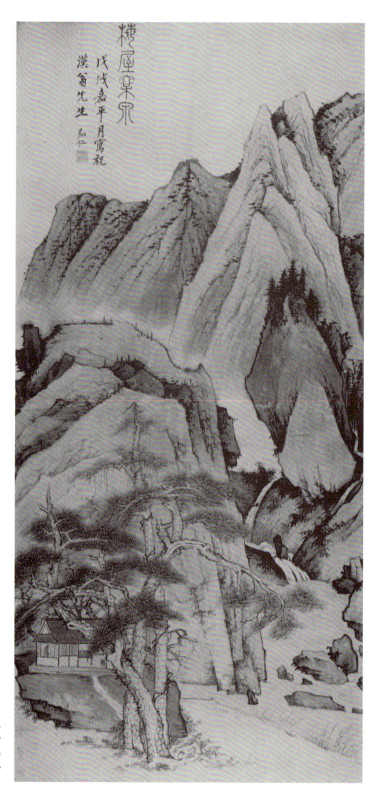

Figure 8. Hung Jen, *Plum Cottage at Pine Spring*, 1659, hanging scroll, ink and colors on paper. Private collection, China. Reproduced from Victoria Contag, *Chinese Masters of the 17th Century* (Rutland, Vt., 1970), pl. 74.

part of the inventive language. Submerged under this web of strokes and textures, the rocks, trees and mountains cling to their particular identity. Nevertheless, objects in nature have achieved a timeless unity, their placement suggests proportions, and as a result a particular group of boulders could be transformed into a mountain range by a slight change in the composition. Wang Shih-min himself only adds the subtle manipulation of tones, lines, and textures. In this refinement of brush and rhythm he transcends the severe limitations of his pictorial formulas.

In 1659, eight years before Wang's painting was done, Hung Jen painted *Plum Cottage at Pine Spring* (fig. 8).[19] A clear, well-defined, and limited number of large angular rocks and mountains dominate the scene. There is a boldness in Hung Jen's painting. Insisting on rhyming shapes, he largely ignores gradations of size and confronts the viewer with a setting which pre-empts the normal perceptions of physically related objects. Obviously this painting derives its strength as little from the dictates of a simply recorded setting as does Wang Shih-min's. Just as the latter artist spaces his areas in a uniform rhythm, Hung Jen repeats the confrontation of large and small, light and dark. The contours and the textures allow only tiny variations and reinforce the austerity of the artist's vision of the world. The well-balanced arrangement—a few carefully chosen shapes, lines, and rhythmic measures of light and dark—resembles an enlargement of a small detail in Wang Shih-min's painting. In their pictorial language both works have much in common; both painters draw nature into a realm of experience strictly controlled by rules of stroke, texture, and shape. In that respect they are equally conditioned by history. However, if Wang Shih-min harmonizes his "subject" as well as his "method" with tradition, Hung Jen seems to do an about-face. He develops the efforts, already heralded in Wang Chien-chang's paintings, to report nature with a newly acquired sense of dimensions, angles, and shapes suggested by the individuality with which each object distinguishes itself from the ordinary. In the evenness of the overall surface and the well-accentuated modules of contrasts, Wang Shih-min avoids eccentricity and conveys the history of Chinese landscape painting. Hung Jen uses similarly restrained strokes and spaced contrasts and applies these to the same subject matter in a close-up view. This forces the viewer to come to terms with the familiar without benefit of well-known textures and surfaces. Wang does not seek new and striking aspects in nature but insists on the idea that the language of tradition has given final shape to nature. If any eccentricity appears in his paintings, it is the undeviating belief that this idea cannot be stated often enough. If nature is brought under control in his work through the subtle manipulation of solutions handed down from the past, in Hung Jen's paintings nature is rebuilt into capricious but well-articulated and telling forms. Undoubtedly these forms exist with reference to tradition, but they have gained a new meaning in their application to nature under the guidance of the artist.

Many other comparisons between the orthodox and individualist artists of the seventeenth century could be made. If one takes, for example, a landscape by Kung Hsien

19. Painted for Han-weng in the twelfth moon of the *Hsü-mou* cycle, which corresponds to January, 1659.

(fig. 9)[20] and compares this with Wang Hui's handling of a similar subject (fig. 10),[21] the conclusions will differ with those drawn from the previous comparison, but, I think, the difference will lie in the stylistic reference rather than in the interpretation of nature. Wang Hui's *Autumn Grove* is a colorful screen of eight trees whose roots seek a precarious hold among the rocks and the multiple rapids which come to rest in the foreground.

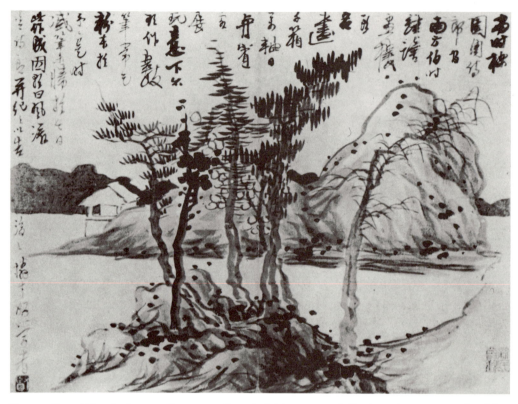

Figure 9. Kung Hsien, *Landscape*, 17th century, album leaf, ink on paper. Collection unknown. Reproduced from *T'ang Sung Yüan Ming Ch'ing hua-hsüan* (Kuangchou, 1963), pl. 68.

The landscape and the house seem more an afterthought than a true setting. The eight trees are tall but cannot dwarf their surroundings; each has its own leaf shape and color, but their individuality tends to be submerged in the expert application of rhythmic lines and vibrant tones. Grappling for life in the rocks, these trees express their struggle with identical gestures. It is again obvious that the subject matter is traditional and is justified less by the desire to render a particular scene than by Wang Hui's brilliant display of controlled lines, leaf patterns, and colors. Wang Hui makes his own presence in his

20. In the inscription Kung Hsien explains that he made this painting for Chou Liang-kung (1612–1672), who owned "a thousand boxes with ten thousand paintings" and who, though he was not a painter himself, enjoyed viewing paintings with his guests. Chou had asked for a painting, and since Kung Hsien felt that his work was now superior to his earlier paintings, he made this leaf in the hope that people of talent and interest might benefit.

21. *Ku-kung shu-hua lu, chüan* 5, p. 455. Cahill's no. CV.32.

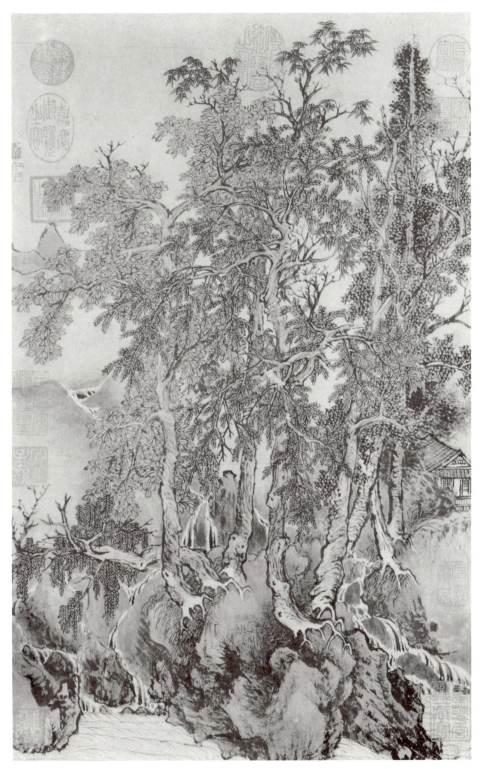

Figure 10. Wang Hui, *Autumn Grove*, 17th century, hanging scroll, ink and colors on paper. National Palace Museum, Taiwan.

paintings more obvious than does Wang Shih-min, but this is due more to the ostentation and skill with which he handles traditional elements than to a different concept of nature. The theme and the method are bound together in their references to tradition; if the manner is brilliant, it is derivative; if the motif is bold, it is still very familiar.

Kung Hsien's painting deals with a similar subject, though the trees in the foreground are part of a larger setting. He uses bold, broad lines of strong tonal variations; the stroke which forms the mountain contour has the same measured rhythm as the stroke which shapes the tree trunk; the soft, broad, wavy lines of mountainsides and rocks seem relatives of those used by Wang Shih-min. The greater sense of reality that he achieves in the foliage of his trees seems to result from greater variations in shape and tone and in the direction of the brush.[22] Kung Hsien bluntly states selected and similar natural shapes in his personal vocabulary of subtle tonal ranges, lines, and dots, and nature seems to thrive under the impact. He bypasses the leaf in order to gain the foliage, and even when he ignores height, size seems to be present; his wavy lines produce firm structures; the placement of mountains and directions of shorelines may play fast and loose with correct visual proportions, but they still create a distance against which the familiar can be measured. Thus in this stylistic analysis certain similarities between these paintings are evident. Even though they cannot be placed within the confines of a homogeneous group, they share certain fundamental attitudes.

The imagery of landscape and nature in general is still a challenge for seventeenth-century Chinese painters, even though tactile sense, humanized proportions, and gradations of tonal contrasts dictated by the ability of the human eye to perceive distances were not their aim and had not been the aim of Chinese painting in the immediate past. The quest for an understanding of the secrets of nature is always present, but the artists of the seventeenth century betray a certain ambiguity: they stress tradition in their inscriptions and in their writings but make sure at the same time to point out the necessity of the study of nature. Even when Tung Ch'i-ch'ang and artists of the following generation are preoccupied with the emulation of tradition, they do so in the conviction that their ultimate aim is to depict the true harmony of nature. References to tradition may be balanced by poetic descriptions of nature's beauty or by direct guidelines for the study of nature itself. Tung Ch'i-ch'ang says at one point that the painting schools used to take the ancients as their models and progressed by copying their works. But, he continues, it is better to take nature as a model, and he then lists detailed instructions for the study of trees and the value of walking through the mountains and watching the changing aspects of the clouds.[23] Wang Shih-min's response to nature is quite spontaneous in his sketches, and this spontaneity can be found in those inscriptions in which he

22. Aschwin Lippe has called these shapes "basic and essential patterns" or "type-forms." One is reminded of Kung Hsien's dictum: "If from the start you keep in your breast the idea of a willow you would never accomplish it." See Lippe, "Kung Hsien and the Nanking School, I," *Oriental Art* 2 (1956): 22.

23. *Hua-ch'an-shih sui-pi*, i/5a. See Victoria Contag, *Chinese Masters of the 17th Century* (Rutland, Vt., 1970), p. 4. See also Wen Fong, "Tung Ch'i-ch'ang and the Orthodox Theory of Painting," *National Palace Museum Quarterly* 2 (1968): 14: "To prevent impostors the scholar-painters should learn first to exhaust the limits of workmanship . . . making Creation their teacher and friend."

describes nature or tells of producing a painting inspired by the sight of beautiful scenery.[24]

One can generally say that the artists of the middle of the seventeenth century are in one way or another burdened by the notion that a thorough study of the history of Chinese painting will guide them to the perfect form. This dependence on tradition seems to reflect a general uneasiness about their competence to render nature on its own terms. The theories of these artists, their response to nature, and their taste and conventions (derived from their historical research and commitments to philosophical dogma) need as much study and consideration as their individual talents. In studying a tree, a mountain, or a waterfall as they appear in paintings of the past, an artist may conclude that a given natural form is durable and unchanging, and this inevitably leads to the development of a visual language of patterns. This inevitability of shape may be tested over and over against the pictorial solutions of the past, in a series of sensitive variations on a theme, or it may become the principle which guides the artist in his vision of nature. Whichever road is chosen leads to creative limitations upon the artist under its spell and to a reduction in the number of thematic choices open to him.

I have discussed a few paintings by Wang Chien-chang in order to comment on the complexities of style in the second quarter of the seventeenth century. Wang is in tune with secondary professional traditions, timidly experimenting with the fantastic and bizarre trends represented in the work of such leaders as Tung Ch'i-ch'ang, Ch'en Hung-shou, and others. In his painting, however, he shows a development and illustrates a style which herald the pictorial forms of the later part of the century. The portrayal of the traditional setting of *Picking Mushrooms on the Way Home* in turbulent shapes is important. The boldness of the painting depends on exaggerated forms, but even in this overstatement the artist expresses a confidence that nature is truly reported precisely in the oddity of each of its parts. Each component thereby gains in individuality, and the burden of the representation is carried by the eye-catching singularity of each shape rather than by its physical conformity to its surroundings. That Wang is aware of this principle can, I think, be seen from the development of his style.

Greater consistency in the pictorial principles indicated in Wang's painting was achieved by artists of the middle and second half of the seventeenth century. When Kung Hsien expresses his views on composition he emphasizes "harmony" in "eccentricity"; one without the other is either dull or awkward.[25] This seems but a development of the ideas of Tung Ch'i-ch'ang, who was torn between the "surprising and the dynamic" and the "equilibrium of the tradition."[26] In his old age he found himself reconciled to the superiority of tradition. Kung Hsien's notions seems to be borne out by the pictorial

24. See Victoria Contag, *Die Sechs Berühmte Maler der Ch'ing-Dynastie* (Leipzig, 1940), p. 22.

25. In P'ang Yüan-chi, *Hsü-chai ming-hua hsü-lu*, iii/78 (the Kung Hsien album is on p. 3, album leaf 8). In the context of a comparison between Kung Hsien's own four important points of painting and Hsieh Ho's Six Principles, Kung Hsien pays more attention to spatial composition (*ch'iu-ho*, "hill and vale," "spaciousness"; see B. March, *Some Technical Terms of Chinese Painting* [Baltimore, 1935], p. 160) than to brush and ink in order to attain *ch'i-yün*.

26. In Wu, "Apathy in Government," p. 290.

forms of his paintings, but one seldom finds the peace of equilibrium in Tung's paintings. He seems to have initiated the ideas which came to maturity in the next generation.

I have tried to identify the pictorial counterparts of these concepts. The revolutionary changes embodied in the bizarre traditions of the late Ming prepared a pictorial language in which the individuality of each object in nature may be expressed. When the existence of each part is characterized by defining its most singular aspect, it follows that the identity of each part gains a new independence. A new unity is thereby realized: the multiplicity of things finds resolution in the most easily identifiable shape. In fact, this conclusion leads to the very basic notion that, in complete negation of their relative size, a mountain is no more than a magnified rock and a rock is a miniature mountain.

The style of Chinese painting in the seventeenth century poses many problems not touched upon in this brief discourse. Analysis based on representational values, of the sort attempted above, takes a back seat in most discussions of the painting of this period. The justification for the insistence of other commentators on the importance of brush-work, tradition, and subtlety of manner is clear from the writings of the artists them-selves as well as those of critics and collectors of the period. In addition, the division into schools, regional groups, and individualists is well established in Chinese treatises. These painters were indeed companions cultivating their ideals of style, steeped in the refine-ment of past elegance. However, it is legitimate to ask what happened to the representa-tion of nature under these conditions. Inscriptions on paintings and other writings leave one with the impression that artists were inspired to paint as a result of seeing works of art. But there are other tales of artists' trips to beautiful scenery, which resulted in a painting. These periods of enjoyment of nature range from short visits to known spots of legendary beauty, perhaps inspiring a painting in the style of a Yüan master, to long sojourns in the mountains, from which have come pictorial records even now easily identifiable. Moreover, paintings of a given scene, whether recognizable or not, whether in the style of a master of the past or not, may, in their turn, cause the viewer to relive and extoll the beauty of a scene he visited many years before.

The pictorial language of these masters is founded in the permanence of the established and sanctioned tradition, whether this tradition is expressed in adherence to the rules of the approved gentlemen of the past or in a conscious appeal to the more free, cosmo-logical system in which the visible world is seen as interacting with its life-giving forces.

No matter where the theories of the artists may lead them, they agree on at least two points: nature is part of their pictorial aims, and the form nature takes has to be sanc-tioned by tradition. Under these conditions, whether they simply explain or rationalize them, nature in its texture and color, its high and low, far and near, large and small, loses its temporal appearance and moves into the immanence of the unchallengeable language. From this common middle ground, artists of the seventeenth century move to one end of the scale or the other. The Yüan masters have the strongest hold over the so-called orthodox painters, and some of their work can be as dry as that of any other academic tradition. At the other end of the scale, the brushstroke becomes an almost

Figure 11. Chu Ta, "Pair of Ducks," detail of leaf 12 from *An Album of Nature Studies*, ink on paper. Private collection. Reproduced from *A Garland of Chinese Paintings* (Hong Kong, 1967), vol. 4, pl. 5 (12).

Figure 12. Chu Ta, "Wild Ducks," detail of a leaf from the album *Pa-ta shan-jen Shu-hua-chi*, introduction by Cheng Ch'i (Kyoto, 1956), pl. 21.

magical and unique formula for the representation of the all-encompassing force of nature.

Complementary to the use of established pictorial language and thought is the sense of self-expression. The artistic personalities involved range from the conscientious and loyal Wang Shih-min to the technically brilliant, success-conscious Wang Hui or to Tao-chi, who could be very critical of restrictive stylistic hierarchy but who himself claimed that one could only truly express oneself by means of the "unique stroke of the brush" (i-hua).[27]

The scale of nature and its representation in texture and color is determined by the patterns imposed by the inclinations of the individual. An artist is identified by his peculiarities, and his development takes place within the very limited confines of identifiable mannerisms, be they the Yüan brushstroke, the angular shapes of Hung Jen, the brooding strokes of Kung Hsien, or the processions of trees and mountains of Mei Ch'ing. The scale of nature is thus adapted to the intimate concern of the artist. What comes to mind is Tao-chi's statement that under the impact of the one universal measure of the "unique stroke" all things can make their full appearance in miniature without any loss to their identity. It is difficult to see what he means, but a painting by his friend Chu Ta may indicate his intent. Two Chu Ta album leaves (figs. 11–12) represent the same subject. Figure 11 is taken from a recent lavishly reproduced book and is obviously a copy of the duck shown in figure 12. The change in the pose of the leg, the blotchy line in the curve of the neck, and the slight shift in the balance of weight show how thoroughly Chu Ta understands the appearance of a duck and the unalterable harmony of its own composition and the source of its power.

The turmoil in landscape painting of the late Ming swept away, once and for all, a relationship between artist and nature which can be delineated by a space and a time bound by the limits of man's own physical measure. Instead, during the seventeenth century painters developed a pictorial vision of nature in which the rock, the tree, and the duck blend, within their identifiable appearance, the condensed rhythm of their own being with that of the world of which they are part. One wonders whether that vision does not partly exemplify the meaning of the "Great Synthesis."

27. For the interpretation of Tao-chi's Hua-yü-lu, see Pierre Ryckmans, "Les 'Propos sur la Peinture' de Shi Tao," Mélanges Chinois et Bouddhiques [Brussels] 15 (1968–69): 11–26.

THE ORTHODOX MOVEMENT
IN EARLY CH'ING PAINTING

James Cahill

The term "Orthodox" has been applied to the school of the Four Wangs, Wu, and Yün[1] in English-language writing on Chinese painting for so long now that it would be difficult to discard even if we wanted to. Still, every now and then someone with an iconoclastic turn of mind (the same sort of person who maintains stoutly that the works of the "Yangchow Eccentrics" are not eccentric at all, they only *look* that way) will object that Wang Yüan-ch'i or some other member of the group was not all that orthodox, and that the distinction between these painters and the "Individualists" is really meaningless. And then it is time to point out once again that the distinction, while not absolutely hard-edged, is nevertheless very real, and that the school, or movement, is as definable as any other.

In a sense, definition is almost superfluous; the Chinese, with their deep respect for genealogy, have done it for us. What we call the orthodox school in early Ch'ing dynasty painting is a movement that was already understood and designated as orthodox (or "true lineage") in its own time, and has been called that ever since (see the appendix to this article). It is made up of those painters who accepted more or less *in toto*, insofar as they understood them, the doctrines and stylistic innovations of Tung Ch'i-ch'ang, and who carried them on in a particular conservative direction, the one set chiefly by his direct followers Wang Shih-min and Wang Chien. This is of course a historical definition, as any definition of an "orthodoxy" must be, and tells us nothing about style; it is "the way things happened." Some other school of painting *could* have become the orthodox movement of the time. The Wu or Suchou school, made up principally of followers of Wen Cheng-ming, by the end of the Ming dynasty had slipped into a kind of orthodoxy, in spite of some innovative accomplishments by such artists as Chang Hung and Sheng Mao-yeh; it could easily, had it carried the day, have provided for the early Ch'ing the "correct" way to paint. Similarly, it is evident from the relative homogeneity of works by lesser masters of the Anhui school, or, even more, of the Nanking school (which Wang

1. Wang Shih-min (1592–1680), Wang Chien (1598–1677), Wang Hui (1632–1718), Wang Yüan-ch'i (1642–1715), Wu Li (1632–1718), and Yün Shou-p'ing (1633–1690).

Kai was able to formularize without difficulty into the *Mustard Seed Garden Manual of Painting!*) that these schools too offered small orthodoxies that might have become "The Orthodoxy" for their age. But as a matter of history it was none of these, but the Kiangsu area followers of Tung Ch'i-ch'ang, who prevailed. Their landscape style became the official one for the Ch'ing court academy[2] and appears to have been all but exempt from criticism both in their time and later.

The stages by which the school attained this status, and the historical stages of its development, need far more detailed study than they have received; we can attempt here only an outline. There was nothing, to begin with, especially conducive to the engendering of orthodoxy in the *style* of Tung Ch'i-ch'ang (as is proved, historically again, by the other, highly unorthodox styles it simultaneously engendered among the Individualists). It was rather the correctness of its lineage according to a system of values Tung himself asserted but did not originate—his style was based, that is, on the kinds of painting accepted by connoisseurs through most of the Ming period as the pinnacles of the art[3]—and the sheer authority (or authoritativeness) of his assertions, both in words and in forms. Tung created the formulas without ever himself being completely bound to them. The reduction of the style to something more easily imitable and manageable by the amateur was the achievement of painters of the next generation, other members of the Nine Friends of Painting such as Pien Wen-yü and especially the two older Wangs,

2. Artists of this school who were active and admired at the Manchu court include Wang Hui, Wang Yüan-ch'i, Huang Ting, T'ang-tai, Chang Tsung-ts'ang, Tung Pang-ta, and others. Their status within the court varied greatly, from those who had high official positions (Wang Yüan-ch'i was Vice President of the Board of Revenue) down to those who were properly court painters. T'ang-tai was the typical Establishment artist in every way; he was considered "the foremost among painters" by the K'ang-hsi Emperor, and was compared by the Ch'ien-lung Emperor to Fan K'uan, Ni Tsan, and T'ang Yin. He held the position of Manager of the Imperial Household. Looking at his paintings today, one suspects that the "rightness" of his artistic ancestry (see the appendix to this essay, no. 8, for his own assertion of it), together with his being a Manchu, had more to do with his success than the excellence of his paintings. For information on him and a translation of his treatise *Hui-shih fa-wei*, see Roger Goepper, "T'ang-tai, ein Hofmaler der Ch'ing-zeit" (mimeographed) (Munich, 1956).

3. I mean, of course, the styles of the Four Great Masters of the Yüan dynasty, especially Huang Kung-wang and Ni Tsan, and Tung Yüan and Chü-jan before them. A marked preference for this lineage can already be observed in the paintings and practice of middle Ming artists of the Wu school, such as Shen Chou and Wen Cheng-ming. The beginnings at this time of what became, in Tung Ch'i-ch'ang's writings, a systematic and doctrinaire reappraisal and reordering of Yüan and earlier painting has been studied by Chu-tsing Li, who made a convincing presentation of it in a paper titled "An Early Shen Chou and the Ming Theory of Art" at the College Art Association meeting in New York, January 27, 1966. There was, of course, a good deal more flexibility in what could be accepted and imitated prior to Tung Ch'i-ch'ang, and even in his time such artists as Chang Hung, Shao Mi, Lan Ying, and others could still paint in the manners of Li T'ang, Hsia Kuei, or T'ang Yin. Later, these were excluded as acceptable models for the Orthodox artists. (Wang Hui's few essays into the manners of Li T'ang and T'ang Yin, as part of his attempt at a "Great Synthesis," are exceptions.) The narrowing of the range of choices of models for imitation, and of desirable pieces for collectors, from the middle to the late Ming is paralleled in the shift in critical opinion that Wai-kam Ho has noted from the early period of Wang Shih-chen and his followers to the period of Tung Ch'i-ch'ang; see "Tung Ch'i-ch'ang's New Orthodoxy and the Southern School Theory," in this volume.

Wang Shih-min (1592–1680) and Wang Chien (1598–1677). These men stand in roughly the same relationship to Tung as do the lesser late Yüan painters—Ma Wan (Wen-pi), Chao Yüan, Lu Kuang, Hsü Pen, and Wang Fu in the early Ming—to the great innovative masters of the Yüan: they produce tamer, somewhat "homogenized" versions of the individual styles that preceded them. How one assesses their contribution depends on the value one assigns to the role of consolidators of a stylistic tradition. The Wangs carried out, to be sure, their own investigations of the past, and these were also important, along with Tung's influence, in the formation of their styles. Some of Wang Shih-min's "original" works do not differ very much from the reduced-size copies that he made of old masterworks (if we suppose that he was indeed the painter of the *Hsiao-chung hsien-ta* album with facing inscriptions by Tung[4]). Wang Chien has a more distinct style, but its distinctiveness appears in subtle and relatively inconspicuous features; there are no obvious idiosyncrasies, and in large part he accepts what is given.

The painters of the next generation emphasize particular aspects of this "given" style while remaining generally within its confines. Wu Li (1632–1720) explores in a cool and intellectual manner the abstract potential of certain dynamic interrelationships of form, which will be discussed below (fig. 1). Wang Hui (1632–1717) virtually exhausts the possibilities of straight-line orthodoxy while incorporating elements from Northern school styles in his Great Synthesis (excellently expounded by Wen Fong in his forthcoming book, *Wang Hui [1632–1717] and His "Great Synthesis"*). He demonstrates what the style could become in the hands of a highly accomplished professional[5] (cf. the more "literary" works of Ch'iu Ying and his relationship to Wen Cheng-ming).

The acceptance of one's own style as true or orthodox means that one does not feel any strong necessity for changing it; the danger attendant on this attitude is, of course, the likelihood that one will stop growing and stagnate. Wang Shih-min, Wang Chien, Wang Hui, Yün Shou-p'ing as a landscapist—all virtually ceased to develop as creative artists at mid-point in their careers. All of them went bad in more or less the same way, settling into the routine and heavy-handed production of stereotyped landscapes. It remained for the youngest of the group, Wang Yüan-ch'i (1642–1715), to raise the production of the school again to a high level and at the same time to bring to an end its really creative phase, in painting that both summed up and went beyond, expanding (without ever discarding) its basic means—color, brushwork, formal and compositional devices (fig. 3).

4. National Palace Museum, Taipei, published as an album reproduction (Peking, 1935). Compare, for instance, leaf 9 with Wang Shih-min's *Verdant Peaks* of 1672 (*Chinese Art Treasures*, [Geneva, 1961], no. 106). Both pictures are after compositions that were accepted, in Wang Shih-min's time, as by Huang Kung-wang.

5. Wang Hui would have objected to being designated as a professional painter, especially as his training was under amateurs (Wang Shih-min and Wang Chien). But he was a painter by profession nonetheless; his whole status and livelihood depended upon his accomplishments in painting. The ambiguities that beset the amateur-professional distinction, especially in the later periods of Chinese painting, make up a large and separate subject that cannot be dealt with here.

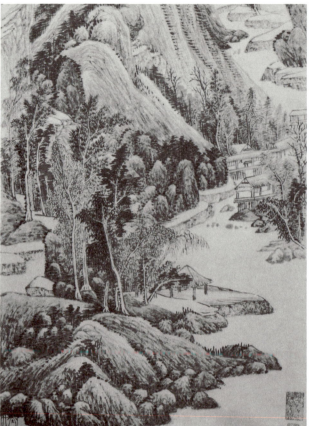

Figure 2. Wu Li, *Landscape*, detail of figure 1.

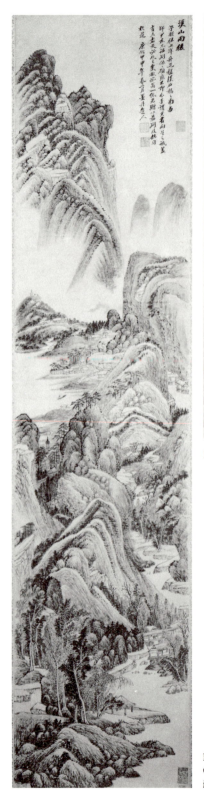

Figure 1. Wu Li, *Landscape*, 1704, hanging scroll, ink on paper. Courtesy of the Smithsonian Institution, Freer Gallery of Art, Washington, D.C. (62.4).

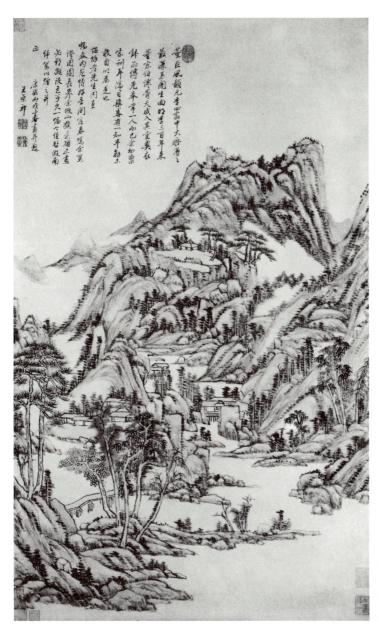

Figure 3. Wang Yüan-ch'i, *River Landscape in the Manner of Huang Kung-wang*, 1706, hanging scroll, ink and color on paper. Courtesy of the Smithsonian Institution, Freer Gallery of Art, Washington, D.C. (62.5).

Little of real accomplishment remained for later practitioners of the style—the "Four Small Wangs,"[6] or followers of Wang Yüan-ch'i and Huang Ting in the court academy, or even such capable later figures as Ts'ai Chia and Fang Shih-shu. Nevertheless, echoes of the style still occupy the center of landscape painting in the early nineteenth century (Hsi Kang, Wang Hsüeh-hao, Tai Hsi) and even later.

6. Wang Ch'en (1720–1797), Wang Chiu (active 1760–1780), Wang Su, great grandson of Wang Shih-min, not to be confused with the figure painter Wang Su (1794–1877), whose given name is written slightly differently, and Wang Yü (active 1680–1729).

173

So much for history. In defining the school in terms of style (without trying to characterize the style as inherently "orthodox," which would be a mistake), we must distinguish it from the styles of the Individualists (Hung-jen, Chu Ta, etc.), who also learned much from Tung Ch'i-ch'ang, as well as from the styles of lesser painters such as Ch'eng Cheng-k'uei who were neither particularly Orthodox nor Individualist, but were also in some way his followers. In other words, our problem is only one part of the larger problem of distinguishing schools and stylistic currents in early Ch'ing painting.

Since the school is in large part a continuation of Tung's revival of Yüan styles (and their Tung-Chü basis), we might begin by asking what Tung found in Yüan (as opposed to Sung) painting and adapted to his new purposes. Late Sung landscape achieves a kind of pictorial unification that has been variously described (as Loehr puts it, "the painters now made entire pictorial complexes their basic elements of design"[7]); objects in the picture are fused in enveloping mists, transitions are blurred, forms are incompletely defined, their interrelationships are typically ambiguous. There is a tendency to simplify the design of the picture, which can be apprehended as a single, unified image and cannot be broken easily into distinct parts. A Northern Sung landscape can; but the parts are put together into structures that are tightly interlocked, stable. The Yüan landscapists[8] (as part of their reversion to the ideals of early Sung or earlier landscape) took up this composite character of early styles and exploited potentials in it that the early masters had never dreamed of. Their landscape is built, typically, of clearly defined parts, as before, and the relationships between these parts form the basis on which the composition is organized; but new and unprecedented relationships are introduced: dynamism, through thrusts and counter-thrusts (sometimes not balanced, and so producing unstable compositions); near-repetitions of shape (particularly common in the Yüan, and foreshadowed, e.g., in the Palace Museum's Yen Wen-kuei[9]); a shift in viewpoint from part to part, or a creation of tension through location of elements in the compositions (as when the interval separating the two parts of a typical Yüan river scene, the near and further shores, is stretched to somewhere near the breaking point). The much-discussed smooth or continuous recession into depth is only one way (not the only one) of interrelating the parts of the painting in the Yüan: they can be placed convincingly at successive points on a continuous ground plane or at successive stages in depth, as defined by overlappings. But that is another problem. In general, as nearly every writer points out, the Yüan artists rely far more than did their predecessors on abstract and formal means of

7. Max Loehr, in his introduction to *Chinese Calligraphy and Painting in the Collection of John M. Crawford, Jr.*, ed. Laurence Sickman (New York, 1962), p. 36.
8. I refer here chiefly to those in the progressive, main line of development as recognized by Tung Ch'i-ch'ang, but the characterization attempted below can be applied as well to much of the work of more backward-looking artists (T'ang Ti, Sun Chün-tse) and is part of what distinguishes their works from those of their Sung forerunners.
9. National Palace Museum collection, Taipei (SV 114); see *Three Hundred Masterpieces of Chinese Painting in the Palace Museum* (Taipei, 1959), no. 71.

expression, including distortions of form and a semi-independent expressiveness of brushwork.

These aspects of the Yüan landscape style are what Tung Ch'i-ch'ang revives (partly in reaction, I believe, to opposing tendencies in contemporary Suchou school painting). Tung's new mode of building a landscape mass out of more or less readymade units, or building blocks, a mode that has been called "architectonic," is based on this same composite quality of Yüan paintings. And Tung's mode of construction is, in turn, what the older Wangs reduce to a system: they set up canonical models for composition, establish a basic repertory of landscape components, reconcile divergences of brushwork into homogeneity and harmony. There is not space here to treat all these elements of the Orthodox style in detail; we can only list them briefly, and say that most of them are found in most paintings of the Orthodox masters, while only a few of them are found in some works of the Individualists and others. But if we can say this of our criteria, we are saying that they define the school stylistically as well as we can ever expect to. All these (except the last) are well exemplified by our illustrations (see figs. 1–3).

1. Compositions, especially large ones, are typically built up of units, which vary in a limited way in size and shape. The large landscape forms, in turn, are built up as composites of smaller forms, which frequently have a life of their own and a direction (pointed, leaning masses), but are usually held in dynamic balance.

2. The compositional instabilities of Tung Ch'i-ch'ang are usually eschewed in favor of more static compositions. When instability is present, it usually arises from movement within the forms; sometimes the movement is the kind of thrusting of masses noted above, and often it is a distinctive heavy flow of masses, as if they were not really solid but existed in a state of viscous plasticity. Large compositional movements are nonetheless present, usually established in accord with Tung Ch'i-ch'ang's and Chao Tso's principle of shih, "force" or "momentum," and are effected by the "dragon-vein" method of linking together the parts by such continuity of force.

3. Depiction of atmosphere is usually limited to patches of mist (as in, for instance, the work of Huang Kung-wang); there is relatively little apparent attempt to render space and distance or light and shadow convincingly. Not only is visual fidelity to nature not a major concern, but (in contrast to the approach of the Individualists) nature is not to the same degree a referent or starting point from which the scenery of the painting departs in such a way as to create tension, or to present a disturbing or otherwise moving vision. (If we were to add that this is much more an art based on art, we would be returning to history.)

4. Type-forms are used extensively (trees, rocks, houses, etc.), sometimes modified by the "style" (manner) being followed (Huang Kung-wang or whichever), but on the whole remaining relatively constant. Some motifs (such as a fisherman in a boat) are virtually reduced to conventional signs—as indeed they already had been in much of earlier Ming-Ch'ing painting.

5. *Ts'un* ("texture strokes") tend to be applied very uniformly and often have a directional function, determining the way the eye moves over the surfaces. *Tien* ("dots") are laid in rows along the edges of forms (trees, rocks) to soften contours, to add to the richness and unity of surface, and to relieve slightly the discrete character of the individual forms. (This is an element of the style sometimes carried to an aggravating excess by Wang Hui, especially in his late period.)

6. Brushwork generally remains within the confines of a special, definable mode of blending "wet" and "dry" strokes, darker over lighter, overlaid to build up a contour or define a surface. These are in turn bound together with washes into a consistent, integrated fabric. This mode of brushwork, which originates in Yüan painting (especially the work of Huang Kung-wang and Ni Tsan), is the basis of the execution of most Orthodox school paintings; it is normally followed, with some variations, no matter what "style"; and it suffices in itself to set off the work of this school from most other early Ch'ing painting. (It is also, of course, a major factor in evaluation and authentication, being a feature on which imitators very often go wrong.)

7. Color generally follows the formalized warm-cool system used by Literati school landscapists from the Yüan onward, but it is developed in some new directions, especially by Wang Yüan-ch'i (a subject too large to treat here).

It should be understood that these were not inflexible rules that any painter of the school was obliged to follow in all his compositions, nor were paintings that adhered strictly to them any more likely to be "academic exercises" or "formula art" than are, for instance, musical compositions that use the diatonic scale, adhere to orthodox rules of harmony, and follow the sonata or some other fixed form. The analogy is not superficial; when we try to work out the interplay of parts, the repetitions and "contrapuntal" movements, in a landscape by Wu Li or Wang Yüan-ch'i (figs. 1–3), we find ourselves involved in a structure as complex, as formal, and almost as abstract as a fugue by Bach.

These and some other features of style, accepted as "given," define the distinct limits within which these artists worked and within which their individual styles developed. In general, we can say that their ideal appears to have been a mature, rich, and (in their own terms) technically finished style, with roots in the past—a style which preserves established values rather than displaying striking departures. Other artists of the time, notably the Individualists, start from different premises, which are beyond the scope of this paper. I would only note again, in the typical works of the Individualists, a much greater involvement with natural scenery (they frequently depict actual places, while the Orthodox masters do so very seldom) and with particular visual aspects or qualities of nature, even when they are subjecting nature to violent distortions, exaggerating light and shadow for dramatic effects, etc. The Individualists also, of course, create highly original and imaginative compositions, employ brushwork that moves further toward one or the other pole of the wet-dry or the dense-sparse scale, and otherwise violate the

principles of conservatism, moderation, and balance that reign within the world of the Orthodox masters.

APPENDIX: THE ORTHODOX VIEW OF ORTHODOXY

In the following quotations, I have in most places substituted artists' proper names (*ming*) for other names (*tzu* and *hao*) used in the original texts, for consistency and easy identification.

1. Tu Ch'iung (1396–1474), in a poem listing famous artists, anticipates the establishment of the Tung-Chü school, and its Yüan period followers, as the "true lineage" (quoted from his literary collection, *Tung-yüan chi*, in Yü Chien-hua, *Chung-kuo hua-lun lei-pien*, 1:103):

> The Assistant Commissioner of the Rear Park is called Master Tung Yüan;
> His use of ink is deep and antique, his texture strokes hemp fibers.
> Chü-jan, in his luxuriant and moistly-rich style, carried on the true lineage. . . .
> Chao Ch'eng-chih [Meng-fu] of the Crystal Palace
> Walks alone in Yüan times, a figure from Heaven.
> Old Ch'ien Hsüan from Cha-ch'uan emphasized delicacy.
> The one who gave rein to his ideas and captured moods was Huang Kung-wang.
> Yün-lin [Ni Tsan], the "Foolish Old Fellow," was excessively pure and simple.
> Mei-hua Tao-jen [Wu Chen] was quite without fetters.
> [Kao K'o-kung from] Ta-liang and Ch'en Lin captured the styles of calligraphy [in their painting];
> Transverse strokes and upright strokes were all suitably done.
> Wang Meng and Chao Yüan were not inferior to them;
> In many houses, on screens their paintings shine with scattered brilliance.
> All these worthies stemmed from the school of Wang-ch'uan [Wang Wei].
> Others are dispersed in disorder, not meriting inclusion.

2. Ho Liang-chün (mid-sixteenth century), writing about the Yüan masters, emphasizes the correctness of their lineage (*Ssu-yu-chai hua-lun*, in *Mei-shu ts'ung-shu*, iii/3, pp. 7b–8a):

> That the works of these masters are all of a surpassing harmoniousness is because they were all men of high character, who scorned to serve the barbarian Yüan and lived in seclusion, wandering among mountains and rivers, so that they were able to capture profoundly their real aspects. Moreover, they derived their styles from Ching Hao and Kuan T'ung, Tung Yüan and Chü-jan; thus their lineage was also correct. How, then, could they do other than surpass by far the preceding age? So we know that the old saying that the first requirement is loftiness in one's personal character and the second is antiquity in one's choice of models is not empty words.

177

Ho, however, does not limit the "right" tradition so narrowly as Tung Ch'i-ch'ang was to do (*ibid.*, p. 9a):

In landscape there are also a number of schools: Kuan T'ung and Ching Hao make up one; Tung Yüan and Chü-jan another; Li Ch'eng and Fan K'uan another; and Li T'ang still another. All these are replete with power of brushwork and divine harmony; they are all worthy of being followed by later painters; all are correct lineages [literally, "arteries"]. As for Ma Yüan and Hsia Kuei of Southern Sung, they also work on a high level ... but they are special cases among artists, and theirs is only an Academy manner.

3. Tung Ch'i-ch'ang makes the basic statement (*Hua yen*, *Mei-shu ts'ung-shu*, i/3, p. 23; roughly the same statement is found in *Hua-ch'an-shih sui-pi*, ch. 2, pp. 15a–b):

Literati painting begins with Wang Wei. Later, Tung Yüan, Chü-jan, Li Ch'eng, and Fan K'uan are his "proper issue" [literally, "children by legal wife" (*ti-tzu*)]. Li Kung-lin, Wang Shen, Mi Fu, and his son Yu-jen all stem from Tung and Chü. From there it goes straight on to the Four Masters of the Yüan period: Huang Kung-wang, Wang Meng, Ni Tsan, and Wu Chen. They all belong to the true lineage [*cheng-ch'uan*]. In our dynasty Wen Cheng-ming and Shen Chou have also distantly succeeded to the robe and bowl [the symbols of succession in Buddhist sects]. As for Ma Yüan, Hsia Kuei, Li T'ang, and Liu Sung-nien, they belong to the lineage of Li Ssu-hsün; they are nothing that we officials ought to study.

4. Tung Ch'i-ch'ang modestly avoids identifying himself as the sole heir in his time to this true lineage, but his friend Cheng Ch'ao-tsung does it for him (note appended to Tung's brief *Lun-hua so-yen*, included in Cheng's *Mei-yu-ko wen-yü*, published in 1627; Wai-kam Ho kindly provided me with a facsimile of the text; see his essay in this volume): "In painting of our dynasty, Shen Chou and Tung Ch'i-ch'ang are considered to represent the Orthodox school [*cheng-p'ai*]. They succeed in establishing ties with the Sung and Yüan masters of the past. When I read the foregoing discussions, I feel respect for my friend: in a thousand ages they will not fall into the pit of the specious and fashionable."

5. Wang Shih-min accepts Tung's formulation (while carelessly including Ch'iu Ying in the lineage) and regards his young protégé Wang Hui as the culmination of the whole development because he can reproduce *exactly* the styles of the old masters (*Hsi-lu hua-pa*, in *Hua-hsüeh hsin-yin*, iii/43a):

The course of painting and calligraphy has its periods of growth and decline. Thus the marvelous works of Chung Yu and Wang Hsi-chih have rarely been equalled in succeeding ages, while later students vie with each other in following the models left by Tung Yüan and Chü-jan. ... After T'ang and Sung, the true lineage in painting runs through the Four Great Masters of the late Yüan and Chao Meng-fu, then through

Shen Chou, Wen Cheng-ming, T'ang Yin and Ch'iu Ying of Suchou, and on to Tung Ch'i-ch'ang. Although their brush manners differ greatly, they all resolutely followed the old masters, as naturally as the nostrils exhale breath. Lately, however, painting has fallen into decadence, as old methods are gradually lost in obscurity, and most people try to produce new ideas, thereby spreading erroneous practices all over. But just when this decline and perversity seemed irreversible, along came Shih-ku, Wang Hui, to save the day. There is not one of the famous masters of T'ang, Sung, or Yüan whom he doesn't imitate.... In every point he seeks out the truth, and when he imitates a certain master, he is completely that master, without mixing in a single brushstroke from someone else's style. If he didn't sign his pictures, even a connoisseur wouldn't recognize them as his. This is something that was never seen before, something that even Shen and Wen couldn't achieve.

6. Naturally, Wang Shih-min himself is placed next in the lineage by his younger friend Wang Chien, who in turn—and so forth (*Jan-hsiang-an pa-hua*, in *Hua-hsüeh hsin-yin*, iii/53a):

Painting has its Tung Yüan and Chü-jan just as calligraphy has its Chung Yu and Wang Hsi-chih: to reject them is to take a heterodox road. Only the Four Great Masters of the late Yüan transmit the true lineage. Lately, after Wen Cheng-ming, Shen Chou, and Tung Ch'i-ch'ang, it seemed somewhat like the Kuang-ling Ts'an [a piece of lute music taught to Hsi Kang by an old hermit and lost with Hsi's death, so that no one else could perform it—a metaphor for the termination of a tradition]. Only Wang Shih-min of our Lou-tung region has deeply understood the school of Huang Kung-wang. I thought there was no one beside him; but then I met Wang Hui.

(He continues with words of praise as effusive as those of Wang Shih-min.)

7. Wang Yüan-ch'i, expanding and elaborating (*Lu-t'ai t'i-hua kao*, MSTS, i/2, pp. 44–45, colophon dated 1712):

There have been famous painters successively from the Chin and T'ang periods, but when it comes to combining *li* ["principles"] and *chü* ["flavor," "interest"], it is only when we come to Wang Wei that these are for the first time gathered together. Arriving at the Sung, we have Tung Yüan and Chü-jan, in whom the "compass and square, level and plumb-line" were all set in place.... As for Liu Sung-nien, Li T'ang, Ma Yüan, and Hsia Kuei of the Southern Sung, it is not that they did not astonish the mind and dazzle the eye; but they had elements of "carved painting" and delicate skill in their work, something totally different from the expansiveness of primeval matter in Tung and Chü, or the older Mi. Chao Meng-fu of the late [*sic*] Yüan period created elegance and beauty out of the well-rounded and substantial; Kao K'o-kung revealed transformations in the surface of brush and ink. With the refined spirit of Tung and Chü and the two Mi's, they make up a single family. Later, Huang Kung-wang, Wang Meng, Ni Tsan, and Wu Chen expanded on their intentions, each with

179

conceptions that go beyond words. In the study of Chao Meng-fu and Kao K'o-kung, we can see that the transmission from the founders has not been empty; in the lineage of Tung, Chü, and the two Mi's, we believe all the more that the original source has its inherent validity. Pa-shu asked me about the "true" [Orthodox] lineage of the Southern school, and I have ventured to reply in this way.

8. T'ang-tai, who learned painting under Wang Yüan-ch'i, elaborates still further the Orthodox school's genealogical claims (*Hui-shih fa-wei*, MSTS, i/5, pp. 24–26, "The Orthodox Lineage"):

> There is an Orthodox lineage in painting, and one should grasp this Orthodox tradition. If one does not, even though he is in step with the ancient rules, he will find it hard to become famous. What is the Orthodox tradition? [T'ang-tai then outlines, as a parallel, the succession of Confucian philosophers from Confucius himself down to Wang Yang-ming in the Ming dynasty.] All these were of the legitimate succession. Now, it is the same with studying painting. The lineage begins with Fu-hsi's drawing of the trigrams. . . . [He follows the lineage as laid out by Tung Ch'i-ch'ang and Wang Yüan-ch'i, in the above quotations, with a few additions, down through the Ming dynasty.] Tung Ch'i-ch'ang in the Ming period amplified their doctrines, designating the Orthodox tradition in painting. In our dynasty, the Three Wangs of Wu-hsia [Wang Shih-min, Wang Chien, Wang Hui] continued this. My teacher Wang Yüan-ch'i learned his family doctrine [i.e., from his grandfather, Wang Shih-min], inheriting it ultimately from the original source.

9. Chang Keng, in his treatment of Wang Shih-min (*Kuo-ch'ao hua-cheng lu*, 1735, ch. 1): "Just then, Tung Ch'i-ch'ang was gathering up [synthesizing] the whole of painting, old and new, and expounding its deepest mysteries, so as to return it to the correct path. In the language of the Ch'an sect, he succeeded in establishing the lineage of the 'transmission of the lamp.' With this true source and in the direct blood-line, Wang Shih-min received this teaching from him personally."

10. Wang Yü, a distant cousin and another disciple of Wang Yüan-ch'i, writes of the perils an artist faces if he strays from this correct path, while putting down the Individualists and Eccentrics (*Tung-chuang lun hua*, MSTS, i/2, p. 30). Note that he attributes to them the same ignoble aim of "astonishing the mind and dazzling the eye" that Wang Yüan-ch'i gave as the dubious achievement of the Southern Sung academic artists:

> In painting, there are *heterodoxy* and *orthodoxy* [false and true paths, *hsieh* and *cheng*]. If the strength of his brushwork seems to penetrate straight through the back of the paper; if his forms have an old-fashioned simplicity and plainness but also brilliantly emit an aura of vitality; if he is lofty in vision and lengthy in stride, with a pride of bearing that defers to none—then this is a great master of the Orthodox lineage. If he is fond of what lies outside the rules, the odd and perverse, the eccentric and wild, and only chooses to "astonish the mind and dazzle the eye," if he is in a hurry to lay claim

to having set up his own school—then he is really a heterodox demon, outside the Way. What you see and come to know, while you are first studying painting, must be fixed [in orthodoxy]; otherwise, you will stray into the company of these [demons]; and then there is no medicine to save you. So beware!

The last words echo Tung Ch'i-ch'ang's similar warning (*Hua yen*, *MSTS*, i/3, p. 18): "If you fall into the demon-world of the professional painters, there is no medicine that can save you!"

In applying to the Individualist masters of his time (and it must be these to whom he is referring) the same terms that Tung Ch'i-ch'ang and Wang Yüan-ch'i had used for Sung academy and professional artists, Wang Yü apparently wants to brand them as the successors to this despised Northern school. While such a reading of the history of painting was decidedly doctrinaire, aimed at discrediting the opposition, it was not totally without validity: the Individualist artists of the early Ch'ing, as I have attempted to show in several studies of particular masters, did indeed swing back to Sung ideals, in contrast to the Orthodox school's emphasis on the Yüan, and did incorporate elements of Sung landscape styles, including Northern school styles, in their works.

PART IV
A MODERN PERSPECTIVE

THE ORTHODOXY OF THE UNORTHODOX

Richard Edwards

Orthodoxy clearly implies the perpetuation of attitudes toward the nature of reality which not only maintain but seek to reinforce the validity of accepted truths. The unorthodox is that which moves counter to such accepted ways. Orthodoxy is buttressed by established values, indeed feeds on them. The unorthodox must throw these aside and find its own way. Orthodoxy is the establishment. Unorthodoxy is the separate individual. In a social context, orthodoxy flourishes when there is no incentive to question the patterns according to which one lives. The unorthodox is ignored because no one can believe it. In times of change and trouble man may well turn to the unorthodox because orthodoxy is failing or has failed. Only then can it be believed, and with general belief the paradox stands revealed. For as men accept the unorthodox it inevitably loses its negative connotation. The old ways of truth are proved false. The new is accepted. Once accepted the unorthodox becomes orthodox. Today's revolt becomes tomorrow's order. Indeed, if pursued far enough, today's revolution may be tomorrow's oppression.

In all of this, art has a special place. Art above all else is a pursuit of reality, and in this pursuit, it must be essentially unorthodox, for the artist, by definition, will see what others cannot see. And if he cannot present the world anew to those caught in orthodox ways, he will at least himself see the world in a new way. Nor need he become trapped in the acceptance of his own vision. Is this not a central driving force in the art of our own day? Modern art in the West may offer certain delights, but it is also a painful process: "Contemporary art is constantly inviting us to applaud the destruction of values which we still cherish."[1] In the realm of the arts this sets the stage for the most complete unorthodoxy the world has ever known.

Seventeenth-century China cannot match this. While it is necessary to remember that in an exact sense no great artist can really be acused of orthodoxy, did seventeenth-century China really produce eccentric painters? Indeed, modern man might well ask wherein lies the claim that Chinese art ever was unorthodox. John Canaday, scarcely a

1. Leo Steinberg, "Contemporary Art and the Plight of Its Public," in *The New Art*, ed. Gregory Battcock (New York, 1966), p. 37.

revolutionary, tells us that "to Western eyes (including mine) the difference between orthodoxy and eccentricity in Chinese painting is never extreme."[2] Was Ku K'ai-chih, for example, truly a shock to his contemporaries? Biographies of the Seven Sages of the Bamboo Grove relate behavior that seems odd enough even for the modern reader, but can we claim artistic unorthodoxy for those beautiful line portraits that come to us stamped on the bricks of a Nanking tomb?[3] I-p'in ("untrammeled class") is a marvelous idea, but what is the real nature of its method?

However, history tells us that in the seventeenth century there were painters that we can class as orthodox and painters that we can class as unorthodox. Artists were very much part of a long historical process. They could look back on the unorthodoxy of the Yüan and Ming and see in its subtly varied expression an accumulation of increasingly acceptable and accepted values. They could seek to age new wine in these old bottles, or they could throw away the bottles and begin again, even going back, as it were, to the vine itself. This is the generally accepted contrast between the art of two great contemporaries: Wang Hui (1632–1717) and Tao-chi (1641–ca. 1720).

To what extent was Tao-chi unorthodox? It may be well to examine the nature of earlier unorthodoxy, particularly paintings associated with the already mentioned i-p'in. Aesthetically recognized, as Shūjirō Shimada tells us, during the mid-T'ang period, "the i-p'in style demolished the 'fidelity to the object in portraying forms' law ... and liberated all of Sung painting that lay beyond from the strictures of faithful depiction of objective, representational form through the use of contours in fine line."[4] But in doing so it seems apparent that there are factors which give it orthodoxy. Certain parts of a free ink painting may be done with varying attention to precision and exactitude. In ink works connected with the figure style of Kuan-hsiu and Shih K'o, the roughness of expression used to give some sections—particularly drapery—their unorthodox individuality is held in check by the generally careful linear definition of such parts as faces and hands. Landscapes in this same ink tradition—particularly among the Ch'an artists Yü-chien and Mu-ch'i of the late Southern Sung—indeed have their rough touches of straw- or sugarcane-drawn mountains or abbreviated suggestion of trees and headlands, but they also may have their subtle suggestions of mist or soft light which inevitably create a calming and unifying ambient.

I can suggest two other important examples of painting where unorthodoxy in one part or parts is countered by more traditional respect in others. One is the fascinating scroll in the Crawford collection, attributed to Li Kung-lin but most certainly executed at a slightly later date, representing the Odes of Pin. Here artless unorthodoxy, particularly in respect to figures, is balanced by the most sensitively exact approach where plants and insects are involved.[5] It is possible that there are important psychological,

2. *New York Times*, Mar. 26, 1967, p. D23.
3. See *Kokka*, no. 857, pp. 15–21.
4. Shūjirō Shimada, "Concerning the 'I-p'in' Style of Painting, III," *Oriental Art* 10 (1964): 6.
5. See James Cahill's analysis of the painting in Laurence Sickman, ed., *Chinese Painting and Calligraphy in the Collection of John M. Crawford, Jr.* (New York, 1962), p. 92.

historical, and technical reasons behind this schizophrenic presentation, but for our purpose the scroll would seem to be a further affirmation that in a clash with orthodoxy, orthodoxy is not forgotten.

Further, it is possible that this kind of "dualism" in painting need not only be found in extant examples close to the thirteenth century. There is no more unique creator of a figure type than the late Ming artist of Suchou, Li Shih-ta. With this "mannerist" painter unorthodoxy is shown by an exaggeration of form, so that in their massive weightiness and stubby contours figures become a travesty on the creations of any previous artist. Although there are hints of dependence on earlier Suchou painters, the figures of Li Shih-ta remain essentially his own unique creations. Still, within the aspects of painting we are considering, Li Shih-ta has his orthodoxy. This is seen particularly in his painting of flowers. In a scroll of T'ao Yüan-ming, now at the University of Michigan Museum of Art (fig. 1), it is the chrysanthemums alone that in their light touch or even contours remain true to a tradition that respects the object, whereas all else speaks either of the artist's personal unorthodoxy or allusions to the antique, ostensibly revived in defiance of accepted contemporary Suchou vision.

Figure 1. Li Shih-ta, *T'ao Yüan-ming Appreciating Chrysanthemums* (detail), 1619, hanging scroll, ink and colors on silk. University of Michigan Museum of Art, Ann Arbor (1960/1.184).

To return, however, to Shimada's article: the existence of an unorthodox-orthodox dualism within the matrix of a single painting as a method of ensuring a stabilizing focus in "far-out" expression can only be one factor making for the respectability of the new and the strange. The second requirement is that the total expression itself should be in harmony with age-old ideas about the aims of painting—specifically, that it should have "spirit consonance" (ch'i-yün). Thus, although fidelity in drawing is a far too constricting frame of reference, the end result is not altered, and different means add up to a traditional end: "the forms were complete."[6]

In the seventeenth century it is above all Tao-chi who stands as the greatest exponent of unorthodoxy. This is so because of his many-sided genius and because throughout his life he seems to have retained the notion that at all costs individuality must be preserved. His painting is proof of that determination. Anyone who has attempted to "organize" Tao-chi's work cannot help but feel a certain frustration. It is difficult to say that he paints one way, because he then turns around and paints another way. Dry brush, becomes wet, a full composition becomes empty, diagonals change into horizontals, a central motif will be countered by a one-sided arrangement, the complete by the incomplete, archaism by modernization.

In an atmosphere that respected the notion of the history of styles, Tao-chi's treatment of them was not of a copybook nature. Kuo Hsi is "modernized" in the great *Waterfall at Mount Lu*, in the Sumitomo collection. And most surely the moist small sketch in the style of Ni Tsan now in The Art Museum of Princeton University would be difficult to recognize as adhering directly to the style of that dry hero of the past were it not for Tao-chi's statement of that fact written on it. We know from literary references that Tao-chi also copied paintings, and it is possible that the extant copy of Shen Chou's *Trip to Chang Kung's Stalactite Grotto* is his rendition of that famous painting.[7] It would not ever, however, be confused with the Ming master. The rather stereotyped phrase to the effect that if an artist's works were mixed up with those of the old masters one could not tell the difference would hardly apply to Tao-chi.

If, then, his own style defies definition; if, in turn, his imitation of the ancients defies the look of the old masters, how can we claim anything but the highest unorthodoxy for one who so deliberately expresses a constantly shifting individuality? I think we come back to the same answers that are found in Professor Shimada's analysis of the *i-p'in* style. There are passages in Tao-chi paintings that clearly convey the appearance of what we expect to see within the known context of Chinese art. In the Boston Museum's *Conversion of Hariti* of the 1680s or an earlier scroll of lohans of 1667 (fig. 2), the rather precise definition of the figures stands as a marked contrast to the surging freedom of the landscape. But beyond this, are Tao-chi's landscapes as a whole truly so eccentric? Quite simply, there are trees and mountains, rocks and streams, cliffs and grasses. There

6. Shimada, "Concerning the 'I-p'in' Style of Painting, II," *Oriental Art* 8 (1962): 9.

7. See Richard Edwards, ed., *The Painting of Tao-chi: Catalogue of an Exhibition, August 13–September 17, 1967. Held at the Museum of Art, University of Michigan* (Ann Arbor, 1967), no. 31.

Figure 2. Tao-chi, *Sixteen Lohans* (detail), 1667, handscroll, ink on paper. Collection unknown. Photograph from the photographic archive at the Department of Art and Archaeology, Princeton University.

is architecture, and there are people (fig. 3). The fact that we recognize Tao-chi's paintings as containing such elements may indeed be due to a degree of expectation, since they are often rather free touches of ink or color; but this degree of expectation must, after centuries of landscape art, have been present in seventeenth-century eyes as well. Tao-chi himself may have referred to the painting now in the Suchou Museum (fig. 4) as *Ten Thousand Ugly Ink-Dots*, but free as are these ink splashes, we clearly read them as leaves and twigs and vines—the spontaneous explosion of a free yet still natural world. And, it must be added, tradition remains: Tao-chi on the same painting cannot help but mention Mi Fu and Tung Yüan.

If details, then, do not do real violence to our expectations of the natural scene, if we still find a certain latter-day "fidelity in drawing," can we also say that the paintings themselves add up to that final satisfying conclusion: "the forms were complete"? In the widest sense this is exactly what Tao-chi achieves, so that today's critics can speak of "a flow of pure force through and beyond the picture, which thus becomes a small segment of a boundless continuum of matter and energy."[8] Or we detect an "enigmatic

8. James Cahill, ed., *Fantastics and Eccentrics in Chinese Painting* (New York, 1967), p. 84.

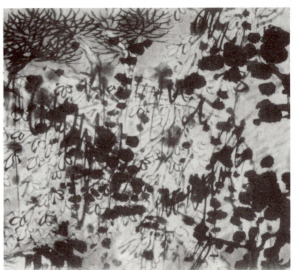

Figure 3. Tao-chi, *Sketches after Su Tung-p'o's Poems* (detail), 17th century, album leaf, ink and light color on paper. Abe collection, Osaka Municipal Museum of Fine Arts, Japan.

Figure 4. Tao-chi, *Ten Thousand Ugly Ink-Dots* (detail), 1685, handscroll, ink on paper. Suchou Museum, China.

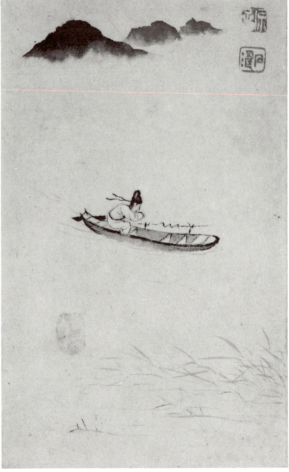

Figure 5. Tao-chi, "Skiff at Pai-sha," leaf from *Small Album*, ca. 1695, album of twelve leaves, ink on paper. Anonymous long-term loan, The Art Museum, Princeton University (L40.65).

link between the artist creator and the world created."[9] These are, to be sure, meta-physical unities, but in painting we are made aware of them because of what we see. They are, above all, unities, and they certainly are as explicit as "spirit consonance" (*ch'i-yün*)—a term not found, incidentally, in Tao-chi's famous *Hua-yü-lu*. Apparently Tao-chi's search was for a principle of origin rather than of aesthetic results. If one finds the source, the rest takes care of itself. Tao-chi finds this principle in the "single stroke" (*i-hua*). At first this may suggest the ultimate "unorthodoxy," for it tells us that each painting must be a separate individual adventure freed of all preconceptions. But in fact Tao-chi is only evoking old truths. The reduction of the incomprehensible confusion of multiplicity to a single exact if mysterious principle is as old as the great philosophers of China. This is the *Tao* of Lao-tzu, and it is Confucius' disclaimer of multiple wisdom: "My Way is such that One threads everything" (*Wu Tao i i kuan chih*).[10] This quotation concludes the opening chapter of the *Hua-yü-lu*.

In the long history of Chinese art the notion of a single unifying principle is, I think, rooted in the expression of space. From the time close to the Han period when Chinese vision broke through the flat screen of surface that was "purely ornamental,"[11] one factor has always established the orthodoxy of its painting—unity, or oneness of space. Figures are always surrounded by space. The elements of a landscape, no matter how much they are seen as contending or contrasting forms, are inevitably tied together by depth of space. Tao-chi's shifting inventions all live in such an ambient (fig. 5). They are still structured by age-old ways of seeing. Space, like the "thread" of Confucius' way, may in Tao-chi even penetrate through the illusion of solid matter and permit us to enter into the very substance of the hills (fig. 6). Starting with the separate freshness of the "single stroke," we end up nevertheless with an orthodox unity of space. To use the flat surface of wall, of silk, or of paper to do other than suggest in varying degrees the notion of "1,000 *li*" simply was not within the scope of Chinese vision. Perhaps it is not going too far to offer a further suggestion: China has yet to become a modern industrial state, and in painting China has not yet affirmed the positive values of the vision of Cubism.

The problem of further explaining "unity, or oneness of space" is, I fear, something that needs more pages and illustrations than can be permitted within the scope of this volume. A difficulty with such "laws" is that by overcondensation (oversimplification) they become meaningless. To state that the world is round is superfluous for anyone who has at hand the photography of the Apollo space flights. To pre-Copernican thought, the claim was dubious if not ridiculous. However, statements about painting are not laws, simply because the study of painting is not a science. The basic validity of "oneness

9. Richard Edwards, "Tao-chi the Painter," in *The Painting of Tao-chi*, p. 52.
10. *Lun-yü*, bk. 4, "Li Jen." Among other translations, see A. Waley, *The Analects of Confucius* (London, 1938; rpt. New York, n.d.), p. 105.
11. Max Loehr, *Ritual Vessels of Bronze Age China* (New York, 1968), p. 12.

of space" cannot lie in mathematical proof. Nor are we likely to find affirmation in combing Chinese texts. Not being able to see otherwise, Chinese critics—at least from the Sung onward—could hardly be expected to see an important alternative with which to contrast their orthodoxy. Proof must lie rather in the realm of contemporary experience, whether or not other eyes than mine find that it states a basic and also meaningful truth as they continue to look at Chinese painting. Here, then, let me explore the notion a little further.

Even at its most "abstract"—by which I mean arbitrarily inventive—Chinese landscape never breaks with physical experience. If space were not consistent ("one") as we move about the physical world, life would be extraordinarily complex. Not only would we be stubbing toes and cracking heads, but it is doubtful that we could find our way back home at night. We look upon the sea, the mountains, the plains, a city street, or just our backyard, and objects there remain—shifting as we move or as the light changes, perhaps, but still objectively consistent within the notion that an encompassing single space holds them in a just and understandable equilibrium.

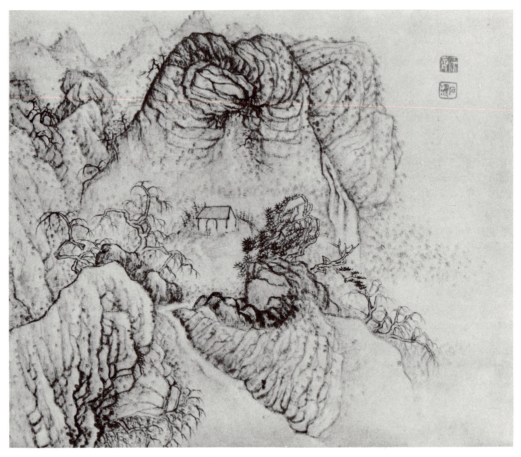

Figure 6. Tao-chi, "The Mountain Path," leaf from *Twelve-Leaf Album for Taoist Yü*, 17th century, ink on paper. C. C. Wang collection, New York.

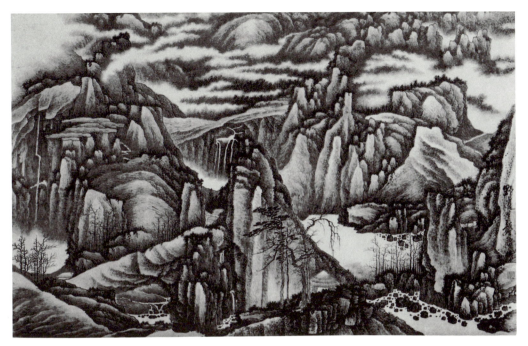

Figure 7. Kung Hsien, *A Thousand Peaks and Myriad Valleys*, 17th century, hanging scroll, ink on paper. C. A. Drenowatz collection, Zurich.

The artist is, however, not bound by this experience unless he so chooses. Historically it was a hard-won discovery for painters in the major traditions both East and West, and hence not something to be readily cast aside. In China it was so well established by the Sung that it could not be ignored by the "individualism" that followed. And if the art of the Yüan, Ming, and Ch'ing turned to pure "style," that style never completely rejected this fundamental root of Sung experience. For the modern West certain denial of this special consistency seems only to have come with Cubism. By turning their backs on the stable measurements of space first discovered by the Renaissance, the Cubists affirmed what no Chinese artist has yet come to believe: that a fractured, broken, *flat* world—where space is glimpsed, lost, found again, but never assumed, never easy—can be a meaningful world.

Let me illustrate this in one other Chinese painting, the great Kung Hsien landscape in the Drenowatz collection (fig. 7). It is appropriate to bring Kung Hsien into the discussion because he was an older contemporary of Tao-chi, and his ideas on painting reflected many of the freedoms that Tao-chi's theories seem to have exemplified more fully.[12] It would be difficult to find a painting more tightly packed (full of forms) than this dark and mysterious landscape. There is no horizon line, a fact which tends to thrust the forms at us so that we feel with a special intensity the sharp lights and deep darks of a strange and brooding world. It would be difficult, too, in Chinese landscape painting

12. See M. Wilson, "Kung Hsien, Theorist and Technician in Painting," *The Nelson Gallery and Atkins Museum Bulletin* 4 (1969).

to find a more varied juxtaposition of shapes. Rocks, valleys, cliffs, grottos, tree, stream, cloud, and mountain peak compel a continual movement which does not allow us to rest for long at any particular point. Form is alive, not alone because of shape, but because of restless and arbitrary juxtapositions. And there the ambiguity of a spatial arrangement becomes a constant reality, a vital part of the shifting life of the painting. In the lower right, sharp squares of ink, a scattering of boulders, dot the surface of shining flat white paper. In the upper left corner is a slightly grayed area of light tone, which melts into a brooding dark, so that we are not quite sure whether it is cloud or whether it is rock, and the whole tends to drift forward, even beyond the picture plane itself. Repeated horizontal, jagged-edge patterns of white lie across the upper portion of the picture. We read these white patches as clouds. There are other ambiguities. The white glow on irregular clusters of peaks—as in the right middle distance—causes them to float forward. A dark pocket with shining white threads of water (bottom left) recedes. Another burst of white which somehow seems both to fall back and come forward is the bright area that silhouettes the brief tree cluster by the lower left edge.

The almost endless manipulations of form and space are exactly what give this dense vision of the world multiple life, and by creating constant and ever-shifting experience the artist can claim a bond with nature itself.

But the individuality of parts, the variety, the ambiguities, the accumulation of different experiences, and, ultimately, the artist's separate creativity are held in focus by what I shall claim is a special kind of unity. Variety alone does not produce a shattered picture, and what above all provides unity is the fact that each separate piece of the painting ultimately joins something (another part). Nothing breaks off from the whole. There is a fusion of parts which brings them all into equilibrium. If you stand back from the painting and see it as a whole, as opposed to examining its detail, all parts do "fit" together. Despite the absence of a defined horizon, they do fall into a space which is consistent with the experience of space in the natural world. The foreground is closer; the far peaks do recede. And this is because the space we sense as the total ambient of the picture is not broken. All variety is ordered by an ultimate unity. The "oneness" of space is affirmed.

I admit that a statement such as this about Chinese painting would be essentially meaningless if we were not able to indicate that there is a different way of approaching the world around us. This, in fact, is to be found on both sides of China, to the west in Central Asia and to the east in Japan. I will not here deal with Central Asia since existing paintings suggest that no major landscape tradition was developed there, and aesthetic considerations must be focused on another kind of subject matter. Historically the Central Asian aesthetic most affected China in the Six Dynasties and early T'ang periods. Japan, clearly, is another matter. Whereas there are times when one finds its landscape painters painting in a very "Chinese" manner, on the whole Japanese imitation of Chinese subjects has little to do with the aesthetics—in the last analysis, the "meaning" —of Japanese landscape.

One of the most "Japanese" of Japanese painters was Sesshū, and his *Winter Landscape* in the Tokyo National Museum is a clear example of this point (fig. 8). Seen beside Kung Hsien's landscape, the differences must be evident. However, despite the fact that there can be no question of specific influences, the forms used by the two artists are not as unlike as one would expect from painters who had absolutely nothing to do with each other. This observation can only be explained by the tenacity of an abstract landscape tradition in the Far East upon which both artists were drawing. The chimney-like pin-

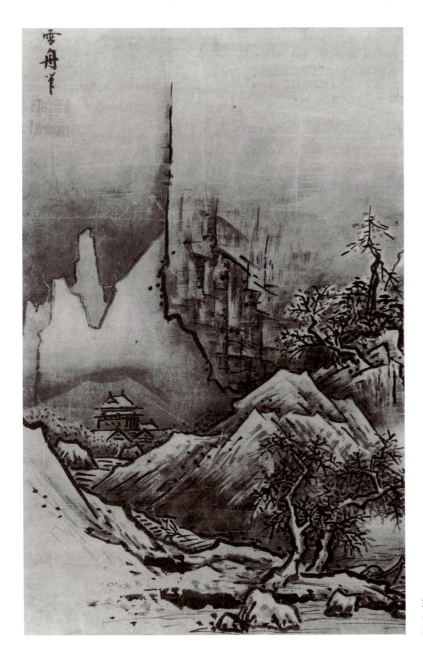

Figure 8. Sesshū, *Winter Landscape*, 15th century, hanging scroll, ink on paper. Tokyo National Museum, Japan.

nacle of a far peak (placed by Kung Hsien in the middle distance), the vertical cliff profile (undercut at the bottom), the triangular middle distance hill-rock (on the right side of each picture), the use of very few trees and then only as selected, isolated accents—these indicate a similar general approach. The paintings are also alike in that Sesshū and Kung Hsien are both emphasizing spatial ambiguities. For Sesshū the top of the picture seems both to come forward and go back, to be both cloud and cliff, not unlike the upper left corner of the Kung Hsien in intent. The life of the picture depends, too, on abrupt changes between light and dark. Boulder, tree, fractured cliff face, brooding sky, and bright towering peaks create an ever-shifting scene, the movement of life, contrasts and tensions. This effect is clearly the result of the artist's own arbitrary manipulations— shapes, juxtapositions, ink values, composition—his own inventions, in a word, his style.

But with Sesshū there is a major difference. His personal vision never does relate to the ultimate unity that is Kung Hsien's overriding necessity. While the parts work together sufficiently to create the illusion that we have before us a "view" of the landscape in winter, it is in the nature of Sesshū's art to have those parts retain their separate identity. The painting thus appears to be built up of isolated elements, whereas Kung Hsien's elements have never been separated from the whole out of which they "grow." Moreover, since in Sesshū parts do not blend easily into something else, we are made all the more aware of what they are: the flatness of white paper, the sharpness of a black line, the exactness of a gray area of wash which often reflects the separated hairs of the brush that placed it there. This means that the materials of art are not disguised. We do not lose track of them in the broad illusion of the landscape. The Japanese artist immediately confronts us with a world that is different in kind from the one in which we live. It is an artificial world. The Chinese artist does not demand this kind of transfer. He will not do it, for, despite his clear awareness of style, he is concealing the physical attributes of art in favor of an illusion of the physical attributes of a world that does not break with nature. A painting is not a flat piece of art; it is an unbroken extension of the world in which we live. Because of this it is easy to imagine the landscape extending beyond the borders of the paper which limit its material definition.

This distinction between the ink painting of China and the ink painting of Japan has generally gone unanalyzed because traditional Chinese eyes and those of most Western scholars have seen Japanese ink painting as essentially an imitation—a rather superficial imitation—of China. Modern European and American experience demands otherwise, and it is with Cubism that the understanding may come:

> We are at a period of artistic creation in which people . . . create works of art that, in detaching themselves from life, find their way back into it, because they have an existence of their own apart from the evocation or reproduction of the things of life. Because of that, the Art of today is an art of great reality. But by this must be understood artistic reality, and not realism—which is the genre most opposed to us. . . . cubism is painting itself.[13]

13. Pierre Reverdy, *On Cubism* (Paris, 1919), quoted in Edward F. Fry, *Cubism* (London, 1966), p. 145.

Figure 9. Sesshū, *Winter Landscape*, detail of figure 8.

Beginning in 1912 the work of Picasso and Braque—and ultimately most major painting of our century—is based on the radically new principle that the pictorial illusion takes place upon the physical reality of an opaque surface rather than behind the illusion of a transparent plane.[14]

The forms chosen were invented, not copied from nature; and this product of intuitive invention differed fundamentally from the Cézannian composite form, which was the result of a cumulative psychological process, closely tied to visual experience.[15]

Cézanne turns a bottle into a cylinder, but I . . . make a bottle—a particular bottle—out of a cylinder.[16]

In a sense, what Picasso and Braque discovered was the independent reality of the pictorial means by which nature is transformed into art upon the flat surface of a canvas.[17]

The aesthetic change suggested in these quotations is the change one must make as one moves from the mainstream of the painting of China to the mainstream of the

14. Robert Rosenblum, *Cubism and Twentieth-Century Art* (New York, 1960), p. 72.
15. Fry, *Cubism*, p. 39.
16. Juan Gris, quoted in Rosenblum, *Twentieth-Century Art*, p. 112.
17. *Ibid.*, p. 66

painting of Japan. Scholar-painting in China was "the result of a cumulative psychological process, closely tied to visual experience." Japanese painting takes place "upon the physical reality of an opaque surface." It is no accident that in a part of Sesshū's *Winter Landscape* (fig. 9) one can find a passage which is analogous to a corner of Picasso's famous *Ma Jolie* (figs. 10–11). Although one might not wish to carry the comparison too far, they are alike in this: rigid lines and shattered planes never really quarrel with the flatness of the surface on which they are brushed and have little to do with the automatic depth of natural space.

That Chinese painting—particularly landscape painting—should be essentially a direct extension of our physical experience is its basic orthodoxy. This is unity of space. To suggest that the coherence and meaning of an aspect of Chinese culture may rest on such a single idea is, as we have already said, hardly foreign to Chinese thought. Several other writers in this volume have indicated this kind of direction in their analysis. F. W. Mote has observed that Chinese artists were part of "a unitary civilization . . . were one group with the elite of government and society, with the elite in the world of affairs, both as producers and as audience." Socially coherent, the main stream of their creative activity was guided by such simple, yet all-embracing terms as *cheng* or *fu-ku*, upon which the notion of individuality or deviation, *pien*, depends. The very fact that the present could not be seen as independent of the past is its own statement of unity. Wei-ming Tu has seen the search for the self, or "inner experience," not as a solely independent act but as something involving "the community of the like-minded," leading to a cohesive *shen-hui* with the ancients. If Tung Ch'i-ch'ang, as Wai-kam Ho tells us, sought to "combine the best" of "two traditions," this is also a very Chinese way. Further, in the visual arts, Richard Barnhart has affirmed that "those masters who chose the path of archaism were often pursuing a deeper substance." Depth in Chinese painting is both a philosophical and a spatial depth: "Beyond the divine continent there are more divine continents."[18] Depth of space led to depth of thought. Depth of thought brought the Chinese into the area of philosophical affirmation that saw truth resting on single principles. This way of thinking is a consistent mark of Chinese civilization itself.

18. Roderick Whitfield, *In Pursuit of Antiquity* (Princeton, N.J., 1969), p. 123. The observation is a seventeenth-century one, written by Ch'eng Sui on an album leaf by Wang Hui.

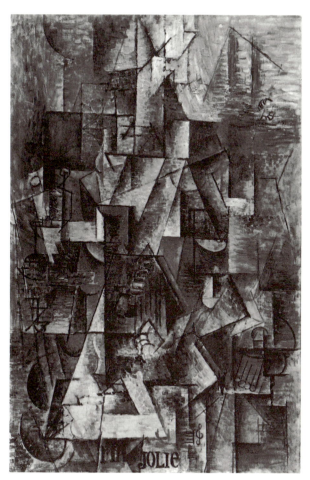

Figure 11. Pablo Picasso, *Ma Jolie*, detail of figure 10.

Figure 10. Pablo Picasso, *Ma Jolie*, 1911–12, oil on canvas. Museum of Modern Art, New York, acquired through the Lillie P. Bliss Bequest.

ORTHODOXY AND INDIVIDUALISM
IN TWENTIETH-CENTURY CHINESE ART

Michael Sullivan

Studies of Chinese art, unlike those of almost any other aspect of Chinese civilization, generally stop well short of our time, of which the momentous events seem at first glance to be separated from the Great Tradition by the apparently featureless wastes of the nineteenth century. Because it is easy to discount the continuity, it is easy to avoid also the question of the nature and effects of the massive two-pronged assault of Western art and Marxist ideology. Yet we must ask ourselves whether in recent years the chain of tradition has been snapped, or merely snarled, and whether the concept of "orthodoxy" has any meaning in the new society. Change is continuous, and it is certainly too soon to assess the effects of the Cultural Revolution of 1966–1968. So what follows must be regarded as extremely tentative.

The art of the twentieth century divides naturally into two periods: 1910–1949, and 1949–1966. The first period was marked by social and cultural chaos, by conflict in art between entrenched tradition and modern, hence foreign, influence, by cosmopolitanism and by lack of encouragement or control from any quarter. The second period (up to 1966 at least) has been one of social and cultural stability, increasing cultural isolation, and direct official control and support of the arts.

Can we speak, in the first period, of any kind of orthodox transmission at all? Traditional painting continued until the 1950s with its vigor undimmed; but at the same time the social and intellectual attitudes that went with it were being undermined. Artists who were not in any sense *wen-jen* were beginning to look on the orthodox tradition, much as did Japanese exponents of the *bunjin-ga*, as a style of painting, not as a way of living and feeling. This helped to ensure its survival after 1949, although it came under attack from the Red Guard and the 4-Antis movements.

The modern movement of the 1920s and 1930s leaned heavily on the School of Paris, and the French Concession in Shanghai became, for a handful of returned students, a transplanted Montparnasse. But their bohemian orthodoxy (Hsü Pei-hung's floppy bow tie and long hair) never took root, and was shattered by World War II. After 1937, painters found a new identity with the people; but there was, perhaps for the first time

201

in Chinese history, no orthodox stream, only some unity of aim: painters felt the need to express, in the Chinese medium, the bitterness they felt about the deepening chaos in which they lived. The very concept of a stylistic orthodoxy, implying a consciousness of the history of style, would have seemed irrelevant.

One might have expected that after 1949 the Party would have imposed a rigid orthodoxy in the arts, and that, as in Russia, this could only take the form of Socialist Realism. Propaganda art (sometimes crude realism, but more often "revolutionary romanticism") certainly has held a dominant place. But there have been many other influences at work, and the situation, up to 1966 at least, has been complex and fluid.

Natural pride in China's cultural heritage led to all old works of art being cherished and protected, even those of a kind which one would think ideologically unacceptable— for example, the painting of the literati and eccentrics, and academic painting, which are perfect examples of bourgeois formalism and, in the case of literati painting, was the exclusive province of a class elite. But the Party theorists, being Chinese, were too sophisticated simply to flatten history with an ideological hammer. Instead of clumsily attacking traditional art, they sought to show that it is, in fact, highly "realistic." For the Chinese painter, these critics said, seizes not upon accidentals but upon the essence. The dragon's claw in a cloud symbolizes the whole creature. Tsung Pai-hua quotes Blake: "to see a world in a grain of sand," and comments, "this is the essence of the realistic creative method of the classical Chinese artistic tradition." He goes on: "it is obvious that this creative method of correlating the abstraction (the essentiality) and the concrete reality has been applied in Chinese painting since very early times,"[1] and cites Ku K'ai-chih. Chang An-chih wrote in 1964, "Most classical landscapes are highly realistic in the sense that they are a synthesis of nature and the artist's feelings and ideas." It is, after all, a way of putting it. The important thing is not whether the Chinese tradition is realistic or not, but that the accepted theorists should have called it so. In this typically Chinese manner, a head-on ideological conflict was avoided.

The ban in China since 1949 on abstract expressionism, op art, kinetic art, minimal art, etc., was not instituted on stylistic grounds. As regards abstraction, for example, the theorists have said that China has no need of it because she already has, in calligraphy, a highly abstract art of her own. So they were clearly not opposed to abstraction as such. These movements were condemned not because they were abstract and formalistic but because they were associated with decadent capitalist culture.

Again, one might have expected the Party theorists to have condemned the use of a vocabulary of conventions in landscape painting. But this has not happened. In 1958 the painter Ch'ien Sung-yen visited Hua-shan.[2] He described how on the cliffs he saw, for the first time, a real specimen of lotus-leaf ts'un. He says the ancients did not concoct this out of their heads but from actual observation of rock forms, but that later painters simply

1. "The Abstraction and Reality in Chinese Art." *Wenyi Bao* (Summer, 1961), translated in *Chinese Literature*, no. 12 (1961), pp. 82–86.

2. Chang An-chih, "The Painter Ch'ien Sung-yen," *Chinese Literature*, no. 9 (1964), p. 103.

copied it until it no longer resembled the real rocks. "As soon as I saw Hua-shan," he wrote, "I realised that the lotus-leaf *ts'un* as shown in painting manuals have lost their authority; they should be refashioned by checking against the rocks of Hua-shan."[3] So when painters today visit the sacred mountains and Chairman Mao's birthplace, it is not simply to refresh themselves at the fountainhead of nature and history, but to "check their *ts'un*." The conventional language is not abandoned in favor of Western-style realism but revised in the light of observation. The same applies in some degree to figure painting, in which, after a perfunctory checking of the figure beneath the garments, the language of the brush takes over. The new solidity of figure painting is an expression of extrovert self-confidence rather than the result of practice in drawing from the nude.

The most influential landscape painter in China today (until 1966, at any rate) has been Li K'o-jan, not because he is a realist or has shown the limits within which the traditional painter may operate (these have not been defined) but because he has most successfully "checked his *ts'un*" and enlivened and enriched the vocabulary with new conventions for rocks and mountains, trees, bridges and boats (the automobile remains intractable). Already other painters—for example, Ch'ien Sung-yen, Lo Ming, and Shih Lu—are adopting his style.[4] If this is "Socialist Realism," it is only socialist in the sense that its content is ideologically acceptable, and it is realist in the almost metaphysical sense of the words I have quoted from Chang An-chih above. Li K'o-jan's following suggests that this checking against nature need not be a continuous process and that, once achieved by one generation of artists, the revised conventions will serve until the genius of an individual breaks through them or external forces create the conditions for a reassessment.

Since 1949, the basic modes of ideation and expression in art have been subjected to two waves of attack. The first, from orthodox Socialist Realism, was deftly turned aside, as shown above. The dangerous moment when Chinese painting might, under Russian influence, have abandoned its traditional vision and methods passed, and in Li K'o-jan and his following we see the first signs of a new orthodoxy as clearly of its period as is the school of Li T'ang. At the same time a variety of traditional styles were revived to depict modern themes: a handscroll, for example, illustrating voting day, in the manner of Ku K'ai-chih; a panorama, *"The Commune Is Fine!"* in the Li Ssu-hsün blue-and-green style; the Sung academy style, used, quite appropriately, for a picture of Young Pioneers visiting the Forbidden City. While the motive was primarily a reassertion of Chinese against foreign art, it was also a rejection of the immediate, decadent, cosmopolitan past and a return to a remoter, solider, more purely Chinese tradition—a declaration that Chinese painting had recovered its true nature and was back on the tracks once more.

3. *Ibid.*, p. 107. For further accounts of the work of recent painters, see Ralph C. Crozier, *China's Cultural Legacy under Communism* (New York, 1970), pp. 226–42.

4. Their work has been reproduced in many issues of *Chung-kuo Hua* and *Chinese Literature*. See also Eva Rychterová, *Li Ko-jan* (Prague, 1963).

This is *fu-ku* in its most literal sense. On a much higher level is the imaginative recapturing of the past in the paintings in the T'ang and Sung manner done by Tseng Yu-ho in the 1950s. Scholarly, sensitive, and profoundly original, they represent not merely *fu-ku*, but *ku i*, the spirit of antiquity living in the present. By contrast, the remarkable parallel between the work of the ninth-century ink-flingers and modern abstract expressionists such as Zao Wou-ki and Liu Kuo-sung is an accidental, or certainly an unconscious, rediscovery of the past.

The second attack, during the Cultural Revolution, has been more devastating because it left no room for theoretical arguments as to whether, for example, Tao-chi was a realist or not, but denied the validity of the past as such. The 4-Antis movement represents a titanic effort to obliterate the past from men's minds. Can it succeed? With the destruction of the intelligentsia as a class it must achieve a great measure of success. Nevertheless, so long as the traditional forms of expression—the ideograph, the conventions of the drama, the formalized language of painting—are not abandoned, they will continue to provide vital links with the past. They remain the custodians of concepts and ways of thinking of which those who use them may not be aware. By becoming infused with new subject matter and associations, these forms are in fact saved from atrophy and given a new lease on life. Whenever a student writes a big-character slogan or an actor in a revolutionary opera opens a door that is not there, he is, whatever his conscious purpose, reasserting the validity, and the vitality, of the traditional Chinese nonrealistic, symbolic mode of expression and communication.[5]

The rejection by the artists themselves of avant-garde trends in Western art has been made easier by a number of factors in traditional Chinese culture referred to by other writers in this volume. The ethical challenge of communism, so overwhelmingly accepted after 1949, embraced that concept of the oneness of the artist with the elite in government and society (i.e., the Party) described by F. W. Mote in his essay. If traditional China was, in his words, "a unitary civilization," how much more is this the case today! The arts in China could never escape, as Mote puts it, "from the same responsibilities that all other activities of cultivated man had to bear." None but an out-and-out eccentric who cared nothing for society—and in China such a man would be an eccentric indeed—would think of practicing forms of art which were incomprehensible to his fellow men. They might not fully appreciate a landscape by Tung Ch'i-ch'ang, but at least they would know what it represented. The story in Kuo Jo-hsü's *Experiences* of the farmer who criticized the buffalo painter for his inaccurate observation (censure

5. Tsung Pai-hua ("Abstraction and Reality") gives the actor's symbolic gestures, and the suggestiveness of Pa-ta Shan-jen's birds and fishes poised in empty space, as examples of "the creative method of correlating the abstraction (the 'essentiality') and the concrete reality," which "has been applied in Chinese painting since very early times." Cf. also Hsia Chou on Tao-chi: "In his volume of anecdotes about painting [*Hua-yü-lu*] he advocated that artists should take nature as their guide but give their own interpretation of it. Fundamentally, then, he was a realist" (quoted in *Chinese Literature*, no. 2 [1966], p. 103). As one would expect, critics in China since 1966 have ignored this problem and have hammered away at one theme only: the need, in all the arts, to infuse old forms and foreign techniques with revolutionary content.

heartily approved of by Kuo Jo-hsü himself) could have come straight out of *Mei-shu* or *China Reconstructs*.[6]

The present emphasis on figure painting, and particularly on pictures of China's new heroes, old and young, not only represents a turning away from elite landscape painting towards a far older and more democratic tradition but is fully in line, says Mote, with that tradition's idealizing of "man's achievements as the only enduring and transcendent value in life." Another approach to this concept of ideas in action is stressed by Wei-ming Tu. In his contribution he cites Wang Yang-ming's conviction that ideas are empty "if they are detached from the concrete experiential bases on which they are meaningfully organized." This ideal too was once, and is now again, a powerful stimulus to figure painting as illustration and example.

Yet another factor that has made artistic conformity acceptable is referred to by Yu-kung Kao and Tsu-lin Mei in the opening paragraph of their essay, in which they note how for centuries after the T'ang dynasty "poems in the Regulated Style of commendable quality, though often of little originality, continued to be mass-produced." "The artists involved," they wrote, "were both crippled and supported by the conventions." Generally, the Chinese painter and poet are content to be orthodox and to work within narrow formal limits: the narrower the limit, the more significant is every nuance of expression and the greater the powers of discrimination and taste demanded of, and developed in, viewer and reader. We must ask, however, whether this attitude is peculiarly Chinese. English poets in the eighteenth century were, almost without exception, content to follow in the footsteps of Dryden and Pope. Then, a high degree of cultural uniformity was taken for granted. It is our modern Western attitude, with its emphasis on original-ity, that separates us from traditional Chinese modes as it has from our own past. The strangeness here is not of an alien culture but of an earlier epoch. Yet it is true that in general Chinese artists have accepted a pressure to conform, direct or indirect, that a European would find intolerable.

To Chinese painters in the decade after 1949 the situation must have looked much as it did to those living under the Manchus in K'ang-hsi's reign who "though they may," as Jonathan Spence puts it, "have been nostalgic for the Ming at times . . . had little to complain about and no incentive to rock the boat." Many were in the position of Wang Hui, and I quote Spence again: "to maintain his position, he needed but to continue to please intelligently; or, to put it another way, he should dazzle but not bewilder." Dazzlement we certainly find in the huge composite landscapes and screens produced collectively by well-known painters in the 1950s. Paraphrasing Spence on Wang Hui's contemporaries, we might say that since 1949, with Kuomingtang fragmentation a part of history, the orthodox painters were those who accepted the early People's Repub-lic as a period of reintegration. The individualists were the unconvinced, those who chose to pursue their personal reintegration in the still fragmented world—of Hongkong and Taipei, Europe and America.

6. Kuo Jo-hsü, *T'u-hua chien-wen-chih*, 6/9b, translated in Alexander Soper, *Kuo Jo-hsü's Experiences in Painting* (Washington, D.C., 1951), pp. 95–96.

CHINESE AND JAPANESE NAMES AND TERMS

Ao Shan　敖善

Aoki Seiji　青木正兒

bunjin-ga　文人畫

Cha-ch'i-weng　霅溪翁

Chan Tzu-ch'ien　展子虔

Ch'an-yüeh ta-shih　禪月大師

Chang An-chih　張安治

Chang Cheng　張徵

Chang Chi　張激

Chang Chih　張芝

Chang Ch'ou　張丑

Chang Fu-heng (Kang-fu)　張復亨（剛夫）

Chang Hsia-chou　張遐周

Chang Hsü　張旭

Chang Hsüan　張宣

Chang Huai-kuan　張懷瓘

Chang Hung　張宏

Chang Keng　張庚

Chang Seng-yu　張僧繇

Chang Shun-tzu　張舜咨

Chang Su-ch'ing　張素卿

Chang Tsai　張載

Chang Tsao　張璪

Chang Tsung-ku　張宗古

Chang Tsung-ts'ang　張宗蒼

Chang Yen-yüan　張彥遠

Chang Yü (1275–1348)　張雨

Chang Yü (1333–85)　張羽

Chao Ch'ang　趙昌

Chao Chih-hsin　趙執信

chao-hsiang　照響

Chao I　趙翼

Chao Ling-jang (Ta-nien)　趙令穰（大年）

Chao Meng-chien　趙孟堅

Chao Meng-fu (Tzu-ang, Ch'eng-chih)　趙孟頫，子昂，

　承旨

Chao Po-chü　趙伯駒

Chao Tso　趙左

Chao Tsung-han　趙宗漢

Chao-yeh-pai　照夜白

Chao Yen　趙宴

Chao Yü-ch'in　趙與懃

Chao Yüan　趙原

Chao Yung　趙雍

Chao Yung-nien　趙永年

Ch'ao Pu-chih　晁補之

207

Ch'ao-yuan hsien-chang t'u 朝元仙杖圖

chen 眞

Chen-che hsüeh-an 震澤學案

Chen-kuan kung-ssu hua-shih 貞觀公私畫史

chen miao 臻妙

Ch'en Chi-ju 陳繼儒

Ch'en Ch'üeh (Hsin-chung) 陳慤（信中）

Ch'en Hung-hsü 陳宏緒

Ch'en Hung-shou (Hui-ch'ih, Lao-ch'ih, Hui-seng, Fu-ch'ih) 陳洪綬（悔遲，老遲，悔僧，弗遲）

Ch'en K'ang-tsu (Wu-i) 陳康祖（無逸）

Ch'en Lin 陳琳

Ch'en Shan 陳善

Ch'en Tzu-ang 陳子昂

cheng 正

Cheng Ch'ao-tsung 鄭超宗

cheng-ch'uan 正傳

Cheng Fa-shih 鄭法士

cheng-fan 正反

Cheng Hsi-ku 正希古

cheng-p'ai 正派

Cheng Ssu-hsiao 鄭思肖

cheng-tsung 正宗

cheng-t'ung 正統

Cheng Yüan-ch'ing 鄭元慶

Ch'eng Cheng-k'uei 程正揆

Ch'eng Ch'i 程琦

Ch'eng Chia-sui 程嘉燧

Ch'eng Hao 程顥

Ch'eng I 程頤

Ch'eng Sui 程邃

Chi-jang t'u 擊壤圖

chi-ta-ch'eng 集大成

ch'i ("breath," "material force") 氣

ch'i ("eccentricity") 奇

Ch'i Chai-chia 祁豸佳

ch'i-chih 氣質

ch'i-chih chih-hsing 氣質之性

ch'i-chüeh 七絕

ch'i-fu 起伏

Ch'i-hsia-ssu 棲霞寺

ch'i ku 奇古

ch'i-yün 氣韻

Chia Shih-ku 賈師古

Chiang-chai shih-hua 薑齋詩話

Chiang Shen (Kuan-tao) 江參（貫道）

Chiang T'ien-ke 蔣天格

chiao-hsüeh hsiang-chang 教學相長

ch'iao 巧

Chien Chih-ch'eng 簡至誠

chien-ku 簡古

chien-wu 漸悟

Ch'ien Ch'ien-i 錢謙益

Ch'ien Chung-shu 錢鐘書

Ch'ien Hsüan (Shun-chü) 錢選（舜舉）

Ch'ien Liu 錢鏐

Ch'ien Mu 錢穆

Ch'ien Sung-yen 錢松岩

chih 質

Chih-ya-t'ang tsa-ch'ao 志雅堂雜鈔

Chin Jen-jui (Sheng-t'an) 金人瑞（聖嘆）

Chin Jung 金榮

Chin Nung 金農

chin-pi 金碧

Chin-ssu-lu 近思錄

Chin-tai san-wen ch'ao 近代散文抄

Ch'in Tsu-yung 秦祖永

Ch'in Tsung-ch'üan 秦宗權

208

Ching-chü-chi　靜居集

Ching Hao　荊浩

ching ku　勁古

Ching-ling　竟陵

Ching-ting　景定

Ch'ing-ho shu-hua-fang　清河書畫舫

Ch'ing-hui ko tseng-i ch'ih-tu　清暉閣贈貽尺牘

ch'ing ku　清古

ch'ing-lü　青綠

Ch'ing-shih-hua　清詩話

Ch'ing shih-lu　清實錄

Ch'ing-shih pieh-ts'ai　清詩別裁

Ch'ing-tai shih-shuo lun-yao　清代詩說論要

Chiu-chen-t'ai-shou Ku Lang pei　九眞太守谷朗碑

Ch'iu Fu　裘甫

ch'iu-ho　邱壑

ch'iu pei　求備

Ch'iu Ying　仇英

cho　拙

Chou Fang　周昉

Chou Ku-yen　周古言

Chou Liang-kung　周亮工

Chou Mi　周密

Chou Shun　周純

Chou Ts'eng　周曾

Chou Wen-chü　周文矩

Chu Ching-hsüan　朱景玄

Chu Hsi　朱熹

Chu Sheng-chai　朱省齋

Chu Ta (Pa-ta shan-jen)　朱耷（八大山人）

Chu Te-jun　朱德潤

Chu Tun-ju (Hsi-chen)　朱敦儒（希眞）

Chu Tzu hsin hsüeh-an　朱子新學案

ch'u ("out")　出

Ch'u Sui-liang　褚遂良

Ch'u-tz'u shu-chu　楚辭述註

Chü-ch'ü-wai-shih Chen-chü hsien-sheng shih-chi　句曲外史眞居先生詩集

Chü Jan　巨然

Chü-yeh-lu　居業錄

ch'ü ("flavor," "interest")　趣

Ch'ü Yüan　屈原

chuan　篆

ch'uan-ku　傳古

Ch'üan T'ang-Shih　全唐詩

ch'uang-t'i　創體

chüeh-chü　絕句

Chūgoku garon no tenkai　中國畫論の展開

ch'un ku　純古

chung hsing　中興

Chung-hua wen-shih lun-ts'ung　中華文史論業

Chung-kuo hua-chia ts'ung-shu　中國畫家叢書

Chung-kuo hua-lun lei-pien　中國畫論類編

Chung-kuo hui-hua-shih　中國繪畫史

Chung-kuo ku-tai hui-hua hsüan-chi　中國古代繪畫選集

Chung-kuo ming-hua-chi　中國名畫集

Chung-kuo wen-hsüeh p'i-p'ing-shih　中國文學批評史

Chung Yu　鐘繇

fa　法

Fa Jo-chen　法若眞

Fa-shu yao-lu　法書要錄

Fan K'uan　范寬

Fang Shih-shu　方士庶

fen-pen　粉本

feng-ch'i　風氣

Feng Pan　馮班

Feng-yü-lou ts'ung-shu　風雨樓叢書

Fou-yü-shan-chü-t'u　浮玉山居圖

209

Fu-ch'ai 夫差

fu-ku 復古

Han Cho 韓拙

Han Chun 韓準

Han Hsi-tsai 韓熙載

Han Huang 韓滉

Han Kan 韓幹

Han Kan Tai Sung 韓幹戴嵩

Han-man-weng 汗漫翁

Han T'an 韓棪

Han-yeh-lu 寒夜錄

hang-chia 行家

Hao Ch'eng 郝澄

ho 合

Ho Ching-ming 何景明

Ho Hsin-yin (Liang Ju-yüan) 何心隱（梁汝元）

Ho Liang-chün 何良俊

Ho Lo-chih 何樂之

Hou Tsung-ku 侯宗古

Hsi Kang 奚岡

Hsi-lu hua-pa 西廬畫跋

Hsi Shih 西施

Hsi-t'ang yung-jih hsü-lun 夕堂永日緒論

hsia-ch'eng 下乘

Hsia Kuei 夏珪

Hsia Wen-yen 夏文彥

Hsiang-shan ch'üan-chi 象山全集

Hsiao-chung hsien-ta 小中現大

Hsiao Ho (Tzu-chung) 蕭何（子仲）

Hsiao-ts'ang shan-fang wen-chi 小倉山房文集

Hsiao Tzu-yün 蕭子雲

Hsieh Chih 謝稚

Hsieh Chih-liu 謝稚柳

Hsieh Fang-te 謝枋得

Hsieh Ho 謝赫

hsieh-i 寫意

Hsieh Shih-ch'en 謝時臣

Hsieh Yu-yü 謝幼輿

Hsien-yü Shu 鮮于樞

hsin 心

hsin-ch'i 新奇

Hsin-t'i yü hsing-t'i 心體與性體

hsing 行

hsing-ch'ing 性情

hsing-ling 性靈

hsing-se 形似

hsing-tao shen-hui 興到神會

Hsü-chai ming-hua hsü-lu 虛齋名畫續錄

Hsü Ch'ien-hsüeh 徐乾學

Hsü Hao 徐浩

Hsü Hsi 徐熙

Hsü Pei-hung 徐悲鴻

Hsü Pen 徐賁

hsü-shih 虛實

Hsü Tao-ning 許道寧

Hsüan-ho-hua-p'u 宣和畫譜

Hsüeh Hsüan 薛瑄

Hu Chü-jen 胡居仁

Hu Ying-lin 胡應麟

hua 華

Hua-ch'an-shih sui-pi 畫禪室隨筆

Hua-chi 畫繼

Hua-chien 畫鑑

Hua-hsüeh hsin-yin 畫學心印

Hua-jen hua-shih 畫人畫事

Hua-lu kuang-i 畫錄廣遺

Hua-lun 畫論

Hua-lun ts'ung-k'an 畫論叢刊

210

Hua-shih ts'ung-shu 畫史叢書

Hua-shuo 畫說

Hua-yen 畫眼

Hua-yü-lu 畫語錄

Huai-jen 懷仁

Huai-su 懷素

Huang Ch'ao 黃巢

Huang Chih-chang 黃知彰

Huang Ch'üan 黃荃

Huang Kung-wang 黃公望

Huang Ting 黃鼎

Huang T'ing-chien 黃庭堅

Huang Tsung-hsi 黃宗義

Huang Yung-ch'üan 黃湧泉

Hui-hua-kuan 繪畫館

Hui-shih fa-wei 繪事發微

Hung-fan wu-shih 洪範五事

Hung-jen 弘仁

i ("righteousness," "principle") 義

i ("dissimilarity") 異

i ("intentionality") 意

i ("untrammeled") 逸

i-ch'i 一氣

I-chou-ming-hua-lu 益州名畫錄

I-ho-ming 瘞鶴銘

i-hua 一畫

i-li 義理

i-li chih hsing 義理之性

i pien wei fu 以變爲復

i-p'in 逸品

i-sheng 一聲

I shu 義書

i tsai yen wai 意在言外

I Yüan-chi 易元吉

I-yüan chih-yen 藝苑卮言

Jan-hsiang-an pa-hua 染香庵跋畫

jen 仁

Jen I 任頤

Jih-kuan (Tzu-wen) 日觀 (子溫)

Jih-lu 日錄

ju 入

Juan Ta-ch'eng 阮大鋮

Juan Yen 阮研

Jung-t'ai-chi 容臺集

k'ai 楷

k'ai-ho 開合

K'ang-chai hsien-sheng chi 康齋先生集

Kao Ch'i-p'ei 高其佩

Kao K'o-kung 高克恭

Kao K'o-ming 高克明

kao ku 高古

kao shih 高士

Kao Shih-ch'i 高士奇

Kao T'ing-li 高延禮

Kao Wen-chin 高文進

Kawakami Kei 川上涇

ko 格

Ko-ku yao-lun 格古要論

ko-lü 格律

ko-tiao 格調

K'o Chiu-ssu 柯九思

ku 古

ku chin 古今

Ku-chin hua-chien 古今畫鑑

Ku-hseüh hui-k'an 古學彙刊

Ku-hua-p'in-lu 古畫品錄

Ku Hung-chung 顧閎中

ku i 古意

211

Ku K'ai-chih 顧愷之

ku-kuai 古怪

Ku-kung shu-hua-lu 故宮書畫錄

ku wen 古文

ku ya 古雅

ku-yeh 古野

Kuan Hsiu 貫休

Kuan T'ung 關全

Kuei Yu-kuang 歸有光

K'un-ts'an 髡殘

Kung-an 公安

kung-feng 供奉

kung-fu 工夫

Kung Hsien 龔賢

Kung K'ai 龔開

K'ung Fan 孔範

Kuo-ch'ao hua-cheng-lu 國朝畫徵錄

Kuo Chung-shu 郭忠恕

Kuo Hsi 郭熙

Kuo Jo-hsü 郭若虛

Kuo Pi 郭畀

Kuo Shao-yü 郭紹虞

Kuo T'ien-hsi shou-shu jih-chi 郭天錫手書日記

kuo-tzu-chien 國子監

Kuo Tzu-i 郭子儀

Kyuka Inshitsu Kanzō Garoku 九華印室鑑藏書錄

Lai Ch'in-chih 來欽之

Lai-chung-lou sui-pi 來仲樓隨筆

Lan Ying 藍瑛

li ("detachment") 離

li ("rationality," "principle") 理

li ("clerical") 隸

Li An-chung 李安忠

Li Chao-tao 李昭道

Li Ch'eng 李成

Li Ch'eng-sou 李澄叟

li-chia 利家

Li Chien 李漸

li-chih 立志

Li Chih 李贄

Li Han-chü 李漢舉

Li K'ai-hsien 李開先

Li K'an 李衎

Li K'o-jan 李可染

Li Kung-lin (Lung-mien, Po-shih) 李公麟（龍眠，伯時）

Li Kung-nien 李公年

Li Meng-yang 李夢陽

Li P'an-lung 李攀龍

Li Po 李白

Li Shih-ta 李士達

Li Ssu-chen 李嗣眞

Li Ssu-hsün 李思訓

Li-tai ming-hua-chi 歷代名畫集

Li T'ang (Hsi-ku) 李唐（晞古）

Li Ya-nung 李亞農

liang-chih 良知

Liang K'ai 梁楷

Liang K'uei 梁揆

Liao-ning-sheng po-wu-kuan ts'ang-hua-chi 遼寧省博物館藏畫集

Lin-ch'uan 臨川

Liu Chüeh 劉珏

liu-fa 六法

Liu Hai-feng 劉海峯

Liu Ku-hsin 劉古心

Liu Kung-ch'üan 柳公權

Liu Kuo-sung 劉國松

212

Liu Sung-nien 劉松年

Liu Tao-ch'un 劉道醇

Liu Tsung-ku 劉宗古

Liu Yung 柳永

Lo Ming 羅銘

Lo P'ing 羅聘

Lou Kuan 樓觀

Lu Chi 陸機

Lu Chih 陸治

Lu Hsiang-shan 陸象山

Lu Hsin 陸薪

Lu Hsin-chung 陸信忠

Lu Hung 盧鴻

Lu Kuang 陸廣

Lu-t'ai t'i-hua-kao 麓臺題畫稿

Lu T'an-wei 陸探微

Lu the *Ya-t'ui* 陸倚推

lü 律

lü-shih 律詩

Lü Tsu-ch'ien 呂祖謙

lüeh 略

Lun-hua so-yen 論畫瑣言

Lun-shu 論書

Ma Fen 馬賁

Ma Ho-chih 馬和之

Ma Yüan 馬遠

Ma Wan (Wen-pi) 馬琬 (文璧)

mao 貌

Mao Yen-shou 毛延壽

Maruo Shozaburō 丸尾彰三郎

Matsumoto Eiichi 松本榮一

Mei Ch'ing 梅清

Mei-shu ts'ung-k'an 美術叢刊

Mei-shu ts'ung-shu 美術叢書

Mei-yu-ko wen-yü 媚幽閣文娛

Men-se hsin-hua 捫蝨新話

Mi Fu 米芾

Mi Wan-chung 米萬鐘

Mi Yu-jen 米友仁

miao 妙

miao-wu 妙悟

Minshin no kaiga 明清の繪畫

Ming-ju hsüeh-an 明儒學案

Mizuno-Nagahiro 水野長廣

mo-hsüeh 末學

Mo Shih-lung 莫是龍

Mou Tsung-san 牟宗三

Mu-ch'i (Fa-ch'ang) 牧溪 (法常)

Nakamura Shigeo 中村茂夫

Nanshū Meiga-en 南宗名畫苑

neng 能

Ni Tsan (Yün-lin) 倪瓚 (雲林)

nien-p'u 年譜

Nihon chōkoku shi kiso shiryō shūsei: Heian jidai 日本雕刻史基礎資料集成平安時代

Ou-pei shih-hua 甌北詩話

Ou-yang Chiung 歐陽烱

Ou-yang Hsün 歐陽詢

Pa-ta shan-jen shu-hua-chi 八大山人書畫集

pai hua 白畫

pai-miao 白描

P'ang Yüan-chi 龐元濟

Pao-chin-chai 寶晉齋

Pao-yen-t'ang pi-chi 寶顏堂秘笈

P'ei Hsiao-yüan 裴孝源

P'ei Su 裴素

P'ei-wen-chai shu-hua-p'u 佩文齋書畫譜

P'ei Wen-ni 裴文睍

213

P'eng-shan mi-chi 蓬山密記

Pi-fa-chi 筆法記

Pi Hung 畢宏

pi-li 鄙俚

Pi Liang-shih (Shao-tung) 畢良史（少董）

Pi-tsang-ch'üan 祕藏詮

pi-tse 偪仄

p'i-chien 僻見

pien 變

pien-hua ch'i-chih 變化氣質

Pien Wen-yü 卞文瑜

Pien Yung-yü 卞永譽

pin-chu 賓主

p'ing-tan t'ien-chen 平淡天眞

Po Chü-i 白居易

Po-erh-tu 博爾都

p'o 坡

pu-chi pu-li 不卽不離

Pu-tai 布袋

P'u-t'ao-she 葡萄社

Ryu-mon seki kutsu no kenkyū 龍門石刻の研究

san ku 三古

Sesshu 雪舟

shan 山

Shan-chü-t'u 山居圖

Shan-hu-wang hua-lu 珊瑚網畫錄

Shan-ku shih-chu 山谷詩注

Shan-ku t'i-pa 山谷題跋

shan-shui 山水

Shan-shui ch'ing-hui 山水清暉

Shao Mi 邵彌

shen 神

shen-chiao 身教

shen-ch'i 神氣

Shen Ch'i-wu 神啓无

Shen Chou 沈周

shen-hsin chih hsüeh 身心之學

shen-hui 神會

shen-p'in 神品

shen-ssu 神似

Shen Te-ch'ien 沈德潛

shen-yün 神韻

sheng 生

Sheng-ch'ao ming-hua-p'ing 聖朝名畫評

Sheng-chiao-hsü 聖教序

Sheng-ching Ku-kung shu-hua-lu 聖京故宮書畫錄

Sheng Mao-yeh 盛茂曄

sheng-T'ang 盛唐

Sheng-tiao-p'u 聲調譜

Sheng-yin-ssu 聖因寺

shih ("momentum," "force") 勢

shih ("seeing") 視

shih ("solid") 實

shih-hsüeh 實學

Shih K'o 石恪

Shih-ku-t'ang shu-hua hui-k'ao 式古堂書畫彙考

Shih Lu 石魯

Shih-t'ao 石濤

shih-wen 時文

Shimada Shūjirō 島田修二郎

Shina bungaku shisō-shi 支邢文學思想史

Shodō zenshū 書道全集

Shu-hua shu-lu chieh-t'i 書畫書錄解題

Shu-p'u 書譜

Shu-shih 書史

Shu-tuan 書斷

Shu-ying 書影

shuo-i 率意

Shuo-shih ts'ui-yü　說 詩 晬 語

ssu　思

Ssu-k'u ch'üan-shu　四 庫 全 書

Ssu-pu pei-yao　四 部 備 要

Ssu-shu chi-chu　四 書 集 注

Ssu-yu-chai hua-lun　四 有 齋 畫 論

Su Ch'e　蘇 轍

Su Hsün　蘇 洵

Su Shih (Tung-p'o)　蘇 軾 （ 東 坡 ）

Su-wang　素 王

Sui-yüan san-shih-liu-chung　隨 園 三 十 六 種

Sui-yüan shih-hua　隨 園 詩 話

Sun Chih-wei (T'ai-ku)　孫 知 微 （ 太 古 ）

Sun Chün-tse　孫 君 澤

Sun K'o-yüan　孫 可 元

Sun Kuo-t'ing　孫 過 庭

Sung Han-chieh　宋 漢 傑

Sung Hsü　宋 旭

Sung-hsüeh-chai wen-chi　松 雪 齋 文 集

Sung Ju-chih　宋 汝 志

Sung kao-seng-chuan　宋 高 僧 傳

Sung Lao　宋 犖

Sung Lien　宋 濂

Sung Min (Hao-ku)　宋 敏 （ 好 古 ）

Sung Ti (Fu-ku)　宋 廸 （ 復 古 ）

Sung-tzu t'ien-wang　送 子 天 王

Sung-Yüan hsüeh-an　宋 元 學 案

ta-ch'eng　大 成

Ta-chiang-chün Ts'ao Chen ts'an-pei　大 將 軍 曹 眞 殘 碑

Ta-kuan-lu　大 觀 錄

Ta-kuan-t'ieh　大 觀 帖

Ta-kuan (Tzu-pai, Chen-k'o)　達 觀 （ 紫 柏 ， 眞 可 ）

Tai-ching-t'ang shih-hua　帶 經 堂 詩 話

Tai Hsi　戴 熙

Tai K'uei　戴 逵

Tai Sung　戴 嵩

Tai Yen-yüan　戴 劄 源

T'ai-chou　泰 州

Taisho daizōkyō　大 正 大 藏 經

Tajima Shiichi　田 島 志 一

T'an-i-lu　談 藝 錄

T'an-lung-lu　談 龍 錄

T'ang-ch'ao ming-hua-lu　唐 朝 名 畫 錄

T'ang Hou　湯 垕

T'ang Hsüan-tu　唐 玄 度

T'ang-shih pieh-ts'ai　唐 詩 別 裁

T'ang Shun-Chih　唐 順 之

T'ang Sung Yüan Ming Ch'ing hua-hsüan　唐 宋 元 明 清 畫 選

T'ang Tai　唐 岱

T'ang Ti　唐 棣

T'ang Wu-tai Sung Yüan ming-chi　唐 五 代 宋 元 名 迹

Tao　道

Tao-chi　道 濟

tao-t'ung　道 統

T'ao Yüan-ming　陶 淵 明

Teng Ch'un　鄧 椿

Teng Wen-yüan　鄧 文 原

T'eng Ku　騰 固

ti-i-i　第 一 義

Ti-i-shan-jen wen-chi-hsü　第 一 山 人 文 集 序

ti-tzu　嫡 子

t'i　體

t'i-ch'a　體 察

t'i-cheng　體 證

t'i-chih ("embody")　體 之

t'i-chih ("genre")　體 製

t'i ch'ün-ch'en　體 群 臣

t'i-hui　體 會

215

t'i-jen　體認

t'i-wei　體味

t'i-yen　體驗

t'i-yung　體用

tien　點

T'ien-fa-shen-ch'en-pei　天發神讖碑

t'ien-jan　天然

T'ien-lung shan　天龍山

T'ien Seng-liang　田僧亮

Ting Fu-pao　丁福保

Ting Yün-p'eng　丁雲鵬

t'ing ("hearing")　聽

Tonkō-ga no kenkyū　燉煌畫の研究

Tou Meng　竇蒙

tsai　載

Ts'ai Chia　蔡嘉

Ts'ao Chao　曹昭

Ts'ao Chih-po　曹知白

Ts'ao Chung-ta　曹仲達

Ts'ao Pa　曹霸

Ts'ao Pu-hsing　曹不興

Ts'ao Tuan　曹端

Ts'ao Yin　曹寅

Tseng Yü　曾紆

tso-chia　作家

tso-i　作意

Ts'ui Po　崔白

ts'un　皴

Tsung Pai-hua　宗白華

Tsung Ping　宗炳

Ts'ung-shu chi-ch'eng　叢書集成

Tu Ch'iung　杜瓊

tu-chuan　杜撰

tu-ch'uang　獨創

Tu Fu　杜甫

Tu Mu　杜牧

Tu-shu-lu　讀書錄

T'u-hua chien-wen-chih　圖畫見聞誌

T'u-hui pao-chien　圖繪寶鑑

tuan-chi　斷繼

tun-wu　頓悟

Tun-yin tsa-lu　鈍吟雜錄

tung　動

Tung Ch'i-ch'ang　董其昌

Tung-chuang lun-hua　東莊論畫

Tung Chung-feng　董中峯

Tung Pang-ta　東邦達

Tung Po-jen　東伯仁

Tung-p'o t'i-pa　東坡題跋

Tung Yüan　董源

t'ung　同

T'ung-ch'eng　桐城

T'ung-yin lun-hua　桐陰論畫

Wang Ch'ang-ling　王昌齡

Wang Ch'en　王宸

Wang Chien　王鑑

Wang Chien-chang　王建章

Wang Chiu　王玖

Wang-ch'uan t'u　輞川圖

Wang Fu　王紱

Wang Fu-chih　王夫之

Wang Hsi-chih (I-shao)　王羲之（逸少）

Wang Hsi-chüeh　王錫爵

Wang Hsien-chih (344–86)　王獻之

Wang Hsien-chih (d. 878)　王仙芝

Wang Hsüeh-hao　王學浩

Wang Hui (Shih-ku, Shih-lao)　王翬（石谷，石老）

Wang Hung-hsü　王鴻緒

Wang Kai 王概

Wang Ken 王艮

Wang K'o-yü 汪珂玉

Wang Kuan 王瓘

wang-liang kuei-mei 魍魎鬼魅

Wang Meng 王蒙

Wang P'in (Hsin-po) 王蘋（信伯）

Wang Shan 王掞

Wang Shen 王詵

Wang Shih-chen (1526–90) 王世貞

Wang Shih-chen (Yü-yang) (1634–1711) 王士禎（漁洋）

Wang Shih-min 王時敏

Wang-shih shu-hua-yüan 王氏書畫苑

Wang Su 王愫

Wang Su (1794–1877) 王素

Wang T'ing-yün 王庭筠

Wang T'o-tzu 王陀子

Wang Wei (415–43) 王微

Wang Wei (d. 761) 王維

Wang Yang-ming 王陽明

Wang Yü (Tung-chuang) 王昱（東莊）

Wang Yüan 王淵

Wang Yüan-ch'i 王原祁

Wang Yün-wu 王雲五

Wei Chung-hsien 魏忠賢

Wei-han (Ku-ch'ing) 維翰（古清）

Wei Hsieh 衞協

Wei Yen 韋偃

Wen Cheng-ming 文徵明

Wen fu 文賦

Wen-hsien ts'ung-pien 文獻叢編

wen-jen-hua 文人畫

wen-mo 文脈

Wen T'ien-hsiang 文天祥

Wen T'ung 文同

Wu Chen (Mei-hua Tao-jen) 吳鎮（梅花道人）

Wu Ch'eng 吳澄

Wu-hsing pei chih 吳興備志

Wu-hsing ts'ang-shu-lu 吳興藏書錄

wu-hsüan ch'in 無絃琴

Wu Hung-yü 吳洪裕

Wu Ku-sung 吳古松

Wu Li 吳歷

Wu Pin 吳彬

Wu Sheng 吳升

Wu tao i i kuan chih 吾道一以貫之

Wu Tao-tzu 吳道子

Wu Tsung-yüan 武宗元

Wu Wei 吳偉

Wu Yü-pi (K'ang-chai) 吳與弼（康齋）

Wu Yüan-yü 吳元瑜

Yang-ming ch'üan-shu 陽明全書

Yang-shih ch'ih-t'ang yen-chi shih-hsü 楊氏池堂讌集詩序

Yang Tsai 楊載

Yao Shih (Tzu-ching) 姚式（子敬）

Yao Shou 姚綬

Yao Yen-ch'ing 姚彥卿

Yeh Hsieh 葉燮

yeh-hu-ch'an 野狐禪

yeh-kuang 野光

yen ("charm") 妍

yen ("utterance") 言

Yen Chen-ch'ing 顏眞卿

yen-chiao 言教

Yen Li-pen 閻立本

Yen Li-te 閻立德

Yen Wen-kuei 燕文貴

Yen Yü 嚴羽

217

Yen-yüan Tai Hsien-sheng wen-chi 剡源戴先生文集

yin-chieh 音節

Yin-jeng 胤礽

Yin Shu 尹洙

Yonezawa Yoshiho 米澤嘉圃

Yoshizawa Tadashi 吉澤忠

yu ("journeying") 遊

Yu-huai-t'ang shih-wen-chi 有懷堂詩文集

Yu-yü ch'iu-ho-t'u 幼輿邱壑圖

yü ("encounter") 遇

Yü An-lan 于安瀾

Yü-chang Huang-hsien-sheng wen-chi 豫章黃先生文集

Yü-chien 玉澗

Yü Chien-hua 俞劍華

Yü Chien-wu 庾肩吾

yü-hsiang 餘響

Yü Shao-sung 俞紹宋

Yü Shih-nan 虞世南

Yü-yang ching-hua-lu chien-chu 漁洋精華錄簡注

Yü-yang shan-jen ching-hua-lu 漁洋山人精華錄

Yüan Chen 元稹

yüan-ch'i 元氣

Yüan Hao-wen 元好問

Yüan Hung-tao (Chung-lang) 袁宏道（中郎）

Yüan Mei 袁枚

yüan-shen 袁神

Yüan-shih 原詩

yün 韻

Yün Shou-p'ing 惲壽平

Yün yen kuo-yen-lu 雲烟過眼錄

Zao Wou-ki 趙無極

Zengetsu-daishi juroku-rakan 禪月大師十六羅漢

THE CONTRIBUTORS

Richard M. Barnhart, professor of art and archaeology at Princeton University, previously taught at Yale. His books include *Wintry Forests, Old Trees* and *"Marriage of the Lord of the River."* He has written extensively on Chinese calligraphy and Sung painting for scholarly periodicals.

James Cahill is professor of the history of art at the University of California, Berkeley. One-time curator of Chinese art at the Freer Gallery in Washington, D.C., he is the author of *Chinese Painting* and numerous other books, exhibition catalogues, and articles. At present he is preparing a multivolume history of Chinese painting and a study of early Nanga painting in Japan and its Chinese sources.

Richard Edwards is professor of Far Eastern art and former chairman of the history of art department at the University of Michigan. Three Fulbright fellowships have taken him to China (first in 1944), Japan, Hong Kong, and Formosa. Among his publications are *The Field of Stones, The Painting of Tao-chi,* and scholarly articles on Ch'ien Hsüan, Li T'ang, and Mou I and on other aspects of Chinese and Buddhist art.

Wen C. Fong is professor of art and archaeology at Princeton University and special consultant in Far Eastern art at the Metropolitan Museum of Art. A frequent contributor to scholarly journals, he is the author of *Sung and Yuan Paintings* and *Summer Mountains: The Timeless Landscape,* both recent Metropolitan Museum publications.

Wai-kam Ho is curator of Chinese art at the Cleveland Museum of Art. He was born near Canton and pursued graduate study in Chinese cultural history there and at Harvard University and the Fogg Art Museum. His articles on Chinese painting, pottery, bronzes, and Buddhist sculpture have appeared in journals published in America, China, Switzerland, and Italy.

Yu-kung Kao, professor of East Asian studies at Princeton University, has particular scholarly interest in Chinese literature with emphasis on classical poetry and vernacular fiction. A graduate of National Taiwan University (B.A.) and of Harvard University (M.A., Ph.D.), he taught at Stanford University before joining the Princeton faculty in 1962. He has written articles for the *Harvard Journal of Asiatic Studies* and other publications.

219

Chu-Tsing Li, a native of Canton, is professor and chairman of the department of the history of art at the University of Kansas and research curator in Far Eastern art at the Nelson Gallery of Art. His books include *Autumn Colors on the Ch'iao and Hua Mountains*, a study of a painting by Chao Meng-fu, and *A Thousand Peaks and Myriad Ravines*, a discussion of the Chinese paintings in the Drenowatz collection. He is a contributor to *Archives of Asian Art*, *Artibus Asiae*, *Oriental Art*, *Asiatische Studien*, the National Palace Museum *Bulletin*, and *Art Journal*.

James J. Y. Liu is professor of Chinese and chairman of the department of Asian languages at Stanford University. *The Art of Chinese Poetry*, *The Chinese Knight-Errant*, *The Poetry of Li Shang-yin*, *Major Lyricists of the Northern Sung*, and the forthcoming *Chinese Theories of Literature* are among his publications.

Tsu-lin Mei is associate professor and chairman of Asian studies at Cornell University. He collaborated with Yu-kung Kao on a series of articles about T'ang poetry published in the *Harvard Journal of Asiatic Studies*. He is also a contributor to *Philosophical Review*, *Review of Metaphysics*, *Bulletin of the Institute of History and Philology*, and *Tsinghua Journal of Chinese Studies*.

F. W. Mote is professor of Chinese history and civilization at Princeton University. One of his contributions to the symposia on Chinese thought appeared as "Confucian Eremitism in the Yüan Period" in *The Confucian Persuasion*, edited by Arthur F. Wright. His books include *Intellectual Foundations of China*.

Christian F. Murck is a doctoral candidate in the East Asian Studies department at Princeton University. His special interests are cultural and intellectual history; he is presently completing a dissertation on the thought of Chu Yün-ming (1460–1526).

Alexander C. Soper is professor of fine arts at the Institute of Fine Arts, New York University. He has published on Buddhist architecture in Japan and on Chinese and Japanese art. He has translated Kuo Jo-hsü's *Experiences in Painting* and served as co-author of the *China* and *Japan* volumes of the Pelican History of Art series. His articles have appeared in the major journals of Asian studies both here and abroad.

Jonathan Spence is professor of history at Yale University He has published two books about the K'ang-hsi Emperor—*Ts'ao Yin and the K'ang-hsi Emperor: Bondservant and Master* and *Emperor of China: Self-Portrait of K'ang-hsi*—and a study of Western advisers in China from 1620 to 1960. Recently he has been concerned with the social history of Ch'ing China and is at work on a study of local society in early Ch'ing Shantung.

Michael Sullivan is professor of oriental art at Stanford University. In 1973–74 he was Slade Professor of Fine Art at Oxford University. His books include *The Birth of Landscape Painting in China*; *Chinese Ceramics, Bronzes and Jades in the Collection of Sir Alan and Lady Barlow*; *The Cave Temples of Maichishan*; and, most recently, *The Arts of China* and *The Meeting of Eastern and Western Art*.

Wei-ming Tu is associate professor of history at the University of California, Berkeley. He did his undergraduate work at Tunghai University, he received his Ph.D. degree from Harvard, and he has taught at Princeton. He has written on Chinese intellectual history and religious philosophy in Asia, and his special interest in Confucian thought is reflected in his articles in *Philosophy East and West* and the *Journal of Asian Studies*.

Harrie Vanderstappen is professor of art in the division of Far Eastern languages and civilizations at the University of Chicago. His interests include Ming court painting traditions and Chinese Buddhist sculpture. He has expanded his studies of Japanese writings on Chinese art and is now preparing a volume on Western writings on Chinese art from 1920 to 1965.

INDEX

Abstract painting, Western styles of, 201–204
An Lu-shan, 68 n.60
Analects, xi, xii, xxi
Anhui school, 149, 169
Antiquity, three stages of, 28
Anyang, tombs at, 21
Ao Shan, 75, 77, 78
Asia House exhibition (1967), xv
Avant-garde art, Western movements of, 202, 204

Blue-green landscape style, 52, 79, 90, 99, 100, 104, 203
Braque, 197
Brushwork, 29 n.28, 176

Calligraphy, xv, 21, 23, 24, 25, 38, 40, 63, 91, 105, 115, 178, 179
Cézanne, 197
Ch'an Buddhism, 115, 116, 121, 125, 129
Chan Tzu-ch'ien, 29
Chang Chi, *White Lotus Society*, 57
Chang Chih, 24, 26, 28, 29, 40, 46
Chang Ch'ou, 57
Chang Fu-heng, 75 n.10
Chang Heng, 22
Chang Hsü, 30, 37, 40
Chang Hsüan, 41, 66
Chang Huai-kuan, 23–28 passim, 29 n.28, 32, 46
Chang Hung, 169, 170 n.3
Chang Keng, 180
Chang Seng-yu, 28, 29, 30, 46, 51, 52
Chang Shun-tzu, *Old Trees and Flying Waterfall*, 86
Chang Su-ch'ing, 33, 36

Chang Tsai, 14 n.18
Chang Tsao, 86
Chang Tsung-ku, 41
Chang Tsung-ts'ang, 170 n.2
Chang Yen-yüan, xvii, 22, 23, 25, 27–31 passim, 89, 90, 99
Chang Yü, 43 n.112, 76, 76 n.13, 77, 78 n.23, 79
Chao Ch'ang, 39, 79
Chao Chih-hsin, 18
Chao I, 18
Chao Ling-jang, 41
Chao Meng-chien, 78
Chao Meng-fu, xviii, 36, 42 n.110, 43, 44, 45, 47, 53, 57, 73, 74 n.5, 75–91 passim, 105, 108, 121, 147–148, 177–80 passim; *Autumn Colors on the Ch'iao and Hua Mountains*, 70, 82, 83, 86; *Eastern Mountain of Tung-t'ing*, 86; *Mind Landscape of Hsieh Yu-yü*, 81, 82; *Poetic Feeling of an Autumnal Mood*, 83; *Rivers and Mountains*, 83–86 passim; *Sheep and Goat* (Freer), 45; *Water Village*, 83, 86
Chao Po-chü, 41, 43, 44, 79, 100, 104, 105, 108
Ch'ao Pu-chih, 41
Chao Ta-nien, 60
Chao Tso, 175
Chao Tsung-han, 39
Chao Yen, 66, 67; *Eight Riders in Spring*, 65, 66
Chao Yü-ch'in, 42
Chao Yüan, 87, 171, 177; *Lion Grove Garden*, 70
Chao Yung, 81
Chao Yung-nien, 41
Che school, 117, 120, 124, 158
Ch'en Chi-ju, 104, 113, 114, 121
Ch'en Ch'üeh, 75 n.10
Ch'en Hung-hsü, *Han-yeh-lu*, 114

Ch'en Hung-shou, xviii, 101–109 passim, 124, 150, 152, 165; *Nine Songs by Ch'ü Yüan*, 103, 104; *Scholar and Priest*, 101–102, 105
Ch'en K'ang-tsu, 75 n.10
Ch'en Lin, 44, 87, 177
Ch'en Shan, 35 n.71
Ch'en Shu, 32
Ch'en Tzu-ang, 45
Ch'eng Cheng-k'uei, 174
Ch'eng Chia-sui, 127
Ch'eng-hua, 117
Ch'eng I, 12, 117
Cheng Ch'ao-tsung, 114; *Mei-yu-ko wen-yü*, 178
Cheng Fa-shih, 29
Cheng Hsi-ku, 41
Cheng Ping-shan, 113
Cheng Ssu-hsiao, 78, 79 n.26
Ch'i, 127
Ch'i Chai-chia, 157, 158; *Figures in a Mountainous Landscape*, 157, 159
Ch'i-hsia-ssu, reliefs at, 94, 96
Ch'i-kung, 113
Chia-ching, 117
Chia Shih-ku, 42
Chiang Shen, 43, 75
Ch'ien Ch'ien-i, 124
Ch'ien Chih-ch'eng, 39
Ch'ien Chung-shu, *T'an-i-lu*, 124
Ch'ien Hsüan, 75–83 passim, 100, 101, 108, 177; *Dwelling on Floating Jade Mountain*, 76, 79; *Wang Hsi-chih Watching Geese*, 100, 101
Ch'ien Liu, 97
Ch'ien-lung emperor, 170 n.2
Ch'ien Sung-yen, 202–203
Chih-ya-t'ang tsa-ch'ao, 42
Ch'in Tsu-yung, 157, 158
Ch'in Tsung-ch'üan, 97
Chin Nung, 104
Chin Sheng-t'an, 18
Ch'ing-ho shu-hua-fang, 57
Ch'ing painting, xviii, xix, xxi, 169–81 passim
Ch'ing poetry, xvii, xix, 131–44 passim
Ching Hao, 29 n.28, 52, 90, 158, 177, 178
Ching-ling school, 121, 124
Ch'iu Fu, 97
Ch'iu Ying, 171, 178, 179
Chiu-chen-t'ai-shou Ku Lang pei, 91
Chou Fang, 41, 66, 105
Chou Ku-yen, 42
Chou Liang-kung, 114, 124, 157 n.15, 162 n.20; *Shu-ying*, 114
Chou Mi, 42, 53, 55, 75, 76 n.14

Chou Shun, 41
Chou Ts'eng, 43
Chou Wen-chü, 66
Ch'u Sui-liang, 27, 29 n.28, 91, 93
Ch'u-tz'u shu-chu (Lai Ching-chih), 103, 104
Ch'ü Yüan, 103
Chü-jan, xv, xvi, 36, 87, 90, 124, 129, 170 n.3, 174, 177–80 passim
Chu Ching-hsüan, 31, 32
Chu Hsi, xii, xiii, xiv, xxi, 12, 14 n.18, 117
Chu Ta, 148, 174; *Album of Nature Studies*, 167, 168; *Pa-ta shan-jen Shu-hua-chi*, 167, 168
Chu Te-jun, 86
Chu Tun-ju, 43
Ch'uan-ku, 38–39, 41
Chuang-tzu, 45
Chuang-tzu, "Ch'iu Shui Pien," 155
Chung Yu, 24, 26, 28, 29, 32, 33, 91, 105, 178, 179
Classical revival, 117
Communism, influence of, on arts: 201–205 passim
Confucianism, xi, xii, xiv, xvi, xvii, 12 n.10, 40, 41 n.101, 45, 46, 47, 67, 68, 78, 92, 115, 116, 117, 120, 121, 122, 123, 125, 129, 180, 191
Cubism, 192, 193, 196, 197
Cursive script, nine masters of, 115

Eccentric painting, xiii, xiv, xv, xix, xx, 103–104, 124, 125, 148, 149, 152, 157, 158, 161, 162, 169–81 passim, 185–99 passim, 201–205 passim
"Eight-legged essay," 125–29 passim
Eliot, T. S., 20

Fa Jo-chen, 148
Fa shu yao lu, 23, 24, 27
Fan K'uan, 32, 33, 84, 155, 170 n.2, 178
Fang Shih-shu, 173
Feng Pan, 18
Former Seven Masters, 116
Four-Antis movement, 204
"Four Worthies," 26
French Concession, 201
Fu-hsi, 180
Fu Sheng, 57
Fung Yu-lan, 92

Gherardini, 147
"Great Synthesis," xii, xxi, 91, 92, 129, 168, 170 n.3, 171
Great Tradition, 4, 5, 6, 14, 20, 105, 108

Han Cho, 115

Han Chün, 57
Han Huang, 34, 51, 52
Han Kan, 31, 34, 43, 51–55 passim, 61, 69, 70;
 Chao-yeh-pai, 54, 66
Han-man-weng, 55
Han period painting, 22, 23, 24
Han-shan, 20
Han T'an, 146, 147 n.7
Han-weng, 161
Han Yü, 45, 46
Hangchow, as cultural center, 74
Hao Ch'eng, 44
Hao-ku, 42
Ho Ching-ming, 117
Ho Hsin-yin, 123, 125
Ho Liang-chün, 56, 177, 178
Hopkins, Gerard Manley, 19
Hou Tsung-ku, 41
Hsi-an school, 149
Hsi-chen, 43
Hsi-chih, 40
Hsi Kang, 173, 179
Hsi-ku, 42
Hsi-t'ang yung-jih hsü-lun, 128
Hsia Kuei, 42, 43, 80, 170 n.3, 178, 179
Hsia Wen-yen, 42 n.108, 74 n.3, 76 n.12, 78, 79, 81;
 T'u hui pao chien, 78
Hsiao Ho, 75 n.10
Hsiao Tzu-yün, 36 n.78
Hsieh Chih, 56
Hsieh Fang-te, 78
Hsieh Ho, 23, 25, 30; Six Principles of, 165
Hsieh-i, 90
Hsieh Ling-yün, 36 n.78
Hsieh Shih-ch'en, 150
Hsien-chih, 24, 40
Hsien-yü Shu, 74
Hsü Ch'ien-hsüeh, 147
Hsü Hao, 29 n.28
Hsü Hsi, 32, 33, 77
Hsü Pei-hung, 201
Hsü Pen, 87, 171
Hsü Tao-ning, 33
Hsüan-ho hua p'u, 34, 37–40 passim, 53, 56, 57,
 98
Hsüan, King, 23
Hsüeh Hsüan, 13
Hsün-tzu, 46
Hu Chü-jen, 12
Hu Ying-lin, 119
Hua chi, 34, 42, 58
Hua Chien, 78

Hua lun, 43
Hua shih, 35, 36
Hua-shuo, 113, 114, 178
Hua yen, 178, 181
Hua-yü-lu, 191
Huai-jen, 91
Huai-su, 37, 40
Huang Ch'ao, 97
Huang Chih-chang, 158
Huang Ch'üan, 33, 35, 38
Huang Kung-wang, 76, 77, 79, 84, 121, 123, 126,
 129, 158, 170 n.3, 171 n.4, 175–79 passim;
 Dwelling on the Fu-ch'un Mountains, 87. See also
 Yüan, Four Masters of the.
Huang Ti, 23
Huang T'ing-chien, 35, 36 n.71, 39, 53, 54, 55, 58,
 91
Huang Ting, 170 n.2, 173
Hui Tsung, 34–41 passim, 73, 98
Hung Jen, 148, 157, 158, 168, 174; Plum Cottage at
 Pine Spring, 160, 161
Hung-wu, 87, 88

I-chou ming hua lu, 33, 98
I-ho ming, 91
I-p'in style, 186, 188
I-shao. See Wang Hsi-chih.
I shu, 26
I Yüan-chi, 39
I-yüan chih-yen, 120
Individualist critics, 17, 18, 19
"Individualist" painting. See Eccentric painting.
Intuitionalist critics, 19

Japanese landscape painting, as related to Chinese,
 194–96, 201
Jen I, 104
Jen-tsung, tomb carvings of, 94, 97, 100
Jih-kuan, 74
Juan Chi, 20
Jung-t'ai-chi, 114, 121

K'ang-hsi emperor, 170 n.2, 205
K'ang-hsi period, 145–48 passim
Kao Ch'i-p'ei, 148
Kao K'o-kung, 74, 177, 179, 180
Kao K'o-ming, 44
Kao Shih-ch'i, 146, 147, 148 n.10
Kao T'ing-li, 117
Kao Tsung, 13, 41
Kao Wen-chin, 51 n.2
K'o Chiu-ssu, 43
Ko ku yao lun, 77

Ku chin hua chien, 35, 43

Ku-ch'ing, 42

Ku hua p'in lu, 23

Ku Hung-chung, 66, 67, 68; *Night Revels of Han Hsi-tsai*, 67, 68

Ku K'ai-chih, xviii, 23, 25, 28–31 passim, 34, 35, 36, 41, 46, 51–57 passim, 61, 63, 68, 69, 81, 90, 98, 147, 186, 202, 203; *Admonitions* handscroll, 56, 57, 81

Kuan-hsiu, xviii, 70, 94, 97, 105, 107, 108, 186; *Sixteen Lohans*, 105, 107, 108

Kuan T'ung, 33, 35, 90, 116, 158, 177, 178

Kuang-ling Ts'an, 179

Kublai Khan, 75 n.10, 76, 77, 78, 81

Kuei Yu-kuang, 126

K'un-ts'an, 148

Kung-an school, 120–24 passim

Kung Hsien, 148, 155–58 passim, 161–65 passim, 168; *Thousand Peaks and Myriad Valleys*, 193–196 passim

Kung K'ai, 78, 79 n.26

Kuo Chung-shu, 39, 60 (fig. 6)

Kuo Hsi, 33, 70, 83–84, 86, 87, 90, 115, 150, 188

Kuo Jo-hsü, 32, 33, 34, 36, 41, 51 n.2, 204, 205

Kuo Pi, 78 n.24

Kuo Tzu-i, 58, 63, 64, 68 n.60

Lai Ching-chih, *Ch'u-tz'u shu-chu*, 103, 104

Lai-chung-lou sui-pi, 114, 121

Lan Ying, 103, 170 n.3

Lao-tzu, 23, 24, 36 n.78, 191

Later Seven Masters, 116, 117

Li An-chung, 43

Li Chao-tao, 32, 79

Li Ch'eng, 32, 33, 35, 51 n.2, 70, 71, 77, 83, 84, 90, 105, 116, 117, 178

Li Ch'eng-sou, 115

Li Chien, 31

Li Chih, 121, 122, 123

Li K'ai-hsien, 120

Li K'an, 74

Li K'o-jan, 203

Li Kung-lin, xvii, xviii, 34, 35, 38, 39, 41, 46, 57–71 passim, 77, 80, 83–84, 86, 87, 90, 91, 98, 108, 178, 186; *Chi-jang t'u*, 57; *Classic of Filial Piety*, 55–57, 62, 63, 64, 68; *Confucius and His Seventy-Two Disciples* (attrib. to), 105, 106; *Dwelling in the Lung-mien Mountains*, 58–61, 64, 69; *Five Tribute Horses*, 53–55, 62–66 passim, 68; *Hua-yen Sutra*, 57; *Kuo Tzu-i Receiving the Homage of the Uighurs*, 57–58, 63, 64, 68; *Nine Songs*, 56; *White Lotus Society*, 57

Li Kung-nien, *Landscape*, 71

Li Lung-mien, 80 n.29

Li Meng-yang, 117

Li P'an-lung, 120, 124, 127, 129

Li-pen, 31

Li Po, 20, 45, 46, 132, 133, 136–41 passim

Li-sao, 45

Li Shih-ta, 149–50 n.2, 150; *T'ao Yuan-ming*, 187

Li Ssu, 23, 24

Li Ssu-chen, 24, 25, 27

Li Ssu-hsün, 32, 34, 41, 51, 51 n.2, 52, 79, 104, 105, 115, 178, 203

Li-tai ming hua chi, 22, 27–32 passim, 42

Li T'ang, 38, 42, 43, 63 n.53, 170 n.3, 178, 179, 203

Li Ti, 43

Liang K'ai, 43

Liang K'uei, 39

Lieh-tzu, 29

Ling, Emperor, 25

Literati painting, xv, xvii, 60, 65, 68, 71, 75, 80, 81, 88, 90, 114, 116, 123, 124, 125, 129, 176, 178, 202

Liu Chüeh, 88

Liu Hai-feng, 127

Liu Ku-hsin, 42

Liu Kung-ch'üan, 40, 46

Liu Kuo-sung, 204

Liu Sung-nien, 178, 179

Liu Tao-ch'un, 31, 32

Liu Tsung-ku, 41

Liu Tsung-yüan, 45

Lo Ming, 203

Lo P'ing, 104

Lohan figures, 92, 93, 96, 97, 98, 100–101, 102, 109

Lou Kuan, 43

Lü Tsu-ch'ien, xii

Lu Chi, *Wen fu*, 126

Lu Chih, 103, 154

Lu Hsiang-shan, 12, 13, 122, 123

Lu Hsin, 105

Lu Hsin-chung, 100–101

Lu Hung, 51, 52, 53, 60, 61; *Ten Views from a Thatched Cottage*, 60, 61

Lu Kuang, 87, 171

Lu Pan, 22

Lu T'an-wei, 23, 25, 28–31 passim, 34, 46, 51, 52, 55

Lun-hua so-yen, see *Hua-shuo*

Lung-men, carving at, 98, 99

Ma Fen, 43

Ma Ho-chih, 42, 44, 60; *Confucius and His Seventy-Two Disciples*, 105–106

Ma-Hsia school, 74, 74 n.3

Ma Wan, 171
Ma Yüan, 42, 43, 80, 178, 179
Manchu rule, 147, 148, 170, 205
Mannerism, xx, xxi
Mao Yen-shou, 25
Marcel, Gabriel, 9
Mei Ch'ing, 155, 168
Mei-yu-ko wen-yü, 114
Mencius, xii, 12, 13, 46
Mi Fu, 34–37 passim, 39, 42, 51 n.2, 57, 60, 70 n.63,
 80, 81, 91, 98, 129, 178, 179, 180, 189
Mi Yu-jen, 60 n.51, 80, 129, 179, 180
Mi Wan-chung, 150
Michigan Tao-chi exhibition (1967), xv, xix, 146
Ming painting, xvii, xix
Ming T'ai-ch'ang, 145, 146
Mo Shih-lung, 113, 114; *Hua-shuo*, 113, 114
Mongol dynasty, 108
Mu-ch'i, 44, 74, 81, 186

Nanking school, 149, 169
Neo-Confucian philosophy, 9–16 passim
Neo-Socratic philosophy, 9
Ni Tsan, xiii, xiv, xvii, 78 n.21, 86, 87, 121, 126, 154,
 170 n.2 and n.3, 176–79 passim, 188; *Jung-hsi
 Studio*, 87; *Lion Grove Garden*, 70; *Pavilion
 among Pines*, 86. See also Yüan, Four Masters
 of the.
Nine Friends of Painting, 170
Northern vs. Southern School, 113–29 passim,
 171

Orthodox Masters, Six, 155
Orthodox painting, xii, xiv, xv, xvii, xix, xx, xxi,
 73, 88, 148, 149, 152, 157, 158, 161, 162, 166, 169–
 181 passim, 185–99 passim, 201–205 passim
Ou-yang Chiung, 98
Ou-yang Hsiu, 35 n.71, 45
Ou-yang Hsün, 27, 29 n.28, 40, 46

Pa-shu, 180
Pa-ta Shan-jen, 204 n.5
Pao-yen-t'ang pi-chi, 113
P'ei Su, 40, 41
P'ei Wen-ni, 43
Pi Hung, 30, 36 n.78
Pi Liang-shih, 43
Picasso, 197, 198, 199
Pien Luan, 32
Pien Wen-yü, 170
Po Chü-i, 120
Po-erh-tu, 146

Po Lo, 22
Po-ya, 22
Pottery, Neolithic, 21
"Primary Principle," 116, 118, 125, 129
Professional painter, designation of, xv
Pu-tai, 67 n.54
Puyō, tile of, 98, 99

"Red-and-blue" painting, 25
Regulated verse, 131, 132, 135

Sakyamuni, 93
School of Paris, 201
Script types, 91
Seiryōji (Kyoto), 93, 94
Sesshū, xviii; *Winter Landscape*, 195–98
Seven Masters, 118, 120, 125, 129
Seven Sages of the Bamboo Grove, 186
Shang rulers, 21
Shao Mi, 170 n.3
Shao-tung, 43
Shearman, John, xx, xxi
Shen-chiao hsü, 91
Shen Chou, 88, 115, 117, 120, 158, 170 n.3, 178, 179;
 Trip to Chang Kung's Stalactite Grotto, 188
Shen Te-ch'ien, 18
Sheng ch'ao ming hua p'ing, 31, 32
Sheng Mao-yeh, 149–50 n.2, 150, 169
Sheng-yin-ssu, lohan figures at, 105, 107
Shih, 127, 128
Shih chi, 45
Shih Chou, 24
Shih K'o, 39, 186
Shih Lu, 203
Shih-wen. See "Eight-legged essay."
Shōkokuji (Kyoto), lohan paintings at, 100–102
Shōsōin (Nara), painting at, 98, 99, 100
Shu p'u, 26
Shu shih, 36
Six Elements, 25
Socialist realism, 202, 203
Southern school (vs. Northern), 113–29 passim
Southern Sung "academy style," 42, 43, 46, 73–
 76 passim
Southern Tours, 145
Ssu-ku ch'üan-shu, 114
Ssu-ma Hsiang-ju, 45
Ssu-yu-chai hua-lun, 177
Su Ch'e, 60, 70
Su Hsün, 46
Su Shih, 35, 53, 54, 54 n.5, 55, 60, 68, 70, 157 n.15
Su Tung-p'o, 36 n.71, 37, 39, 42, 45, 75, 80, 81

Suchou school, 169, 175. See also Wu school.
Sui-T'ang era, painting in, xvii, 4
Sun Chih-wei, 41
Sun Chün-tse, 74, 174 n.8
Sun K'o-yüan, 39
Sun Kuo-t'ing, 26, 27, 28
Sung academy style, 203
Sung Han-chieh, 52
Sung Hsü, 149–50 n.2
Sung Ju-chih, 74
Sung Lao, 146, 148 n.10
Sung Lien, 117
Sung Min, 42
Sung painting, xvii, xviii
Sung period, Northern vs. Southern, xii, xiii, xvii
Sung Ti, 41

Ta-chiang-chün Tsao Chen ts'an-pei, 91
Ta-kuan, 121
Ta-kuan t'ieh, Sung rubbing of, 147
T'ai-chou school, 121, 122, 123, 129
T'ai-ku, 41
T'ai-tsung emperor, 91
Tai Hsi, 173
Tai K'uei, 30
Tai Sung, 43
Tai Yen-yüan, 78 n.22
T'ang ch'ao ming hua lu, 31
T'ang Hou, 35, 43, 44, 54, 58, 80, 81; Hua Chien, 78
T'ang Hsüan-tu, 36
T'ang poetry, 131–32
T'ang Shun-chih, 126, 128
T'ang-tai, 170 n.2, 180
T'ang Ti, 84, 86, 174 n.8
T ang Yin, 170 n.2 and n.3, 179
Tao-chi, xii, xiv, xv, xvii, xix, 104, 128, 146, 148, 168, 186, 188, 193, 204, 204 n.5; Conversion of Hariti, 188; Hua-yü-lu, 191; Landscape after Ni Tsan, xiii, xiv; Sixteen Lohans, 188, 189; Sketches after Su Tung-p'o's Poems, 189, 190; sketch in the style of Ni Tsan, 188; Small Album, 190, 191; Ten Thousand Ugly Ink-Dots, 189, 190; Trip to Chang Kung's Stalactite Grotto (copy after Shen Chou), 188; Twelve-Leaf Album for Taoist Yü, 191, 192; Waterfall at Mount Lu, xv, 188
Tao-hsüeh school, xii
Tao-kuan, 43
Tao te ching, 23
Taoism, 45, 115
Teng Ch'un, 34, 37, 39, 53, 56
Teng Wen-yüan, 83
Three Antiquities, xvii, 23, 24

Three Yüan brothers, 120, 121, 123, 125
T'i, 10, 11
T'ien-fa-shen-ch'an pei, 91
T'ien-lung-shan, 92, 93
Tien Seng-liang, 31
Ting Yün-p'eng, 103
Tou Meng, 31
Traditionalist critics, 17
"Transmission of the Lamp," 180
Ts'ai Chia, 173
Ts'ai Ching, 37, 40
Ts'ai Yung, 22, 25
Ts'ao Chao, Ko ku yao lun, 77
Ts'ao Chih-po, 121; Two Pines, 86
Ts'ao Chung-ta, 34, 51 n.2
Ts'ao Pa, 43, 52
Ts'ao Pu-hsing, 75
Ts'ao shu, 40
Ts'ao Tuan, 12
Ts'ao Yin, 146
Tseng Yü, 53
Tseng Yu-ho, 204
Ts'ui Po, 39, 41, 67
Tsung Pai-hua, 202
Tsung Ping, 7
Tu Ch'iung, 88, 115, 177
Tu Fu, 34, 46, 177, 129
T'u-hua chien-wen chih, 32
T'u-hui pao chien, 74 n.3 and n.4, 78
Tu Mu, 133, 141, 142
Tun-huang, paintings at, 93, 94, 95, 96, 99, 100, 109
T'ung-Ch'eng school, 127
Tung Ch'i-ch'ang, xiv, xvii, xix, xx, 51 n.2, 55, 56, 73, 87, 88, 90, 91, 93, 104, 105, 107, 108, 109, 113–29 passim, 147, 150, 152, 164, 165, 166, 169, 170, 170 n.3, 171, 174, 175, 177–81 passim, 198, 204; Dwelling in the Ch'ing-pien Mountains, 152
Tung-Chü tradition. See Tung Yüan and Chü-jan.
Tung Chung-feng, 128
Tung Chung-shu, 92
Tung Pang-ta, 170 n.2
Tung Po-jen, 31
Tung Yüan, 36, 51 n.2, 70, 83–87 passim, 124, 170 n.3, 177, 178, 179, 189; Hsiao-Hsiang t'u, 83; Summer Scene: Waiting for the Ferry at Mountain's Opening, 83; Wintry Trees by a Lake, 83
Tung-yüan chi, 177

Vimalakīrti, 36

Wan-li period, 117, 121, 145–48 passim
Wang An-shih, 35–36 n.71

Wang Ch'ang-ling, 133, 139

Wang Ch'en, 173 n.6

Wang Chien, xv, 98, 158 n.18, 169, 171, 180. See also Wangs, Four.

Wang Chien-chang, xix, 152, 157, 161; *Island of the Immortals*, 154; *Picking Mushrooms on the Way Home*, 149–52 passim, 165; *River Landscape*, 153, 154; *Solitary Colors of the Autumn Woods*, 155, 156; *Spring Ravines in the Yü-hua Mountains*, 152, 153

Wang Chiu, 173 n.6

Wang Fu, 87, 88, 171

Wang Fu-chih, 19; *Hsi-t'ang yung-jih hsü-lun*, 128

Wang Hsi-chih (I-shao), 24–27 passim, 29, 31, 33, 75, 91, 92, 93, 105, 178, 179. See also Wangs, Two.

Wang Hsi-chüeh, 145, 146

Wang Hsien-chih, 26, 75, 97. See also Wangs, Two.

Wang Hsiung, 32

Wang Hsüeh-hao, 173

Wang Hui, xiv–xvii passim, xix, xxi, 3–7 passim, 88, 104, 145–48 passim, 158, 168, 169, 170 n.2 and n.3, 171, 176, 178, 179, 180, 186, 205; *Autumn Grove*, 162, 163; *Colors of Mount T'ai-hang*, xv; *Imitating Chü-jan's "Mist Floating on a Distant Peak,"* xv. See also Wangs, Four.

Wang Hung-hsü, 146, 147

Wang Kai, *Mustard Seed Garden Manual of Painting*, 170

Wang Ken, 14

Wang K'o-yü, *Shan-hu-wang hua-lu*, 114

Wang Kung, 37

Wang Meng, 87, 157, 177, 178, 179. See also Yüan, Four Masters of the.

Wang P'in, 13

Wang Shan, 145, 146, 147

Wang Shen, 39, 51 n.2, 178

Wang Shih-chen, xix, 117, 119–22 passim, 124, 125, 129, 170 n.3; *ch'i-chüeh*, 131–44 passim

Wang Shih-min, xv, 145, 146, 158, 161, 164, 168, 169, 173 n.6, 178, 179, 180; *Hsiao-chung hsien-ta*, 171; *Mountain View after Rain*, 158, 159. See also Wangs, Four.

Wang Su, 173 n.6

Wang T'ing-yün, 70

Wang T'o-tzu, 31

Wang Tsai, 32

Wang Tuan-kuo, 158 n.18

Wang Wei, 7, 32, 51, 51 n.2, 52, 53, 57, 60, 61, 69, 70, 77, 79, 83, 115, 116, 129, 177, 178, 179; *Wang-ch'uan t'u*, 60, 61

Wang Yang-ming, 11, 12, 121, 122, 123, 125, 180, 205

Wang Yü, 173 n.6, 180, 181

Wang Yü-yang, 19, 119

Wang Yüan, 87; *Meeting of Friends in a Pine-Shaded Pavilion*, 86

Wang Yüan-ch'i, 88, 145, 169, 170 n.2, 173, 176, 179, 180, 181; *River Landscape in the Manner of Huang Kung-wang*, 171, 173. See also Wangs, Four.

Wangs, Four, xv, xix, 73, 148, 158, 169, 170, 175. See Wang Shih-min, Wang Chien, Wang Hui, and Wang Yüan-ch'i.

Wangs, Four Small, 173

Wangs, Two, 4, 24–28 passim, 35, 36, 40, 46, 93. See also Wang Hsi-chih and Wang Hsien-chih.

Wei-han, 42

Wei Hsieh, 23, 41

Wei Luan, 30

Wei Yen, 86

Wen Cheng-ming, 120, 169, 170 n.3, 171, 178, 179

Wen-jen-hua group, 81

Wen T'ien-hsiang, 78

Wen T'ung, 70, 75, 80

Wu Chen, 87, 177, 178, 179; *Hermit Fisherman at Lake Tung-t'ing*, 87; *Two Pines*, 86. See also Yüan, Four Masters of the.

Wu Ch'eng, 75 n.10, 77, 78

Wu-hsing, as cultural center, 74, 75, 76, 78, 79, 81, 84, 86; "Eight Talents of," 75, 78

Wu Hung-yü, 114

Wu Ku-sung, 42

Wu Li, 73, 148, 169, 171, 172, 176

Wu Pin, 103, 150; *Thousand Peaks and Myriad Rivers*, 152

Wu school, 117; 169, 170 n.3. See also Suchou school.

Wu Tao-tzu, 28–31 passim, 34, 35, 36, 41, 46, 51, 51 n.2, 53, 57, 61, 63, 66, 68, 89–90, 98; *Hell Scene*, 57; *Sung-tzu t'ien-wang*, 69

Wu Tsung-yüan, *Ch'ao-yüan hsien-chang t'u*, 68

Wu Wei, 117

Wu Yü-pi, 12

Wu Yüan-yü, 38

Wu Yüeh, 36

Yang Hsiung, 45, 46

Yang Tsai, 70

"Yangchow Eccentrics," 169

Yao Shih, 75 n.10

Yao Shou, 88

Yao Yen-ching, 84, 86

Yeh Hsieh, 19

Yen Chen-ch'ing, 40, 46, 75, 105

229

Yen Li-pen, 66

Yen Li-te, 31

Yen Wen-kuei, 32, 75, 174

Yen Yü, 116, 118, 119; Primary Principle of, 116, 118, 125, 129

Yin-jeng, 145, 146, 147

Yin Shu, 45–46

Yü-chien, 186

Yü Chien-wu, 25

Yü Shih-nan, 27, 29 n.28, 40, 46, 93

Yü-yang shan-jen ching-hua lu, 136

Yu-jen, 178

Yüan Chen, 120

Yüan Ch'ien, 30

Yüan, Four Masters of the, 90, 129, 170 n.3, 178, 179. See Huang Kung-wang, Ni Tsan, Wang Meng, and Wu Chen.

Yüan Hao-wen, 115

Yüan Hung-tao, 120, 124

Yüan Mei, 18

Yüan painting, xvii, xviii, 46, 73–88

Yüan Yen, 36 n.78

Yün Shou-p'ing, 73, 169, 171

Yün-yen kuo-yen lu, 42, 53, 55

Zao Wou-ki, 204

Zen, self-cultivation in, 133